Hunting
North American
Waterfowl

AN OUTDOOR LIFE BOOK

John O. Cartier

Hunting North American Waterfowl

Drawings by Douglas Allen

Outdoor Life Books
New York
•
E. P. Dutton & Co., Inc.
New York

Contents

PART II Goose Hunting

PART III Miscellaneous Lore

Preface

I am convinced that all waterfowlers are romantics. They love the swish of wild wings over decoys, the shoulder thump of a heavy shotgun against layers of woolens, the blood-sparkling excitement of frosted fall, the whitecaps and rolling waters of sudden storms, and the fragrant beginning of a new day in a wild place with wild things. It is a partial purpose of this book to recapture these sensations and images. If I succeed in returning your thoughts to bygone days spent in favorite blinds I will have accomplished one of my objectives.

There are two other, perhaps more important, ones: It is my hope that this book will help all hunters to develop their skills, and will instill in them a deep appreciation of a precious heritage that has endured for hundreds of years.

Modern waterfowling, in many respects, is an entirely different game than it was a generation ago. So important are these changes in theory and hunting methods that many successful practices of years gone by are almost a total waste of time today. And similarly, there are modern tricks capable of filling quick limits that would have been laughed at years ago. This is not meant to imply that waterfowl books previously published are obsolete. Some of those volumes are superlative works. Millions of words have been printed on basic waterfowl characteristics and elementary hunting procedures. It is assumed that the reader of this book already possesses much of this knowledge. If he does not, the material is readily available. Thus, this book is intended as a supplement. It describes methods and techniques which represent the most successful up-to-date hunting practices.

Sincere appreciation is extended to the publishers of *Outdoor Life, Field & Stream, Sports Afield,* and *True* for permission to reprint in this book parts of the author's articles and stories originally appearing in those magazines.

JOHN CARTIER
Ludington, Michigan

I

Duck Hunting

1

The Realm of the Duck Hunter

Even to nonhunters, seasonal migrations of waterfowl are one of the most familiar and spectacular of all wildlife phenomena. The freedom of V-shaped flocks winging across gray skies and the mystery of where they come from and where they go never fails to arouse a sense of awe in all who see them.

Waterfowl gunning has retained its appeal for Americans since the beginning of our country. There can be no doubt that pioneers felt the same tingling excitement watching wild ducks that the modern wildfowler feels today. The pioneer found it difficult to kill a duck for needed food. Today's hunter accepts the same challenge as a measure of recreation. All else remains substantially the same.

The objects of the hunt are the same birds. They have maintained their habits, their same migration routes and timetables. The changes in wildfowling have been entirely brought about by man—his technological improvements in hunting equipment and transportation, and his practices of land management, practices that have, in effect, limited his sport to a mere fraction of what it might be. The ducks do not know these things, but they continue to exist and multiply in sufficient numbers to furnish the most exhilarating outdoor excitement in the sporting world.

Successful duck hunting is more complicated than most shooting games. Such winged targets as quail, pheasant, and grouse can frequently be gunned simply by tramping selected farm cover or woodlands. Not so with ducks. Some fundamental

knowledge is a must, as most shooting requires luring a wild and always suspicious bird within killing range. This requires knowledge of the birds' habits, the ability to handle boats in smooth and rough water, to rig and set decoys, to hide yourself and your boat, to use duck calls, and to know where the birds will be and when they will be there. In addition to all this we must use the right combination of gun and ammunition and be outfitted in special clothing to withstand the rawest weather.

Wild duck hunting today isn't as great as it could be. The untold millions of waterfowl that darkened skies over the North American continent a hundred years ago have diminished to far fewer numbers. Qualified professional conservationists tell us that unless continued attention is directed to wild duck production and protection, duck shooting as we know it today could become merely a fond memory.

Fortunately, these experts know what to do and how to do it. Unfortunately, they can't bring about the remedy by themselves. A fine future for duck hunting can only be brought about by hunters and others interested in ducks as a valuable resource. Strange as it may seem, duck shooting as we enjoy it today would undoubtedly have passed from the scene long ago if it hadn't been for the efforts of earlier hunters.

The waterfowl family, on a worldwide basis, comprises some 225 species. Sixty-one of these are native North Americans. Many are born and remain throughout life largely within the continental United States. Greatest numbers, however, are hatched and raised in the immense reaches of Canadian prairies.

In early fall, as their homelands become covered with ice and snow, these birds form great flocks and migrate to winter locations in sunny southlands. The gulf marshes of Louisiana and Florida attract huge concentrations. Others set up shop in the southern marshes of both the East and West coasts. Still others journey as far as Mexico and South America.

When spring comes, reverse movements begin. Across the breadth of the land the great flights are on the move. The birds, driven by the primordial instinct to mate and the urge to find new places to rear their young, again fill the heavens with wavering wedges, this time flying north.

Shooting seasons open in Canada in late summer. They close in the southern states approximately the middle of January. A duck hatched in Canada runs a gauntlet of guns for nearly four months before settling down for a winter in the

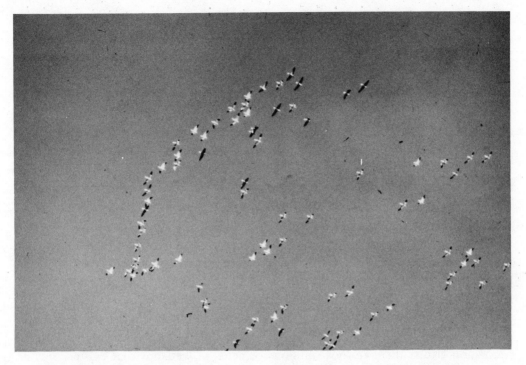

Mixed flock of snow and blue geese head south during autumn migration.

south. It is a cause for much wonder how sufficient numbers survive to offer ample shooting enjoyment.

Speculation is certainly not unfounded but there is no legitimate cause to exclaim murder. It is known that the hunters' legal kill amounts to approximately 19 million ducks each fall. (United States hunters harvest an average of 15 million, Canadians take 3.5 million, and Mexican gunners bag half a million.) In comparison, drought on the nesting grounds kills some 22 million, crows and magpies destroy over 16 million, and fire or dry spring marshes wipe out another 13 million. Losses other than from hunting destroy nearly six and a half times as many ducks as the gun.

Such statistics indicate that increasing populations must be accomplished by controlling much more than sport hunting. We must restore breeding marshes, improve wintering refuges, control predators. This costs money.

And who supplies the cash? Mostly the duck hunters. They supply it through

state and federal license fees and contributions to such conservation organizations as Ducks Unlimited. So, in the end, it is the hunter himself who saves the ducks. How this program began, and how it is rolling forward, is a story of nonprofit promotion and international cooperation.

Until the early part of the century, hunting restrictions were few and waterfowl were slaughtered in fantastic numbers. Market gunners made their livelihood by annually taking thousands of birds. Sport gunners hunted with live decoys over baited areas during both spring and fall migrations. Coupled with such factors was the wanton destruction of breeding marshes by draining for supposed agricultural benefits. Sportsmen and conservationists who looked ahead to future years recognized an inevitable end if uncontrolled killing continued and nothing was done to reinstate breeding and wintering areas.

Shooting ran from September into May. Perhaps more waterfowl were killed on northward migrations in the spring than were harvested in the fall. Many of these birds had already mated and were prepared to bring on new broods. Fortunately, such wanton destruction is a thing of the past.

The annual show begins with arrival of spring flights on the breeding marshes of our northern states and Canada. Thanks to federal, state, provincial, and private restoration efforts there are now millions of acres of wetlands that existed only as dust bowls thirty-five years ago. The ducks don't all arrive at once, but appear with remarkable punctuality by species: mallards and pintails first, early in April, then canvasbacks, redheads, goldeneyes, and others late in April. Last to arrive are the white-winged scoters, which do not come until the second week of May. Paired birds arrive first, followed by waves of largely unpaired groups, some in courting parties, some showing no intentions.

As days go by all potential nesting hens find mates. Individual couples then retreat to small restricted areas termed "territory" to carry out family functions. A territory has no definite boundaries; it is simply an area that the drake viciously defends against intrusion of other sexually active birds of his own species. Not just any water area will serve as territory. It must contain four specific components: water, loafing spot, vegetation nesting cover, and adequate food.

Territories are selected by the female, and requirements vary considerably according to species. Some species prefer potholes, sloughs, or ditches; others the

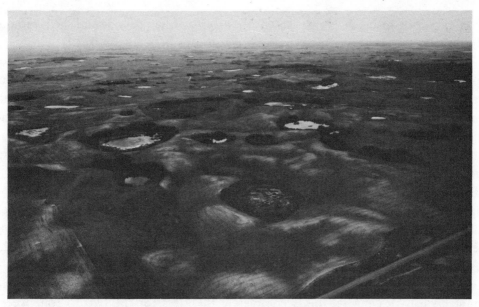

Canada's prairies and parklands, with their myriad ponds and waterways, produce the majority of North America's ducks. This reproduction area is northwest of Regina, Saskatchewan.

more open water of bays or lake shorelines. Most ducks nest in ground cover close to water, a few in emergent vegetation, and a very few in trees. Incubation of seven to ten eggs averages twenty-one to twenty-four days. Total span of nesting periods of all species covers a period from late April through July. After hatching, various young ducks require from eight to eleven weeks to attain flight.

From these basic facts one conclusion is easily drawn. Because of the dozens of species with their own definite territorial needs, countless variations of land and water must be maintained. These conditions must prevail through all of the spring and summer months. Of course, it would be much simpler if all ducks arrived on the marshes at the same time, were compatible as to territory, and started nests concurrently. Such a situation would provide adequate territory for many times current populations, cut losses from extended drought, and concentrate predator attacks in a much shorter period.

Even if this ideal were possible, many problems still would remain. The existence

of an excess of males in North American waterfowl has been established without doubt. The ratio is generally accepted for purposes of study as 60:40.

Say, for example, we have a single marsh population of 10,000 ducks. Instead of a possible 5,000 breeding pairs, we have 4,000 at best. Some females will be non-breeders and others will lose clutches or parts of clutches. Waterfowl biologists estimate 61 percent of each average clutch is lost through natural causes. Let there be a serious drought during any part of the long preflight season and it becomes very possible that any given flock might not be able to reproduce its numbers, much less show an increase.

Even the unlikely combination of high brood success and bountiful water is no guarantee of a population increase. Certain inherent peculiarities of waterfowl spell trouble for both young and old. Some species abandon their ducklings, forcing them to shift for themselves long before the flight stage. Such youngsters become unwary targets of predators.

All adults undergo a curious method of molt: all flight feathers are shed simultaneously, leaving the birds completely flightless for the two to four weeks necessary for development of replacements. During these summer molts, ducks are extremely vulnerable to their natural enemies and to the elements. All of these factors suggest that any one duck has a hard time surviving to attain a place in the fall flight south.

Most hunters divide ducks into two general classifications: puddlers and divers. The puddle ducks are those frequenting shallow waters of ponds, sloughs, marshes, and rivers. They secure their food by dabbling and wading, picking up morsels from the weeds and bottoms. They are among our finest table birds, especially when they have been feeding on grain. They are also among the most colorful of all wildlife.

The divers or deep-water ducks are, as their name suggests, birds that prefer open lakes or large bays with deep water. They secure their food by diving to great depths, uprooting underwater vegetation, then consuming the rootlets, tubers, and seeds on the surface. They attain fantastic airspeed; some species have been clocked at over 70 miles per hour. They are, as a group, more heavily feathered and more hardy than the puddlers, traveling farther north and acclimating readily to extreme conditions of snow and ice. In general the gunner will need more equipment and more know-how for divers than he will for puddlers.

Two Main Gunning Methods

Duck-hunting techniques are many and varied, because of extremes in habitat preference of the two classes and extremes in geographical conditions of water and food. But all hunting is by one of two methods: enticing the game to the gunner, or going to the game. The second is the simpler—cautiously approaching resting or feeding birds either afoot or by boat. This method is mostly limited to puddlers and is practiced usually by occasional gunners and the dedicated boat hunters who silently drift over small rivers and streams.

Floating is perhaps the most suspense-filled and colorful of all duck gunning. Each bend of the stream, each clump of cattails or brush may explode with a flock of skyrocketing mallards. Each stretch of lowland glitters a new array of frosted color. A light breeze often swirls a carpet of red and yellow leaves freshly fallen on a fragrant side hill. The supreme excitement comes when you hear a mallard's feeding chuckle around the next bend. The slow action of current moves your boat forward at a snail's pace. The gunner in the bow freezes in anticipation of sure action; the man in the stern, who is guiding the boat, feathers his immersed paddle, lest even the rhythmic dripping of water should generate alarm. Yard by yard the distance narrows. Then, suddenly, the bomb is touched off; mallards explode from clouds of spray. A shotgun roars, then again. A duck tips over, plummeting to water in a slanting splash. A retriever leaps at command of "fetch!" The gunners change position—safety prescribing that only the bow man shoots—and the boat drifts down the sparkling sun-touched waterway to new adventure.

Enticing ducks to the gunner requires expert use of decoys, blinds, boats, and duck calls. This, the most popular form of duck hunting, is practiced everywhere, being equally effective with either puddlers or divers. In fact, it's the only method of consequence by which divers are taken. Hunting theory is simple. Decoys are placed in areas the birds are known to frequent. Gunners conceal themselves in blinds constructed to blend with surroundings and hope that wild birds will accept their presentation of decoys and their calls as a flock of feeding friends.

This deception is by no means easy! A distant flight of ducks is merely an opportunity; the birds don't do the hunter any good unless he can offer deception with foolproof naturalness. Since wild ducks are among the wariest of all game birds, the techniques of creating this deception constitute the art of waterfowling. Take, for example, the canvasback, recognized king of the divers.

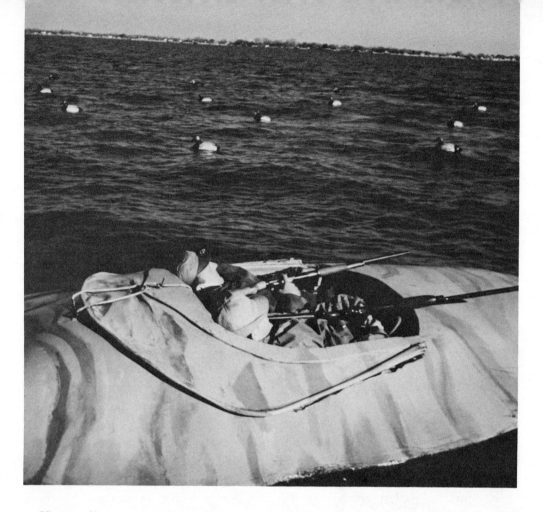

Hunters lie prone in a layout boat, their heads tilted just enough to spot incoming flights of ducks to their decoys.

In the puddler group the mallard reigns supreme, not only with hunters but with all other shallow-water ducks. When the mallard says "Let's go," other ducks go immediately. When he says "We will all be safe here," his word is gospel. With legions of gunners the mallard is top trophy; to harvest a limit is to prove the utmost in skill. His elusiveness, however, is only part of his appeal. He is the handsomest and most plentiful of all ducks. His velvet green head, richly colored body, and saucy curled tailfeather brand him with nobility. His choice of the best food guarantees that he's excellent food himself.

No ordinary blind and set of decoys will stop a flight of mallards. Perfection is

a must. Decoys must be absolutely lifelike. Blinds must blend seamlessly into the landscape. But faultless decoys and blinds aren't enough to entice mallards within shotgun range. This duck wants to be "told" everything is safe, then invited to participate in the apparent food bonanza. To do this requires expert manipulation of a duck call: knowing what to say, when to say it, and how to say it exactly like a contented duck.

Even perfection in all these factors rarely fools gun-wise mallards. They will fly many circles of the area, investigating each tiny detail, before descending to decoys. When they do come down they frequently alight beyond effective killing

Hunter in a pit blind swings into action as ducks swoop toward his spread.

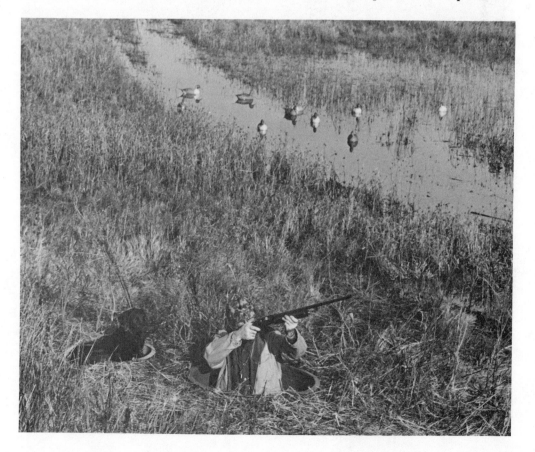

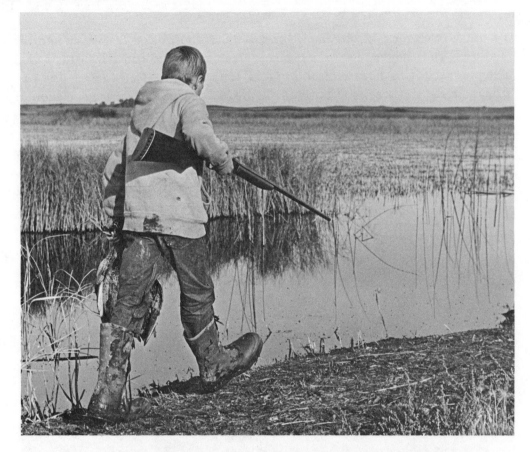

Young hunter needed only knee boots and single-shot gun to bag his ducks.

range, remaining suspiciously alert for many minutes before assuming all is serene. No wonder, then, that duck shooting demands precise skill.

Hunting Pressure and the Census

Migration routes are followed by the same groups of individual ducks during successive years. Designation of these routes as "flyways" was announced in 1935, but it was not until 1948 that hunting regulations were established by the flyway

concept. The fact that ducks breeding in Canada funnel through designated tiers of states during migration helps to make it possible to determine hunting pressure.

Stated in another way, it can be positively forecast that a poor crop in any section of the North will result in small flights all along the flyway these birds are known to follow. If flocks are large, shooting restrictions may be eased; if small, restrictions must be increased.

There are four flyways: Atlantic, Mississippi, Central, and Pacific. All hunting seasons in terms of length, bag limits, hours, and minor restrictions are determined according to estimates of the number of birds populating each flyway. These regulations are federal, being set late each summer after careful consultation between the United States Fish and Wildlife Service and the various game representatives from individual states and wildlife organizations. Regulations are based on the abundance of the crop to be harvested, a population total that is derived from a careful census of all continental waterfowl.

Truly accurate counting of millions of ducks is, of course, impossible. What's actually accomplished is a determination of probable totals by averaging known statistics. Small cross-sections of widely pinpointed areas are selected for visual count by waterfowl experts in boats, planes, and land vehicles.

The waterfowl census is obviously important, and tremendous effort is expended to make it reliable. Take, for example, a recent winter's survey by the United States Fish and Wildlife Service, the first of three annual counts. A total of 1,691 persons throughout the continent participated. Over 130 planes registered 1,055 flight hours, flying 100,027 miles; 1,091 vehicles were driven 106,990 miles; and 92 boats tallied 4,047 miles. Total populations were evaluated by projecting sample counts to unobserved areas incorporating similar habitats.

Most veteran duck hunters can predict whether a waterfowl census covering the entire country will show more or fewer ducks. It all ties in with water levels on the breeding grounds. In high-water years ducks reproduce with astonishing success. The opposite is true during a dry year.

It appears from observation that drought on the prairies represents history repeating itself. In the 1930s, yearly successive droughts took a continuous toll of nesters until waterfowl populations reached a new low. But high-water marks in the mid-1950s enabled production of so many ducks that hunting resembled the good old days. Then nature again reversed itself with dry years through most of the 1960s. But the tide turned back in 1969 with high-water levels throughout the

prairies. The result? In the Mississippi Flyway duck populations bounced up to 40 percent higher than the previous 22-year average. Mallard numbers catapulted an astonishing 86 percent in 1969 alone. All those ducks found ideal nesting conditions through most of the 1970s.

Modern droughts, though serious, have diminished considerably from the catastrophes of the 1930s. Water-control projects have functioned as designed to reduce the severity of drought cycles as they occur.

Conservation programs, both governmental and private, assure the continuation of breeding-ground restoration work that, with an assist from nature, could supply bountiful duck hunting to twice the number of today's gunners. We now have more than seven times the number of continental waterfowl that existed in 1934.

Such facts mean that your children and their children will be able to thrill to rushing wings over the marshes. Now that man has replaced persecution and disregard with restoration and knowledge, the grand old sport of duck hunting should endure for generations to come.

2

The Good Old Days

All waterfowlers have heard about the good old days when duck and goose shooting was of such fabulous quality that it can never again be duplicated. But when were those days? And did the old-timers really enjoy quality shooting, or was it the quantity of game they bagged that produced the legends and folklore?

Some market hunters claimed that professional duck hunting was the most miserable and difficult job a man could choose for earning a living. They pointed out that to make a good day's pay a market gunner had to kill more than fifty ducks. At the end of the day he would have to draw and pack his birds and get them off to a commission house. That would take half the night. And to keep his wages coming he would have to be shooting every day at dawn seven days a week. There was little sport in that business; it was all hard work, long hours, and low pay. It was a type of duck hunting that would appeal to practically nobody today.

The gunners who belonged to duck and goose clubs made up the majority of hunters who shot for sport prior to the turn of the century. Gunning camps run by and for rich men were operated on desolate marshes, tidal rivers, and bay and lake shores over much of the country. A big share of the legend of the good old days is based on records kept by those clubs. It's enough to make the modern gunner drool (or get violently angry) when he hears that upwards of 15,000 ducks were killed in a single day on Chesapeake Bay back in the 1870s.

Today redheads are relatively scarce, but records of the Winous Point Club show that members killed over 1,400 redheads alone during a single season. One member of a Palmer Island club bagged 160 canvasbacks during one day's shooting on Currituck Sound. About the same time four members of a West Coast club downed a day's bag of over 400 teal.

Those are the things we hear about the good old days. But if we were living back in the late 1800s it's a good bet that we wouldn't have participated in that fabulous gunning. It was reserved for a very few wealthy men.

I have in my file a yellowed newspaper clipping, so old it's about ready to disintegrate. It tells the story of Lake Erie's Long Point Duck Club, which was established in 1866. The sub-headline reads, "Ducks at Lake Erie club cost millionaire members $20 to $100 per bird." A study of that story casts a new light on what some of the good old days were really like.

The original property consisted of 14,000 areas of marsh and land that was purchased for $19,000, a fortune at that time. A few years later the official club was formed with a capital investment of $50,000. One of the pioneer club members, the late Charles Harris of Toronto, recalled that duck hunting had little appeal for many members because the sport was too cold and uncomfortable. He contended that most men got their fill of shooting from wild turkeys, wild pigeons, partridges, and woodcock. Even so, club archives for 1870 chronicle a total kill of 11,030 ducks for the season.

The club sold surplus ducks to the market. One early sales-ledger entry records "two tons of ducks." Canvasbacks were in great demand. The Knickerbocker Club of New York purchased thousands of the fine birds. King George V, while he was still a prince, and his partner once killed 141 ducks in two days at the club. He said later, "It was the most charming holiday of my life."

The club maintained a regular bar presided over by a uniformed barkeep. Each member had his own comfortable cottage. There was a central house with a dining hall and billiard rooms. The buildings were set above the marsh on pilings and were connected by raised sidewalks. A lush setup, but membership fees and overhead costs were so high that even millionaires began to wonder if the cost per duck was worth it. Membership fell off rapidly in the early 1900s.

It's interesting to note, though, that club officials eventually learned that overshooting could ruin their sport. Strict rules governed hunting in the club's later years. Some of those rules were harsh even by today's standards. Pump guns were

prohibited. No shooting was allowed before 9 A.M. or after 4 P.M. No member could shoot within 400 yards of his neighbor. All birds bagged had to be turned in to the headkeeper, who was responsible for seeing that no member killed more than fifteen ducks per day. Even more astonishing was the fact that no shooting was allowed until October 1, even though the legal duck season opened in early September.

Most of the old-time duck and goose clubs weren't so elaborate or restrictive, and many offered shooting that bordered on being no sport at all. They usually consisted of a clubhouse where members ate, drank, relaxed over cards, and slept. In many cases trenches connected the clubhouse to blinds where guides watched for birds working in to live decoys. When enough wild birds were available for a barrage of shooting, the guide would ring a buzzer that sounded in the clubhouse. Members would grab their guns, sneak through the trench, stand up in the blind, and slaughter the birds as they flushed. After the shooting was over they went back to their cards and hot buttered rum. Such activities would be repulsive to today's hunter, or anyone who considers waterfowling a sporting challenge.

Before the era of clubs and market hunters there weren't any good old days. It has been estimated that there were 500 million ducks and geese in North America when the Pilgrims landed in 1620. The amount of sport hunting during the following 250 years amounted to just about nothing. The bell-mouthed blunderbuss of the early settler didn't kill many ducks. It wasn't until colonial days when improved gunpowder was invented that it was even practical to shoot a duck—big-game animals provided much more meat from the costly cap-and-ball guns. The picture began changing when the invention of buckshot made it a little more practical to fire a charge of death into a maze of swimming waterfowl.

Still, there was little damage to the vast hordes of ducks and geese for many more years. The human population was very small and concentrated in the eastern part of the country. Men didn't have time to hunt for sport; they were too busy felling trees, clearing fields, building cabins, and trying to exist in a harsh new country. They killed only for food and clothing. The majority of wild waterfowl lived out their lives without ever hearing the blast of a firearm.

It wasn't until the 1800s that trouble brewed for the vast flocks. Settlers surged westward. The human population exploded from 4 million in 1790 to 50 million by 1880. Pioneers built new towns along the ever-lengthening ribbons of gleaming railroad tracks. Big cities blossomed in the East and their rich men developed an

insatiable appetite for wild game. The slaughter of game birds and animals began to become a rewarding business.

Men with a hunting instinct migrated into waterfowl breeding and wintering areas where ducks and geese blanketed the water and darkened the sky. There were few game laws, and nobody paid much attention to those that existed. Some men, the original market hunters, discovered that there was more excitement in killing game than in logging or tilling the soil. The market back East could swallow more ducks and geese than gunners could kill with regular guns. Cannons were developed that were too large to be fired from the shoulder. They were mounted on scows, and they fired monstrous charges of shot that could annihilate an entire flock of swimming ducks or geese.

Nets, traps and all sorts of mass killing devices were developed to satisfy man's greed. The records of waterfowl killed and shipped to eastern markets stun the imagination. Some killers managed to average 200 birds a day for years. There is a record of one southern dealer shipping out over 5,000 mallards and black ducks in a single day. The men responsible for those sickening acts were businessmen, not sportsmen. Perhaps they were no more responsible for their acts than were the loggers who raped the forests. Nature's supply of everything appeared unlimited.

By the mid-1800s a few thinking men became aware that wildlife populations were shrinking at an alarming rate. The passenger pigeon was already on the brink of extinction; the herds of wild buffalo were disappearing. Up until this period nobody even considered that killing wild game should be considered a sport. The "good old days" of hunting for fun were still in the future.

The new era began when legislation established the first laws that limited the taking of wild game by time and method. The regulations varied from state to state, but a glance at the chronological history of Michigan's waterfowl laws will serve to show how and why market hunting ceased to be a profitable business.

The first legislation involving waterfowl was Public Act 175, enacted into law in 1859. It established a fall shooting season on mallards and teal that began on August 15 and ended on February 1. Similar seasons were established on other ducks, geese, and swans in 1863. Two years later Public Act 278 outlawed punt and swivel guns. Traps, nets, and snares were banned for harvesting birds in 1871. It was now obvious that the ruthless killing of ducks and geese for market was history. The businessmen-murderers faded from the picture.

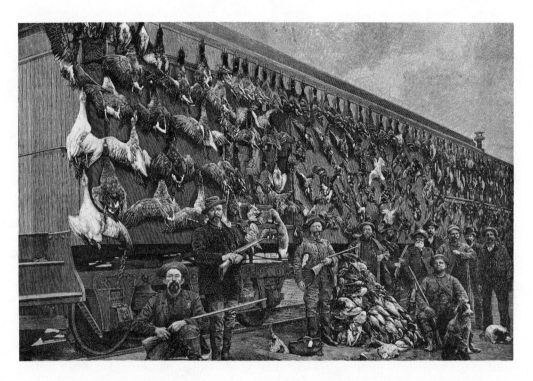

The result of a day's hunt near Webster, Dakota. By the mid-1800s, market hunters had seriously decimated the waterfowl of North America. *Bettman Archive.*

Now began the period that built the legends of the legitimate market hunter, the grizzled and nimble old-timer who fired his shotgun with awesome accuracy. This man had the original thrilling itch of sport hunting throbbing in his veins. He had to hunt ducks and geese because he loved the game more than any other way of making a living. He began the period of duck-hunting skill, the original era of carving superb decoys, building special-design hunting boats, designing blinds, and learning the habits of wild waterfowl.

He became an expert hunter because his wages depended on it, and there were still enough ducks and geese left to teach a man how to hunt through the single medium of experience. These men pioneered the sport of waterfowling as we know

it today. We owe them thanks for the benefit of their hunting knowledge, which was passed on for scores of years from fathers to sons. What an irony it is that these men were actually destroying the things they loved most.

Many years ago the market hunter was looked upon by sporting men with the same reverence accorded to early frontiersmen. Now this forgotten American has become a source of national shame. If he were operating today he would be the worst kind of criminal. It is cause for amazement that his acts were once supported by society. In the end it was society—and the passing of the great abundance of game—that put the market hunter out of business.

Legal shooting seasons became shorter. During the late 1880s Michigan's waterfowl seasons usually ran from September 1 to May 1, with a slight interruption during winter. In 1905, Public Act 257 limited fall shooting from September 1 to January 1; and the spring season was shortened to March 15 to April 10. The same act imposed the first bag limits. Market hunters roared with disapproval when they learned that they could not kill more than twenty-five birds per day.

In 1913, spring hunting was outlawed and the first Michigan hunting license was required. Market hunting was doomed. It went out of the picture entirely in 1918, when further legislation prohibited the selling of migratory birds. Twenty-five years later it was hard to find a man who could tell of his personal shooting exploits during the heyday of gunning for the market. A unique phase of American history faded into oblivion.

Duck and goose hunting legislation continued to be more restrictive. Use of guns larger than 10-gauge was banned in 1919. Only one gun was allowed per hunter. Airplanes, sailboats, and power boats were prohibited for the use of taking waterfowl. In 1925 the daily bag limit was reduced from twenty-five to fifteen ducks. A few years later the first shooting hours were established and the shell capacity of guns was restricted. The laws had become somewhat comparable to what we have today. Waterfowling had truly come of age as a challenging sport.

It is my contention that the good old days didn't belong to the market hunters or any gunners who preceded them. Those groups shot from necessity; they had no time to enjoy themselves. The true good old days emerged in the early years of this century, when sport gunning boomed.

Waterfowl shooting for fun is a luxury. Such luxury could not have been possible for the average man until the pioneering was finished, small-town America was built, and citizens finally found the time and inclination to give some thought to

enjoying themselves. Along with this came the automobile and highways. It was now possible to travel to good hunting areas. Fine shotguns were being mass-produced and sold at prices a working man could afford. Ammunition, decoys, and boats were also reasonably priced. Top duck and goose hunting suddenly became within the reach of almost anybody..

Those good old days got strong assists from the facts that no-hunting signs were almost nonexistent, gunners found little competition, bag limits consisted of more birds than you would want to clean, and huge concentrations of waterfowl still filled the skies. A few examples will prove the point.

One of the first duck hunters I knew passed on at eighty-five years of age a few years ago. Pete Hardy, in his middle age, was one of a new breed of gunners who shot for fun. He and his companions gunned divers on a large inland lake near my home. When I was a very small lad I used to watch those men shoot.

They worked from a sneak set. The sneak boat was painted white and the gunners wore white clothing. They placed about seventy-five decoys 200 yards off an upwind shoreline. My blood just about boiled with excitement when I watched them drift into flock after flock of divers that had pitched to landings in their decoys. The shooting was fantastic. It never lasted more than a few hours, since the men couldn't take care of more ducks than they killed during that time. During the rest of the day they cleaned birds, relaxed, laughed a lot, and thoroughly enjoyed life. This was the way duck hunting should be, a far cry from the wretched life of the market hunter.

One of the last of the old-time duck hunters in my area told me about a duck hunt in the 1920s that began with a fishing trip. He took a small cabin cruiser out on the lake and began trolling for walleyes on a sun-washed October afternoon. After trolling down a shoreline a couple of hours he approached an enormous raft of bluebills feeding close to a wooded point.

"There must have been 5,000 ducks in that raft," he recalled. "I had a couple of dozen decoys, a shotgun, and two boxes of shells in the boat. I pitched the blocks out where the birds were feeding, then tied my boat behind a couple of stumps. You just couldn't keep those ducks out of there. I shot my shells up almost as fast as I could stuff 'em in the gun. I bagged twenty-three birds, two short of my limit. You talk about the good old days and I think about the 1920s. We had 107-day seasons then, and there were ducks by the thousands almost anyplace. We had more shooting than we could handle in those days."

Another oldster told me about his Philippine houseboy who was the most enthusiastic duck hunter he ever saw. "He'd slave like two men to get his housework done just so he could go duck shooting down on the lake. He used a dozen or so battered decoys in front of a clump of shoreline bushes. He used to bring so many ducks home right after World War I that I finally told him he couldn't shoot anything except redheads and canvasbacks."

During my first hunt for mallards on the prairies of Canada, I was amazed to see thousands of ducks feeding in a single stubble field. My farmer host was amused when I told him I'd never seen so many mallards in one place.

"It's nothing like it was when I was growing up fifty years ago," he recalled. "In those days the ducks would pour out of the skies like black clouds. They could just about bankrupt a farmer by eating up all his wheat. The kids in my time had the joyous job of trying to keep the ducks out of the fields. It was a bit illegal, but we shot them by the hundreds. I can remember many a day when we took a horse-drawn wagon out into the stubble and half filled it with mallards we shot. It wasn't really a big sin, though. Food was scarce during the Depression, and a grain-fed mallard makes the finest eating you can get. We could have given away twice the number of ducks that fell to our guns."

Another old-timer, now so crippled with arthritis that he hasn't been able to hunt for fifteen years, gave me his account of the good old days. "When I was a teenager I ran a trap line to earn money to buy shotgun shells. I must have trapped an awful pile of muskrats, because I sure shot a lot of ducks. I'd figure it was a bad day if I couldn't bag my limit of twenty-five birds. Late in the fall, after the ponds and lakes froze over, I'd float-hunt on rivers. The ducks were stacked on those open-water currents like cordwood. I can still recall that fabulous shooting as if it happened yesterday. I feel bad about being an old man, but I'm glad I was a youngster during duck hunting's greatest era."

And so the stories go. The best of the good old days were likely enjoyed from the very early 1900s up until the duck depressions of the 1930s. Perhaps the top period was from after the end of World War I to 1930, the year of the last 107-day season. Money was plentiful after the war and wages were relatively high. Almost any ambitious man owned an automobile and a shotgun. Waterfowl bag limits were still high, and most good hunting areas were free to roam.

But the end was in sight. Duck and goose habitats dwindled as hunting pressure boomed. Sport hunters (collectively) killed more birds in one year than the old

market gunners harvested in ten years. Then came the great droughts that withered grain fields, shrank lakes, and turned prairies to deserts. Waterfowl breeding grounds dried up and the huge flocks of birds disappeared.

Of the original 500 million ducks and geese that once winged over North America, only 30 million remained in 1934. Hunting was drastically curtailed by reduced seasons and bag limits. The good old days were gone forever. It was to be a long road back to the modern waterfowling that we know today.

3

How to Identify Ducks

The October morning was bright and still. An Indian-summer sun was low in the eastern sky and the air was so clear it seemed sterilized. My partner and I were pass-shooting at ducks trading between two marshes in central Minnesota. Several varieties of puddlers were crossing a half-mile-wide strip of grass knolls. We had picked a knoll under a flight lane and had flattened in the grass. We simply jerked to shooting positions as flocks of low-flying ducks whipped over us.

My partner was a novice waterfowler. His idea of the greatest thrill in the world is ruffed grouse hunting, and he's one of the world's best at that game. We had traveled to Minnesota to hunt over his expertly trained pointer. After filling our possession limits of grouse we decided to spend a couple of days enjoying the area's great duck hunting. It was a fine idea except we had to be very careful in picking our targets. Daily bag limits that year allowed only one mallard and one wood duck. Both species were winging over us almost continuously.

The air was so washed with sunshine that the ducks appeared against the blue sky as clearly as the color photographs on calendars. I've never been on a hunt where species identification was so easy. Most of the birds were angling by on a 45° angle. Their body shapes and broadside colors were clearly discernible. I've been hunting ducks for nearly four decades, so I was able to identify the species of each approaching flock long before the birds were within gun range.

But my partner didn't have that ability, and his lack of species knowledge almost got us into trouble. To him a duck was a duck, and each one had the same appearance. Several times, after we had bagged our mallards and wood ducks, he leaped to his feet and shouldered his gun as flocks rushed past us. Each time I yelled, "Don't shoot. They're the wrong ducks."

After we harvested our bag limits we unloaded our guns and watched the flocks continue to parade by. It was a wonderful opportunity for me to point out the fundamentals of duck identification. In a few hours my companion learned more about the subject than he had discovered in his entire lifetime. "You know," he said later, "if a guy knows what to look for it isn't such a tough job to identify ducks."

That statement is a bit oversimplified but the thought behind it is the most important principle of species identification. If you know precisely what to look for you can correctly identify ducks far beyond shotgun ranges. I'll describe another hunting incident that proves the point.

A few years ago Jim Foote and I were gunning from a layout rig two miles off the shoreline of Lake Erie. It was a dark and windy day. Gray clouds scudded across the sky and our little boat pitched and rolled in white-capped waves. Identifying the species of flying ducks on a dark day is a tough job, but when you're lying flat on your back in a bouncing layout boat the chore becomes even more difficult. Our gunning was limited because we were hunting during a special season in which bluebills (scaup) were the only legal target.

Before I go on I want to mention that Jim Foote is one of the most knowledgeable duck hunters I've met. Formerly a waterfowl biologist for the Michigan Department of Natural Resources, he's now a famous wildlife artist. He puts in more hours of duck hunting in one year than you and I are likely to enjoy in ten years. It was part of his job to supply wild ducks for scientific and biological studies in several state and federal laboratories. That means he holds a special collector's hunting permit and is often required to shoot ducks during various times of the year. Jim is one of the few sportsmen who know what winter and spring shooting is like.

Most of his life is wrapped up with ducks. He carves and paints the most realistic decorative decoys I've seen. If they were placed on a pond and you were unaware that they were decoys you would swear that they were live ducks even when viewed from a few yards away. He paints waterfowl-hunting scenes on large pieces of canvas. Their realism is startling. I mention these things to point up the fact that

Jim knows more about wild ducks and how they appear than the ducks know themselves.

Anyway, there were flocks in the air almost continuously that November day. Many of the flights were pitching down and landing near a shipping channel hundreds of yards to our east. Giant seagoing freighters often put the birds in the air. Jim never hesitated in identifying the various species, even though they were often little more than specks in the distance. At one time a flock of ducks winged by a passing ship and my partner exclaimed, "Widgeons. I wonder where they came from. Most of the widgeons went south weeks ago."

Those ducks were so far away that I had to study them for a few moments to determine that they were puddlers and not divers.

Another time a flock of twenty or so divers angled toward us, then flared off 300 yards beyond our decoys. Suddenly they banked and decided to alight in our rig. I was sure they were all bluebills as I slid my hand to my gun.

"Be careful," Jim whispered. "There are a few redheads in the back of the flock. Just shoot at the bluebills."

Those ducks approached 100 yards closer before I was able to determine that Jim's species identification was correct. The day was so dark that I couldn't distinguish colors on the birds at long range, and the profiles of redheads and greater scaups are almost exactly the same. Identification of the two species is close to impossible when you can't recognize colors, yet my companion had no problem in spotting the protected redheads.

The ability of the average duck hunter to identify the species of a flying duck falls somewhere between the knowledge extremes of the two men I've mentioned. The point is that species identification can be learned, it doesn't have to be a mystery.

There is no question that the hunter who knows the identity of his targets gets far more enjoyment from his hunt. He also gets a better-quality hunt because he is able to fill his bag limit with the largest and best-eating birds. Of most importance, he is able to participate in more shooting opportunities. Modern duck-hunting regulations are being keyed more and more to favor the hunter who knows exactly what he is shooting at before he pulls his trigger.

Several states have opened extra-shooting seasons to only those hunters who successfully pass a species identification test. In other words, if you know your ducks you can go hunting; if you don't you stay home. Similar bonus shooting is

offered in limited-species seasons and in bag limits that are determined by applying point values to various species of ducks. The special December seasons on mallard drakes that are offered in several states are other examples.

Say the daily bag limit is established at 100 points. Female mallards count 90 points each, but the big greenheads rate only 20 points. Obviously, if you know your targets, you can go home with five prime ducks. If you don't know what you're shooting at you'll likely be violating the law if you down more than two birds. (See Chapter 34 for a complete discussion on this subject of bonus-shooting seasons through species management.)

There is no substitute for experience in any field of knowledge and this is certainly true in the game of duck identification. It may sound ridiculous, but species knowledge was vital to old-time market hunters. Those fellows were paid as high as 85 cents for a pair of canvasbacks and as low as 15 cents for a pair of gadwalls. It was important for those gunners to know what they were shooting at. They had no books to teach them species identification. They had to learn the hard way. They had to go out in the marshes, sloughs, lakes, and fields and learn from experience.

The modern hunter has no chance to spend week after week in duck blinds. He is faced with the necessity of learning species identification but he can't gain his knowledge the way the market hunters did. Fortunately, there are shortcuts to solving the problem. There are modern ways to gain knowledge of the science of ornithology that the old-timers never dreamed of. Today you can become well on your way to being an amateur naturalist without leaving your easy chair.

Part of the secret is in the availability of high-speed, close-up color photographs that show duck identification factors in far more detail than you would witness if you spent a month in the marshes. Another part of the secret is in eliminating the scientific textbook approach to species identification. Today's hunter doesn't have the time to study mysterious biological descriptions. He wants to read in plain English about those identification clues that will help him distinguish the various species in flight. I'll emphasize "in flight" because there are plenty of books boasting color plates that will enable you to identify your target *after* you have killed and retrieved him. Today's hunter must possess identification knowledge before he shoots. He wants basic information, the kind of material that will solve the biggest share of his species-identification problem in the quickest manner possible.

Will simplified information suffice? Let's look at an analogy. How many times

have you seen a boy gaze at a passing plane and say, "There's a 727." Perhaps he correctly identified any one of scores of aircraft. He does the same thing with automobiles speeding down highways and boats flashing across blue lakes. How did he gain this astonishing ability for identification? He gained a lot of it by studying the color photographs and paintings on model-kit boxes. He gained more by analyzing the diagrams, parts, and characteristics of his models as he put them together. In short, he was subjected to basic identification factors and not to technical and mechanical considerations. Obviously the technique works. The remainder of this chapter will apply similar thoughts to the problem of duck identification. If a boy can learn identification aspects of complicated machinery, you can learn how to identify ducks.

The boy builds his complete model by putting together a series of interrelated parts. Identifying the species of a flying duck is accomplished by observing a series of characteristics. The basic keys to identification are:

1. *Areas frequented by the birds.*
2. *Manner of takeoffs and landings.*
3. *Flock formations.*
4. *Migration timetables.*
5. *Relative size.*
6. *General color patterns.*
7. *Body contours.*

The main pitfall for most hunters is the confusing thought that there are so many different species of ducks that learning to identify them all is an impossible job. Authors of waterfowl hunting stories seem to have a penchant for pointing out that there are dozens of species of ducks and that they all have different characteristics and color patterns. That's not quite true. Even if it was the point is misleading. The odds are that there are eight or fewer species that frequent your region, and that 90 percent of your bag will be made up of two or three species.

I've bagged ducks over much of the United States, as well as in Canada and Mexico. I've been fortunate in being able to enjoy diversified hunting. With that background it may come as a surprise when I state that I've never seen thirteen of the forty-one species of ducks that are native to North America. The point is that learning to identify a multitude of ducks is a waste of time. When I hunt a new

area I ask what species are predominant. When I get my answers a big part of my duck-identification problem disappears.

Many beginning duck hunters have asked me to explain the most important point of species identification. My answer is always the same. I point out that the hunter should write his state conservation department for harvest statistics on waterfowl killed in his state. That information will tell him what species frequent his hunting areas. He is then in a position to eliminate much of the work of learning how to identify ducks. He can forget about studying all of the species and concentrate on those few that he is likely to encounter.

The next step is to realize that there are several characteristics which will enable you to place your ducks in one of two groups long before exact species identification is necessary.

All ducks are divided into two groups: puddlers and divers. Puddlers, such as mallards, blacks, pintails, teal, baldpates, and wood ducks, are found in marshes, sloughs, ponds, streams, and backwaters offering shallow water and emergent vegetation. If you hunt those areas you're going to be gunning puddler ducks, because the divers seldom frequent them. Conversely, if you hunt the deep-water areas of large lakes and bays your targets will be divers, since the puddlers can't exist in deep waters.

There are very few exceptions to the above paragraph. Any veteran gunner knows that baldpates occasionally intermingle with divers to steal the bulbs and roots the deep-water birds bring to the surface. Black ducks will sometimes seek refuge on lakes. In some areas divers and puddlers will use the same flight lanes over pass-shooting stands. Such exceptions are rare. It's safe to emphasize that divers and puddlers seldom frequent the same water areas.

It's even safer to point out that divers don't feed in fields. Their legs are spaced so far toward the rear of their bodies that it's difficult for them to even walk on land. If you see ducks foraging in a field you can bet you're looking at puddlers.

Another key that narrows the identification problem is the knowledge that most divers attain flight only by a half-running, half-flying takeoff. They have to gain speed before they can become airborne. Puddlers, because of their larger wings, don't have that problem. They leap off water or ground and immediately achieve almost vertical flight.

The two groups also vary in their landing approaches. Puddlers usually circle decoys from a position high in the air. When they decide to land they'll drop like

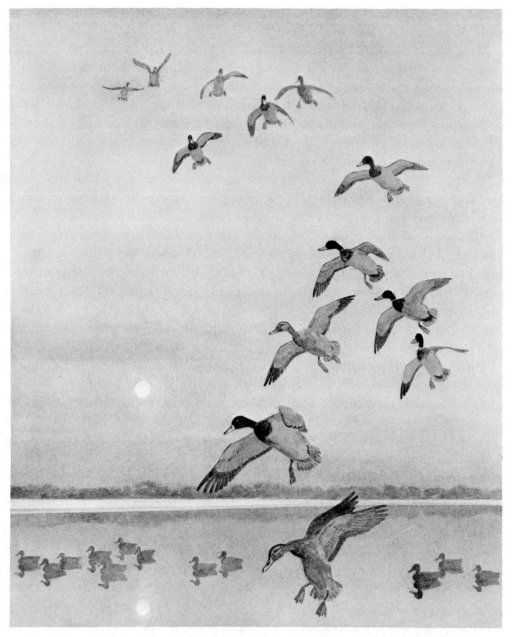

Puddlers usually approach decoys by circling, then dropping straight down.

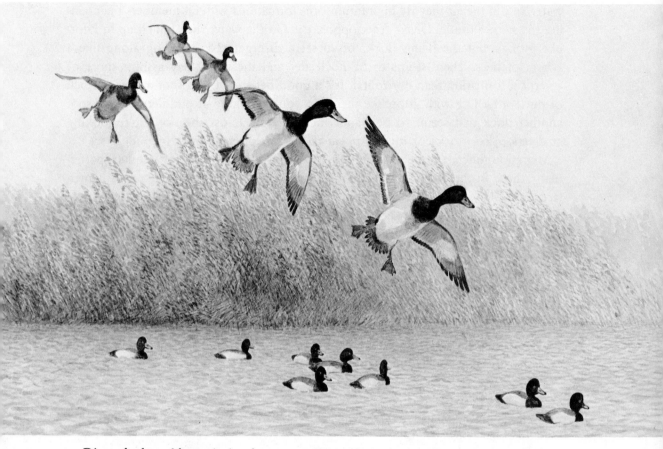

Diver ducks seldom circle; they normally come in low to the water, barreling straight toward the decoys.

falling leaves and splash directly into the water. Divers have an opposite approach. Normally they don't circle at all, preferring to fly directly into decoys. They come in low to the water. If they do circle they'll swish right over the decoys and make a tight bank. When they land they skid across the water's surface like crash-landing aircraft.

Flock formations offer other valuable clues to whether your ducks are puddlers or divers. Most puddlers tend to scatter in loosely grouped flocks while on the

water, but in the air they fly high in uniform formations with all members maintaining the same altitude. Divers react oppositely. On the water they bunch up in knot-like groups, but the flying flocks often seem disorganized, barreling along like a swarm of bees. There seems to be no leader and the flock may assume more of a vertical formation than horizontal. It's a good bet that if you spot a distant flock of ducks traveling with gooselike precision you're looking at puddlers. If you spot another flock that seems to be wandering aimlessly across the sky you're looking at divers. Also, flocks of divers appear to fly faster than flocks of puddlers.

Migration timetables are another clue to species identification for gunners, particularly those in the northern half of the United States. Most puddlers, except mallards and black ducks, are early migrants. Teal, baldpates, wood ducks, and gadwalls are usually gone from northern waters by the time the first divers arrive. And the first divers to show are lesser scaups and redheads. Then come the buffleheads and canvasbacks. A few weeks later the greater scaups and goldeneyes put in their initial appearance.

Early-season midwestern gunners are normally limited to targets of local mallards, teal, baldpates, gadwalls, and wood ducks. Diver hunters know that their late-season targets will consist mainly of greater scaups and goldeneyes. Western Seaboard gunners plan their hunting trips to coincide with peak migration periods of scoters, brant, pintails, mallards, and scaup,

Because of their relatively small wings, divers attain flight only by a half-running, half-flying takeoff from the water.

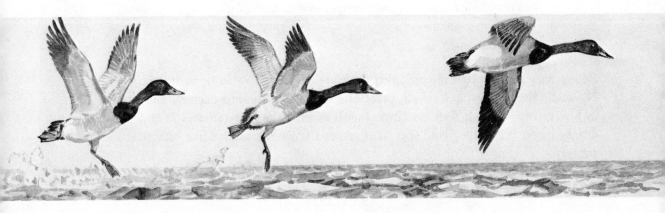

The point is that various species of ducks migrate at various times during the three-month fall period. A knowledgeable Wisconsin gunner doesn't waste time trying to identify a goldeneye in early October because he knows there aren't any goldeneyes present during that period. Nor does a North Dakota hunter worry about shooting a teal in November for the same reason. Any duck gunner, in any state, is subject to similar regional migration patterns of waterfowl. Learn those patterns (from local veteran waterfowlers, experience, or state conservation officials) and your species identification problem will become even more simplified.

The major keys to species identification come into play when your ducks are approaching shooting range. Quick decisions must be made now, because flying ducks are here and gone in seconds. One of the best clues is relative body size. A hen teal looks somewhat like a hen mallard in color and body shape, but the mallard is twice as large. A similar comparison exists between buffleheads and goldeneyes in the diver group. Drakes of the two species have identical contours and similar black-and-white colorations. Flight habits are similar too, but all comparison ends there since the bufflehead is half the size of a goldeneye.

There is no point in going into detail here on the size of various ducks. Your local library has books offering complete information on measurements of all birds. It's likely you already own a book about birds. Anyway, once you know what duck species frequent your area it's an easy job to look up their physical measurements. You'll find that common wild ducks vary in weight from less than 1 pound to over 4 pounds.

Under ideal conditions general color patterns can offer a quick clue to duck identification. Divers, particularly, can be color-grouped rather easily. The males of most popular diver species are predominantly black and white. The females are brown or brownish gray with white undersides. If you see a flock of ducks sporting the color combinations of black, white and brown you can bet that you're looking at divers.

Puddler ducks are the most colorful of all waterfowl. Nobody can make a mistake in identity when he sees the glorious green head and white neck ring of a mallard drake. Male wood ducks are among the most beautiful birds in the world. Their colors, many of them iridescent, range from brown through red, violet, white, green, blue, and orange. Male shovelers sport a unique color pattern of dull-green heads, white breasts, and rich-brown undersides. Male green-winged teal boast a green patch around the eye and on the back of the neck. Male blue-

winged teal have grayish-hued necks and heads that give off purple reflections. This beauty is offset by white crescents in the front part of the head that run from above the eyes down to the throat. Both males and females of all puddlers have brightly colored wing speculums.

Those descriptions are enough to point out that puddlers, as a group, are far more colorful than divers. Through the years authors of duck-hunting books have claimed that color patterns are the main clue to species identification. Today's waterfowl managers wince at that reasoning.

Color patterns are great identification clues once you have killed and retrieved your bird. Sport hunters of years ago were primarily interested in knowing the species of a bird after it was bagged. Modern hunters must know species identification before the shot is made. Making those decisions on the basis of color is risky for several reasons.

Early-fall ducks have not yet attained full winter plumage; their feathery dress is far less developed than the fashionable color plates you see in bird books. During early parts of hunting seasons males and females of many species wear plumage which resembles the year-round habit of the female. Young-of-the-year birds (both males and females) will resemble females well into hunting seasons. Of even more importance is the fact that top duck shooting is often enjoyed during dawn hours or on dark days when colors are difficult to recognize. Suffice it to say that species identification based on color patterns alone leaves a lot to be desired.

The majority of waterfowl managers agree that the study of body-contour outlines of ducks is a far more reliable tool. Any given species of waterfowl (juvenile or adult, full-plumaged or dull) has a body contour that doesn't change. That contour (on the water or in flight) presents the same silhouette on bright and dark days. Here are the combinations of colors and contours to look for in the most popular species of ducks.

Puddle Ducks

Black Duck: A very large sooty-dark duck. Males and females are alike in plumage. They usually swim faster on the water than other ducks. Their flight is swift and direct. They fly high in small flocks of less than a dozen birds. Their color

characteristics are very dark bodies with contrasting underwing linings of white. They have long necks which are stretched straight out in flight. Legs are usually red. Flying flocks are V-shaped or in long single lines. The flashing white underwings are very clearly noticed on overhead flocks. When taking flight they spring straight upward as do all puddlers. Contour characteristics are: a very large duck, large centrally located wings, and long neck.

In southern Florida and parts of the gulf states, hunters bag a duck that is officially named the Florida duck. Some experts claim this bird is a subspecies of the northern black duck, which it strongly resembles. The argument against this claim is that the Florida duck is not a migrant. It has a slightly lighter tint throughout than the black ducks, and its wing speculum is green without a violet cast. It is also about 2 inches shorter in length than the black duck.

Still another bird in this group is recognized officially as the mottled duck. It is a nonmigrant and remains principally in the states of Texas and Louisiana. It is a bit smaller than the Florida duck and its feather pattern appears slightly mottled, hence its name. Hunters often refer to this bird as the summer black duck to classify it separately from the migrant northern black duck.

Mallard: Body contours and size similar to black duck except that mallards in flight carry their heads and necks slightly upward. The mottled-brown female is distinct from the colorful male. Very large flocks of mallards are common. Flight speed is not as rapid as that of black ducks. A basic identification factor is sound since both males and females are very talkative. The female utters a loud resonant quack, the male a low reedy quack that carries a long distance. Mallards and black ducks are the largest of the puddlers.

Pintail: A medium-large duck with a contour of an extremely streamlined body. Slim neck and head with long bill. In flight the drake can't be mistaken because of his very long and pointed tail feathers, a body-contour characteristic not shared by any other puddler. Both males and females are fast-flying birds, and both carry their long necks stretched out. Pintails have a white edging at the rear of their wings. Males are considerably larger than females, a good profile clue. The long, slender necks are very apparent whether the birds are on the water or in the air. The female's coloration is similar to the female mallard and gadwall; but her sharp, pointed wings and tail feathers are giveaway contour lines.

Mallards, the duck hunter's favorite quarry, are big ducks with underwing linings of white.

Baldpate: Somewhat similar in size and color contrast to the pintail, but very different in important body-contour lines. Baldpates have rather round heads, short necks, and short bills. The short neck is readily observed on both flying and sitting ducks. A distinguishing field mark of sitting baldpates is the tails that are well elevated above the water line. (A contour characteristic of all puddlers is the elevated tail. The tail feathers of swimming divers are flush with the water's surface.) Both males and females have white bellies, more distinctly white than males and females of other puddler species. Spot a flock of puddlers with short necks and white bellies and you're likely looking at baldpates. The tail feathers are another good contour clue. They are longer and more pointed than most puddlers except pintails.

Another contour clue is that baldpates sit extremely buoyantly on the water, chests low and tails high.

Wood Duck: The brilliant colors of the male are so spectacular that a close-up identification mistake is almost impossible. But both male and female have body-contour lines that make species identification easy even when colors cannot be readily distinguished. Wood ducks fly like buzz bombs. They delight in zipping low across marshes and trees. During their swift and direct flights they carry their heads high above the body level. Their bills point down at a discernible angle. Both sexes have white undersides, but they can't be confused with flying baldpates because of the high head and down-pointing bill. The heads and bills of baldpates are pointed straight forward.

A distinguishing field mark is the crested head of both male and female. No other puddler has distinctive crested head feathers in both sexes. The female has a white ring around her eye which shows up at surprising distance. She is also more colorful than females of other species. Wood ducks are chatty birds, too. Their squeals and whistles can be plainly heard when they are flushed. They are small ducks, larger than teal but smaller than baldpates and pintails. They are much smaller than mallards and black ducks.

Gadwall: This duck is the only puddler with a white wing speculum, a very evident mark in flight. Gadwalls are medium size, and their body contour looks like a small edition of a mallard. Both sexes tend toward brownish coloration, a distinctive feature when trying to tell whether you're looking at mallards or gadwalls. The male's black rump is also very evident in flight. Gadwalls have a slender appearance when in the air but shouldn't be confused with pintails, which have longer and more pointed tails. Gadwalls sit low and flat on the water, offering a contour that's not shared by most puddlers. The female's call is pitched much higher and is not so raucous as that of the mallard.

Shoveler: These ducks can hardly be mistaken by gunners who have studied the body contours of waterfowl. The shoveler gets his name from his outlandish spoon-shaped bill. The bill is longer than the head and is extremely wide. I shot my first shoveler many years ago in the flooded pin-oak flats of Arkansas. When I retrieved the bird I wondered if I'd shot some kind of freak. I've shot many of

them since in several states, and that enormous bill tells me I'm looking at shovelers long before the birds are within gun range.

The thick head, short neck, and huge bill are easily identified whether the ducks are in flight or on the water. The sitting birds carry their bills in a downward slope as if their burdens were too heavy to hold level. The females are mottled brown but the males show distinctive dark-brown-and-white patterns. The wings appear to be set farther back on the body than other puddlers. This factor, plus the large bills and contrasting dark and white patterns of the males, makes shovelers easy to identify even when they are flying in the distance. They are medium-size ducks.

Teal: Green-winged, blue-winged, and cinnamon teal are all very small ducks, by far the smallest of the puddlers. They fly like bullets, low and in fairly large flocks. The male cinnamon teal has a cinnamon-red coloration that is distinctive from any other duck. All teal have body contours that make their silhouettes appear as very small mallards. There is no problem in identifying teal simply because they are so much smaller than other puddlers.

Diving Ducks

We'll switch our discussion now to diving ducks. There are several general-profile characteristics that put divers in a separate group from puddlers. Their wings are typically smaller, beat more rapidly, and are spaced more toward the rear of the body than are the wings of puddlers. The legs are also decidedly rearward. The hind toe of all divers is lobed. The hind toe of all puddlers is not lobed. The feet of diving ducks are larger than the feet of puddlers. The tail feathers of divers are shorter than puddlers'. A definite body-contour identification mark of flying divers is that their long legs and big feet often are visible. Sometimes they protrude beyond the characteristically short tailfeathers. The bills of most divers are shorter and broader than the bills of puddlers. Both sexes of divers are approximately the same size. The females of puddler species are generally smaller than the males. When ducks are approaching head-on the wing span of divers appears much narrower than the wing span of puddlers.

Canvasback: A very large duck with a long, bull-like neck. The wings are pointed. From a distance the body of the male appears white, the tail and forward sections dark. The long head and almost straight-plane forehead are body contours that distinguish the canvasback from other divers. The extreme white-gray coloration on the back of the male is a pronounced identification feature. The female is gray-brown but otherwise resembles the male. Canvasbacks are extremely fast-flying ducks, usually traveling in large flocks and maintaining V-shaped formations. Like most divers the canvasback sits low on the water. In an alert position, this duck's long neck and head seem out of proportion to his body, but in flight the body appears large and bulky.

Redhead: Another big diver with a heavy-looking body when in the air. They resemble the canvasback except for darker coloration and decidedly different head and neck profiles. The redhead has a shorter neck, a big puffy-looking round head, and an abrupt forehead. The bill is much shorter than the canvasback's, and is blueish gray instead of black. On the wing they appear shorter and darker than canvasbacks. The flocks fly slower and their formations are much more erratic. The bright-red head of the male is much redder than the head of a male canvasback and is a very discernible field mark in clear weather.

Scaup: There are two subspecies of this bird, the greater scaup and the lesser scaup. The greater scaup is a bigger duck, but the subspecies resemble each other in profile and coloration. Both scaup closely resemble the redhead in body contour, habit, and flight. As I mentioned previously it is almost impossible to distinguish by silhouette between a redhead and a greater scaup on a dark day. Color patterns are the best identification clues. Male scaup appear to have all-black heads, necks, breasts, and tails. The mid-body appears all white. The females are brown with a white belly and a white ring around the base of the bill. That white ring is very discernible at distances up to 100 yards. Scaup generally fly low to the water's surface in seemingly disorganized flocks.

Ring-necked Duck: Similar in size and contour to the lesser scaup. The brown neck ring is hardly visible, but a white ring near the tip of the bill is plainly seen. Broad white wing patches distinguish this bird from the scaup. The male has a sug-

gestion of a head crest (actually long feathers of the crown) that is lacking in the scaups. Ringnecks usually fly in small flocks of less than a dozen birds—a habit rarely shared by scaups. Unlike most other divers ringnecks will often feed in marshes. They are slightly smaller than lesser scaups.

American Goldeneye: The body of the male appears to be almost all white. The top of the back is black, and the head appears black, although close examination will show it to be a highly glossed metallic green. The face has a round white patch between the eye and the base of the bill. The female is brownish gray with a large brown head. The most obvious identification feature of goldeneyes is the sound they produce with their wings. They are usually called "whistlers" because their wings produce an extraordinary vibrant whistling. You can hear that whistling at distances far greater than the range of a shotgun.

The contour of a goldeneye is a strong clue to his identification. His big round head and short thick neck make him easily recognized. Both at rest and in flight these ducks appear to have no neck at all. And goldeneyes are big ducks. If you see a large duck that seems to be almost all white with a stubby body you're looking at a drake whistler. Flocks of these ducks are always very small, seldom numbering more than half a dozen birds.

The Barrow's goldeneye is similar in appearance to the American goldeneye. The females cannot be distinguished by sight, but the male Barrow's boasts a crescent-shaped white spot in front of the eye instead of a round white spot. He also presents more of a black-and-white appearance than all white. Like the American goldeneye this species is a tree nester, but they are found only near the northern East and West coasts and along the Continental Divide. American goldeneyes are found across the nation.

Bufflehead: Very small ducks, only slightly larger than teals. Both sexes look like miniature goldeneyes, but there are distinct differences. The top of the male's crown shows a deep V of white coming down almost to the bill. The female, like the male, has a relatively large round head, and she boasts a white face patch behind and below the eyes. These divers, commonly called butterballs, are able to spring immediately into the air somewhat like puddlers. Because of this ability they are occasionally found on marshes and rivers, though they normally favor lakes and large bays. The flocks are generally small, and they fly very close to the water's

surface. The flight is swift and direct; buffleheads always seem to be in a hurry to go somewhere. Unlike most divers they sit very buoyantly on the water.

Scoters: White-winged scoters are known by New England coastal gunners as coots. They are the largest of the scoters. Both sexes appear almost all black except for white wing speculums, which are very distinctive when the birds are in flight. This duck is found occasionally on the Great Lakes but it is most common on the East and West coasts, particularly the East Coast. The birds are very heavy-bodied and their flight seems labored. Their head outlines appear knobby, especially the males, because of their swollen bills. If you spot a large, thick-bodied, short-necked black duck with a white wing speculum you have to be looking at a white-winged scoter.

The surf scoter is another big sea duck commonly called a coot. The males of this thickset species are identified by white patches on the nape and forehead. The peculiar bumpy bill is a contour characteristic that can be recognized from a considerable distance. The dark-brown female has two whitish face patches. These ducks gather in large flocks and fly very low in irregular formations. They are a bit smaller than mallards and they appear almost solid black in flight. They are common on both seaboards.

The male of the American scoter can be identified by the complete lack of any white on his body. While other scoters hold their bills in downward positions this species holds its bill horizontal or pointing slightly upward. The head is also held high. They appear much more ducklike than their two cousins. Their flight is not so labored; they like to fly around and the flocks are generally higher than other scoters. They gather in enormous flocks on the East Coast.

Old-Squaw: This species is well distributed throughout North America, but isn't seen often because it's so hardy it prefers the Arctic regions till driven out by ice. Only occasionally does the old-squaw show up in southern states during gunning seasons. A good-size bird, this species' body shape is more like that of a pigeon than a duck, and it can dive from the air directly under water without being hurt. The male has an extremely long, slender tail. Both sexes are colored with patterns of brown, white, and grayish white. Knowing hunters don't shoot them, since they are animal and fish eaters and their flesh is not good eating.

Harlequin Duck: The food of this duck is also largely animal, and the species is seldom shot. But drake harlequins are strikingly beautiful birds with their leaden-blue colors splashed with white inserts bordered in black. Since it breeds mostly in Alaska, Greenland, and British Columbia, this duck winters along the Pacific Coast and is rarely found along the Atlantic side of the continent except in northern Maine. It also can dive directly into the water from flight. The female is brownish white and somewhat resembles a scoter.

Eiders: The eider subspecies include the Steller, spectacled, northern, American, Pacific, and king eiders. The drakes of all eiders are basically beautiful birds of black and white with green and pinkish hues about the neck and breast. The hens are basically mottled brown. Most are sea ducks, mussel and fish eaters, and are of little importance to gunners, since their range is the far-north sections of the continent.

Ruddy Duck: Spot a comical little duck with an upturned tail and you will be looking at a ruddy duck. Another easy identification characteristic is the ruddy's short, chunky, thick-necked body. When molested these ducks will dive rather than fly, since their wings are short and their bodies heavy for their size. They must paddle and run a considerable distance over the water's surface before they become airborne, and their flight is low, uneven, and jerky. The male with his chestnut-colored back, black head crown, reddish-brown throat and upper breast, and silvery-white underbody is a beautiful bird. The female is much duller in color but still a striking duck. This species is distributed throughout North America and is particularly abundant along the southern Atlantic Coast. A further identification characteristic is the ruddy's landing style. He is not graceful. He splashes heavily into the water as if he's crash-landing.

Fish Ducks: Kill a duck with a narrow, long, peculiarly rounded saw-type bill and you will have bagged a fish duck. These fish feeders are worthless for table fare and most hunters ignore them. The American merganser and the red-breasted merganser are big ducks, measuring about 24 inches in length. The males of both species are predominantly black and white with deep-glossy-green heads. All the fish ducks have long-feathered head crests, but it's barely perceptible on the male of the American merganser. The eyes, bills, and feet of these two species are a striking bright red.

Hooded mergansers are smaller than their cousins, though both sexes sport a pronounced head crest. The drake boasts a pure-white triangle that begins behind the eye and spreads out toward the back of the head. His bill is black. Both sexes show yellow eyes and yellow-brown feet. The female's bill is yellowish brown, her crest is rusty, and she has an overall brownish-white appearance. Hooded mergansers are often found along rivers and the edges of marsh, whereas the larger fish ducks frequent open lakes and bays.

4

Puddlers Are Getting Smarter

Many years ago an early-season puddler hunter could look forward to consistently fine waterfowling. He could spread a decoy rig in a marsh, and if he was handy with a call and kept his face down he could get plenty of gunning. If he liked jump shooting there were streams and rivers harboring enough sky-bounding ducks to make him wish for no more. Or he could take a boat and poke around marsh shores of lakes and bayous and again count on reasonable satisfaction.

But the always-easy hunt is seldom achieved today. Now you have to work for your ducks. And you have to be smarter too. Modern ducks don't fall for all the old tricks.

The beginning of the new era arrived with the appearance of sky-busting hunters. They began showing up when the numbers of gunners boomed due to more leisure time and bigger paychecks. They descended on the marshes in great numbers with new shotguns and little know-how, and they set out to prove that ducks could be killed 200 yards in the sky. The amateurs didn't realize you had to get your duck within 60 yards to knock him clean dead. They didn't prove anything except that they liked hearing guns go off. Such activity left little room for the serious hunter who knew how quick a puddler duck gets smart. Unfortunately, much of today's gunning in marshes is left for those who would rather shoot than hunt.

A similar situation just about clamped the lid on the old-time sport of jump shooting from float boats on rivers and streams. It still works fine in remote areas, but in well-populated parts of the country it didn't take many years after World War II before the sport began going downhill. Money was part of the problem. It's cheaper these days, and more people are boat-conscious. There are more hunters today with more boats and more money than ever before. Your float trip may not be a game of slow silent surprise, but instead a race to see who gets downstream first. Such doings quickly alert the ducks.

The obvious answer was to move hunting operations farther into the back country. The hitch was that ducks supposedly like lots of water, and today's unknown marshes and sloughs are becoming less and less unknown. A lot of serious hunters gave up on puddlers and switched their gunning efforts to divers. I almost did the same thing, until I fell over the answers some years ago.

A farmer friend living near a back-country river started the wheels rolling. "The ducks aren't shot out," he told me. "It's just that most people never see 'em after the first day of the season. They're getting smarter, like the deer. Soon's the shooting begins they hightail it for tiny sloughs and puddle swamps, places where they're not bothered. They're not looking so much for water as they are for refuge. You're likely to find 'em anyplace."

So far it sounded a bit unusual, but I listened for more.

"Like one day last fall," he continued. "I was back in the brush walking up grouse when I stumbled into a flock of mallards feeding off an oak-lined sidehill. They exploded out of there like a covey of quail. You ought to go back in the brush—that's where the ducks are."

So that's where I went. The technique worked, but it wasn't quite that simple.

My first try was an opening-day session in a slough built from the headwaters of a creek that flowed to a small river. Two partners and I drove my car the length of an old two-track woods road that ended on a high hill overlooking the stream. Beyond that point our travel would be pure manpower and sweat, but it would take us away from other hunters.

When we piled out of the car, dawn was still an hour away. Below us the river reflected a thin break in the blackened landscape. It was cold and dead still, and the last of the moon hung dimly behind thin clouds. Somewhere off in the distance cars groaned through the darkness—other hunters moving toward the popular marsh a couple miles downstream.

We juggled our gear downhill to the duck boat we had hidden in the rushes some days before. The boat was more of a convenience than a necessity; it left us free to wade without carrying heavy gear.

Then we were in the river, wading upstream behind the stabbing flashes of two bouncing flashlight beams. Every step took us closer to a small hidden marshland where two freshly built blinds were waiting in the darkness. Shortly we turned from the main channel and followed shallower water up a small connecting creek. Black woods closed in on us, and our faces were frequently splashed with dew-wet branches. The creek almost vanished. Then the thickets fell away, exposing a broad flatland of grasses and low clumps of brush and scattered pockets and puddles of water.

Morg and I took the first blind, built smack in the middle of a tight thicket. John went on to the second, 100 yards to the east, where the sky was showing pink. Decoys went out in careful placement. We had a leisurely cup of coffee. The east lightened and streaked the sky. Watch hands said it was a new duck season. The distant booming of shotguns in the big marsh downstream snapped us to readiness.

Then we saw ducks, maybe two dozen, all strung out and coming in high over the last trees where the brown marsh began. Even in the distance we knew they were mallards as the big shapes tilted and banked broadside, showing flashes of white as powerful wings blinked against dull skies. Our calls pealed out, pleading in high volume, then falling lower into contented chuckling as the birds came around. They swung in that long curve that mallards make when looking for friends. Then they climbed and banked toward the main river.

Our calls kept going. In less than a minute the ducks were back, lower, much lower. They routed through a wide circle, and when they went over the second time we could hear the hens chuckling and we knew the next time around some would drop in. But there wasn't any next time around. They kept on going, upstream to a different rendezvous.

Two hours later we had one wood duck in our bag. Mallards and black ducks were working the area, but the birds were flying high and wide. Most flocks were apparently flabbergasted at the sudden mass invasion of their privacy in the big marsh.

About nine o'clock we began noticing a change. Flocks were smaller, lower, and faster. Apparently the big family groups were broken up and had scattered like

buckshot. Now they were looking for places to hide and feed away from the bigger marshlands. If our reasoning was correct, we should begin to do business. We did.

A small bunch of mallards appeared over the trees in front of us. They turned off 100 yards out, then glided straight to John's decoys. They went in on cupped wings, then they suddenly flared, and two of them tumbled as John's shotgun roared three times.

Minutes later John dropped a single coming in from his end of the area, then Morg and I went into action. We up-ended three widgeons from a flock of eight that worked perfectly.

There were more shooting opportunities, a lot more. Some we cashed in on, some we didn't. The action contributed to the best opening day we'd had in years. After it was over, the answers to our success were obvious. In the years since, those answers have continually provided me with superb puddler-duck shooting. They will work for you too.

The key to the whole deal is space, lots of it. If any of the sky-buster hunters are close enough to your rig to spoil a puddler's normal approach patterns, you're licked. These ducks need lots of room to work; give them that and the rest is up to you. And the rest can be reduced to simple tactics.

Let's analyze some theory. The puddler's time-honored habitat has always been big marshes, wild rice beds, and flooded river bottoms. These have been select hunting locations because they have supplied the best food, water, and refuge.

Today's army of opening-day gunners swarm into these areas with barrages of gunfire. The ducks get out. They try to get back for the next few days but meet the same situation. Then they get out for good.

Hunting success during these early-season days consists of taking advantage of the fact that ducks are still working their usual flight patterns. They have been used to feeding in the marshes, river bottoms, and adjacent sloughs. Then, suddenly, shotguns start ripping them apart from blinds in the marshes and float boats on the rivers. They are confused by these abrupt invasions of hunting armies.

But while they're still confused, they will continue, for a few days, to use normal watershed flyways in hopes of finding safety in familiar surroundings. Big decoy spreads and lots of calling will fill limits if you locate in an area free of other hunters. This is much more easily done than it sounds.

Forget the popular marshes. Concentrate on rivers, ponds, sloughs, and larger

creeks leading to and from places ducks have normally been working. Most locations along these waterways are ignored by other hunters because they don't look "ducky" enough.

Select a spot that appears least likely: a section of river flowing through timber, an area of small marsh, a feeder creek, any place that seems to be a poor hunting location but is still in or near the general flyway. Hundreds of such naturals exist near most duck marshes. Other gunners never rig in these spots because they don't harbor ducks before hunting seasons.

Here's what happens on a typical opening day. Ducks are blasted from popular hotspots shortly after dawn. They go anywhere except where they've usually been because that's where all the hunters are. They're looking for the safe havens of

Hidden pockets of backwater become meccas for puddlers when they vacate popular gunning marshes.

other ducks regardless of where they may be. If you're rigged in an area free of sky-busters, and can reach passing flights with the sound of your call, you can pull those ducks to most anyplace.

The next part of this act is lots of calling. The terrific value of calling was proved to me in the flooded pin-oak flats near Stuttgart, Arkansas. I have enjoyed fabulous shooting there, gunning that would be impossible without call work. That flooded timber is a good example of cover so heavy you don't see ducks until they're right on top of you. The veteran hunters there use a deadly technique. They just lean against trees, stick calls into their mouths, and start a continuous melody of mallard talk. There may not be a duck within a mile, but there may also be a nice flock crossing just behind the trees. If that flock happens to be looking for safety the unseen caller will attract them like boys to a fire-engine siren.

Heavy timber means nothing. You don't have to see the ducks until they get within shotgun range. They can't see your decoys either until they get close, and the calling is what gets them close. Then the decoys pull them into gunning range like magnets.

Put down two thoughts as most important for early-season success:

1. Spread your decoys in an unhunted water area under a general flyway near a popular gunning area.

2. Lean into that duck call. (If two hunters are calling, so much the better. One can work while the other rests, and the variations add realistic effect.)

These tactics offer the birds exactly what they want during a period of fright and confusion.

Later in the Season

Today's puddler duck is no dope; he doesn't stay confused very long. While the above procedures work to perfection the first days of the season, their effectiveness wears away in a hurry as the ducks quickly abandon their flyways and relocate in places where they're not bothered.

Where do they go? Consider the possibilities. A mallard, wood duck, teal, shoveler, baldpate, or other puddler is equipped physically to feed and rest on dry

land as well as on water. This being so, they get along fine with small amounts of water such as that provided by creeks, ponds, ditches, and puddles. With a small amount of water the puddler also needs food and cover. This explains where those thousands of puddlers go. They are hidden in back-country sloughs, south-forty farm ponds, tiny wooded creeks, spring holes, bayou swamps, etc.

How do you find these areas? Terrain is all-important. Scouting should begin with definite ideas. Follow tiny creeks downstream; they often level out in ravines to form backwaters or small marshes. Adjacent lands to river bottoms and marshes are often excellent bets. Small ponds or backwaters may be hidden just over the hill. Get to know landowners and farmers—they know where these choice areas are located. Most important, recognize that these tiny gems are where the ducks are hidden. They have to be. Most puddlers can't sit in trees and they can't stay continually in the air. They have to come down, and these are the places they come down to.

Although most puddlers will feed and hide in these spots, they don't always roost there. Many will return to the big marshes just at dark and leave again before dawn. These passing flocks offer excellent opportunities to determine locations of hideaways. Check their flight line in late evening and early morning when the birds move to and from roosts. Following them with a car and binoculars is the best bet. It may take a few days of effort to stay with them to the end of the line, but eventually they'll pitch down. After that it's all fun.

Once ducks have relocated in one of these hidden spots, they won't abandon it until gun pressure or migration drives them away. To save time, look for these wet places before the gunning season opens, then check again when you have shells in your gun.

You hunt these spots in two ways: sneaking with hopes of jump-shooting chances, or hiding and waiting for returning targets. Calls and decoys get into the act for the latter practice, but they're employed in an entirely different manner than during early days of the season. Your ducks now know exactly where they're going. Lots of calling and large decoy spreads are unnecessary. A few oversize blocks combined with well-spaced feeding chuckles from your caller provide sufficient attraction. Too much call work should be avoided, because gunshy puddlers don't advertise their presence when hiding in a tiny slough or puddle. They drop to where they're going and keep quiet.

The water in areas of flooded timber is usually too calm to animate decoys. This hunter has rigged his decoy with a cord attached to a screw eye at the front. The cord runs through another screw eye on the stake and into the blind. When ducks approach, hunter jerks cord and animates decoy.

These areas usually have dead-calm water, making ordinary decoys appear something less than lifelike. Any animation can be of vital importance. Pulling a string running from a decoy to your blind is an old and good stunt. A few jerks on the string will create enough ripples to give lifelike appearance. Pebbles tossed among decoys while swinging ducks are momentarily out of sight will add realism to still water. Any such ideas are good, and should be tried if terrain conditions permit.

The usual mallard, teal, baldpate, or other puddler duck hideaway may contain anywhere from a small flock to a hundred or more birds. It's usually a concentrated area, and therefore will be shot out in very few hunts. Blinds should be constructed

Method of rigging tipping decoy. If a heavy boat anchor is used at *A*, no anchor is needed at *B*.

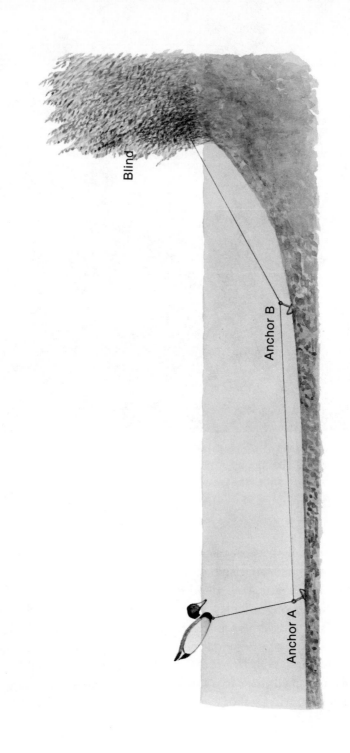

Method of rigging swimming decoy. Pulling line No. 1 makes decoy swim toward blind; pulling on line No. 2 returns decoy to original position.

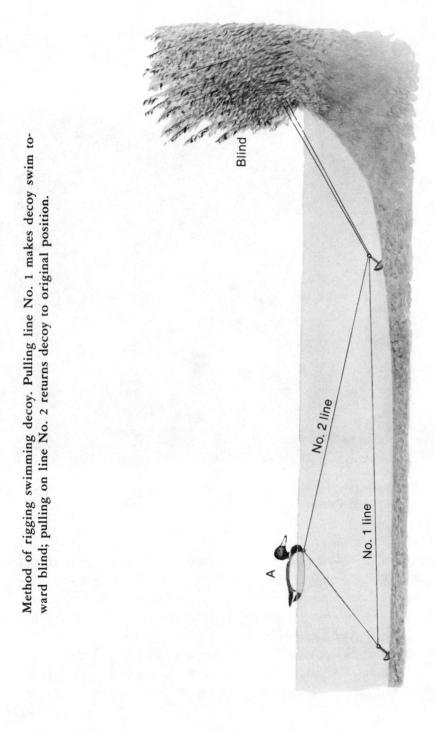

Simple and effective puddler blinds can be made in shallow water by cutting
branches and jabbing sharp ends into the bottom.

with this thought in mind. Most birds will drop down from above, with little of
the circling usual in open marsh areas. They approach with the single intention of
getting tucked away as soon as possible. If they see a few birds already resting, plus
some lifelike activity, they're pretty much fooled. Toss them a couple of feeding
chuckles and they'll drop their flaps right then.

Simple brush blinds are the rule. Build them so most cover is provided above
you instead of on the sides. Keep blind materials to the minimum that will provide
adequate concealment from above. Building an elaborate blind is a waste of time.

You discover a spot and shoot it a couple of times—spaced at least a week apart—then move to another find.

There is one technique of modern puddler gunning that often brings exceptional rewards. It probably should be termed "river walking." Instead of floating the stream in a duck boat, you wade the shallows and adjacent sloughs in a downstream course—downstream because your waders or hip boots make less commotion going with the current than against it. Ducks are far less suspicious of natural noises than they are of disturbances made by dripping paddles, or boats brushing against branches or scraping over logs. They sit tight longer, probably expecting to see a deer, coon, more ducks, or other creatures of the wild. The secret is slow progress, wading a course that produces the least noise. This method is especially effective with the arrival of migrant flocks. They don't know local conditions and are more likely to sit tight, hoping that the unknown noisemaker will pass without investigation.

The one major exception to all rules mentioned occurs in late fall when last flights of big northern mallards or black ducks arrive. These are the huge, fully colored birds with bright-red legs, ducks that wait in Canada until snow and ice forces them out. Weather conditions and haste of migration often make suckers out of these prime specimens.

Here is a type of gunning that offers fabulous action many duck hunters are unaware of. By late season most gunners have given up, or have been frozen out and have left the big marshes in despair. These ducks swarm in for a day or two of rest and feeding before moving on. They hit the convenient and most likely-looking spots. They usually arrive just ahead of sudden cold snaps and freezes. Watch your weather reports, and when conditions are right get out and check your marsh, preferably in the evening.

If you hit it right you'll be amazed at the activity—duck activity, not hunter activity. The same marsh that was swarming with gunners many weeks earlier is now empty and desolate. There's not a gun to be heard or a boat to be seen. Where tall green cattails waved with a gentle breeze against a blue sky there is now a brown and empty flat, pressed with gray clouds and close to blasts of winter. If ducks are present you'll see them pitching hither and yon with reckless abandon. Don't wait; they'll move out within a day or so. Use big decoy spreads and lots of calling. These ducks are new to the area, roaming freely to quickly discover feed locations. They're looking for friends who have already found a choice dinner

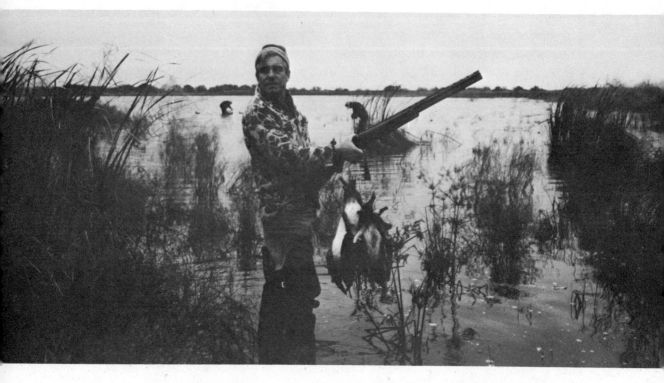

Author with puddlers bagged in Mexico during January hunt in 1979.

table. They are hungry and tired and they respond to invitations with gun-warming suddenness.

Wood Ducks

The foregoing discussions in this chapter cover duck-hunting problems relating to most of the puddler species. Wood ducks fit into a special category of their own. This bird's history is like the duck himself—wild, beautiful, and laced with intrigue. Everything about him seems out of the ordinary. For instance, today's populations of most wild ducks are far lower than they were back in the good old days. Not the wood duck, though. His numbers have increased. He is becoming an important

part of the gunning picture for hunters in states east of the Mississippi River and along the Pacific Coast. For these reasons the wood duck deserves special mention.

Most wood ducks are bagged as a by-product of other duck hunting. There are few hunters who go afield specifically to shoot a wood duck, probably because of lack of knowledge of proper hunting techniques. Those who do hunt them enjoy a fascinating game. They also leave themselves wide open to despair and frustration. A case in point comes to mind.

One day I put my tiny duck boat in a small wooded stream just after daybreak. The morning twanged with frost, and it was so still that you could hear the yellow and red leaves fall to the ground. I'd planned a short float trip for jump-shooting ducks and I figured on being home no later than noon. I was an hour downstream when about a dozen wood ducks flashed overhead. There was no chance for a shot, but the ducks hadn't seen me and they twisted down through the trees 200 yards to my right. I knew they'd landed on some hidden pond or puddle.

"Yup," I mused, "I've got those birds dead to rights. I'll sneak 'em!"

I slid my boat into the trees, pulled up my hip boots, and took off.

A half hour of pussyfooting later, I discovered a beaver pond. It was a beauty, covering an area the size of a city block and laced with dead trees and brush—a real wood duck paradise. I was delighted. By pure chance I had stumbled upon a hidden hotspot!

Then came a further stroke of good luck. Two more wood ducks brushed in over the tree tops and almost turned inside out when they spotted the ducks I was stalking. They slammed on the brakes, literally tipped sideways, and dropped like rocks to the birds on the water. Now I had all the aces; I knew exactly where those ducks were hidden.

I tried to be as slow and silent as possible, but they heard me coming. I was still out of gun range when I heard the nervous "cr-r-eek, cr-r-eek" that a wood duck makes when suspicious. Then a lot of them started talking, and I figured they were going to bust out of there any second. I froze in silence, but nothing happened. After long minutes I moved ahead again. When I got to the place where the ducks should have been, they weren't. Then I heard a melodious chorus of "cr-r-eek, cr-r-eek" again, far ahead and to my right. This time I splashed after them with much less caution.

If you've ever tried sloshing around in the muck and tangles of a beaver pond, you've got some idea of the chore I had ahead of me. When beavers build a dam

the resulting rise of water kills many trees. Most of the rotted birch and poplars fall in crisscrossed snarls. The cedars and hemlocks, being hardier, usually die but continue standing like naked monuments. A beaver pond is a thing of wild, spectacular beauty and cathedral-like silence. It is true wilderness, but it is also a man trap without equal. Any sane human gives a beaver pond a wide berth. But I wanted a chance at those ducks pretty badly, so I plowed straight ahead.

My feet stuck in muck. I'd drag one foot out of slimy ooze and my next step would snag a hidden root. Dead cedar branches scratched my face and hands, and limbs knocked my hat off and hooked in my clothes. Twice I tripped to my knees and icy swamp water rushed into my boots. This was fine in a way. A cool early sun had now seemingly bloomed into a blazing ball of fire. Perspiration smarted in the scratches on my face and hands. And I still couldn't get those ducks to flush!

They were playing games with me. Often I would stop to splash cool water on my perspiring face. Each time I could hear the ducks ahead of me. Their "cheep-cheep" and "cr-r-eek cr-r-eek" were maddening. Those ducks were smart enough to know I couldn't catch up. They also knew they were much safer on the water than in the air; if they flushed they'd be wide open to my gun. All they had to do was stay hidden and stay on the water and they could elude me forever in that jungle.

I eventually came to the same conclusion. A feeling of futility and exhaustion flooded over me. I was completely licked. The morning was gone when I finally staggered back to my boat.

Although you'll often see the wood duck on open stretches of water and in grass or cattail marshes, his normal feeding grounds are the vicinity of heavily wooded streams, creeks, and ponds. I've found that successful gunning technique involves roughly 10 percent skill and 90 percent hard work. This duck lives in the loneliest, thickest, and most tangled maze of bottomland forest you can find. If you want him you've got to go in there after him. There are several approaches to this problem.

I've killed more wood ducks by use of the float-trip technique than in any other way. I pick the smallest navigable stream I can find that snakes its route through woodlands. Some streams wind through suitable wood duck habitat for their entire course, others will show potential only in their upper reaches. The thought to keep uppermost is the presence of trees and brush. You'll seldom find wood ducks along

a big river, or even a small creek that meanders through meadows and fields. This duck is true to his name: he wants to be in the woods.

When floating these watersheds you'll jump some ducks off main channels, but most action will be found in connecting backwaters, creeks, and sloughs. This is precisely where most float hunters err in judgment, whether they're after wood ducks or other species of puddlers. They unknowingly float past many available targets. Floating to these connecting waters, then parking your boat and exploring farther with hip boots is always a good bet, and it's the most consistently successful method I've found to hunt wood ducks. It's back-breaking work but there are two good reasons why this technique works to perfection.

First, the wood ducks' choicest food—acorns, hickory nuts, beechnuts, etc.—is found along hillsides and banks. Usually, a big proportion of the main current of your stream moves through flatlands while its connecting waters backtrack into surrounding banks and hills. The ducks follow these connecting waters to choice food locations, and they'll often leave the water to forage on dry land. Such areas are sometimes far removed from the float gunner who stays with main currents.

Second, most of these backwaters originate from springs or flood water. Their greatest surface area is where they join the main stream, but their water volume always lessens as they meander back to higher ground. Eventually they dead-end into dry earth. So when you wade these waters upstream, you may be pushing swimming ducks to the same dead end. When a wood duck runs out of adequate water, he'll either try to hide or flush. It takes him a long time to make up his mind, but in the end he usually decides to bust out with an excited whistle and a rocketing leap. No duck hunter enjoys a more thrilling or difficult shooting opportunity.

Though floating is the easiest way into wood duck habitat, the same type of gunning may be found by wading or walking the banks of streams that are too small or bush-choked to float. Another deadly procedure involves wading small timbered ponds. Never pass up the possibilities of the smallest puddle. If it's bordered with choice food, you can bet you've discovered a potential hotspot.

Equipment for this type of shooting involves nothing more than a shotgun, a pair of hip boots, and a pocketful of shells. For all wood duck gunning I use a modified choke and high-base No. 6 shot.

There's only one easy way I know to shoot a wood duck, and that's in the marsh or lake where he comes to roost. Although these ducks feed and spend the day

in tiny trickles of water, they demand bigger and safer waters on which to spend the night. Here's where their susceptibility to decoys proves their greatest downfall.

Several years ago while grouse hunting, Bob Wolff and I discovered a small, shallow lake that was edged with thick grasses and cattails. The lake was a half-mile long and a couple hundred yards wide, plenty big enough to offer suitable protective covering for a roosting area. By chance, we happened to be hunting the edge of the lake near evening. Suddenly a flock of wood ducks whipped in over the trees, dropped to the water, and immediately melted into the thick grass. Bob was 20 yards to my left in the brush. I called over, "See 'em?"

"Aha, I guess," he exclaimed gleefully. "I even heard 'em!"

We stayed and watched the spectacle until almost dark. Flock after flock of wood ducks pitched it. No circling, no caution, no anything. They just brushed in over the trees, plopped to water, and scurried for cover.

A week later, on the afternoon of the opening day of duck season, Bob and I hauled a light duck boat into that lake. We paddled into the cattails, made a blind, threw out a half-dozen mallard decoys, and settled back to wait. There was still an hour of sunlight left when the first flock arrived. We didn't see them coming and the sound of their wings at a distance of only a few feet was like a roar. They saw us and kept on going without missing a wing beat.

Ten minutes later another flock pitched in. This time we saw them before they saw us and they were right in our laps when we started shooting. Two dead ducks hit the water.

We have gunned that lake many times since. The pattern is always the same. On the first day of each new season the ducks come in early with absolutely no caution. We usually collect our limits and get out before the main flight even starts. We don't want to wise up any more of those ducks than necessary. A few days later, we go back, making sure it's a dark, rainy day when the ducks are apt to head for their roost at an earlier hour. On this second shoot we usually don't have any trouble getting our limits. But going back a third time has proved to be wasted effort. Wood ducks may start out dumb, but they get smart in a hurry. A roosting area will give you one to three shoots, but after that the ducks don't come in until the legal shooting hour has ended.

5

Pothole Puddlers

I should have been discouraged that morning. I was hunting alone and I'd worked hard enough to bust twenty ducks, but my first shell was yet to be fired. I had gone out on the lake long before daylight, spread fifty diver decoys off a point blind, then watched the blossom of day pour across a duckless sky. There should have been some bluebills, enough to fill a limit in an hour or so.

But they didn't show and the wind changed, pouring straight at me in gusts of 30 miles per hour. Well, picking fifty blocks by yourself after three hours of being skunked is a chore at best. With wind pushing your boat all over the place it gets to be dragged-out work.

The ride back to the boat ramp was no picnic either. Whitecaps smashed against my boat and spray whiplashed me like driving rain. Back on shore I had decoy lines to untangle, the boat to bail, soggy clothes to peel off—and no ducks. A fellow could get discouraged.

Years ago I would have gone straight home with a "the-world's-against-me" attitude. This day I strolled into my garage some hours later with a grin of satisfaction, tossed four prime puddlers on the floor, and figured this duck shooting game to be indeed a sport of kings.

I had been pretty sure I could get those ducks in the first place. But I figured the divers would be a good bet too; and if I drew a zero I could cut the blind ses-

sion short and go hunt puddlers. They'd be waiting till I got there and then flush in point-blank range. If all this sounds too simple, it's intentional. We'll get to the work part later.

I got into my station wagon at the lake, then drove five miles into adjoining farm country. I slowed at a gravel four-corners, then coasted to a stop at the bottom of a hill. The fields on my left were green-tinted with winter wheat, and those on the right showed machine-picked corn. Two hundred yards out in the corn was a tree-filled depression maybe thirty yards wide by a hundred yards long. To a casual observer this stand of trees was merely a piece of ground some farmer had neglected to clear. If the casual observer had ducks on his mind, he might have figured those trees hadn't been cleared because their roots were anchored in ground low enough to be covered with water. This fact I knew; I'd been here before.

I stepped out of my car into farm country that looked far removed from duck-hunting locale. Roadside grass that had been starched solid by night frost was now limp with dampness from Indian-summer sun. The sky was as blue as the gulf ocean, and the wind scurried through treetops with a harmless October rumble. I hooked up hip boots, slid into my hunting vest, poured three high-base No. 6's into my 12-gauge pump and strolled 100 yards across the corn to the tree-filled depression.

I had waded maybe 15 yards when a greenhead that looked as big as the Statue of Liberty jolted up right in front of me. You think you have all kinds of time but that cornfed bundle of color almost got behind a tree before my shot pattern slammed home. He came crashing down through a snapping of limbs and hit the water with a resounding splash. He was stone dead and belly-up and one red leg gave a couple of feeble kicks. Before I got to him, I saw the brown breast puffed out like a billboard and the green head that took a ray of sun like a jewel in a showcase.

This was the best a man could do; you don't kill a better duck. His weight in my game pocket made me feel about ten feet tall.

That was the beginning. At the other end of this pond a flock of six baldpates put a lot of trees between their tails and my Winchester in a single thunderous jump. One lucky shot out of three upended a hen that had tarried a split second too long. Two birds in the bag and I hadn't been gone from the car more than fifteen minutes.

I waded out of the pond and walked 300 yards to my right, where the corn ended in a field of tangled brown hay. Down in the middle of this 40-acre field was another clump of trees and thick brush. There was water there too.

I came in from the blind end and stepped into the water with as little fuss as possible. This sort of thing is hard on the nervous system. I knew that if ducks were present they'd be pretty close. When they flush in that type of situation they blast a small chunk of the world apart right in your face. The pressure is terrific, and you're tense as taut wire. The pressure keeps building till you've covered the area, and if there's nothing the release suddenly leaves you limp as a rag. There was nothing.

There were no ducks in the next five potholes I waded. This is standard procedure. If you find ducks in one out of six or eight of these puddles you're about par for the course.

The next spot was a little house-sized pond tucked in a ravine behind a cherry orchard. I pussyfooted through the trees, bent low while sneaking to a grass-grown fence, then peeked over the top. Three teal were perched on a mud bar not 15 yards away. Two were asleep with their heads under their wings and the third was looking me straight in the eye. He waddled off the mud into the water with his neck stretched like a ramrod. He swam a couple of feet, then jumped. The other two catapulted off the mud like they'd been thrown by springs. I didn't shoot; I had plenty of time for two more bigger ducks.

There was a lot of thick grass growing in that pond, enough to help me remember a hard-learned rule. I stepped over the fence and went down to the water. The bottom was mucky, and I was just stepping out of muck that threatened to pull my boot off when a drake wood duck belted out the far end. My first shot was spontaneous reaction and probably missed him by 10 feet. The report put two additional wood ducks in the air, but I stayed with the drake, and continued to miss him clean. Well, that was that. You can't hit all of them, but easier shots just don't happen. The three empty shells floated almost together, and I picked them up to remove the advertising.

The fourteenth slough I covered that day filled my limit. It was a permanent pond in a field not 50 yards from a well-traveled farm road. You couldn't see water from the road, but tall grass and a few cattails were a dead giveaway. Not one duck hunter in ten would give the place a second look on the theory no wild duck would plop in so close to traffic.

I stepped out of the car, jammed three shells in my gun, and strolled straight to the water as bold as day. No use sneaking here; there was nothing to sneak behind. If there were ducks in the slough they knew I was coming. They would likely sit tight, hoping I might wade right past them. I was halfway across the pond when they couldn't take the suspense any longer. Five pintails were suddenly pumping the air. I accomplished my customary miss with the first shot, then dumped two birds with clocklike precision. I was done for the day!

This kind of duck shooting is really successful, yet few gunners know it exists. This gunning is by all odds the simplest and easiest duck shooting available today. It is unquestionably some of the best.

As discussed in the previous chapter, the first thing to realize is that a modern puddler is just about the smartest thing that flies. When he's subjected to any amount of serious gun pressure he's going to figure a way to avoid it. The only way to avoid it is to relocate.

Today's hunting pressure immediately rules out any place that looks the least bit like a good spot for a duck. Those ducks are hidden in the puddles that nobody pays any attention to. Many of these places are no bigger than the size of your kitchen. And I'll bet a good duck dinner that plenty of puddlers never see a hunter from the big scare of opening day till freeze-up. Yet it is entirely possible that most of these ducks listen to nearby automobile traffic every day of the season. A lot of that traffic consists of duck hunters rushing to some river or marsh with their boats and canoes, never realizing they are speeding by the ducks they won't see when they get where they're going.

So, how do we find these places? Again, we get to the work part. You have to get out and scout; you have to go look for them. There's no other way, but in the end you'll run triple amounts of shells through your gun. Fortunately, there are definite landmarks to look for, and you can find your hotspots before hunting seasons open, thereby losing no actual hunting time.

The most surprising factor in looking for potholes is the amazing number you'll find. They show up in the most unbelievable places. You'll find water in spots you'd bet a hundred to one were dry as a bone. This is precisely why you'll find ducks there; nobody bothers the birds. No water area is too small for a puddler; if he can wet his feet the spot is an excellent possibility. It can be right out in an

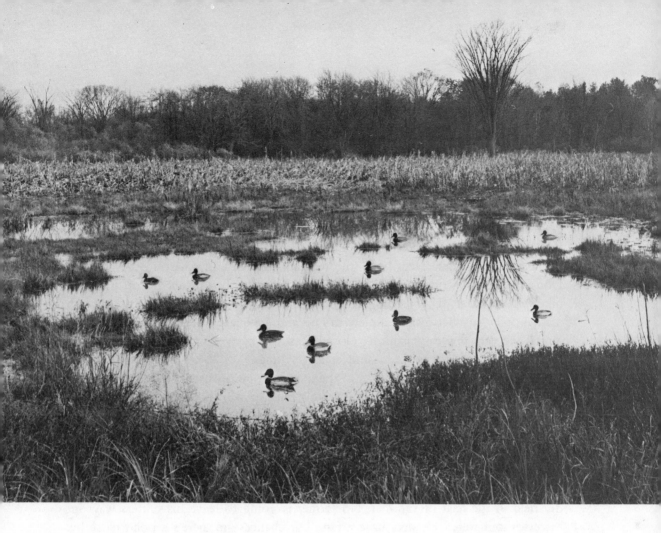

This puddle is only 100 yards from well-traveled road, but is hidden from view by knoll. Puddlers head for such spots after being driven from popular marshes by excessive gun pressure.

open field with just enough grass to cover a sitting duck and be a gun-emptying possibility. It can be way down at the back end of a distant field or tucked right behind a farmer's barn. Those ducks will find them; you have to do the same.

Some years ago I started hunting these spots in two townships near my home. The first couple of years I found about ten good possibilities and killed some prime ducks. Looking at my county map now (where I mark these spots with a red X) I count thirty-four places where I've jumped ducks in these same two townships.

This is mentioned simply to indicate that most hunters just don't have any idea how many possibilities exist.

Begin your scouting by inspecting any small area in lowland country that isn't tilled. There's a reason why it isn't cleared, and it's usually water. High grass and weeds are another good sign. If you spot cattails you've hit paydirt. Pay particular attention to areas bordered or surrounded by grain fields. A machine-harvested grain field is stamped Grade-A Prime to the eyes of a puddler, particularly mallards. If there's a hideaway pocket of water in the package you can almost bet on potential gun action. These facts hold true for farm territory anywhere in the country. Don't plan on spotting many of these places from a road. Walk up on hills and hike across country. U.S. Geological Survey maps are of tremendous help, although many ponds vary between complete dry-up and adequate water from year to year. You'll see very few ducks during closed season. They usually don't start working these places until they've been shot at a few times.

The farmer who lives and works in the area is an indispensable help in this hunting technique. When you ask permission to hunt he will more than likely put you wise to a couple of other spots. He might think you're nuts wanting to hunt ducks in a weedy puddle, but he's the guy who knows the country. He's also the man who will probably clue you on how to drive right out through his fields, thereby saving a lot of lost time in walking.

Always take a close look when you see cattle grazing far out in an apparently dry field in the heat of summer. No farmer is going to leave his critters way out there without water. He may have a tank but chances are there's a pond close by.

The best way of finding these water holes is the same way the ducks find them—by air. From a plane 800 feet in the sky every piece of water will show up like a glittering diamond. An experience some years ago serves to demonstrate.

I had spent $10 hiring a two-seat plane to take me over farm country for the express purpose of finding new places to mark on my map. I was in for a big serving of surprises. I saw waterholes I didn't even know existed in the same areas I had been consistently hunting. Near one pond that had been a good producer I saw two more just a stone's throw over a ridge. A big pond showed on an abandoned farm whose fields from the ground looked flat and dry. One good-sized chunk of water glittered in a patch of thick brush that I drive past dozens of times during a hunting season. And that was the one that turned up the most fabulous single session of jump shooting I've ever been a part of. The next day, to be exact.

My partner and I had spent most of the afternoon hitting some twenty ponds, and we were getting a bit disgusted. Place after place had shown no ducks. John had gone over his hip boots and it was getting colder and later. We had to find them pretty soon or it was going to be one of those rare trips with no action. I was driving fast over a little-used gravel road when I happened to think of that spot I'd seen from the plane.

I turned off the road and pulled to a stop close to the top of a small rise. On our left were grazing fields slanting up gradually to solid woods. On the right was a stubble field angling down to the patch of thick brush a hundred yards from the road. The brush covered an area comparable to a baseball diamond. Golden wheat stubble completely surrounded it.

"You mean here?" John exclaimed unbelievingly. "Where's the water?"

"Right there in the brush. At least it was yesterday."

"I've never seen any ducks around here," John opined. "Are you sure you haven't got your directions crossed?"

"Could be," I answered. "Let's find out!"

We walked down there and readied our guns as we came up to the edge of the thicket. There was water all right, lots of it.

"I'm going to wade it," I said. "Why don't you walk . . . " And that's all I got out because right then the ducks started boiling out. When those eight or ten mallards bounced above that brush they weren't 20 yards away and they looked big as geese and a couple of the hens were really sounding off.

Then the gun work started and that touched off the real bomb. Mallards exploded all around us. That little patch of brush seemed to erupt a duck from under every branch. The big drakes took the sun like a painting on a magazine cover.

You don't remember too many details in a session like that, but I do recall I'd barely started shooting when my gun was empty and ducks were still flushing out at point-blank range. I jabbed frantically for more shells; grabbed one, jammed it in the chamber, threw up the gun, and pulled the trigger. I did the same thing two more times. The fourth time I fired at a duck that wasn't more than 40 yards away, scored a miss, and then it was over. I had stood in one spot and fired seven shells from a plugged gun. You know you're into a pile of ducks when you can do that! And, as usually happens, such pandemonium is not conducive to accurate shooting. We had six ducks down.

"How do you like my pothole?" I jibed at John.

"So you lucked out," he grinned. "Let's find those birds!"

I reloaded from pure habit, stepped over a fence, and waded into the water. That brush was mighty thick and I pushed through bushes and snapped twigs and splashed around like a steer stuck in a muck hole. I finally worked into where those ducks had dropped and slowed down enough to begin looking. I had waded about two minutes when an excited quacking and a rush of wings pounded up 20 yards ahead.

Two mallards were in the air, two iron-nerved constituents who had decided to sit it out when all the shooting started. The hen was behind brush but the drake couldn't have made a greater mistake. He flushed in the open, hanging against the sky like a kid's kite. I waited momentarily while he picked up suitable distance, then touched off my shot. The No. 6's spun him in a circle, dropped his feet, and crashed him lifeless into the stubble. Therein lies a most important lesson.

The tremendous success of this game must be attributed to the one flaw in the puddler's clever bag of tricks. He's so super-smart he makes a practice of outsmarting himself. He'll do it most every time. After he gets his dose of opening-day scares he adopts a theory. He figures he won't get shot at if he isn't in the air, and why get in the air if he's got something to hide behind? He figures just like a gun-shy grouse; he won't jump unless you practically step on his tail.

What's all this mean? Two big things. One, if you can sneak within 100 yards of a "sitter" you can walk the rest of the way in plain sight. He'll jump if he's got plenty of distance, but if he hasn't he'll take his chances on sitting it out. That's a big reason why those ponds close to a road are always a good bet.

Number two, if you don't wade right through and all over a pond you won't flush half of your potential targets. If you just walk up to the edge of water-supporting cover, those ducks figure you don't see them and eventually you'll leave. But with the wading act sooner or later you get pretty close and head right at them. Then they figure they're spotted and about two seconds after that you've got a sky full of prime duck shooting.

I mentioned earlier that if you find ducks in one out of six or eight of these puddles and ponds you're about par for the course. Add to this the fact those ducks aren't likely to go back to a spot where they've been shot at. This means that over the full course of a season you're going to cover a lot of territory to consistently fill limits. All of which boils down to the fact that a planned system of travel eliminates a lot of driving and offers more time for actual hunting.

I follow the practice of marking every hot spot I know on a county road map, then numbering each spot in a sequence which eliminates back travel by car. This is more important than it sounds. You'll find—after you've located a few dozen hot spots—that it's difficult to keep all of them in mind without a handy reference.

The one bad part (or good, depending on how you look at it) of this type of hunting is the hard work involved. If you're averse to slogging all over the country-side in a pair of hip boots or waders this isn't for you. When you get home after an afternoon of plowing through hayfields, climbing hills, busting through brush, and wading ponds—all in duck-hunting gear—you'll know you've been someplace. But on the other hand, there's the constant challenge of opportunity. If there are no ducks in one pond, they'll likely be in the next.

Unlike most duck-hunting activity, early morning is the worst time to hunt pot-holes, simply because there will be more ducks in these potholes in direct relation to how hard they're hunted in popular shooting areas. Usual shooting pressure will clear the marshes and rivers of many ducks a few hours after daylight. By early af-ternoon they're tucked away in their hiding spots. This jump shooting, then, is al-ways most productive later in the day.

Procedure in approaching these ponds to gain most advantageous shooting posi-tions should be carefully planned. It's always a good idea, if possible, to approach with the sun at your back, simply because your shooting area will not be blinded by sun rays. Also, the closer you can get to these water areas before the birds are aware of your presence, the more likely they will hide instead of flushing. Take ap-proach advantage of hills, trees, knolls, brush, and so forth.

Puddlers tend to sit longer if they have plenty of heavy cover to hide in. If one end of a pond has considerable cattail or weed growth while the other end is more or less bare, always approach from the bare end. In this situation the ducks will swim to the cover, hide themselves, and, usually, feel quite secure in the hope you will pass them by.

On the other hand, if you approach from the cover end, the birds find themselves with insufficient camouflage and backed against open water. They have no choice but to get out . . . which they usually do far out of gun range.

In larger potholes, always approach from the biggest side in terms of water area. Puddlers naturally tend to work the smallest and shallowest sections because that's where the most cover is; if given a chance to get sufficiently hidden upon discovery of danger, they'll most likely take it.

If one side of a pond is edged with trees, try to approach from the opposite side; puddlers hate to have to clear timber before leveling off. This, again, is simply corraling your ducks into a position where they would rather take a chance on sitting it out. These factors further emphasize the extreme importance of thoroughly and completely wading each pond. Once those ducks have decided to wait it out, they won't jump unless you practically step on them.

Some duck-shooting authors have recommended that all jump-shooting approaches should be made upwind to lessen noise of stalking. The reverse is true for this type of hunting. First (and I point this out again because it's important), most of these birds know you're coming before you get within shooting range; they sit tight not because they're not aware of your presence but because they think they'll outsmart you. Second, when they do jump they will jump into the wind, offering best shooting opportunities.

Some ponds, of course, are better producers than others. Food and cover must be provided or the ducks will not use them. Any pond that is too deep for the tip-up feeding practice of puddlers should be discarded. Ditto for any water area that does not provide sufficient emergent growth to conceal feeding or resting ducks. This protective growth, however, need not cover the entire pond; a bushy end or an edge of cattails or high grasses will prove acceptable to most ducks.

Another good rule to keep in mind is that your ducks seldom journey farther from the marshes and rivers than is necessary to find isolation. This means that the ponds and puddles closest to popular shooting areas will usually show best gunning. By closest I mean within a radius of not more than 8 miles. Always remember also that any pond—provided it has the duck necessities already mentioned—is a good bet regardless of how close it may be to a road or a farmer's barn or a schoolhouse or what-have-you. Some of the finest jump shooting I've enjoyed has been within window-busting range of automobiles or farm buildings. These thoughts point out the truth that a puddler will hide in any place he thinks is free of usual hunting activity.

As mentioned before, U.S. Geological Survey maps can be a great aid in finding locations of these ponds. Any pond that existed when the map was made will be shown. These maps are readily available for any section of the country. If you live west of the Mississippi write to: United States Geological Survey, Distribution Section, Federal Center, Denver, CO 80225. If you hunt east of the Mississippi

write to: United States Geological Survey, Distribution Section, Washington, DC 20242. When writing ask for your state index, then order those maps which apply to your hunting area.

I have saved perhaps the most important part of this discussion until the last: that's the return you will get on your $10 if you hire a small plane to fly you over your hunting locale. You will discover ponds more quickly, more easily, and more cheaply than by any other method. But don't just go for a ride; here again definite procedure makes a big difference.

First, familiar landmarks look considerably different from the air, and they slide out of view mighty fast. Before you go up, spend some time with your survey map (or county road map) so you can quickly orient your position when in the air. Select familiar landmarks, circle them in red, and add an identifying number in the circle.

On the border of your map, list the numbers and write identifications, such as: 1. Victory Town Hall, 2. Lidke's General Store, and so on. Then when you are in the air, positioning is easily accomplished. You'll spot one of these landmarks, check its number on the border of your map, inspect the circles till you find the corresponding number, and thereby pinpoint your position.

Any pond in the area can then be quickly checked as to exact location and marked on your map with a small X. The second point in this plane deal is not to fly aimlessly. Remember that the most productive ponds are going to be relatively close to the marshes and rivers that puddlers are used to working. Fly directly to these places, then cruise in ever-widening circles. Also concentrate on farmlands close to lakes and fly parallel to river courses at 1-mile spacings.

Decoys often play an important part in this modern hunting technique too. It's a good bet to have half a dozen in your car at all times. A recent opening day proved a fine example of what can happen.

Bob Wolff and I had covered over two dozen potholes during the afternoon and had two baldpates to show for a whale of a lot of work. But that's the way it is when you hunt with Bob. He's an iron man of the first order. When you pothole-hunt with this guy you either keep up with him or you don't get any shooting. Anyway, late in the afternoon he finally slowed down enough to consider some decoy work.

"This place I know," he began, "is an old lake bed tucked in some hills back in a woods where I hunt deer. Some years there's water in it but most years it's

dry. If there's water, there will be ducks. And if they're in there nobody has bothered them. So if we just flush'em out easy-like, with no shooting, we ought to be able to pull them with decoys and calling when they come sailing back. Make sense?"

"Anything that doesn't involve any more of this cross-country footrace makes sense to me," I answered. "Let's go."

To cut the background short, there were both water and ducks—lots of both. We walked through a mile of timber, then waded in through scattered cattails and high canes with guns empty and five of Bob's huge homemade decoys. We splashed right into a flock of at least seventy-five puddlers that roared up like an oncoming locomotive.

"You feel kind of stupid with that gun hanging wide-open empty?" I asked Bob.

"Yeah," he grinned while watching the ducks disappear over a tree-lined hill. "Let's dump these blocks right where they jumped."

About half an hour later a pair of blacks came back and our calls and decoys pulled them as though we had them on strings. They worked in high over the hills with necks stretched down and wings just barely pumping. When they saw our decoys they skidded into a tight bank and came into approach patterns with all caution gone. Then their wings cupped almost together and their necks crooked back and they dropped straight at us. They didn't stop dropping till they hit the water somewhat busted with No. 6 shot.

"Uh-huh," Bob chuckled. "This little ol' show will be all over in no time flat!"

And it was. Long before sunset we were back in the car with limits of big ducks. "Thing about a deal like that," Bob said, "is we didn't frighten those ducks when we jumped them. If we'd loosed off in that flock on the jump they'd never have come back. We'll let it rest for a week, then go get another shoot."

If you live near any kind of pothole country you have the same opportunity staring you right in the face!

6

Calls, Decoys and Blinds
for Puddlers

Calls

The big question in calling puddlers is not so much what to do, but what not
to do. What's left, if properly mastered, will give any duck hunter all the practical
knowledge needed to efficiently use calls. The knowledge of three important princi-
ples will take much of the mystery out of the entire subject.

1. *All puddlers accept mallard talk without question. There's not much sense in try-
ing to master the calls of other puddlers, because all shallow-water ducks will react
perfectly to the call of a mallard.*

2. *It is seldom necessary for a hunter to cultivate a great many different mallard
calls. Any gunner who can realistically produce four common calls will kill 95 percent
of the puddlers that he would have bagged if he were expert at reproducing a dozen
calls.*

3. *For every duck hunter who can call effectively there are a hundred amateurs
whose calls scare ducks instead of attracting them. Learning to call isn't difficult,
but it must be learned correctly.*

The biggest single factor beginning callers should realize is that proper call learning is not nearly as much physical as mental. Forget all the ballyhoo of mysterious tone volumes, music scales, and muscle contractions. Properly forcing the breath through the call is simple automatic compensation of breathing muscles to produce a specific tone. When the learner interprets correct tone and call duration he simply practices by ear until he duplicates. Procedure merely involves purchase of a good calling record and playing it over and over while practicing. Memorize the musical inflections of the call notes much as you would memorize the musical inflections of a song. It doesn't take long to learn how to whistle a tune, nor will it take any longer to learn how to blow a duck call. Concentrate on "thinking" the proper tone and notes while practicing and all the mystery of duck calling will disappear.

Don't worry about the pitch of your call. Mallards, like humans, have various voice tones. It is for this very reason that there is no such thing as a perfectly tuned call. Experts will agree, though, that a high-pitched call will work best on some days while a low-pitched call will pull more ducks on another day. I don't know why this is, but I think it ties in with varying weather conditions and barometric pressure. All I can say for sure is that I've experienced hundreds of hunting trips when a high-pitched call was far superior to a low-pitched call, and vice versa. The simple answer to this problem is to carry two calls and experiment with each one at the beginning of each day's hunt. You'll find out in a hurry which one appeals most to the ducks.

In the old days there were very few hunters who were expert duck callers. In fact, during the days when live decoys were legal, hunters who used mechanical callers were almost nonexistent. Some guides used calls in conjunction with their live mallards, but when the "susies" were outlawed the art of calling became a necessity. Even then not many hunters became proficient callers since they had to take their lessons from live ducks in a marsh. It was a time-consuming way to learn.

Modern hunters don't have that problem. You can hear more duck talk on a commercial record in five minutes than the old-timer could hear in a marsh in five hours. And you can play the record over and over, concentrating on each call until the notes and tones become as familiar as your favorite song.

There is no successful duck hunter who uses his call poorly. An inefficient caller can't be successful, simply because he'll flare flocks instead of attracting them. Hunter A who makes wise use of decoys and blinds but poor use of his call will

kill far fewer ducks than hunter B who has equal equipment but doesn't call at all. But hunter C, given the same advantages plus proficient calling ability, will enjoy double the number of shooting opportunities a noncalling gunner will.

A good caller is a true conservationist too. He can attract his targets into clean-killing range, thereby eliminating the wasted cripples that result from long-range shooting. A further advantage is that if you can call a puddler successfully in your local marsh you can also call puddlers successfully any place in North America. Though hunting methods vary in different sections of the country, the art of duck calling remains constant.

The first step in learning to call is learning how to hold the instrument. You must grasp your call between your thumb and the base of your index finger at the place where the stopper joins the tube. The palm of your hand is cupped over the end of the call. During the actual calling you help control the volume and pitch of the notes by opening and closing your hand over the end of the instrument. The upper part of the end of the call should be placed firmly against your upper lip. The bottom part of the mouthpiece should barely touch your lower lip, since you help to form notes, tone and volume with actions of your lower jaw. Your teeth should be almost touching when you are ready to begin calling.

All experts at calling claim that the most important principle for the novice to understand is that he should talk—not blow—through his caller. Once you learn how to correctly force air through your instrument you will have licked the biggest problem in duck calling. The sound is not made by blowing as you would blow out a match, but rather by forcing air from your lungs up through your throat. It's the same kind of air control used by a trumpet player.

Stomach muscles play an important part in producing the proper sound. Here's a good example that will show you how to get the right air control. Say "whoosh" just as you would say any other word. You'll note that you say the word easily by using nothing more than your mouth and tongue. Now try saying "whoosh" while attempting to clear your throat as you would if you had a cold. If you feel your stomach muscles working you're forcing air out of your lungs in the proper manner. You'll note that when you grunt into your call with this air-producing manner it will blow very easily.

Each good duck caller will produce slightly different tones and pitches than other callers, but they all speak the same duck language. Every time a wild duck says something to another duck his sound has definite meaning. Knowing the wild

Proper way to hold a duck or goose call. Note how palms of hands are opened and closed to control tone of call.

bird's basic vocabulary is all-important. A gunner who doesn't know what to say and when to say it will never fool many ducks. When you want somebody to do something your request must be made in understandable and logical language. Common sense tells us that we must use the same approach when calling ducks.

The basic quack is the first call to learn. Divide the word into two syllables—qu-ACK—and say the word without moving your lips. Now say it through your duck call with the last three fingers of your hand partially closed over the end of the instrument. When you say the second syllable open your fingers. If you go through the motions properly you'll make a noise that grates on your nerves, but it will sound like a duck. Now is the time to listen carefully to recorded duck calls. Just keep practicing until you can make a quack that sounds like those coming out of the record player.

The next easiest call to reproduce is the hi-ball, an attention-getting call. It begins at the top of the scale with two loud, high-pitched basic qu-acks, followed by a series of six or eight drawn-out quacks that go down the scale. You'll recognize it immediately when you hear it on your instructional record. What if you don't have a record? I'll just point out that it's almost impossible to learn how to call ducks without help. The best way to learn is to get an expert caller to help you. If you can't arrange that, you must buy an instructional record or you might as well forget about becoming a successful duck caller.

After you have mastered the basic quacks you have to learn the short note that is spelled "w-HUTT." Grunt this note into your call with a distinctive tongue action on the syllable "hutt." This note, and the basic quacks, are the foundation notes of most of the calls used by mallards. You are now ready to try the comeback call, one of the most important calls, since it pleads with ducks to come to your decoys.

The comeback call begins with one or two take-off notes, is blown with fast, pleading grunts, and ends with a series of short w-HUTTs. It reads something like: "qua-qua-Quack-Quack-Quack-quaack-quaack-quaack-whutt-whutt-whutt." Again, you'll recognize it on your recording. Play it over and over and practice until you can duplicate it.

The fourth call you must know is called the chatter, cluck, or feeding call. This is normally a close-in call. It is one of the hardest calls to master, but it also is one of the most effective, since it is made by mallards when they are feeding happily. It requires a great deal of practice because it requires considerable tongue-tip action. It is made by saying "took-a, took-a, took-a" or "tic-a, tic-a, tic-a." Master the sound first, then practice for speed and pitch. There are many variations of the feeding call. It can be made high and fast for long-range birds, or slow and low for closer ducks.

You will bring in plenty of puddlers when you become proficient with the four calls we have discussed. When you master them you will probably want to learn other calls such as the lonesome-hen call, the paducah, the mallard drake call, the surprise-greeting call, several varieties of feed calls, and others.

The sequence of calls to use is just as important as reproducing proper tones. Consider, for example, how stupid it would be to use a loud comeback when ducks are already gliding into your decoys. Your call wouldn't make any sense to the

birds, and they would wonder immediately what was wrong. Let's follow through with an average situation.

Normally, you'll first see your ducks in the distance. This is the time to open with the hi-ball, blowing as loudly as you can and directly toward the flock. If the birds turn toward your decoys you switch to lower, more excited quacks. If the flock doesn't turn, you try pleading with the comeback. When and if the ducks work into approach patterns you send out a series of feeding calls mixed with contented quacks.

Most puddlers, especially mallards and blacks, are extremely suspicious birds. They often decide to alight on the far side of decoys, then sit and inspect the setup before swimming in to feed. This is the situation where a good call really proves its worth. At the first sign that the ducks are going to drop in short, hit them with increasingly excited feed calls. Tell them, in effect, that the imagined food in your spread represents the best dinner table in the country. Tell them not to waste any time joining the feast. If you're saying the right things in the right language, you'll never alert them to danger. In fact, a sudden stop in calling will usually make the birds suspicious immediately.

There is only one time to stop a sequence of calling—when a flock swings directly overhead. Calling at that time will likely give away your concealment. Another time when it's advisable to keep quiet is when ducks catch you by surprise and you don't spot the birds until they're fairly close. If they're already working to your rig they'll likely keep coming.

Keep in mind that a sitting duck calls from her position on the surface of the water. The acoustics of your call will be more natural when you direct your close-in calling downward. Such technique also tends to hide your face. The only time to call directly at birds is when they are over 100 yards away. The calling by two hunters provides double the deception, assuming, of course, that both partners know how to call correctly.

All good callers carry more than one call, for logical reasons. A broken instrument could put you out of business for the day if you didn't have a spare. Some experts also tune one call for long-range work, a second for softer, close-in talking.

A good duck call is a delicate instrument and should be treated accordingly. It should be kept clean, and that means occasional washing of all four parts in warm, soapy water. Rinse each part thoroughly and wipe them dry with a lintless cloth.

If there is any corrosion or gunk on the reed it should be removed with fine sandpaper. When you reassemble the call be sure to center the reed on the sounding plug and slide it back against the sounding-plug stop.

Tune your call until it sounds like the call on your record. Tone is changed by changing the curve of the reed. Do this by drawing the reed across the rounded surface of the sounding plug with one hand while pressing it down with the thumb of your other hand. A high-pitched tone is gained by accentuating the reed's curve. If you want a low pitch, curve it less. The truest tone comes from a reed with a graceful curve.

Decoys

All decoying ducks are attracted by sound, sight, or a combination of both senses. Proper calling takes care of the sound attraction, but no smart ducks will decoy into shooting range if blocks aren't realistic in outline, position and color. The best caller in the world will pull very few smart mallards into inferior decoys, but the noncaller will sometimes get fine shooting over superior decoys. It stands to reason that the gunner with the best calling ability plus the best decoys is going to get the best shooting. (It should be pointed out that we are discussing puddler ducks only in this chapter. Decoying divers is an entirely different game.)

A few excellent puddler decoys are far superior to many poor ones. A dozen will suffice in most situations. I've had many fine hunts over four or five oversize blocks. Number becomes important when you have to carry decoys into hidden potholes or out into fields. Decoy weight becomes just as important in the same situations. The puddler hunter often has to paddle a small boat or canoe considerable distances before he starts hunting. Here again decoy weight and number becomes a factor. A boat loaded with balsa or synthetic blocks will be a lot easier to pull over mud flats or through cattail marshes than the same boat loaded with solid cedar decoys. Several manufacturers produce very fine decoys that are extremely light and durable.

The modern hunter can also purchase kits of materials that enable him to make his own decoys at very low cost per unit. These kits contain cast aluminum molds

and easy-to-use expandable plastics. No special tools are required to bake your own decoys much as your wife makes a cake. Further information on such kits and the manufacturers of decoys can be found in the advertisement sections of such magazines as *Outdoor Life*.

Some hunters prefer to make their own decoys out of various materials. Cork used in modern construction is very lightweight, durable, and easy to work. A friend of mine recently made a dozen black duck blocks out of slabs of construction cork that were already impregnated with perfect coloration. It took him only a few hours to cut, shape, and glue the bodies, and a few more hours to carve the heads out of soft pine.

There are a couple more reasons why puddler duck decoys should be as light as possible. The lighter the decoy, the more it will swing and move with the effects of light breezes and water currents. A lightweight decoy will also ride high in the water, making it easier to see.

The second most important thing to consider in a puddler duck decoy is size. When I say decoys should be oversize, I mean they should be giants. Let me give you an example. Some years ago my partner made a dozen mallard decoys out of cork. The bodies of those blocks measured 19 inches long. That's about 4 inches longer than the body of an average wild drake mallard. Our decoys also sat considerably higher in the water than a real duck. Those decoys worked fine, but we finally decided they still weren't large enough. That's when we got the idea of buying some balsa goose decoys. Bob repainted the bodies of those blocks with mallard and black duck colors, and replaced the goose heads with giant duck heads carved from pine.

Again, those enormous decoys pulled ducks in fine shape, but Bob still wasn't satisfied. He decided to make some puddler decoys that would be masterpieces in all respects. He put in an enormous amount of work to produce giant blocks of hollowed-out cedar. Then he painstakingly painted those decoys with intricate feather designs of mallards and black ducks. They are far larger than most commercially available goose decoys, and the paint jobs are amazingly realistic. I couldn't even guess how many puddlers we've shot over them. To say they are efficient is a gross understatement.

They have provided us with a lot of laughs too. Many times when a hunt is going successfully we'll let occasional ducks alight among the decoys just to watch their

Some of today's working decoys (right) dwarf their counterparts of decades ago. Oversize decoys are the waterfowler's greatest asset.

antics. You can imagine the surprise of a big mallard drake when he discovers that he is less than half the size of the decoys. Usually his neck will shoot up, he'll back-pedal in astonishment, he'll stare incredulously at the other decoys, then he'll leap into flight and roar away.

Anchor lines on puddler decoys should be of a dark color so as not to contrast with dark marsh bottoms. They should also be of sufficient length to allow the decoy to move about when pushed by wind and water currents. It's always best to anchor your blocks in current areas if they are available. If you happen to come up with a bright day remember that the sunny side of a pond or marsh will display your decoys to the best advantage.

Place your spread within easy gun range, as most puddlers frequently drop in a bit short, planning to swim the remaining distance to the decoys. If possible, set a couple of decoys on shore; that trick helps to offer the illusion of a perfectly contented flock. Sleepers and feeding decoys create a natural appearance if placed

Anchor lines on puddler decoys should be at least twice as long as depth of water. Long lines enable decoys to move about from effects of breezes and/or water currents, giving the appearance of live, swimming ducks.

correctly. Put tip-up blocks closest to your blind, because incoming ducks often glide dead-on for the feeders, hoping to lose no time getting to the dinner table. Always try to place your sleeper decoys far enough out in the water so that they don't blend in with the shoreline. They're great as trademarks of an unsuspicious flock. Incoming ducks will seldom decoy to sleepers, so it's a good idea to use them as range indicators. In other words, place them about forty yards downwind from your blind. You'll know that any flying ducks inside of those decoys are within deadly shooting range. This is good procedure to follow with a decoy or two in any rig whether they're sleepers or not.

An important rule to follow—when possible—is to scout your gunning area before the hunting season opens. Watch how the ducks use the area and determine where they normally feed and rest. Those specific hot spots will be the best places to build blinds and locate decoys. This principle holds true especially in the hidden river and pothole areas where you won't have to compete with other gunners. An army of hunters in the big, popular marshes easily ruins the best of plans.

I personally like to mix my decoys in the ratio of half mallards and half black ducks. This, of course, would be poor procedure west of the Mississippi River where there are few blacks. But east of "Old Miss" it's a good stunt for several reasons. Mallard decoys are colorful and thereby easily seen. There is no more cautious or suspicious duck than the black duck. Most wild ducks assume immediately that an area is safe if it holds swimming blacks. Mallards and blacks are both big birds, so you can realistically use the big decoys that are more easily spotted than small blocks. In addition to all those factors a calling hunter must use mallard or black duck decoys if he is using a mallard caller.

Smart puddler hunters always place their decoys in an area where incoming ducks can make easy approach patterns into prevailing wind currents. Ducks, like airplane pilots, plan into-the-wind landings. The area downwind from your decoys should be open water, low marsh, or at best the lowest landscape available.

Blinds

The rules for blind building by a puddler hunter are basic. Most puddlers are smart. They won't come near some of the outlandish blinds to which divers pay

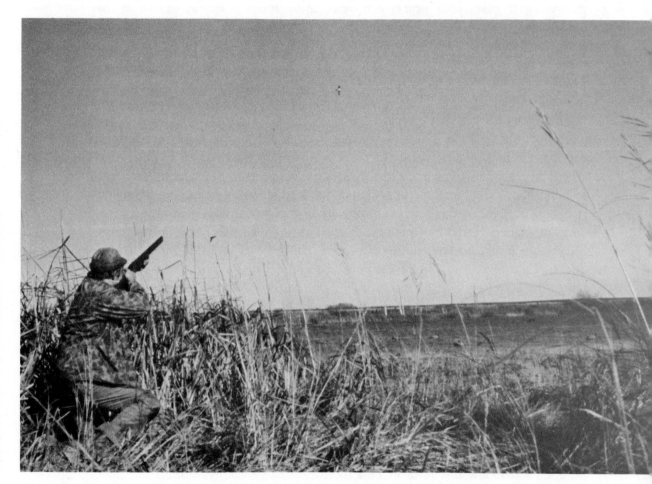

Cattail clump offers a readymade natural blind.

little heed. The primary consideration is that a puddler blind must be inconspicuous. Don't build a blind of wood in grass country, or a blind of cattails in flooded timber. Any successful blind will be one that affords concealment without intruding on a natural setting. Fortunately, puddlers locate in areas that usually harbor plenty

of natural growth. The simplest blinds are made on the spot from tree branches that are cut and jabbed into the ground or mud. Short willow clumps can often be trimmed into fine blinds. A duck boat shoved into a thick stand of cattails will provide an ideal blind in minutes. Don't overlook the possibilities of old muskrat houses, shoreline stumps, or fallen, dead timber.

Never build your blind any larger than necessary. If you're hunting alone, don't build it large enough to accommodate two gunners. On the other hand, don't build it so small that you can't shoot from it without making perceptible movement, or

These hunters are building an excellent blind by gathering clumps of high weeds and tying them together.

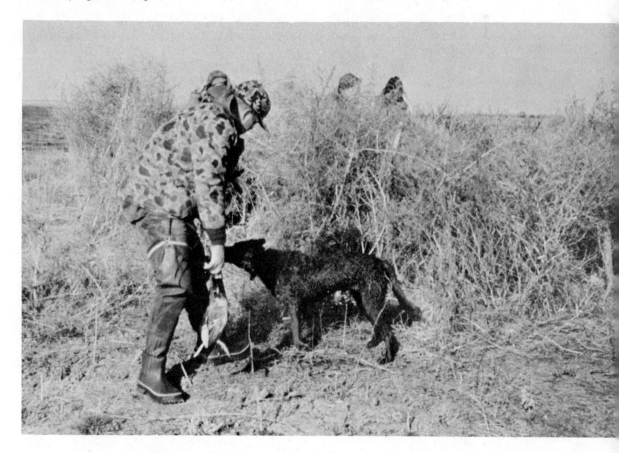

so perfectly concealing that you don't have a reasonable view. One old duck-hunter friend claims that a two-man blind is always too big when hunting mallards. "Two guns in a blind is one too many, since the blind will almost have to be too large to be natural. It's far better to have two small blinds spaced several yards apart."

There is one important exception to these thoughts. Hunters who know exactly where they're going to hunt often build more elaborate blinds long before the gunning season opens. Such blinds are accepted eventually as natural parts of the landscape by ducks using the area. There is no blind as efficient as one that the birds have tested many times and found harmless.

It goes without saying that the closer a hunter's outside garments match the color of his blind the less chance he takes of being seen. But proper color clothing is not nearly as important as the ability to keep still when birds are working. The time to grab your gun, get your call in your mouth, and hunker down is when the birds are still far out of shooting range. The most successful puddler hunters are the ones who freeze still as ice and keep their faces hidden while ducks are circling.

7

Timber and Field Shooting

Flooded Timber

There were perhaps forty mallards cruising across the trees 30 yards above me. The hens were chuckling and the sound of wind swished through cupped wings. An early sun bounced off the big chestnut breasts and shining green heads of the drakes. Those ducks should have seen me plastered against a pin-oak tree, but they didn't. They went on past, swung behind trees to my left, and started back in response to the pleading calling of Darrell Armstrong and Claude Wiggins.

They were still 100 yards out and just starting down through the limbs when another flock came out of nowhere, pouring across behind us. The hens were loosing off a batch of excited chatter. That pulled the first flock up and the whole works joined into one huge mass of ducks bending into another wide swing.

Darrell and Claude blew themselves hoarse trying to tell all those mallards that right in front of our feet was the biggest pile of pin-oak acorns in the world. They did it, too. What seemed like a split-second later the trees all around us were full of dipping and twisting ducks dropping for water.

Guns began crashing. Surviving mallards started up through limbs as if they were suddenly catapulted by unleashed springs. I lined my barrel ahead of the biggest greenhead I could focus on and pulled the trigger. The duck's head snapped back

and he tumbled into branches. The second shot from my over-under scored a clean miss.

I looked around to see how my two companions had done. Darrell was splashing off through the woods after a cripple with his Browning automatic half raised to his shoulder. Suddenly he stopped, twisted sideways for a better view through the trees, then fired. A cloud of spray jumped thirty yards ahead of him. He kept looking for a few seconds, then lowered the gun and jammed in another shell. Claude was wading around too, and it was obvious he was looking for downed ducks. When we regrouped my partners were carrying four mallards, all fully colored, fat and prime. The three drakes were flawless beauties with curled tail feathers adding elegance to perfectly colored bodies.

Such is the way gunning puddlers in flooded timber can go if you're in the right spot at the right time. The most famous right spots are in the pin-oak flats of Arkansas and neighboring states. Flood water is the ingredient that produces the shooting bonanzas. The country is so low that heavy fall rains easily cause many rivers to overflow. The water backs up into low-lying timber and stands until the rainy season is over. Depths of the flood water measure from 6 inches to a couple of feet, making it perfect for wading hunters and shallow-feeding ducks. The attractions for puddlers are the acorns that fall off pin-oak trees by the thousands. All the ducks have to do is swim around and gobble them up.

How many ducks can such an area attract? I remember one hunt when I waded out of the flooded timber near Stuttgart, Arkansas, just at dusk. I climbed up on a hill where I could see far out across the trees. The puddlers, mostly mallards, were flying in from rice fields and other floodlands to roost in the timber. They were coming in huge numbers that could only be guessed at and they were coming from all points of the compass. Everywhere I looked there were ducks in the sky. Big flocks, little flocks, high, low, everywhere. As it got darker they still came on endlessly, pitching down across the red sky and melting into the trees. It was a sight I couldn't leave until darkness curtained the view.

Mark it down in your rule book that wherever there is flooded timber in puddler country there will be ducks using it. A couple more examples will serve to demonstrate just how much shooting potential these areas produce.

A local friend of mine dammed up a small creek on his 80-acre property to build a trout pond. As the pond formed, so did backwaters that spread out over several

acres of timber. My friend is not a hunter, but he did tell me one day that he had noticed dozens of ducks using his property. When I hear something like that it really rings a bell because when a nonhunter mentions seeing a dozen ducks in timber you can bet that there are probably at least fifty that he didn't see.

I checked the flooded woodlands before hunting season opened and what I found caused me to grin like a kid with a new toy. There were at least fifty baldpates using the area. There were also flocks of wood ducks, mallards, and teal. My son was eleven years old at the time, and I recognized this opportunity as a surefire bet for teaching him the basics of puddler hunting. The first time we hunted the timber we just waded in and ducks erupted everywhere. Jack had a ball blasting away with his 20-gauge. We waited a few days and then had another great shoot over decoys. We didn't want to burn the area out, so we hunted it only four times during the entire season. It produced action every time.

Three years ago we had an exceptionally wet fall in my local area. As the rains continued I began shuffling my puddler-hunting plans. I was familiar with several lowland timbered areas that seldom hold water, but when they do they become puddler-hunting bonanzas. One of my favorite spots is in cornfield country. The ducks work those mechanically picked fields every year, but they normally spend midday and roosting hours in a big cattail marsh several miles away. When the timber is flooded they don't want the risky seclusion of the distant marsh; instead they pile into the nearby trees.

I'll never forget the first hunt of the season when my partner and I waded into that 120 acres of flooded oak and beech trees. Hundreds of ducks just hated to leave the place. Even while we were jump-shooting our birds there were new flocks gliding over the trees above us. Ducks seemed to be everywhere, exploding off the water ahead of us and flying in all directions. That's timber shooting at its best. Such gunning is often overlooked because most hunters don't realize its potential. Sure, the pin-oak hunting of the South is well known, but the much smaller hot spots of many states go unrecognized.

Timber hunting opportunities are more numerous for the modern hunter than they were for the old-timer. Consider the great shooting my son and I had as the result of a landowner building a trout pond. Hundreds of thousands of such fishing and water-storage ponds have been built in recent years over much of the United States. Not all of them hold flooded timber, but many do, and they are meccas

for puddlers. Even an acre or two of such habitat will likely show plenty of ducks. Consider also the hundreds of large reservoirs that have been constructed in recent years. South Dakota, long considered a prairie state, now has more than one acre of water for every resident of the state. A lot of that water is backup water that flooded fields and woodlands when the reservoirs filled.

There are, in several states, many flooded woodlands that have been engineered and constructed by waterfowl managers for the express purpose of providing duck-hunting opportunities. I recently hunted one of these areas in Minnesota and I found great gunning.

Contact with landowners is a fine key to success in hunting flooded timber. Ducks fly to and from their feeding and roosting areas, and landowners are bound to see those flights. Local conservation officers are top information bets too, because many flooded lands are hard to discover on your own. Often the major part of a forest shows bare ground while only a small part is under water. And, as I mentioned earlier, wet years will show many more acres of flooded trees than will dry years. Conservation officers keep up to date on conditions throughout their districts.

The best way to hunt small patches of timber is by using the wade-and-shoot technique. If several gunners are involved they spread out and wade straight ahead. If only one or two gunners seek action, they should follow zigzag courses that enable them to cover an entire area. These are basic jump-shooting techniques . . . shooting as ducks flush ahead of your wading approach.

In the big areas of timber . . . those that cover many square miles of water—the wade-and-shoot method is combined with a unique form of decoying. You don't carry decoys because you never know where you're going to set up. The majority of ducks using an immense area of inundated trees may select one section today and another section miles away tomorrow. So you wade and hope for jump-shooting opportunities as you scout for large concentrations of ducks.

When you find a hot spot, pick a big tree and flatten against the trunk. Now calls get into the act. When flying ducks are spotted, you attempt to attract them to your area with caller appeal. As soon as they show interest you kick up ripples in the normally dead-calm water with your feet. The commotion of spreading ripples convinces flying birds that other ducks have settled and are feeding busily. All the while a flock is in the air you try to remain hidden by circling the tree and

keeping the trunk between yourself and the birds. When they pass directly overhead you freeze and turn your face downward.

As ducks are bagged they are set out as decoys with the simple procedure of cutting off growing twigs six inches above the water and shoving the duck's mouth down over the rooted stick. A single stout twig will keep a duck in a realistic pose and anchor him in any desired spot. The improvised decoys should be placed in relatively open areas where they will be seen from above. Every duck that's killed is set up as a decoy as soon as it's retrieved. If you're gunning in a group, and you have good shooting, a flock of these "real" decoys glistening in the sun will be one of the most colorful waterfowling sights you'll ever see.

Because of the shallow water, boats are seldom used. Some local hunters, however, build comfortable and permanent blinds in spots that show fine gunning year after year. Boats get a big play with these gunners for easy transportation of regular decoys. They also eliminate some of the natural hazards of wading. Timber water is muddy and it hides roots and submerged limbs. Smart hunters wade slowly and cautiously.

Ninety-five percent of decoying success in timber hinges on the hunter's ability to use a call. The other 5 percent is in keeping your shooting area looking absolutely natural. Clothes must blend with tree trunks. Gun-shy puddlers will never descend through the limbs if they spot floating lunch wrappers, empty shotgun shells, or other debris. But top calling ability is the heart of the system. Because of the trees, you can't see many flocks until they're in your immediate area. That's the reason that veterans keep calling almost continually. They'll frequently pull ducks they don't even know are in the vicinity. As soon as the birds are spotted the calling is toned down and the water-disturbance trick begins.

When everything works correctly the puddlers come down through the trees like falling leaves. When that happens with a big flock you'll shoot your gun empty while ducks are still trying to land and flare at the same time. You'll be attempting to reload frantically as ducks seem to be zipping in all directions. Puddlers don't back-pedal their retreat through branches the same way they come in; they explode through the trees like a covey of quail. It's mighty exciting gunning, but you'll have to work to find the action. Like any other duck hunting you'll have to find the areas the birds are using, and you'll have to employ the procedures we've discussed before the fun starts.

Dry Land

The same thinking holds true for field shooting, another duck gunning technique that holds fabulous potential for the puddler hunter. Field shooting is becoming more and more productive as increasing gun pressure forces ducks to abandon the popular hunting areas of marshes and rivers. Modern agricultural methods enter the picture too. In the old days small grain-drop fields were the rule. Today, the fields are immense and the crop is harvested mechanically. Mechanical harvesters leave plenty of waste grain in the fields. Today's puddlers are well aware of these facts. Years ago, in my area, it was almost unheard of to bag a wood duck with corn in his crop. Now, in some areas where I hunt, it's unusual to shoot a wood duck that hasn't been feeding on corn. And if you've never eaten a big drake wood duck that's been fattened on corn, you're in line for a delightful surprise.

It's been common knowledge for years, of course, that grain-fed wild ducks can't be beat as table fare. There's nothing new in the fact that field shooting of puddlers has been going on since the old days. What is new is that field gunning is taking a larger and larger share of the puddler-hunting limelight.

Success in this phase of duck gunning depends almost entirely on pinpoint selection of the proper place to hunt. Use of decoys and blinds differs considerably from use of the same tools over water areas. Field shooting is usually of short duration during any one session, since puddlers do most of their feeding during early-morning and late-afternoon hours. During other parts of the day they're hidden in isolated potholes, sloughs and backwaters.

The first step in this kind of hunting is to find a field that ducks are using for a dinner table. The best bet by far is to cultivate friendships with farmers and landowners who live near large crop fields. If you lay your groundwork correctly, such people will alert you when puddlers begin using their property.

The next best procedure is to drive your automobile along rural roads during the early morning and late evening hours when ducks are flying to and from their feeding meccas. Try to follow these birds to their destinations. You'll lose some flocks before they settle, since roads don't always run in the direction you want to travel. Then you have to find another road in the same area and continue your search another time. The effort usually pays off because puddlers will return to a prime grain field day after day. Once they select a specific field—and they're not molested—they'll work it until they clean it out.

There are a couple of tricks of the trade that will help you find hot spots. Most puddlers won't fly far from roosting areas if choice grain fields are nearby. Do your scouting in the big fields that are close to the marshes and lakes where ducks spend the nights. Field-feeding ducks also head out of roosts through what prairie hunters call "wind tunnels." A wind tunnel is nothing more than a flyway route that may be a couple of miles wide and up to 15 miles long. You'll know you've found a wind tunnel when you see several flocks using the same general path across the sky. Depending on area, you may find a couple of wind tunnels within a few miles of each other. In another location they may be 10 miles apart. Between these wind tunnels you won't see many ducks, but in them you'll often see flock after flock of flying birds. And puddlers flying to food usually fly a straight line to their destination. When you find a wind tunnel you not only have found a well-traveled flyway route, but you have also determined the direction of a feeding bonanza.

This wind-tunnel theory might be better explained by comparison with a lopsided wagon wheel. Let's say that the prairie lake or marsh where the ducks enjoy sanctuary represents the hub of the wheel. The spokes are the wind tunnels that the birds use in fanning out to feeding areas. Some spokes run a few miles, others many miles. Somewhere at the end of these spokes ducks drop to feed.

Don't even bother rigging out under a wind tunnel where ducks are traveling high. They'll seldom work to your decoys no matter how impressive they may be. High flocks have definite intentions of going to specific destinations. You have to keep following the birds until you find the end of the rainbow. When you see flocks down to an altitude of 100 yards you're getting close. You need travel no further when you see low-circling flocks, ducks bunching into knots of disorganization and brushing across the ground to back-pedaling landings. Be in that same spot in the evening or the next morning and you'll fill a quick limit.

The problem of an efficient blind in a wide-open field is handled in one of two ways. If you don't locate many ducks, or if you plan a one-time hunt, the best bet is to lie flat on your back in the depression and cover your body with hand-raked stubble stalks or other native material. Your shotgun is nestled across your chest and you don't move a muscle from the time you spot flying ducks until they glide within easy shooting range. Then you snap to a sitting position and start shooting.

The best bet for a field that looks as if it might provide several good hunts is to dig a pit blind. Veterans shovel pit dirt into boxes and haul them away so there

are no telltale signs of fresh activity. This work must be done, of course, during midday or night hours when no ducks are using the field. (And, of course, the pit must be refilled when the hunts are over.) When a hunt begins, gunners lay weathered boards across the top of the pit and cover them with straw. When ducks drop in, the hunters shove the boards aside and come up shooting.

Decoys are all-important in most field shoots, especially in the vast prairie country. In these areas puddlers have such unlimited available food that their problem of finding something to eat is nonexistent. They know exactly where they want to go down, but if they see anything suspicious they have no trouble at all in gliding to a nearby field and finding the same unlimited food. Still, they have to get on the ground to eat it, and they're smart enough to know that some chunks of that ground may suddenly blossom with shotguns.

Concealed in a pit blind, his decoys spread nearby, a hunter takes aim at an incoming flock of puddlers.

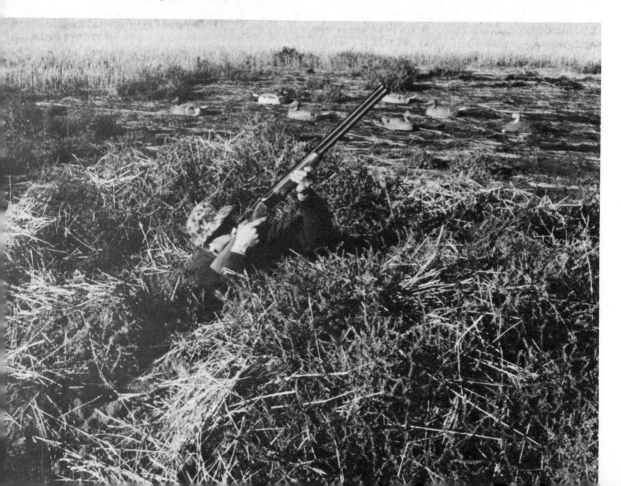

They are mighty cautious in handling this problem. They don't like to drop out of the sky until they're sure their chosen area is safe. There is only one guaranteed sign that assures them safety, and that's an already grounded flock happily stowing away the grain. A big flock of decoys in an otherwise bare stubble field will pull puddlers from the sky with the certainty of a magnet in a barrel of steel shavings. The experts know this fact. They wouldn't think of embarking on a prairie puddler hunt without dozens of decoys, and preferably a hundred or more.

A lot of these hunters use silhouette field decoys because they stack easily and are readily transported. Such inferior decoys wouldn't pull the first duck if used over water, but they work well in fields because open-area ducks seldom circle a spread. They're approaching through a wind tunnel over flat lands where visibility is perfect. They can spot decoys at incredible distance and they drop into approach patterns up to half a mile from a rig. In such cases silhouette decoys work fine because incoming flocks of ducks bore straight in.

Most prairie hunters put their decoys upwind from shooting positions, not downwind, as is the correct practice for shooting over water. Silhouette decoys will be recognized as fake as soon as ducks get above them; shooting must be started while the birds are still unaware of trouble. And, as we discussed earlier, all puddlers often plan landings short of decoys. When a hunter is located downwind of his decoys, he frequently has ducks dropping almost in his lap. Many a time I've snapped to a shooting position when a huge flock of ducks was gliding scant yards above me. When that happens the birds flare skyward with a thunderous roar of wildly pumping wings. It's a sound and a sight that just about drains you with excitement. When you swing your barrel on a close-range mallard that's jetting straight up you're enjoying one of the greatest thrills of duck gunning.

If there is any key to choosing a prairie-hunting hot spot it would be proximity to water. Not pond water, but lake water. Give a prairie duck a lake big enough on which to spend safely the hours of midday and night, and he has found paradise. The bigger the lake, the more ducks it will hold. The more ducks, the more wind tunnels and feeding fields. Any prairie area has its gas-station attendants, sporting-goods dealers and conservation officers who are familiar with the hot spots. These men, in addition to farmers, are the contacts to make when you're hunting a new area for the first time.

If you're a serious duck hunter and have never gunned the prairies, you should make every attempt to do so. That fabulous hunting in the North Central states

and neighboring Canadian provinces has to be experienced to be believed. It's simply astonishing to watch empty skies suddenly fill with thousands upon thousands of ducks. The emotional feeling can be described as no less than shock. You will marvel again and again that a man can hide in a stubble field and see 25,000 ducks in a single morning.

Though the prairies are the meccas for field shooting, the same action to lesser degrees can be enjoyed in every state of the Union by using the techniques we've talked about. In my home state of Michigan, field gunning is practiced very little, but the knowing hunters who have adopted the method find exceptional shooting that's getting better as the years go by.

One should consider special advantages that the system offers too. You don't have to contend with rough waters, boats, decoy lines, hip boots, and other such gear. And you don't have to worry about the accessibility of a hot spot; you simply walk to any area you choose. Sometimes you can drive your automobile to your shooting area, unload gear, drive the vehicle to a hiding place, and walk back empty-handed. One of the most important factors is that you don't lose any cripples. In stubble fields you just walk them down. There's no such thing as a wounded duck getting away—he has no place to hide. There's no wasted game in this sport; you collect everything you can knock out of the sky.

8

The Diver Hunter
Is a Specialist

Gunning the divers is a game where necessary equipment expense runs high, technique is a must, and gunning is often undertaken during inclement weather. Equipment expense in itself rules out participation by any but serious gunners.

Decoy costs alone usually run over $100. Divers are flock birds, and flock attraction must be the prime requisite. A rig of anything less than four dozen good decoys will offer little invitation to most flocks of food-searching divers. Ninety percent of hunting is done over large bodies of water, necessitating seaworthy boats and dependable motors. Some of these boats are of such special design that they are practically useless for anything else.

Most shooting is done from blinds, as this sport requires enticing the birds within killing range for waiting shotguns. While all blinds are constructed as hiding places, some also contain special features enabling unique gun work, use of retrievers, and handy access to odds and ends of equipment.

In addition to needing costly equipment, the diver hunter must also be a keen naturalist, for without complete knowledge of the habit patterns of diving ducks he is doomed to failure. More than in any other hunting sport, the margin between sensational shooting and no shooting depends completely on how much the hunter knows about the game he is playing.

In many ways modern diver-hunting techniques aren't much different than they were in the good old days. The ducks themselves haven't changed their life-styles to conform with today's conditions. Unlike modern puddlers, which are far smarter than their ancestors, the divers go about their business as if the world hadn't changed much in the last seventy-five years. That's why most of the diver-hunting techniques developed by veteran hunters of years ago are still the best techniques today.

But there are two modern methods of harvesting divers that you should be aware of—methods which would have been laughed at generations ago. In the old days hunting seasons were so long and ducks so plentiful that gunners didn't waste time spreading decoy rigs until migrations were peaking. The scattered early flights were ignored because they didn't offer enough shooting to fill large bag limits. A lot of fine diver shooting goes to waste because the traditional idea that foul weather is necessary for top gunning still persists in the minds of many gunners. That's faulty thinking. I'll go into more detail on the subject in the next chapter, but I want to mention one phase of it here, since it's a prime example of how the diver hunter must specialize.

I keep close checks on my favorite diver-hunting lakes beginning with the opening day of duck season, even though the main diver flights don't arrive until several weeks later. As soon as I spot that first flock of bluebills I plan a hunt for the next morning. It's almost a sure bet I'll get some shooting, because newly arrived ducks are hungry from traveling and haven't the slightest idea where they're going to find a feeding area. This means they're going to fly scouting trips shortly after dawn, and they're going to fly relatively close to shorelines, since those areas normally show the best food beds. Another important factor is that early-migrating ducks have been subjected to very little shooting pressure, perhaps none at all in the northern states that represent their first stop from remote breeding grounds. These ducks are dumb, and they're in the very best of decoying moods because they're looking for feeding friends.

It doesn't matter where you spread your decoys now as long as you place them where they can be seen easily. A long, narrow point jutting out into a lake from an upwind shoreline is the ideal location. At no time during the entire season will a point blind be more effective. Later, when the main flights arrive, divers will soon locate and establish primary feeding areas. After this happens, the point blind that

showed red-hot shooting earlier may be worthless. As the season wears on the birds know exactly where they want to go and they'll lose no time getting there.

Another advantage in the early shooting is that the birds don't tend to flock in large rafts. Smaller, individual groups will arrive on a lake or bay and go it on their own while looking for food. Later, as feeding areas are established, the flocks group into huge rafts. The moral is that you'll get far more shooting from four flocks of twenty-five ducks each than you will from one flock of one hundred birds.

Last fall I scouted a local lake in early October and spotted four small flocks of bluebills. The next morning my partner and I were barely settled in our blind when seven ducks zeroed in on our decoys as if they couldn't close the distance fast enough. We killed three out of that flock and three more out of a second flock that sailed in ten minutes later. Our limits were filled in less than an hour's hunting. As I drove home in bluebird weather I happened to pass the golf course. Golfers were just beginning to tee off on a perfect summerlike day. It was hard to believe that I'd just enjoyed some superb diver shooting. The same type of thing happens every fall.

Another myth held over from the old days is the theory that decoys should be spread off a lee shoreline. This is nonsense—divers favor the shoreline area nearest a good feed bed whether that shore is lee or not.

I discovered this truth many years ago by accident. At the time I had five duck-hunting guests who were primed for a long weekend of shooting. The first morning of the hunt a brisk south wind complicated my shooting plans. I had hoped for a north wind, which would be perfect for two point blinds in the area where I knew the bluebills were building up. I hadn't shot that feeding area, since I didn't want to disturb the ducks until my guests arrived.

All of my friends were veteran diver hunters, and we all put stock in the theory that we must rig decoys from a lee shoreline. So we rigged one set of decoys off a south shoreline point and another set 200 yards offshore farther down the lake. Dick McCarty and I tended the second set with my floating blind.

Action was very slow, and I was extremely disappointed, since I was anxious to show my guests top hunting. Several times I mentioned to my partner that if we could hunt the area I'd selected we wouldn't be able to keep the ducks out of our decoys. Finally he came up with an idea that was so contrary to diver-hunting tradition that I wondered if he was putting me on.

A good decoy set, and it's one old-timers would frown at. They believed all decoys should ride facing into wind, but commonsense tells today's experts that feeding ducks swim in various directions.

"We can certainly try the area with this floating blind," he said. "We can rig far enough offshore to offer fine decoy attraction. I'm sure the birds won't try to land downwind, but they may make an initial pass over our decoys, then figure on landing out in the lake and swimming in. Maybe it's a crazy idea, but let's try it. We're wasting our time here."

If I live to be one hundred I won't forget what happened during the next few hours. Hundreds of divers rose in a black, white, and brown cloud as we motored into the feeding area. As we placed decoys into the choppy water, I was sure that waves would roll and pitch our blind so much that the ducks wouldn't come anywhere near it. We were still placing decoys when the first flock of ducks returned. I don't know why they didn't see us, but they didn't flare until they were 30 yards away.

"I think," Dick grinned, "that we'd better load our guns."

We had three dead ducks on the water before we had the blind anchored. I'm sure we could have killed twenty-five birds in the next hour. None of the flocks were attempting to land among the decoys, but they sure wanted to fly right above them. After we harvested our limits we left the decoys in place and went to get our companions. Their eyes just about popped when they saw our prime divers. An hour later they were shooting from the floating blind and it wasn't long before we had five limits of ducks.

The wind held from the south the next day, but it was much stronger. I thought it was too rough to hunt the same spot, but my companions wouldn't have any part of a change in plans. I very seldom rig decoys in whitecaps, but we did that morning. The shooting wasn't nearly as fast as the previous day, but we managed to fill our limits from a very bouncy blind. It was the first and only time I've ever become seasick while duck hunting. But the fine shooting was another example of why the diver gunner must be a specialist. He must use special techniques if he is going to cash in on the potential action.

The nature of diver gunning requires much more than the knowledge of when and where to hunt. It also involves knowing the proper types of equipment that should be used and how such items should be employed. The best equipment is not always the most expensive. We'll discuss all of the important rules and procedures in following chapters. But before we get into technicalities it's important to emphasize that the successful diver hunter operates somewhat like an engineer. He

must understand how to use the proper equipment, he must have that equipment, and he must plan a hunt as an engineer plans a construction project. Good diver hunting, unlike good puddler hunting, is seldom achieved with little effort. This is the reason there are relatively few successful diver hunters. But those hunters who know the rules of the game enjoy the fastest and most exciting duck hunting available today.

9

Nine Tricks
for Bagging Divers

The margin between sensational diver shooting and no shooting at all depends entirely on how much the hunter knows about the game he is playing. More than in any other shotgunning, success with divers depends on knowledge rather than luck. If you know why a diver does what he does, when, where, and how, you're in business. He does these things not because he's smart, but because he conforms to the only patterns he knows. He's plenty wild but he's not intelligent. His reactions can be predicted with remarkable consistency.

A hunter may arrange a set of the most expensive decoys in front of the most perfect blind and have divers fly by all day without offering a shot. Another hunter in the same general area will kill a limit almost as fast as he can load his gun. The second man knows his ducks. The difference is that simple, assuming, of course, he also knows his equipment.

Practically all divers bagged in America are dropped from migrating flocks over waters with which they are unfamiliar. These waters can be any place, of almost any size. Most divers like salt water as well as fresh. The East Coast of the United States shows tremendous rafts from which thousands are gunned each fall. The same shooting is enjoyed on the bays and inlets of the West Coast. Freshwater diver shooting extends across the width of the nation.

When these flocks arrive on any given body of water they immediately search for unknown feeding areas. Where they find this food will often vary from year to year or even week to week. Once these dinner tables are discovered, only excessive shooting or continued migration will cause abandonment.

These locations are the only pinpointed areas where your ducks know there is food. They will fly past the best decoys in the world because they know where they want to go, and they'll lose no time in getting there. And you can't drive them away. You can flush them out, but they'll pitch back as soon as your boat has departed.

These facts ring the bell on trick #1, the most important rule in diver hunting. Scout your lake or coastline to find where ducks are feeding. Knowing where to rig is everything. Follow flying flocks with binoculars; mark the area where they go down. Run your boat over there and see how many ducks are working. If there are fewer than a hundred, forget it and move on. Two hundred or so represents a good possibility. If there are 500 or more you've hit paydirt. Then, and not until then, should you start dropping decoys.

Forget the old business of being set up before daylight. This is the worse thing you can do. You can't know proper location until you can see well enough to discover it. Don't worry about missing the dawn flight; divers work feeding areas all day.

There are some other popular theories that divers don't abide by. Let's lump these ideas under trick #2.

Take weather, for instance. I feel that the accepted idea that foul weather is necessary for good shooting holds little merit. Once ducks arrive in my area I hope for quiet weather; basically because I can easily scout and calm water is much easier to work with. Diver hunting in a rough sea can be hard labor.

I don't worry that ducks won't fly in bluebird weather. That theory is ready for the ashcan. It was developed on the basis of observation that ducks go zipping all over during and after the first fall storms, and any storm thereafter. True enough, as far as it goes. The ducks show because storms trigger new migrations from northern breeding grounds. But once they have arrived at stopover points, weather means little.

The birds fly for only three reasons: they are either hungry, afraid, or uncomfortable. They require daily food regardless of weather conditions. Their winging

away from danger has no bearing on climate. That leaves only a possible one-third of flights toward decoys affected by wind, low temperature, and such. And how important is that one-third?

A diver spends his life on open water. Conditions highly adverse to the hunter are taken in stride by the ducks. If they didn't like wind and snow and sleet, they would be long gone before these conditions existed. What is mighty uncomfortable for the hunter is just another day for the ducks.

Knowledgeable gunners hope for new storms to bring birds in, then hope for calm days so they can find their ducks and decoy them, regardless of where they might be.

I would venture that there is half a chance a duck prefers moving about on a quiet day. Other wildlife does, why not waterfowl? It would seem that high winds with driving rain or snow would make mighty uncomfortable flying at 50 to 90 miles an hour. The fact that the biggest migrations take place on quiet, bright nights tends to support this contention.

While we are on the subject of wind, let's take a couple of minutes to talk about its effect on decoy action. Regardless of why a diver is approaching your particular section of water, the one most important factor in luring him within gun range is decoy layout. The blocks that look and act the most realistic are going to pull the most birds. Physical appearance is readily handled by obtaining good-quality lifelike decoys and keeping them in tiptop condition as to repairs and paint. But action of your blocks depends entirely on wind and water currents.

Since most divers are shot at over big, open waters, let's forget about currents. No matter what materials your blocks are constructed from they can't possibly exactly duplicate the swimming action of a live bird. Wouldn't it be reasonable to assume that the more your decoys are pitching and twisting about in rough waters the less they will look like the real thing? The ideal situation is just enough breeze to ripple the surface. Such a breeze will keep your decoys properly spaced, eliminate tangled lines, and add enough movement to give an active appearance to the whole spread.

Another big advantage of calm water is that your decoys are easily seen from great distances. A flock of bluebills highballing down a shoreline are much more apt to consider your invitation if offered in time to catch their undivided attention. Many a time I have sat in a windy blind watching ducks moving up a flight lane apparently completely oblivious to decoys just a short distance away. Diving ducks

travel fast, in more or less straight-line routes. Spotting other flocks far ahead gives them time to change direction and maneuver into planned decoying patterns.

Divers are about as dumb as ducks come, so far as blinds are concerned. For actual purposes of concealment, you don't need any blind at all. I've shot many divers while standing in waders on sandbars covering shallow water. But I remained absolutely motionless when ducks were working. A moving gun barrel, a jerking hand or flash of movement, will alert a diver at 300 yards. A diver may not understand what a man is, but if he spots movement where everything should be motionless, he'll spook immediately.

Blinds, in this game, are used to blend boats and hunters into the insignificance of surrounding landscape, an attempt at arresting movement and contrast. Divers will pitch with abandon to blinds that a mentally deficient mallard would flare from at limit of vision. You can decoy divers from a houseboat, as long as you park it in the right spot.

Trick #3 concerns physical characteristics of these ducks. Their wings are short and stubby, built for high speed, straight-ahead power flight. Their area of operations is over open water, where quick maneuvering is uncalled for. They require lots of room for approach and landing. They always land into the wind. They always plan landings in the main flock or overshoot the entire rig. Keep these thoughts in mind before placing decoys. Never rig in narrow channels of rivers, tight against hilly shorelines or restricted marshes. Get as much open water around you as possible. Give your diver room to work according to his natural patterns. If you don't, he'll pass you by, hot-spot feeding bed or not.

The rest of our tricks concern equipment and how to use it. I would be wrong if I said you can't gun divers successfully without use of special gear and technique. If you're in the right spot at the right time you can blast a quick limit with field loads in a single-barrel shotgun—over antique decoys that haven't seen paint in twenty years. But don't count on it. Today's gunning conditions seldom present such bonanzas. But they consistently offer conditions where proper equipment and use show sensational shooting otherwise unattainable. Take decoys for instance—trick #4.

Divers, particularly bluebills, redheads, and canvasbacks, are flock birds. The sooner you offer flock attraction to distant flights, the easier it is for them to work into approach patterns. Here is the supreme case for oversize decoys. I feel the switch to monster blocks is the biggest technical improvement in diver gunning

during the last twenty-five years. They're seen at twice the distance, both at low silhouette and high in the air. Big decoys have wide, flat bottoms, eliminating roll and pitch—a dead giveaway to today's gun-wise ducks.

By oversize I mean twice the size of a live duck. The big blocks pull targets from unbelievable distances, ducks that would pass an average spread without even seeing it. That's a significant factor if you have competition from other hunters. Also, you can get by with fewer decoys. Three dozen of the big ones, properly rigged, present more flock attraction than five dozen of the standards. The advantages are obvious.

Trick #5 is simple, but of tremendous importance: rigging of decoys—lines especially. Suppose you locate a feeding area you can't hunt because anchor lines won't reach bottom. All other equipment and knowledge is useless. You're licked right there.

The answer is in measuring water depths of probable hunting areas before the season opens, making sure lines are long enough for any location. Actually, for most effective decoy presentation, lines should measure twice the length to bottom. These longer lines permit free floating, allowing decoys to swing in wide arcs and eliminating the jerking and pulling of lines that just reach bottom. That doesn't sound like much, but don't underestimate decoy-wise ducks. They've looked at a lot of them, and they're cautious. Decoys must look lifelike from the time they're spotted until your ducks are well within shooting range.

Another thing about lines. Buy them dark or dye them with waterproof dye. White lines spell something wrong from high in the air.

Trick #6 is simpler yet. But it's a surefire method of doubling lifelike decoy appearance. For years duck experts have proclaimed that anchor lines should be attached to decoys dead center at the front end. They say ducks always swim into the wind, and decoys should do likewise. They're absolutely right, up to a point. And it's a big point.

Swimming ducks do head into the wind, but feeding ducks don't. Feeders dive and come up in all directions. Feeding ducks are also completely at ease and without fear of any kind. This is the exact impression you want to create. You do it by attaching about 20 percent of your lines at various positions on bottoms of decoys. What about roll and pitch? Oversize decoys eliminate a lot and loose lines take care of the rest.

Trick #7 corrects the common mistake of decoy placement—not where but how. Let's explain with an example. Say we're 300 yards from fifty live ducks. If those ducks are tightly bunched they don't appear as much of a flock. If there are 5 feet between birds the flock looks twice as big, mainly because it covers twice as much area. If there are 10 feet, the impression is again doubled. So it is with decoys.

Most hunters start pitching blocks from their boat as fast as they can get them out, with the end result that many end up practically kissing each other. Don't do it. Carefully space them at distances of at least 8 to 10 feet. You'll get twice the drawing power. With divers you need all you can get.

Some pages back we mentioned flight characteristics and landing patterns. The point here is that divers need a landing field. Be sure your decoy placement offers that attraction. I've found that two separate flocks, with a big hole in the middle, are hard to beat. This landing field should be up to 20 yards wide, completely void of any decoys.

The next stunt in decoy placement is a string of attraction decoys. Start from the outside edge of one of your flocks and run ten or twelve blocks straight out into your lake or bay. Space them at least 20 feet apart. These decoys have anchor lines attached at the head end, allowing all to face in the same direction, directly toward your main flocks. The impression created is that of birds in a hurry to join their feed-bag friends. The effect is twofold.

First, the far end of the attractors will be up to 100 yards from your blind, thereby catching earliest attention of distant flocks. This means that the sooner you have them turned, the more likely they are to come all the way. Also, once turned, they'll catch sight of your main flocks right away. Second, incoming ducks pull first to the attractors, following the same general path to main flocks. If your blind is properly located in relation to your decoys, the birds' attention will be diverted from your position.

In talking about shooting positions, let's splice in a gem of information that—because of its importance—we'll tag as trick #8. When a diver makes up his mind to definitely land, he'll come in low to the water every time. If he's indefinite, or just checking, he'll be 20 to 100 yards in the air. This is a diver characteristic. He'll frequently come in high with all intentions in the world to make a swing, drop down, and sail back for easy landing.

It took me years to learn that these high fliers weren't flaring from suspicion but merely reacting to inborn habit. I've wasted many hundreds of shells on long-range birds that, if I'd waited, would have swung and provided easy shots. Think over your own experiences; I'll bet memories come back in a hurry. And while you're at it, how many divers have you busted over decoys that weren't piling in just above the water? Remember such thoughts this fall. Wait them out! You'll double your take with half the shells.

Trick #9 is the most important of the lot, but I've saved it until here because its advantage is emphasized by everything already mentioned. Where to locate your blind in relation to decoys will spell final success or failure.

There are two rules to remember. First, decoying ducks naturally direct attention on your decoys. Since you've already given them a wide-open landing field, they're going to aim for it. Never obstruct this opening, or any area near it, with your blind. In other words, don't focus suspicion on the landing field by drawing attention to an unnatural object.

The second consideration is wind direction. With a perfect offshore wind, always anchor your blind near the outside edge of the decoy flock terminating with attractor blocks. The logic is simple. Incoming birds follow attractors to the open landing area. Once they have maneuvered into approach patterns they see nothing but decoys and an open-water area. Your blind, off to the side, is out of the line of vision, but still within easy shooting range.

Crosswind blind location is determined by the simple rule that divers land into the wind. The best location is normally off to the side of the upwind side of the entire decoy spread.

All such thoughts are for initial location only. I've found these ideas usually best, but I've also discovered that you sometimes have to relocate a half dozen times. A 20-yard switch frequently turns the trick. One day a partner and I had a heck of a time before we finally got our floating blind into a spot where it worked. We moved the blind five times. At each location ducks would come sailing in, then flare off.

"Well," groaned Bob, "let's try it outside the decoys!"

"You're nuts," I protested. "The idea of the blind is to blend into the shoreline. We'd stick out like a lump!"

"Baloney," he insisted. "Let's try something new. I'm desperate!"

We tried. It worked like a charm. I couldn't explain why if my life depended on it. I can only guess that decoying divers have a blind spot in vision for any given approach pattern. Where it might be depends on combinations of wind direction, degrees of brightness, and shoreline details. But one thing is sure: somewhere around properly rigged decoys you can locate a blind that divers fail to respect. I could count on my fingers the times I've seen this theory fail. Keep in mind that replacing decoys in relation to a permanent blind has the same effect as replacing a floating blind in relation to a static spread of decoys.

Another thing about divers is that they're always most willing to decoy after they pile onto new water. The first feed beds they find will draw every duck for miles. You hunt them then, and they'll practically fly into your boat. Such shooting is absolutely fabulous!

10

Diver Decoys

Knowing where to put your decoys—as discussed in the last chapter—is fundamental in successful diver gunning. But what kind of decoys you put there, how you rig them, and how you handle them are all important too. Since divers are flock birds, other ducks represent the best lure possible. If the gunner's artificial attractions appear genuine, his chances of luring today's ducks into gun range are far greater than if he uses a rig with imperfections.

That wasn't true in the old days. Ducks weren't as wary then because they were subjected to far less gun pressure. The odds were about one in a thousand that a flock of swimming ducks would turn out to be decoys. Just about any decoy that partially resembled a live bird would do the job, since wild ducks had little reason to be suspicious. Modern ducks aren't that dumb. They won't set sail for a decoy spread unless they're convinced that the blocks are live birds.

Oversize Decoys

Though I mentioned several diver characteristics in Chapter 8, I want to emphasize a few extremely important points. The first thing to consider is that you must get the duck's attention from as great a distance as possible. Divers fly extremely

fast. Because of their relatively small wings they can't maneuver like puddlers. Mallards, for example, can change directions suddenly and sideslip into landing areas. Divers don't do this because they can't. They have to plan landings from far beyond gun range. A diver is much more apt to swing to your decoys if he can spot them from a great enough distance to plan an easy approach pattern.

I'll repeat that this is the reason why oversize decoys are so significant. It's also the reason why four dozen decoys are more effective than two dozen, and eight dozen are more effective than four dozen. Lots of big decoys are the most effective calling cards you can use when gunning divers. I had that lesson drilled into my rulebook the hard way many years ago.

Back when I was a teenager, my friends and I gunned from a point that jutted out into a large lake. A veteran diver hunter of the times shot from a similar point 350 yards away. Before we began offering competition, he killed all the ducks he wanted over a spread of thirty-five small, round-bottomed bluebill decoys. My partners and I didn't get much shooting over our eighteen similar blocks.

Oversize decoys are essential for luring divers into gun range. Note difference in size between mature bluebill drake and decoy.

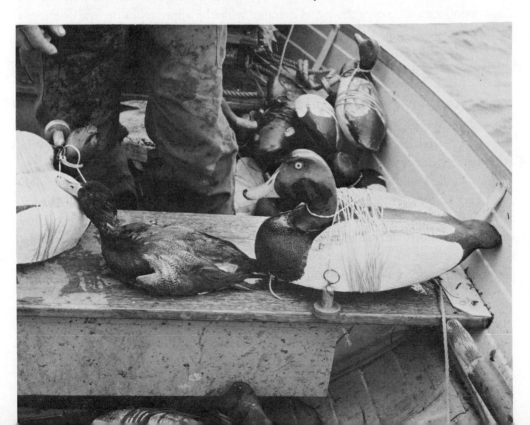

We finally reasoned that our neighbor got most of the action because his bigger spread offered the best attraction. So we made decoys the following winter from any suitable wood chunks we could buy or beg. Our decoys were crude by today's standards, but we spread fifty of them in front of our blind the next fall and they worked like charms. We enjoyed the best share of the shooting for a couple of years. Then our neighbor decided to outdo us in style.

The next fall he spread seventy-five oversize decoys that made our rig pale in comparison. The results were totally frustrating to teenagers who couldn't afford to buy good decoys. Scores of times we would watch flights of divers come up the lake, bank for our decoys, then tip away and sail into the better spread.

Realistic Decoys

Assuming all other conditions are equal, a gunner working with the biggest and most decoys will always get the best diver shooting. (For a single exception see Chapter 14.) The second most important rule is that the gunner working with the most realistic decoys will get the fastest action. Even today, when a diver sights a decoy layout, he immediately accepts the spread as the real article. Whether the target continues to accept the rig as genuine while he approaches depends on many factors. Keep in mind that a diver's airspeed enables him to move within minutes to other locations miles away. A few minutes of flight time means nothing to a duck. Your rig has to be good enough to say, "Stop right here. You can't find a better deal anywhere!"

It's my contention that many diver decoys on the market today are designed and colored to appeal more to the hunter than to the ducks. As a rule they are too brightly colored, and too much attention is given to intricate feather and body details. Perfect decoys are best when working with the more wary puddlers that frequently circle while checking every detail, but divers usually roar in on a straight line. They're well within gun range before such niceties are distinguishable. Coloration and body outline are the two most important features to consider in a diver decoy, since both can be analyzed at long distance.

Most commercial decoys are colored to represent the gaudy spring plumage of live birds. Proper coloration should represent the much duller fall plumage that

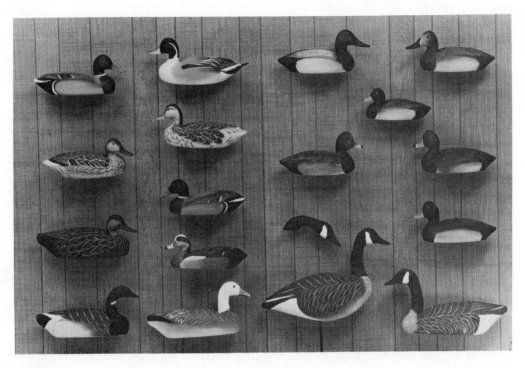

Today's decoys, produced with the aid of modern technology, are superior to any that were used years ago.

most wild ducks wear till hunting seasons are well along. How to lick the problem? There are several solutions.

If you have more decoys than you need, use hens only during the early part of the season. Substitute more and more drakes as you begin to notice the arrival of fully colored ducks. Another trick is to scrub the bright paint jobs of new decoys with steel wool. The abrasions will tend to reduce the gloss and dull the paint surfaces. Although it takes a little time, I prefer to rework paint jobs with a little touch-up painting of my own. Many commercial decoys show too much white. I deemphasize that color by painting the proper parts with blacks, browns, or grays.

For my money the average decoy manufacturer doesn't make his product look like a real duck from the body-outline standpoint. Some of these decoys look great

on a dealer's shelf, but they have an entirely different appearance in water, since they're partially submerged. The worst offender is the manufacturer who produces decoys with life-size heads on otherwise oversized bodies. The head of a decoy is a prime attention-getter, since it's positioned above the body where it's easily seen. Decoys with big heads stand out like billboards. Several of my hunting friends replace the heads of decoys they buy with giant-sized heads they make from plastic materials.

Basic body-contour lines are all-important in diver decoys too. They are the general attractions that incoming ducks focus on. The birds expect to see the same body outlines that they've been looking at all their lives. Let's use an example to illustrate what can happen when the wrong decoys are used.

Say someone offers to sell you a few dozen fine mallard decoys. You don't need them for puddler hunting, but you figure that with a good paint job you can make fine divers out of them. I made that mistake many years ago and I couldn't understand why flock after flock of apparently well-fooled divers would suddenly flare away before reaching shooting range. Though my paint jobs were good enough to fool those ducks at a distance, the high-riding tails of mallard outlines spelled "fake" upon closer examination.

What all this means is that if most of the divers in your area are bluebills, you can't go wrong by using good-quality bluebill decoys. If you don't know what good-quality decoys are, don't buy them on your own. Get the advice of a local veteran duck hunter. And don't be fooled by price. I've seen decoys that sell for $150 a dozen that don't work nearly as well as another brand that sells for $50 a dozen. The three basic things to look for in a diver decoy are: oversize dimensions, dull coloration, and lifelike body outlines. Good diver decoys can be far cheaper than good puddler blocks, since detail colors and feather designs are unnecessary.

Decoy Materials

Many gunners have heard that a solid cedar decoy can't be beat. That reasoning just doesn't make sense today, though I'll admit that cedar does have some advantages. First of all, cedar is tough; decoy bodies carved from cedar blocks are difficult to break or chip. Wood takes quite a barrage of shot without damage, and

it holds paint better than synthetic materials. Wooden decoys are also dense enough to ride level in the water.

On the debit side, they are heavy, very heavy when made oversize. They also require keels, which add further bulk and weight. They sink low in the water, and thereby lose much of their outline effectiveness. Their necks are vulnerable to breakage from the rough handling that's frequently a necessity in diver hunting.

When the incredible modern plastics came into being, the advantages of the heavy wooden decoy faded rapidly. I'm personally partial to the light decoys that are made of durlon. They're solid, so shot holes don't affect them. Heads are made from a plastic that is reasonably shot-resistant. They ride high on the water, thereby offering top body-outline attraction. They're light and far more easily handled than cedar blocks. I've used them for years, and I haven't broken a neck on a single decoy. They don't hold paint as well as cedar, but touch-up paint jobs can be made in a hurry. Their surfaces absorb paint in such a way that finishes are naturally dull. There's no more deadly giveaway than the gloss-bright finishes that result from painting smooth wooden decoys.

Fine decoys are made of cork too. I won't recommend other blocks made from modern materials. Pressed-paper and rubber decoys are fragile, usually are undersize, and exhibit poor body outlines. And stay away from synthetic decoys that are hollow. A shot hole in a hollow decoy can lead to a frustrating experience. The first time I saw a hollow plastic decoy sinking out of sight I could hardly believe my eyes.

Lines and Anchors

As far as decoy anchors and lines are concerned, I'm a pessimist when it comes to products manufactured for duck hunters. Labor and material costs are so high today it's almost impossible to buy good-quality anchors and lines because they can't be produced for a price that the average duck hunter will pay. Most commercially produced anchors are far too light to hold diver decoys in rough water. The lines are too thin and weak.

There isn't any way to lick the line problem except to pay your money and take your choice. By this I mean that good lines are going to cost you plenty, but they'll last for years. I prefer a one-eighth-inch nylon line that's designed for tent and

awning cords. Surplus stores and cash-discount stores often carry this cord in bulk, and that's the way to buy it. Electrical-supply stores for electrical contractors usually stock the thick cotton cords used in electric motor windings. This material makes excellent decoy line.

There are other heavy-duty cords that work just as well. The one problem with all of them is that they are normally white. White is no good for a decoy line, since it contrasts with dark-colored water. Such cords should be dyed a dark green or brown.

This is only one acceptable way to attach your line to the decoy. Tie the line first to a giant snap swivel, then snap the swivel on a brass screw eye attached to the bottom of the decoy. The swivel eliminates the fraying that's bound to occur if you tie the line directly to the decoy. All screw eyes should be brass to eliminate rust.

You'll have the best anchors if you make your own. That's easy to do with chunks of stiff copper wire, an old fry pan, a small box of sand, a small tumbler glass, and some scrap lead.

Snip the copper wire (don't use steel—it'll rust and rot your lines) into 8-inch lengths. Bend each length into a U-shape and put a short right-angle bend on each end. Moisten the sand slightly so that it will maintain the impressions you make by pressing the bottom of the glass into the mold material. Melt lead in the fry pan, hold the inverted U in the cavity in the sand, and pour the lead around it. Hold the wire a moment until the lead solidifies.

I've found that anchors weighing about half a pound are ideal. A little experimenting will tell you how deep your mold should be to produce an anchor of that weight. A half-pound anchor may sound heavy, but it sure licks the problem of decoys that drift away because of anchors that are too light.

Some diver hunters prefer to multiple-rig their decoys to do away with the necessity of individual lines and anchors. There's a best way for that setup too. Eleven to thirteen decoys should be permanently rigged 12 feet apart on a 200-foot length of #8 sashcord equipped with 5-pound anchors on each end. The first and the last decoys of each string are tied 20 feet up from the anchors. All decoys are attached to the sashcord with 2-foot leader lines. Their spacing is always maintained because the leader lines are tied to 1-inch brass rings knotted on the sashcord.

When placing this rig, throw out an anchor on one end of the sashcord, then pitch decoys over the side of the boat while drifting downwind. When the blocks

Best way to attach line to decoy is with a snap swivel. This arrangement allows decoy to ride naturally, eliminates twisted and frayed lines.

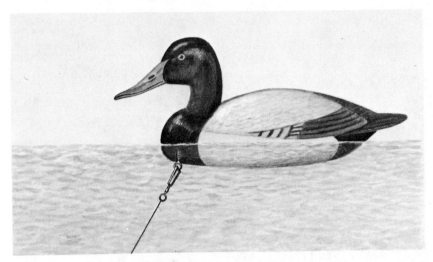

Method of making decoy anchors. Lead is melted in fry pan and poured into sand mold, trapping wire. Anchor should weigh about ½ pound.

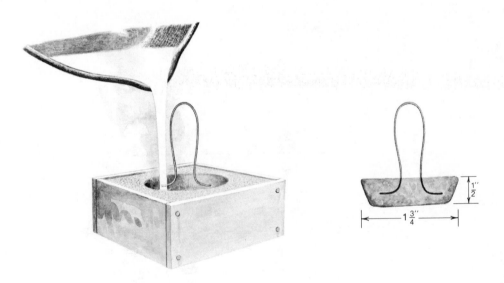

Two methods of laying out multiple-rigged decoys.

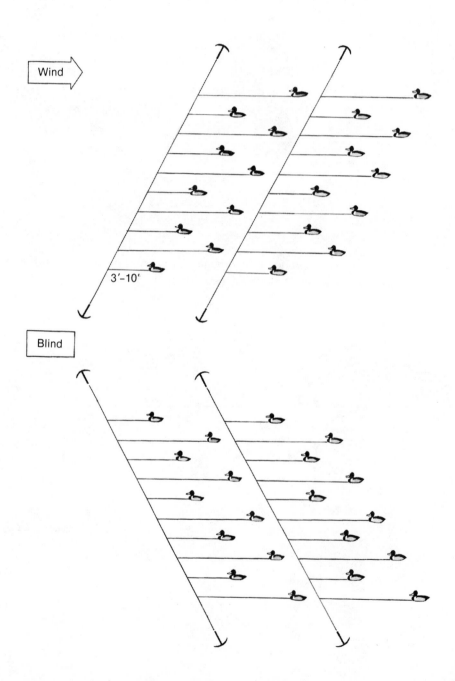

Two methods of laying out multiple-rigged decoys.

10'–20' 10'–20'

Layout boat

3'

Main line

are out, pull the line tight by tugging on the second anchor before dropping it over-board. Two men can put out eight or nine lines of multiple-rigged decoys in fifteen minutes, and they can pick them up almost as rapidly.

Placing the Decoys

This is as good a place as any to talk about decoy formations for divers. The multiple-rigged decoys I've just mentioned are used by most gunners working from layout boats. I've shot from a lot of them, and I can say flat out that they work like a charm. If flock formations of decoys were really important, a layout rig wouldn't work at all, since all the decoys are arranged in straight lines. No live flock of ducks will ever show all its members arranged in straight lines. Still, the multi-ple-rigged decoy setups pull ducks like magnets.

Draw your own conclusions, but I think most authors of duck-hunting material have gone overboard on decoy formations. No duck in the world ever studied ge-ometry. I doubt if it's possible for a duck to recognize the so-called advantages of spreads such as the V, fishhook, diamond, L-set, halfmoon, and others. Any vet-eran gunner will admit that the formation of a feeding flock of divers will be changing constantly. Where you put your decoys is far more important than any formation you might put them in. However, if you're gunning near a shoreline, it is very important to offer incoming flocks a readily available landing field. We dis-cussed the best decoy formation for that condition in the previous chapter.

One of the biggest mistakes some diver hunters make is placing their decoys at extreme gunning range. They seem to feel that the farther their decoys are from the blind the better the chances that birds will work to them. This isn't true. A diver that's tricked well enough to come within 60 yards of a blind will normally come within 40 yards without a second thought. The time when he decides that all is safe is when he's 200 yards or more away from your spread. Don't handicap yourself with long-range shooting; it just isn't necessary.

There are a couple of thoughts about putting out and taking up decoys that the gunner should keep in mind. When you have a crosswind in front of your blind, it's best to start placing decoys in an upwind area. This method enables you to pitch out decoys while your boat drifts slowly downwind. Use the same technique at day's end when you pick up the blocks. Run your boat to the upwind end of

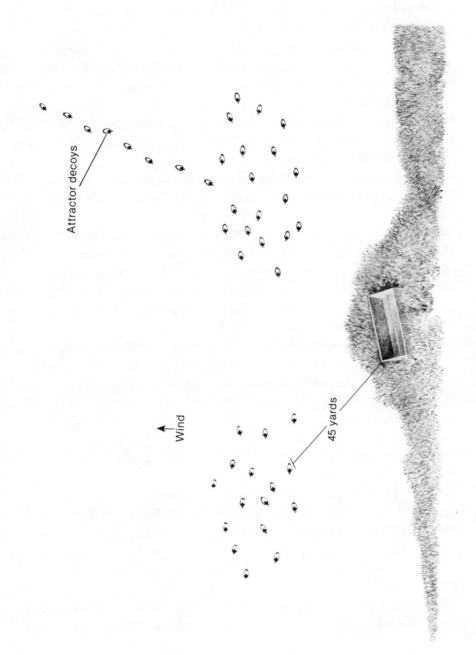

Proper decoy spread for gunning divers from shoreline blind. There should be an open landing field at least 20 yards wide between the two flocks of decoys.

Attractor decoys

Wind

45 yards

the spread. As you drift downwind you'll float right to many of the blocks; others will be easily reached with slight effort on your oars. If you're using an outboard motor, be careful not to get the prop of the engine near anchor lines.

Many diver hunters find it necessary to rig decoys with various lengths of anchor lines. One of my favorite point blinds has shallow water on the west side and deep water on the east. When I take in my decoys after hunting this spot I put the long-line blocks in the front of the boat and the short-liners in the back. This technique solves the problem of telling which decoys are which when I'm in a hurry to get them out the next morning.

There's another problem with hunting that point that's easily licked too. My long-line decoys have 25 feet of cord on them, but that's still not enough to reach bottom in the 40-foot depths where my line of attractor decoys must go. I use a color combination on my anchor cords to distinguish those special decoys from all the rest. The first 10 feet of the anchor cord—at the decoy end—is dyed the same dark color as the rest of my lines. After the initial 10 feet I use plain white cord. When the cord is wound around the decoy the white color makes up the majority and the last of the turns. In other words, the decoys wrapped with white cords are easily distinguishable in my boat.

One of the most overlooked rules of working with decoys is never to mix good and bad decoys. Consider what would happen if you saw a 7-foot-tall man walking along with a companion measuring 3 feet tall. You'd do a double-take because the sight would be unusual. The same attention-getting situation develops in the duck world when oversize decoys are mixed with small, old-fashioned wooden blocks. The bulk of oversize decoys are never noticed by ducks when all the decoys are the same size, but mix good with bad and your quarry's suspicion is sure to be aroused.

And it almost goes without saying that mixing puddler and diver decoys in the same flock is a mistake. Most live puddlers and divers just don't mix. Some diver hunters work in areas that occasionally harbor black ducks, and they cash in on the opportunity by using a few black duck decoys. But they spread them off the side of the diver flock so there's no question about the possibility of the blocks being mixed.

A few goose decoys are often used in the same manner. The purpose isn't so much to attract geese as it is to employ the great attention-getting size of goose

decoys. Ducks will often spot four or five oversized goose decoys before they notice the smaller duck blocks. Just be sure that your goose decoys represent a species that is found in your area.

11

The Best Diver Blind

Today's duck hunter gets relatively few really good chances at excellent gunning during an entire season. Many times he sits helplessly in a favorite shore blind watching flight after flight of ducks parade by without the slightest interest in his well-planned spread of decoys.

"If I only had my blind out 200 yards in the lake," he rationalizes, "I'd be right in the flyway." Or, "If I could move this whole outfit down the lake to where those birds are feeding I'd really rack 'em up!"

How many times have such near misses happened to you? Probably quite a few. Ingenious devices have been developed to lick the problem but always fall short in many important details. Consider what is involved. First, the blind has to be portable enough to move easily to wherever the ducks are working. It has to be readily handled and not interfere with decoy work or retrieval of downed birds. Most of all, it has to be effective.

Years of attempts have come up with some pretty fair answers. The layout boat puts you into the ducks, but drawbacks are considerable. Only one or two men can shoot at a time. And the elements can knock you without mercy. Lying flat on your back with rain dribbling on your face and a rough sea rocking you back and forth leaves at least something to be desired.

Then there's the floating blind—a good rig but about as unhandy as a speedboat in a cattail marsh. You have to tow it wherever you want to go, a slow and ponderous procedure. They are hard to handle in rough water, and the building of one is a major construction project.

There's also the platform blind, a permanent affair anchored to lake bottoms with jetted-in support poles. But if we build it here, the ducks are down there; and if we build it there, the birds are back where we should have built it in the first place.

So the problem shapes up. We need a light rig that will cover a boat with sufficient concealment, and can be quickly erected, easily transported, and effectively used in most any location without regard for wind directions. With such an outfit, two to four hunters can go any place at any time, carry complete equipment, and be in business within minutes.

A close look at the illustrations will show how such an affair can be easily built with a minimum of time and materials. The first step is to design the frame sections to fit your particular boat. The theory is that the camouflaged frames should attach to the side of the boat so that the bottoms ride at water level and the tops are at eye level of seated hunters.

An ordinary 16-foot outboard is well hidden with five frame sections: three completely covering the side of the boat toward your decoys, and two on the shoreward side from which ducks are unlikely to approach. The middle area of the boat on the back side is left open so that hunters or retrievers can get in and out.

After determining required frame sizes, build the sections out of 1x2-inch lumber with lap-jointed corners. A brace or two is good insurance, as this equipment will take quite a beating through several seasons of use. Height of frames should be determined by standard widths of the chicken wire that is used to hold camouflage material. Exact duplication saves time and expense. The wire is put on with small staples and should be stretched as tightly as possible to eliminate flexing action of wind. When this work is done give the whole works, wire and all, a solid coat of nonglaring waterproof paint with color corresponding to the type of camouflage you are going to use.

Camouflage should be selected to blend with natural shoreline growth of the lake or marsh you intend to hunt. It's a good idea to use two or more different types. Such combinations tend to break up solid outlines. A good arrangement is cattails mixed with cedar twigs and a few oak-leaf clusters. Whatever the material,

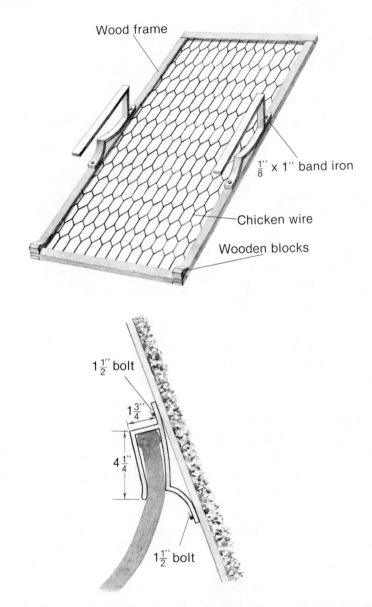

Wood frame

$\frac{1''}{8}$ x 1'' band iron

Chicken wire

Wooden blocks

$1\frac{1}{2}''$ bolt

$1\frac{3}{4}''$

$4\frac{1}{4}''$

$1\frac{1}{2}''$ bolt

Frames are built of 1x2s, lap-jointed at corners and covered with chicken wire. Iron clamps, which can be made by a weldor, are bolted to the frame and slip over gunwales. Other method of attaching blind is shown on page 131.

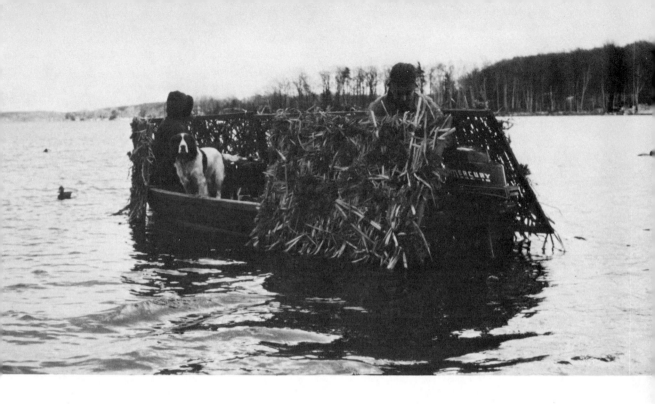

Shoreward side of blind is open in middle to allow retriever to exit and enter.

Front view of blind shows how well boat is hidden. Here it is being used to retrieve downed ducks.

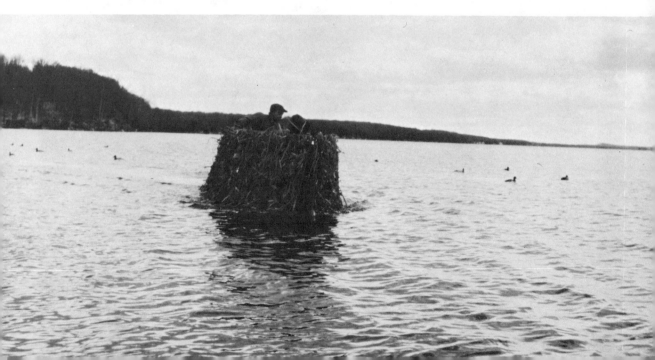

take pains to weave and interweave through the chicken wire to insure against later loss by rough handling and wind and water action.

Be sure to use material that will not fall apart when it dies. Cedar twigs maintain most of their color and needles stay intact. Oak-leaf clusters hold together for long periods. In contrast, hemlock turns brown rapidly and its needles fall quickly. Most broadleaf twigs will give the same trouble. A blind of cedar and oak will last for years with only small seasonal additions of fresh color. A blind of hemlock and maple twigs will look like a skeleton midway through the season.

Ideal boat blind consists of wooden frames covered with chicken wire that are attached to the gunwales. Foliage that matches shoreline growth is woven through the wire.

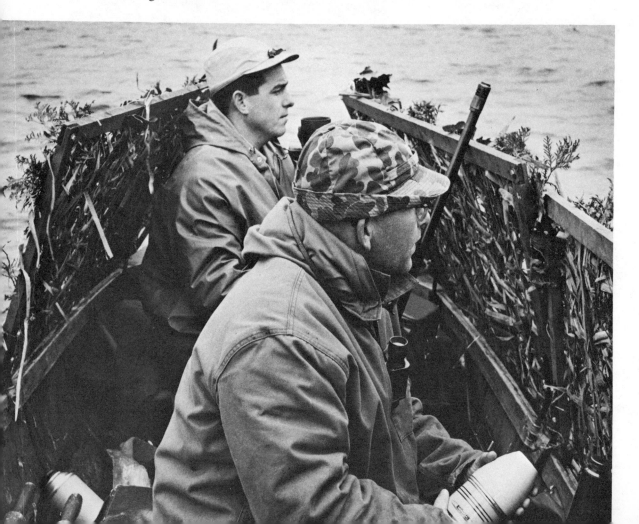

Other method of attaching frames—iron bars slip into oarlocks.

Now comes the problem of how to attach finished blind sections to your boat. Many arrangements can be used: clamps, hooks, pegs and sockets, and so forth. The easiest deal is U-shaped clamps bolted to the blind section. These clamps slide and nest over gunwales of your boat. This makes for sturdy construction and allows the blind to be installed with sections tilted to provide maximum concealment from above. (See illustrations for various arrangements.)

That's how to build your blind. Effectiveness will be doubled by following proper techniques of use. Mark your blind sections with readily seen numbers. Put corresponding numbers on your boat to identify where each section fits. When

beginning a trip, store the blind in the bow of the boat where it is out of the way. Put bow sections on the bottom of the pile, middle section next, and stern sections on top. This arrangement allows the least confusion and fastest installation at the scene of a hunt.

The matter of where to place and how to arrange your blind in relation to decoys is all-important. The object is to place the blind in a position where it attracts the least possible attention but still remains within effective gunning range.

Because most ducks decoy into the wind and aim straight for your decoys, be doubly sure you don't anchor the blind directly behind your spread. Move it to one side so decoying birds aren't looking right at you as they swing in. Try to choose a location where the blind will blend best against the shoreline. The best procedure is to anchor broadside to decoy layout so all hunters have ample gun-swinging room.

Use of two anchors is a must to prevent the blind from turning in all directions with wind pressures. Anchor lines are attached near the bow and on the stern. Long lines are best, and anchors should be placed as far apart as possible. The long lines enable you to pull in or let out the exact amount of footage required to stabilize the blind in the most effective position. Use heavy anchors to eliminate dragging. The boat ends of the anchor lines should be equipped with floats, as it is necessary to leave position to retrieve downed ducks. Don't pull the anchors; just untie the ropes and throw out the floats.

Now let's toss in a couple of quick tips on duck lore to make your efforts doubly effective.

Remember first, last, and always that when divers solidly establish a feeding area, they are mighty hard to drive out. If you try to decoy them some distance from where they want to be, you are consistently doomed to failure; but rig your decoys where ducks are used to working and you'll bust your limit in the shortest possible time. That's the beauty of this portable blind. You cruise your lake or bay until you find the exact location of the ducks' dinner table. Then you set up exactly where you want to be in the shortest possible time with complete tools for every part of the operation contained right in the boat. Nothing could be simpler or more effective.

Remember also that a blind of this type presents minimum concealment because it is a lump by itself on otherwise open water. Try to freeze long before ducks are

Proper decoy spread for gunning divers from portable boat blind. Boat must be anchored at bow and stern to keep blind broadside to decoys and shooting area. Note that blind is positioned at right side of open landing field, out of direct vision of ducks following attractor decoys.

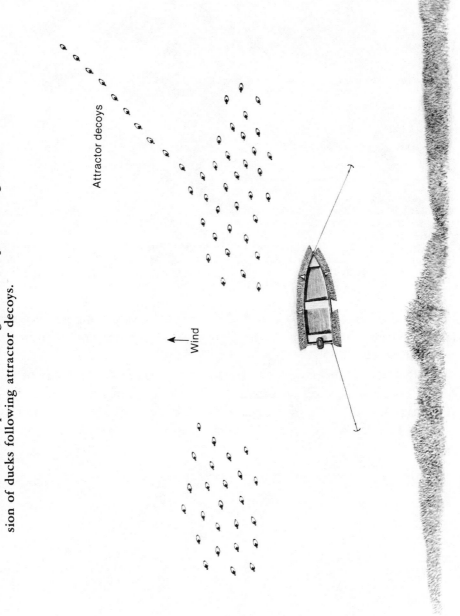

Attractor decoys

Wind

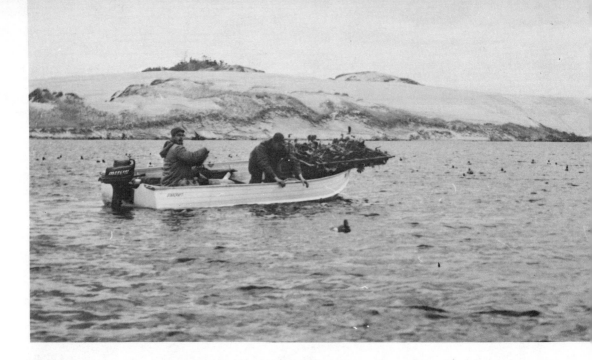

When it's time to collect decoys and go home, blind is easily transported in bow of boat.

in range to eliminate any movement. A diver will spot a moving gun barrel or turning head at incredible distance. The slightest strange movement will turn him away at full throttle.

Whether you're a beginner or a veteran waterfowler, a careful study of these pictures, a few dollars' worth of material, and a few hours of preparation will help put you smack in the middle of the best diver shooting available today. And the same blind will work like a charm in puddler duck marshes everywhere.

12

Other Diver Blinds

Though effective concealment is the purpose of any blind, divers can be fooled much more easily than puddlers. Puddler blinds are designed to conceal the hunter himself, since many puddlers know what a man looks like and what he represents. Mallards and black ducks in particular are well aware that the presence of a man spells potential danger. Divers don't share this basic fear of the sight of a human being. They'll show as much alarm at the sudden appearance of a deer. The two big things that alert divers are sudden movements where there shouldn't be movement, and objects that are out of place in a natural environment.

Those principles have been proved to me many times, but several hunts stand out in mind. One time I was attempting to gun along a shoreline edging huge sand dunes. Since the dunes were devoid of all cover, I decided that no blind at all would be the best bet. I figured that if I huddled motionless I might pass for one of the water-logged stumps that dotted the shallows. I put out my decoys, beached my boat a quarter mile down the shoreline, then walked up the beach to my decoy spread. The ducks soon began returning but they wouldn't decoy. They'd come barreling in, then flare off about two gunshots away. I couldn't believe that they were flaring from my presence.

When I analyzed the situation I realized suddenly that I'd made a blunder when I put out my decoys. A shallow sand bottom ran far into the lake, and some of

my decoys were riding over that yellow bottom. Since all divers get their food from dark-colored bottoms capable of growing roots and weeds, my decoys were certainly out of place. The ducks didn't recognize the flaw until they got close to the blocks. Then their inspections told them that something was wrong.

I knew that if I replaced all my decoys over the far-out dark bottom, they would be out of gun range from the shoreline. Then I remembered I had a pair of waders in my boat. An obvious solution to the problem came to mind. I could reset all my decoys in the proper place, then wade out into the shallows about 50 yards from shore and stand motionless. I knew if I could make like a stump while ducks were working, I'd probably get some shooting. As it turned out, the gunning didn't last long. I killed my limit in half an hour. I've successfully used the same "body-booting" trick many times since that day. Mark it down in your rule book that any shallow sand bar or flat that can be waded is a potential hot spot if it edges deeper water.

Several years ago I was on a goose hunt near Devil's Lake, North Dakota. One day my guide asked me if I'd like to take in some sensational bluebill shooting after the morning's goose hunt was finished. "Sure," I said. "I assume you're talking about working with decoys."

"Nope. I don't bother with them. I just wait until the wind is blowing from the north, then I walk out to the end of an abandoned shipping pier that juts 80 yards into the south end of the lake. The bluebills zip over the pier during their feeding flights along the shoreline. We'll just sit there and pound away at them as they fly by."

"Do you have a blind on the pier?" I asked.

"Don't need one," my partner replied. "But you have to sit still as a rock. Move a gun barrel while those ducks are coming dead on and they'll flare every time. Keep still and they'll figure you're just another blob on the landscape."

That's the way the hunt turned out. Occasionally ducks were flying almost into our laps before we jerked to shooting positions. I'll always remember that day as one of the easiest duck hunts I ever enjoyed. There was none of the usual work involved, and it was one of the few diver hunts I've made that didn't require the use of a boat. The north wind was the key factor, since all of our dead birds drifted quickly to shore.

Such hunts point out that diver blinds don't have to conceal a man so long as the hunter is dressed in clothing of a color that blends well with native surround-

ings. But duck hunters can't sit or stand motionless at all times. That's why good diver blinds should be designed to conceal the body movements that are usually necessary. Divers don't always come straight to your decoys; you often have to move your head while you watch flight patterns develop. Many times you'll be watching a flock to the south when your partner alerts you to a closer flock approaching from the north. You naturally turn, and if your blind doesn't conceal that movement you'll surely spook the birds. There are dozens of other examples of movement that must be concealed. Some of the more common ones are raising and lowering binoculars, reaching for more shells, pouring a cup of coffee, putting on or taking off rainsuits, and putting down smoking materials.

The function of a blind in concealing objects that are out of place in natural surroundings is all-important too. Another example will serve to illustrate.

One outboard motor I purchased was painted white. I didn't like the color, but white was the only finish offered in the make and model I wanted. My previous motor was a dull gray. It blended well with fall colors, but even so I'd made a hood for it out of a burlap bag. I always used that hood when I gunned from my floating blind. The first few shoots I had when my boat was equipped with the white motor turned out fine, so I was puzzled when the divers wouldn't work during a following hunt. I finally figured out what was wrong.

During this particular day I was hunting with a crosswind situation instead of the normal condition of a wind blowing against my back. Since divers prefer to approach decoys by flying into the wind, I was playing the game under different rules. Now, instead of watching ducks come directly at my blind from straight out, I was watching them fly broadside to my rig. Then, after they passed me, they would bank into approach patterns on my right. Everything worked fine until the birds finished their banking maneuvers. At the point where they would normally cup their wings and begin gliding, they spooked suddenly, picked up flying speed and beat it away from the area.

Such activity didn't make sense till I rationalized that every decoying flock sensed danger from the same approximate position. Something had to be wrong with the motor end of my blind. I inspected the stern area of my boat and I discovered the problem immediately. My outboard motor hood hid the top half of my motor in fine shape, but part of the lower unit of the engine stood out with its glaring white color. That blob of white was definitely out of place in otherwise natural surroundings. I tied the burlap motor hood around the lower half of the engine and covered

the top half with my rainsuit. The next flock of divers decoyed perfectly, and I was on my way to a fine shoot.

A fascinating fact about diver blinds is that it often doesn't matter how big they are as long as they are constructed of materials native to the area where they are used. The largest blind I ever shot out of was owned by a barber who did his diver gunning on Muskegon Lake, Michigan. It was a rectangular floating blind that was carried on mammoth logs. The blind was 30 feet long and 8 feet wide. It was camouflaged by cedar branches that were tied to a wooden framework erected above the logs. The back end of the blind was hinged to accommodate entering and exiting with a large outboard boat. The boat, when not in use, was hidden in an open boat well that took up about two-thirds of the length of the blind.

A wooden platform took up the front third. The platform was complete with gun racks, cushioned chairs, and a charcoal stove. We gunned in comfort from that blind, but not as much comfort as hunters found years ago in the Lake Champlain houseboat blinds. These floating palaces were built somewhat on the order of the floating blind I've described, except they were larger and more elaborate. They held two boats side by side. The bigger boat well held a large power boat used for transportation. A smaller and handier skiff was used for working with decoys and picking up dead ducks. The forward end of the blind held a cabin in addition to a shooting platform. The cabin was equipped with double bunks, cookstove, table and chairs, toilet, sink, and gun cabinet. The entire "island" was covered with cedar branches. You didn't just hunt from these blinds, you lived in them for days at a time. The fact that they offered exceptional shooting is hard to believe. The moral? It's almost impossible to build an open-water diver blind that's too large as long as it's constructed of the proper materials.

I'm not in favor of permanently located blinds for reasons I mentioned in the previous chapter. I'll repeat that a top diver blind should be one that can be moved easily to a location where the ducks are feeding. Blinds fitting this category are layout boats, sneak boats, and various types of floating blinds. I'll talk about them after mentioning the various types of permanently located blinds.

In some specific cases shore blinds and stake blinds can offer decided advantages over floating blinds. They are definitely more comfortable, and they are conducive to more accurate shooting since they offer stable gunning positions. Such blinds are best when they can be placed in traditional flyway or feeding areas. I do a lot of gunning from a point blind that offers more shooting than I could get from

a floating blind in the same area. It just so happens that this blind is located on the end of a long narrow point jutting out into a narrows that is the connecting link between two large lakes. The narrows acts somewhat like a funnel. In other words, low-flying flocks of ducks passing from one lake to the other are forced to fly relatively close to the wooded point. Any type of floating blind would have to be a second choice here since it couldn't possibly be as inconspicuous as a shore blind hidden in natural woodlands.

My uncle built the first blind on that point over forty years ago. My hunting partners and I have rebuilt and relocated the blind several times since then. During every rebuilding session we incorporated improvements that were backed by lessons we learned during hundreds of hunts made in all kinds of weather.

A rectangular blind is more efficient than a square one because overhead flocks look down on much less suspicious area. Many items of a duck hunter's gear will spook divers if they are seen. Shell boxes, gun cases, lunch bags, polished cameras, and binoculars are examples of items that should be hidden from sight. The problem is easily handled if the blind is constructed properly. More on this in a moment.

The width of your blind should be about 5 feet. Length is determined by how many gunners you plan to accommodate. Allow about 3 feet of blind length for each seated gunner. If you use a retriever, remember to plan an extra 2 feet of length. Personally, I feel that a shore blind's capacity should be limited to three hunters and a dog. Larger blinds are too easy to spot, too difficult to control. In general, the smaller the shore blind the better it will work, because divers characteristically hate to decoy against shorelines. They'll always flare at the slightest suspicion of danger. It's much better to build two small shore blinds a few yards apart than one large one. This rule doesn't hold true for offshore stake and floating blinds.

The best shore blinds are anchored to four corner posts and two midsection posts set deeply into the ground. Creosote the posts for protection against weather and rot. A seventh post should be dug in on the side of the blind where you want your door opening. Be sure to plan placing the door on that side of the blind which is best hidden from the water area that will hold your decoys. Many times I've been out of my blind when I've seen ducks alight in my decoys. Since my door opening was hidden from the ducks, it was a simple matter to sneak back into the blind and grab my gun.

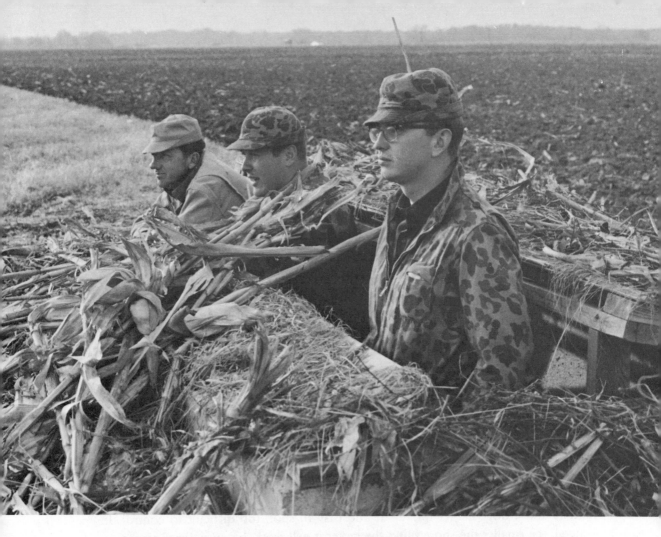

Elaborate pit blind is covered with lumber framework with a sliding cover. Entire framework is camouflaged with native materials.

After digging in the posts, the next step is to nail a wooden framework completely around the blind, except, of course, the door area. The two sides and the front of your blind should measure about 46 inches from floor level to the top edge. This will put the top edge of your blind at about eye level for the average man. If it's higher, you can't see out properly from a seated position; if it's lower, you're not taking advantage of maximum concealment. The back side of the blind should be about 15 inches higher than the front and sides. This added height serves as a windbreak. It's important to use weather-beaten unpainted lumber for this framing

job. No matter how you cover new lumber with camouflaging paint your blind will still stand out to a much greater degree than if it's built with naturally dull weather-beaten boards.

Your door and all inside construction should also consist of old lumber, which, incidentally, can be purchased for much less money than new materials. It's even likely that you can find somebody who will give you old boards just to get rid of them.

Since old boards won't edge together as perfectly as new ones, your blind won't be windproof. This isn't much of a problem, but I always correct it, since the solution is simple. I nail tarpaper over the air leaks in the walls. Don't cover the outside walls—except for the back wall—because tarpaper glistens under some conditions when it's wet.

Now you're ready to build seats and shelves. Boards will have to be notched in the proper places to fit around your posts. The seat along the entire back of the blind should be about 20 inches wide and placed 15 inches above the floor. This may seem low, but I use boat cushions on top of the board seat and they add the right amount of height for a comfortable seating arrangement. The seat should be braced securely but not boxed in, since the under-seat area makes a fine storage compartment. Any gear stored under the seat won't be seen by flocks flying overhead.

Two shelves should run the length of the front of the blind. The first shelf—8 inches wide—should be positioned about 20 inches from the floor. The top shelf is wider for two reasons. First, it overhangs the bottom shelf, thereby hiding shotgun shell boxes, thermos bottles, and such from sight. It also protects those items from rain and snow. The wider shelf is notched in front of each hunter position to safely hold the barrels of shotguns that are placed in standing positions. Because the top shelf is widest, the guns are in free and clear positions where they can be easily reached with downward hand movements that are concealed from approaching ducks.

If you build this shore blind on level and solid ground, a floor isn't needed. Many times, however, such blinds must be constructed over uneven ground or a base surface that is mucky and marshy. If this is your situation, you'll need a floor. I've found that the best material for this purpose is thick, marine plywood. It's sturdy, sheds water in fine shape, and makes a level shooting platform. Even though marine plywood is very water-resistant, it should be covered with several layers of good

waterproof paint in a dull color. Brace your floor with several 2×4 runners placed under the plywood area. The runners, of course, should be nailed into position before the floor sections are laid.

Some gunners feel that when they invest considerable amounts of time and money in a shore blind it should be complete with a roof offering protection from foul weather. I'll just say that I've used roofs on several of my blinds through the years, but I've reached the conclusion that they do more harm than good. Some of my earlier blinds had fixed roofs. I learned that this was a mistake since it eliminated all chances at overhead shots. Then I went to hinged roofs that could be folded behind the back of the blind during nice days. They served the purpose of offering protection from the elements, but they necessitated a flaw in basic blind design.

No blind should be built any larger than necessary for adequate concealment and freedom of movement. If you insist on a roof you must build additional height to the back of your blind to hold the roof components. Such construction produces a "boxy" outline that isn't at all in keeping with natural surroundings. The lower your overall blind outline, the more inconspicuous it will be. For my money, the advent of modern clothing and foul-weather gear just about does away with the need for roofed blinds. I prefer to pass up an edge in comfort for the chance of better shooting.

When you build a new shore blind, build it during the spring months. Shiny construction components like nail heads and door hinges will weather during the months until fall and signs of fresh ground-area activity will disappear. Smart hunters look for some type of fast-growing native growth to plant around a new blind, and spring is the time to plant it. In my area willows are the best bet because they grow almost as fast as weeds. In a few years willows will grow taller than the blind itself. Then it's an easy job to clip their tops at just the right level to offer perfect visibility of the shooting area by seated hunters. A blind surrounded by close-growing willows is almost invisible before leaf-falling time. Even after willow leaves have fallen, the trunks and branches of the bushes are fine camouflage.

If you plan on using your shore blind many times during each hunting season, it's a good idea to build a storage bin against the outside back wall. The bin should have a cover and be fitted for a padlock. Such bins are used to store extra decoys, charcoal stoves, fuel and lighter fluid, pots and pans, and other gear. If you use

a bin you don't have to transport portable gear back and forth between home and blind during each hunting trip.

It goes without saying that some shore blinds have to be built on private property. Most landowners will offer permission to build if they're approached properly. The best bet is to point out that you'll do all the construction work, but that the landowner will be more than welcome to use the blind on days when you're not hunting. If he's a nonhunter your promise of a few wild ducks for dinner will usually turn the trick.

Stake blinds serve the same function as shore blinds except that they're placed over open water, usually far out from shorelines. These blinds are often modeled after floating blinds in the sense that they incorporate boat wells and shooting platforms. The main difference is that a stake blind is permanently located to posts that are jetted into lake, bay, bayou or river bottoms. The stakes are tied together with timber stringers, and the blind is built around the stringers. Some stake blinds are built high enough to conceal a boat under the floor, thereby doing away with the necessity of a boat well.

The advantage of a stake blind is that it can be located far out from shorelines. In some areas (particularly the East and West coasts, and more particularly Cur-

Stake blinds are built over open water, far from shoreline.

rituck Sound and Chesapeake Bay) they can be placed far enough from shore so that they can be used regardless of wind direction. In other words, decoys can be placed on any side of the blind. This is a decided benefit when stake blinds can be erected in areas that traditionally hold feeding ducks. When these blinds are built well in advance of hunting seasons, the ducks pay little attention to them.

During my gunning career I've built four stake blinds, and I'll never build another. Though they're very successful in saltwater coastal areas, I've had little luck with them on the inland lakes of the Midwest. The main problem in my area is winter ice. No matter how solidly you jet the stake posts into a lake bottom, they can't take the ravages of spring ice breakup for more than a season or two. Tons of breakup ice moving with shifting winds have smashed my stake blinds like matchsticks. If you can't place them on waters that are ice-free year round, it's best to forget them. In any event a floating blind serves the same purpose as a stake blind, and its utility is far greater since it can be moved to the best hunting areas.

There are many types of floating blinds, but the best type I described in the previous chapter. The problems with most other types are that they're bulky and heavy and have to be towed to shooting areas. However, there is one type of modern floating blind that is catching on with hunters and works very well. The main problem is that its expense all but rules out its purchase primarily for waterfowling. I'm referring to the increasingly popular pontoon boats that many people are buying for summer pleasure crafts. With roofs removed, and proper camouflaging materials placed around the railings, pontoon boats make effective blinds and extremely stable shooting platforms. They can travel almost anywhere and are well powered with outboard motors. If you're lucky enough to have a pontoon boat, you can convert it into a fine floating blind with a minimum of effort. One thing you must do is paint all shiny surfaces with a dull, dead-grass paint. Remember, too, that a pontoon boat is mighty unhandy for working with decoys. It's best to tow along a skiff that's easily hidden behind the larger craft during actual hunting periods.

The traditional floating blinds are built above huge logs or 55-gallon drums. It was quite a job making a drum blind until the modern floating docks were designed. Now you can purchase float brackets that make it easy to fasten wood frames to drums. A drum blind is now so easy to build that the old-time log blinds are obsolete in most areas.

Layout Boats and Sneak Boats

Layout boats and sneak boats are by all odds the most effective floating blinds from a shooting standpoint since they're small and inconspicuous. Which would be the most effective for you is determined by what species of divers predominate in your area. Layout boats are by all odds the best in areas where bluebills make up most of the diver bag. Bluebills have the unfortunate tendency of not staying with decoys after they have landed among them. They become suspicious in a hurry and swim rapidly away. They'll seldom "hold" long enough for sneak-boat hunters to drift into shooting range. Other divers, however, can be gunned quite successfully by expert sneak hunters.

The best layout and sneak boats were built generations ago by craftsmen with access to far better materials than are generally available today—materials for layout and sneak boats, that is. Lumber quality just isn't what it used to be. These tiny boats are two of the very few waterfowling items that were of better quality in the old days than they are today. Lucky is the modern hunter who has found a layout boat stored in an old boathouse or barn. Some of these boats are still in fair shape, and a covering of fiberglass will put them in fine working condition.

I tried for years to find authentic blueprints for layout and sneak boats. I never succeeded and I would advise against trying to build one of these boats on your own with guesswork as to construction details. My hunting partners and I have gone through the act, and our results were far from satisfactory. The best bet is to locate an area where these boats are used and ask veteran hunters for information. The lower Detroit River near Detroit, Michigan is a very popular layout shooting area. That area is a good example of a place where a few layout boats may be for sale. There are a couple of craftsmen there who will build you a layout boat, but the price will be high—at least $300. These boats are very difficult and expensive to build; that's why commercial boat manufacturers don't get into the act. There isn't a big enough market to justify manufacturing investments.

Layout boats are designed to be nearly invisible when floating within a large spread of decoys. Their gunwales must be flush with the water's surface so that no sharp outline of the craft can be observed. Gunners lie prone in the cockpit with only enough of their heads showing to allow them to see over the decoys. The boats are so small and they're usually rigged so far out from shorelines that the

ducks seldom see them. When they do they rarely show fear. That's why layout boats can show the fastest shooting action, but they're mighty uncomfortable to work with.

Layout boats are towed to shooting areas by large power boats. Then they're anchored fore and aft with a special technique in positioning. Decoys are placed from the power boat after the layout is anchored since it's important to rig most of the blocks downwind from the shooting position. The layout boat should ride just inside the upwind end of the decoy flock, since a few decoys close to the boat tend to hide its presence. The boat is anchored properly with relation to decoys when the wind is blowing at a 15° angle over the gunner's right ear. This gives a right-handed gunner maximum gun-swinging potential on normally decoying divers. Effective shooting from a layout boat is tough at best; you need every advantage you can get.

When the rig is in readiness the gunner or gunners—some hunters use two-man layout boats—step from the power boat into the layout boat. They assume prone positions with guns on their chests. The power boat retreats about 300 yards upwind to act as tender. Gunners change position from layout to tender frequently, usually after one or two barrages of shooting. Because the shooting is often so fast—and uncomfortable—this game is a top bet for a large group of hunters. I was

There are various types of sneak boats used for taking divers. This one has such a low profile that water will wash over the decks but not into the gunner's cockpit, and resting or feeding divers will pay no attention to its presence until gunner gets within shooting range. Boat is propelled by a sculling oar.

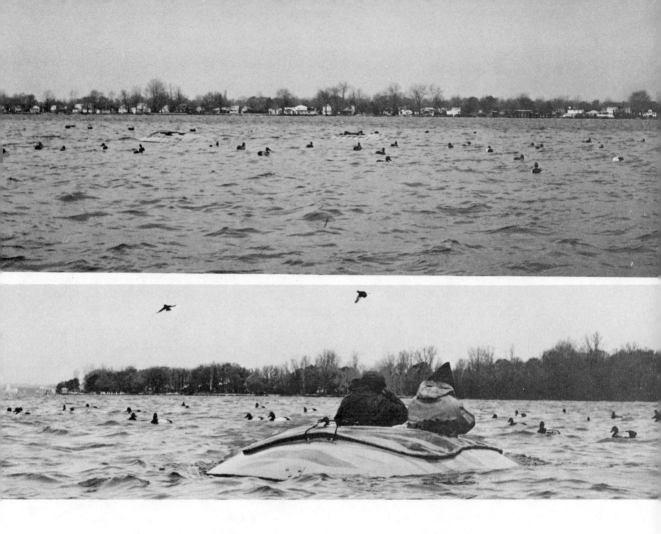

From the distance, two layout boats among the decoys are almost invisible (top). When the ducks come in, gunners rise from prone position and start shooting.

on a layout hunt one time during which sixteen gunners all filled five-duck limits from a single spread of decoys. Though we operated from two layout boats, the bluebills swarmed into the decoys almost continually.

From a percentage standpoint, sneak-boat hunters see more ducks rush to their decoys than other diver hunters. That's because their decoys are far out on open water and there is no blind of any type near the blocks. In other words, a sneak hunter's decoy spread appears as an entirely natural attraction. Several types of

sneak boats are used in various localities, but all of them serve the same purpose: to drift downwind into shooting range of decoyed ducks.

Sneak hunters are hidden behind an upright screen that acts as a sail as well as concealment. The screen is attached near the bow and the man behind the screen does the shooting. The smaller the sneak boat, the greater its effectiveness. These boats are designed to sit low in the water to offer the lowest possible silhouette consistent with safety. Hunters sit on the floor of the boat, thereby reducing visibility and increasing stability. The bow man watches the sitting ducks through a slit in the screen (usually made of plywood) and gives hidden hand signals to the stern man, who paddles and guides the craft with a short-handled paddle.

The best bet for handling a sneak boat between shooting sessions is to tie it to an anchored buoy about 200 yards directly upwind from the decoys. As soon as ducks alight in the spread, the line from the buoy is cast off and the sneak begins. If the direction of the wind changes during the day, the anchored buoy must be moved so that it is positioned straight upwind from the decoy spread. You're in the correct position during anchored sessions if the wind is hitting you on the back of both of your ears.

Plenty of amateur sneak hunters forget that the downwind trip to shooting action is easy, but the upwind journey back to the buoy can be tough. For this reason I always plan a sneak hunt involving at least three companions and a power boat. It's far easier to be towed back to the buoy than it is to paddle back.

Perfectly designed sneak boats were developed by the market hunters. The price of a good one—preserved from the old days—is astonishingly high. But unlike the layout boat, the sneak boat can still be reasonably effective even if its design leaves something to be desired. Some of the modern aluminum low-draft duck boats will serve as reasonably effective sneak boats when painted with locally correct camouflaging colors and fitted with efficient plywood screens. The screen should be no larger than necessary to hide hunched gunners sitting on the floor of the boat, and to hide the paddling movements of the stern man. Such screens will extend about 15 inches beyond each side of the boat's gunwales and about 17 inches above the gunwales. Be sure that the lower sides of your screen aren't so low they drag in the water. The best screens are hinged to a bracket mounted on the boat. This trick enables the shooter to get the screen out of the way by pushing it down flat when he's ready to begin firing.

Proper decoy spread for gunning divers from layout boat. Boat is anchored before decoys are set so some can be placed close to boat and help to camouflage it. Boat must always be at upwind side of decoys.

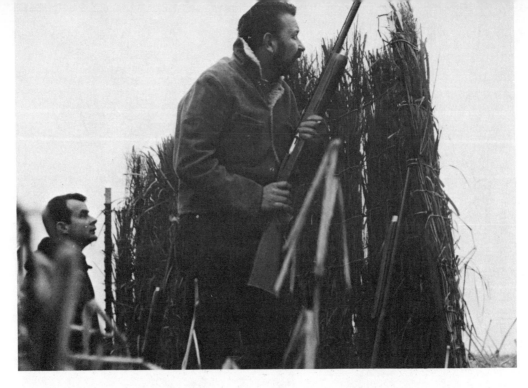

An improvised blind made on the spot of native materials and wire.

Improvised and Temporary Blinds

The last of blind types used by diver hunters might be termed temporary blinds. These are usually shore blinds, and they're often improvised by using existing natural cover. In some localities rock blinds are quite efficient. Many of these blinds are made by piling up rocks in a semicircle much as an Eskimo builds an igloo. Fallen trees can be used as blinds. Driftwood blinds are easy to construct on upstream points of islands in many of the country's larger rivers. A few minutes' work with twig clippers can hollow out a hiding spot in thick brush. The big problem with already existing natural cover is that it's seldom located in the precise area where a blind should be.

One way to lick this problem is to bring your temporary blind with you. The catch here is that it must be portable, which in turn means that it must be light enough to handle easily. Some hunters figure that the best bet is a 10-foot roll of chicken wire covered with burlap. The blind is unrolled at the hunting site and

erected by tying the wire to four stakes. Then the outside of the blind is camou-flaged with native branches, weeds, or grasses. There's one big thing wrong with this arrangement. Wind will cause burlap to ripple, which in turn produces move-ment where there shouldn't be any movement.

A far better bet is camouflaged netting of the type sold in military surplus stores. Wind goes right through this stuff. I once hunted on the Missouri River with a couple of local hunters who used camouflaged netting as the basic part of their temporary blind. When they added twigs and grasses to the outside of the netting they had a blind that was almost invisible from 20 yards away. I don't think such a rig can be beat when hunting in brushy country.

If you live in northern states where snow fences are available, you're close to the raw material for another type of fine temporary blind. A 10-foot roll of snow fence is a bit heavy to carry, but it's sturdy, easily erected in any shape you want, doesn't move from wind pressure, and will stand upright almost by itself. Tie a few clumps of grass and twigs to a section of camouflage-painted snow fence, and you'll have a fine blind.

13

Bluebills Make
the Best Shooting

On the thirteenth of November, 1935, a skinny nine-year-old kid slid a 16-gauge double over the gunwale of a sneak boat and sighted wild-eyed at a rapidly swimming bluebill drake. When distance narrowed to some thirty yards the duck rushed into flight. The boy pulled the trigger and the gods of chance connected the charge of shot dead center on target. The recoil of the gun jolted enough blurred vision that young eyes missed the plummeting fall of a clean kill. But in seconds the picture was clear. Out there on cold leaden waters, looking like a mountain amid the decoys, floated the belly-up bluebill. From the back of the sneak boat a father's voice chuckled, "Son, your first shot at a duck was amazingly perfect!"

On the eighth of November, forty-odd years later, a middle-aged somewhat out-of-shape addict of duck shooting whistled a load of No. 6 shot into another bluebill drake. This one, too, hit the water belly-up. But this time the twisting, cartwheeling fall and the geyser of white spray did not go unseen. The man with the shotgun looked again at the same sight of many years before. There were the same fall-painted waters, the same clean kill, the same tremendous thrill of accomplishment. The only difference was in measure of time.

I am that bluebill hunter. I will go to any amount of trouble to hunt these birds.

I frequently endanger my happy home and my career for the ridiculous chance of stuffing shells into a bluebill gun. I have journeyed onto treacherous waters hundreds of times for no other reason than the possible opportunity of lining a shotgun barrel at a jet-streaking bluebill. I would rather shoot one 24-ounce bluebill than 6 tons of elephant. I will miss sleep and meals, refuse to go to parties, antagonize everybody and not give a single darn if I think there's the slightest chance at bagging another bluebill. I've gone through the act in many states and several provinces.

But my craziness is not madness. In a way, it's just plain common sense. We bluebill hunters enjoy a bonanza that modern civilization hasn't been able to wreck.

Take trout. Many years ago I took limit catches of native brook trout from clear cold streams within 5 miles of where I sit pecking at this typewriter. Today those streams are ruined from the plow and fertilizer and the gnawing of chain saws. The brook trout are gone, the challenge faded.

Take grouse. One of my old-time blueberry thickets has been replaced with spacious lawns surrounding an $80,000 ranch house. A hot-spot thornapple thicket now reposes under the guise of a crop field. I could name dozens of such examples.

Take pheasants. I've bagged few pheasants in my local county in ten years. Clean-farming practices have eliminated too much natural habitat.

Take bluebills. The lake where I killed that first one many years ago is the same lake where I do a lot of my shooting today. An amazing thought! After three decades that produced such world-shaking events as global war, atom bombs, moon landings, and computer brains, my bluebills remain unimpressed. They still pour out of autumn skies. And they come when they are ready. We, who know the bluebill for what he is, must await his presence until it suits him to visit us. He is royalty. He arrives when he feels like it and he comes with all the pomp and glory that befit his stature. Each fall it happens like this for my group.

We wait through Indian summer. We hope for an unseasonable blast of cold weather. It doesn't come. We rig decoys with high hopes and get little shooting.

Then it happens. Late October newspapers carry pictures of a North Dakota town buried in snow. The early storms sweep out of the Northwest, boil across the North Central states, and roar eastward. They slam into Michigan with December fury. Do the bluebills ride in with them? Here's how Bob Wolff and I checked the situation one fall.

We parked on a side road, then walked a half mile up a high hill overlooking the lake. The wind was roaring up there, moaning through bending trees and eating through our street clothes with chilling ease.

"There they are," muttered Bob. His voice packed the excited crispness of a man discovering gold. I checked his line of vision, then raised my binoculars.

Far out in the lake, perhaps a mile from our hilltop, I zeroed in. Five hundred ducks? A thousand? It was hard to tell in that rough water. But they were unmistakably bluebills. A torn carpet of black was rolling and dipping with whitecaps. Individual ducks were standing up and shaking their wings. New flocks moved into the main raft. Close-knit gliding knots of birds kept flashing across my field of vision. I swung the glasses to catch up and watched as the ducks banked around; then black and white bodies melted into abrupt splashes of landing.

We watched new flocks come in high out of the north, flickering black lines riding the wind. Many bunches never skipped a beat as they bored into the south, disappearing from view as tiny moving dots. But not all kept going. Some flocks seemed to cut speed high over the lake, hesitate, then explode in seeming disorganization as they tumbled to the water like accelerated falling leaves.

Such sights leave a duck hunter weak with excitement. We were shaking with the cold, but we watched the parade until dark. We discovered other large rafts. We watched bunches rise from midlake and head shoreward in search of shallow feed beds. We knew that royalty had arrived.

"Well, duck hunter," I said, "think a man might be able to shoot a bluebill?"

"I won't sleep much tonight," Bob said with a grin. "Tomorrow morning is a long time away!"

Tomorrow morning was a pale hint of orange light in the eastern sky when we arrived at the lake. The wind had died to almost nothing and the western horizon was charcoal darkness. We waited till dawn, then loaded decoys and my portable blind into the boat. In minutes my 16-footer lifted on sheets of dull spray, heading for the bluebill concentration three miles down the lake.

Fifteen minutes later we blundered into them. Hundreds of bluebills poured from shoreline areas near a cove. They evacuated in blobs of wing-blinking movement heading for mid-lake. Flocks and more flocks moved out close to the water. Then the ever present singles and doubles made their escape, the less suspicious stragglers hating to leave choice dinner tables. Some of these last birds were almost

within gun range. We knew they'd be back. Bluebills always come back to feeding grounds.

We rigged decoys in a hurry. Ducks were already returning, boring in and then flaring from our activity. Tremendous anxiety turned fingers to thumbs. Bluebills do these things to a man.

Eventually we were in business. Heavy duck loads slipped into shotguns. Hot coffee from a thermos helped jangled nerves. And then the action. Bluebills working in, dark shapes with blurred wings moving straight at us like giant bumblebees. Then the dipping and twisting and cupped wings and the dropping of webbed feet.

The rapid staccato blasting of duck guns is the sweetest music a waterfowler can hear. It happened often that day. Many of the explosions echoed clean misses, but the misses allowed our sport to last longer. It was a day to remember.

There have been many other days during many other years. There have been good days and bad—some exceptionally good and some exceptionally bad. You tend to remember the exceptional.

There was that day in November 1943, when my brother and I took a friend out to a point blind. My brother had a 12-gauge automatic. I was still lugging that 16-gauge double, and the friend had a 20-gauge pump. He must have been brainwashed by our stories, because he packed along four boxes of shells.

My brother shot up his two boxes of shells before the morning was two hours old. I managed to explode the last of my fifty loads shortly thereafter. The ducks paid no heed. They kept pouring in. Soon the three of us were taking turns with the 20-gauge gun. We burned up eight boxes of shells and scored on twenty-nine bluebills, one less than our thirty-bird limit.

None of us kids had the knack for hitting ducks that day. The morning was still young when we picked up decoys. Still the bluebills sliced in. They skittered to landings almost alongside the boat, then pattered into frightened flight.

There was the twelfth of October, 1946. I had a three-day pass from the Air Force base in Sioux Falls, South Dakota. My plan was a day to get home, a day of bluebilling, and a day to return. I hadn't been home in two years.

My wooden outboard 16-footer was full of dried-out seam leaks. My five-horse motor wouldn't run. I settled for my 12-foot double-pointed river boat. After I

piled three dozen decoys into it, and shells and a gun and an ax to build a blind, I shoved off with bare inches of freeboard.

I rowed a half mile across the lake in order to rig on the lee shore. I was ready by daylight and shaking with anticipation. But I had been dealt an empty hand. There were no ducks. The migrations had not arrived. The wind came up. Then a real blow came on; hail and snow belted down and the lake went on a rampage.

The sheltered shoreline had belied the ferocious change in weather. I was concerned enough about recrossing the lake to tie my gun to an oarlock with broken decoy string. I might tip over, but I didn't want to lose that gun. Two hundred yards from shore I was shipping water. I turned back and rowed with all the power a nineteen-year-old could muster. I didn't quite make it. The boat went out from under me in 4 feet of water.

I spent the night and most of the next day in a cedar swamp without fire or food. Then the wind went down and I struggled home in near pneumonia stage. I got back to the Air Force base three days late and recorded as AWOL. My story that I had been duck hunting put me on the court-martial list. I had to do plenty of explaining to escape that rap. I still don't think anybody believed me—nobody could be that nuts about duck hunting!

There was October 1948. I was a student at Michigan State University, pining at missing the fall flights. There was a Thursday with no classes. I hitchhiked 160 miles home on Wednesday night. Thursday morning at dawn I was rigged and ready. Again I missed the flight. At noon I pulled my decoys, changed clothes, and hitchhiked back to East Lansing. Again I had not fired a shot.

I went through three years of hitchhiking home after bluebills.

And there was the mid-1950s. During those years you couldn't miss. I'd take a week's vacation, invite a couple of friends, and set up bluebill camp in a cottage on the shore of the lake. All the world's problems went to pot during this week in November. We shot bluebills all day, sat before a roaring fireplace in the evenings, and fell asleep in stinking hunting clothes. We had the world by the tail. Nobody, nowhere, could even approach us in measure of contentment.

Bluebill hunting gets into a man's blood. Out of dozens of men who have tasted good bluebill shooting, I know of only two who quit. Both became obsessed with pursuing money to such a degree that they forgot about many of life's values.

Bluebill hunters come in all sizes and all ages, from skinny nine-year-old kids to wistful old men. They come from machine shops, supermarkets, doctor's offices,

out of classrooms and from lavish executive suites. They come from village cross-roads, small towns, and large cities. Their individual net worth varies from zero to millions of dollars. To the bluebill they are all equal, worth nothing and worthy of but momentary concern.

Such a phenomenon is fantastic. How can a little duck produce such attraction?

Perhaps the bluebill's lure is psychological. To hunt this duck you alter your complete routine of life. A day begins with a heaping breakfast in predawn hours when normal people are asleep. You don't bother with shaving or washing and you crawl into layers of insulated underwear and woolens that feel like fun instead of work. There is the blood-sparkling excitement of frosted fall as you load gear into your boat and move out onto diver waters. Then comes the whir of activity as daybreak rolls the night away westward. There are no telephones out there. No piles of paper to be processed, gas to be pumped, or orders to take. There is only nature's world, unspoiled, unhurried. A place to relax, a place to anticipate unknown adventure.

The shooting that follows, if any, is the drawing card that permits the foregoing to be indulged in without the general populace labeling the indulger as some kind of nut. But even after the shooting there are further ingredients.

You've had a long day, twice as long as your normal work day, because you've crowded in twice as much living. You have been served a cup of the very nectar of the gods. The shooting you may have achieved was necessarily but a small part of the total day's enjoyment. I'd like to know how the antigun cranks could tear all this apart with anything even approaching logic!

Aside from the psychological lure, there are other very basic facts.

There are lots of bluebills! (More on this later.)

They're hard to hit!

They can be very cautious.

Funny thing about bluebills. They don't fit the same mold as most other wild ducks. They do everything differently, and they get away with it. The drought years of the mid-1960s decimated redhead and canvasback populations to all-time lows. But the little bluebill didn't read the fine print. His numbers increased. He always holds his own because his breeding grounds are in the permanent water areas of northern Canada and Alaska. There will always be plenty of bluebills to bag . . . if you can find them.

The reason these ducks are hard to hit is hard to analyze. (That's the simplest

way for me to admit that I don't know the answer.) I honestly believe that I connect a higher percentage on mallards than I do on bluebills. I'm thankful I have trouble. I like to shoot! With bluebills you'll explode more shells, more often, with more misses and more fun than in any other hunting sport existing.

You don't have to fool a bluebill as you do a mallard. To bust a mallard you have to be smarter than he is. To bust a bluebill, all you have to do is be in the right place at the right time. The right time, obviously, is when migrations arrive on your favorite lake, river, coastal bay, pond, or most any chunk of water. They come when they get ready and they leave on the same basis. You can't plan a thing like this. If your timetable doesn't coincide with theirs, you lose and they couldn't care less. You either luck out or you waste your time. If you hit it right, you're into the most fabulous shooting of the space age. Hit it wrong and you don't bust primer number one!

If you're lucky enough to be able to go bluebilling any time you feel like it, you can't miss. Once the ducks have arrived, the procedure is simple. The key is in locating a feeding area and rigging in that exact spot. If you find a feeding area that the birds are really working, it's almost impossible to drive them away. They'll come back to the most unlikely decoys imaginable, and the worst blind imaginable. They'll pile into mallard decoys, or goose decoys, or even black tin cans. You can anchor a houseboat out there for a blind and they'll still come back. Not all of them—they're not all completely stupid—but enough to warm your gun barrel.

Your shooting will be a lot faster in direct proportion to how realistic your decoys, your decoy pattern, and your blind are. Oversized decoys, arranged in perfect pattern and aligned in perfect relationship to a perfect blend-in blind will provide shooting so fast you'll have difficulty keeping shells in your gun. But you put this same rig in an area where the ducks aren't working, and you won't pull a trigger all day. You don't lure bluebills; you just get where they want to go.

All of this makes the bluebill a magical creature. He'll drive you nuts, force you into risking your life on storm-tossed waters, convince you that your shells are loaded with sand, and generally make shambles of your normal sanity. He'll try to fly down your gun barrel today, and tomorrow you won't be able to get within half a mile of him. You'll occasionally lose patience and swear off for life. But by tomorrow morning your resolution will have dissolved in memory of other days of great shooting, and you'll be right back at them.

After all, the memories of the last great hunt may not go back any further than last week and certainly can't be any further away than next fall. I like to think that with a little luck I might still be chasing bluebills for another twenty years.

There is one major problem with the rosy picture I've painted, and it's one that the old-timers would have never dreamed possible. There's a solution. But first, let's see why bluebill hunting has been ruined for many gunners.

Historically, until the last couple of decades, bluebills offered the diver hunter his very best gunning. Through the 1950s, these ducks always poured out of Canada each fall in flocks of tens, twenties, hundreds and thousands. Great hunting would last for a month or more.

During the 1960s, the flocks apparently began diminishing. Through the '70s the once enormous flights seemed to dwindle drastically. Look at these bluebill harvest records for three of the nation's top duck states:

Years	Minnesota	Wisconsin	Michigan
1959	120,000	39,000	60,000
1979	47,000	17,000	19,000

Here are more statistics that show an even bleaker picture. Shown below are the average numbers of bluebills utilizing once famous diver gunning areas in Michigan.

Years	Saginaw Bay	Lake St. Claire	Detroit River/ Lake Erie
1951-55	32,000	61,000	82,000
1971-75	2,000	7,000	5,000

The above statistics come from a technical paper presented to the Fourth International Waterfowl Symposium (sponsored by Ducks Unlimited) held in 1981 in New Orleans. The paper was written by Robert L. Jessen, a wetland wildlife-population expert for the Minnesota Department of Natural Resources. In the paper, Jessen provides convincing evidence that bluebill populations haven't changed from the great gunning days of the 1950s.

"Breeding populations of scaup are quite stable," Jessen says. "There has been an average of 7.3 million breeding birds during the past fourteen years. I perceive no evidence that scaup numbers have changed greatly since the initiation of continental breeding ground surveys in 1955. Further, the average fall flight of all diving ducks numbers 17,300,000; of which at least 10,000,000 are bluebills. But hunters just aren't getting them like they did years ago."

Almost any veteran bluebill hunter—and I've gunned these ducks with a passion for nearly forty years—is almost bound to choke with disbelief when he hears what Jessen has to say. The veteran steadfastly proclaims, "The bluebills just ain't there no more, regardless of what some biologist tries to stuff down our throats."

Well, in addition to studying Jessen's technical paper many times, I've discussed the situation with him personally. I don't think there's any question that he has the situation pegged perfectly. Before I get into the facts on what has happened, I'll describe a gunning incident that will prove a great help in understanding the picture.

Last fall (1980), my home state of Michigan had a split duck season. The shooting began early in October, then closed for eight days during the peak of the bluebill migration period. The day before the second segment of the season opened, I checked a traditional bluebill build-up area on a large local lake. It was loaded with ducks.

Dawn was a pale hint of yellow the next morning when I headed down the lake with my twenty-one-year-old son and one of his buddies. Our 16-foot outboard was loaded with my portable boat blind, five-dozen decoys and other gear. By the time we made the three-mile trip good shooting light was coming on fast. The bluebills were still in the hot-spot feeding area. They evacuated in waving black lines as our boat approached.

When bluebills leave a choice feeding ground like that they're not going far, and they won't be long in returning. We began placing decoys in a hurry. Some ducks were already winging back before we had the boat anchored and the portable blind sections in place. After we were finally organized, I watched a scene that brought back vivid memories of the mid-1950s.

It was one of those days when you shoot just about as fast as you can load your gun. The boys did most of the shooting, and we filled our limits in about forty-five minutes. The next morning it took 1½ hours to fill up. The third morning most of the ducks were gone.

Now listen to Robert Jessen.

"Scaup have an extreme wariness to all kinds of disturbances, especially sport hunting. Excess disturbance causes them to greatly reduce their use of traditional fall habitats. In the Upper Midwest, where historical records suggest annual harvests of close to a million bluebills, current harvests are way down. When migrating birds move into a traditional stop-over water where they're not disturbed their numbers will build up. If they're subject to too much disturbance they'll leave."

So much for why the boys and I had that great hunting last fall. The eight-day closure to gunning allowed great numbers of bluebills to build up without disturbance.

A logical question then is why disturbances didn't seem to bother the ducks decades ago when there weren't any split seasons?

"Two factors are involved here," Jessen explains. "First, today's hunting pressure is far greater than it was in the old days. Hunter numbers in Minnesota alone are now higher than in the provinces of Alberta, Saskatchewan, and Manitoba combined. The hunting is still good in Canada, but when the bluebills get into the U.S. they find greatly increased gunning pressure.

"Second, the birds face far more other disturbances than they did years ago. The prime example is the tremendous increase in the numbers of boats on our waters. Decades ago there were very few fishermen on our lakes after Labor Day; now a great many anglers and other boaters use the waters almost until freeze-up."

Okay, then where do the bluebills go to escape disturbance? According to Jessen, these ducks are unique in having a well-developed salt gland (supraorbital gland) capable of allowing them to winter on saltwaters. This gland secretes salt at concentrations several times as high as any kidney is capable of handling. Other diving ducks cannot winter on pure saltwaters without frequent access to freshwaters. Salt gland adaption, plus a propensity to feed on small bi-valves (scallop) offshore, allow scaup to remain on saltwater areas far removed from hunting activity.

Also, once in migration, bluebills are capable of nonstop—or only briefly interrupted flights—to wintering grounds, largely offshore in the Gulf of Mexico. In short, these birds have no need to endure unwanted disturbances.

These insights still don't prove that scaup populations aren't way down, a definite conviction held by veteran diver gunners.

"Mid-winter inventories done by various resource agencies have vastly underestimated bluebill numbers," Jessen emphasizes. "For example, a recent mid-winter in-

ventory totaled less than two million bluebills in all four major flyways plus Mexico. In aggregate, conventional surveys tally only about 10 percent of the calculated fall flight. Such inventories must not be taken to represent the population status of scaup. They don't reflect the millions of birds that form tremendous offshore rafts in the Gulf."

Jessen also points out that bluebills are the only diving duck for which harvest rates are known to be low, even though they number two-thirds of all the diving ducks in North America. Also, in contrast to other diving ducks, their nesting habitats are always in prime shape. Many of the divers, such as canvasbacks and redheads, require prairie breeding habitats which are threatened by weather and human activity. Bluebills nest farther north in the deeper waters that remain stable.

It all boils down to the fact that we have lots of bluebills, but we don't get a chance to harvest many because of the man-made disturbances that have developed during the past few decades.

"The problems have occurred by chance, not by planning," Jessen told me. "The solution is in the development of specific areas. I don't know what directions will have to be taken. All I can point out is that we won't get our great bluebill shooting back until we make out gunning waters attractive to the birds again."

Now go back and take another look at those statistics I mentioned. Note that the bluebill harvest figures (in terms of percentages) didn't drop nearly as drastically as the bluebill use figures from those once-famous diver gunning areas in Michigan. Also note that the great 1980 shooting I just described occurred on a large inland lake. That lake (over 5,000 surface acres), and all of the once-famous bluebill gunning waters have one thing in common: they're all big.

The big waters used to attract the biggest share of the bluebill flights, and they're the same waters that have shown the dramatic increases in the duck disturbance factors that Jessen talks about. Those disturbances haven't hit the smaller lakes, ponds, and river pools that show little human use. That's why bluebill harvest figures haven't dropped as much as we might expect. The gunners working the smaller waters are still getting great shooting.

Years ago I used to do 95 percent of my bluebill gunning on the large lake the boys and I hunted. Last fall I found the majority of my shooting on a lake containing about 160 surface acres. This little lake is one of several in local farm country. Almost nobody uses it in fall. One of my hunting partners has the only blind on

the lake. We never saw another hunter—or fisherman—on the lake during the many times we gunned it.

During a couple of weekends there were several thousand divers rafted on the lake during the peak of migration. Other times there were far fewer ducks, but we always got shooting, sometimes limits. These smaller waters are the gold mines for today's bluebill hunter. I've recognized this situation developing for several years, but I was at a loss to understand the reasons for it until I got in touch with Robert L. Jessen.

14

Whistler Wisdom

The late-October morning began with a guarantee of a bluebird day. Not a breath of wind stirred the fragrant predawn blackness. I turned my outboard to the lake and opened the throttle. The aluminum 16-footer leaped forward, slicing sheets of silver spray into the moonlit water.

I was far down the lake when the glittering canopy of stars began to lose brilliance. Behind me an orange glow was building in the east, uncluttered by clouds, a sure promise of another day of warm sunshine.

I was silly enough to be going diver hunting in Indian-summer weather. After three days of being almost completely skunked, I was going back at them. But one thing for sure—I was going by myself. None of my partners could be talked into another wasted day. I had a gimmick, though: I had a brainstorm that might run some shells through my gun.

Maybe it was a good thing I was alone. I began engaging in a series of activities that would have caused my usual partners to raise a furor of argument. I did everything in almost exact reverse of what the old-timers would have considered as proper diver technique.

First, I cruised in to 20 yards from shore and began pitching decoys. No good, the rule book says, you've got to use a layout boat or floating blind and get hundreds of yards from shore.

Next, I set only a dozen decoys, and I bunched most of them in a tight knot. Again I went completely against the book. Nobody gets divers without at least fifty decoys, and you have to spread them far apart to create the illusion of a huge flock.

Lastly, I pulled my boat up on shore and clamped my portable blinds over the gunwales. My usual partners would have really laughed at that act. This rig is designed to camouflage my boat out on open water. Erecting it on shore seemed the height of stupidity.

Dawn had the night snuffed away when I stuffed shells in my Winchester 12-gauge over-under. Right on schedule, I figured. I ought to see ducks any minute. If I had been looking in the right direction I could have proved myself a prophet. I was scanning an empty lake to the south when the whistling trademark of goldeneyes erupted to the north. By the time I swung around, four big ducks were climbing from approach patterns and bending away from the shoreline. When they kept hooking in a tight circle the sudden realization hit me that they were sailing right back to my decoys.

This time they came barreling straight in, wing-tipping the water, three hens and a big black-and-white drake. There was no hesitation, no thought of ambush. They never saw me as I bounced up. My charge of No. 6 pellets caught the drake head-on. He crumpled, his head snapped back, and he crashed to the water like a bucket of cement. The hens recovered in a flash, tipped broadside, and turned on the steam. One was 10 yards closer to me than the other two. She was so close that I could distinguish her yellow legs tucked under her fanned tail as she scrambled through a getaway turn. It's hard to miss such an easy shot, but miss I did.

I shoved the boat from shore, began to step in, then hurriedly jumped in. A pair of whistlers were pulling the same stunt that the previous four had enacted only moments before. Like two chunks of gliding tinfoil they were zeroing straight at me. I crawled over boat seats to the stern, grabbed my gun, and came up shooting. Both ducks took loads of shot and tumbled into geysers of spray.

Short minutes later, I cartwheeled another buck whistler out of a decoying flock. It suddenly dawned on me that I was done for the day; I'd filled my four-bird limit almost before I'd started hunting.

I had my decoys picked up and was roaring back down the lake just as a big yellow sun was spilling over the eastern horizon. With great satisfaction I smugly decided that I had proved a personal conviction.

This abbreviated hunt occurred in 1955. Since then I have used the system many

times. It works like a charm. It's worked on enough hunts so that I now consider it a permanent part of my bag of tricks.

The most unusual part of this deal is the association of whistler shooting with bluebird weather. Whistlers are normally considered late migrants, cold-weather ducks moving down from the north just ahead of snow and ice. But let's analyze this thought. Think back over your own experiences these last few years and determine for yourself if any of the following ideas make sense.

Modern authorities on waterfowl migration claim that at least a portion of fall flights are urged south on a calendar basis. In other words, these birds migrate when any given twenty-four-hour period reaches a designated balance between daylight and darkness. This migration urge has little to do with weather conditions.

In my section of the Midwest we always, in years past, knew that the last week of October and the first two weeks of November provided our best diver gunning. The shooting was available for the simple reason that the birds were available. We always assumed that they arrived because this particular period of time also was associated with the first stings of winter.

Back in the early 1950s those first blasts of freeze and snow didn't develop until around the middle of November. But by strange coincidence the ducks continued to arrive the last week in October. Looking back I can remember many expressions of amazement. "It doesn't make sense," one of us would say. "Look at all the divers pouring in. Now what are they doing here in the middle of the summer?"

The point, of course, is that the ducks were on schedule but the weather wasn't.

Because the weather wasn't on schedule, the ducks didn't react as they should. But the fishermen did. If this sounds complicated, bear with me a moment. Let's take the ducks first.

Our ducks showed up in beautiful, clear, Indian-summer weather. Were they concerned about protection from storms? Of course not; no storms. Did they have to get up and fly once in a while to keep snow and ice from working into their tailfeathers? Nope, no snow and ice. Did they have to worry about working shoreline shallows during daylight hours to dive for succulent weeds and roots? Ah-ha! You bet they did!

Those shorelines were occupied by fishermen who came out in droves to enjoy the fine weather. Not only that, but where one boat-owning fisherman appeared years ago, there are now four to compete with him. The boat and motor boom of modern years simply must be recognized by the duck hunter. The diver hunter

will be smart if he realizes that he has an entirely different set of rules to contend with than he did twenty years ago.

So what did the ducks do? They began feeding the shorelines on clear moonlit nights when there were no fishermen to bother them. And what did they do during the daylight hours? They sat in tight knots on the big, blue, flat, open lakes and preened their feathers.

This was about the time when I got my original brainstorm. It happened on one of those clear, bluebird October days.

My partner and I had rigged one hundred decoys that morning. We anchored my boat blind at one end of the spread. We were 200 yards from the nearest shoreline. There were 5,000 divers on the lake, most bluebills. Dawn came and went with few ducks in the air. We stuck it out in disgust.

When the sun popped up and flooded its golden warmth over the lake, things began to happen. Out came the fishermen. They began to cruise the lake, and, sure enough, they began to put ducks in the air. Huge clouds of bluebills knotted against the sky. The big swarms roared into flight, sailed up the lake a few hundred yards, then plopped back into the calm water. There they sat, in solid black lines of contentment, until another fisherman's boat nudged close enough to flush them again. Up in the air they'd go and right back to where they were paddling around in the first place. Never did the big rafts break up, and seldom did a duck come within hundreds of yards of our blind. Disgust reigned supreme. I'll bet you've grumbled through the same experience dozens of times on your own favorite lake or bay.

Anyway, on this particular morning, a startling fact suddenly crossed my mind. Although the bluebills paid us no attention whatsoever, the whistlers did. They didn't work close enough for shooting, but at least they looked us over.

Another interesting fact also evolved during that balmy morning. Although the great rafts of bluebills only took flight when fishermen happened to cross mid-lake, there were singles, doubles, and small bunches of whistlers cutting the air with frequent regularity. These things were confusing at the time, but at least they made an impression.

Over a period of a few days I put the pieces of the puzzle together. The proof that my answers were right has resulted in dozens of highly successful diver shoots; red-hot gunning enjoyed while other hunters sat at home and wished for the storms that would make the ducks react according to the out-of-date rule book.

Here's why and how the system works:

In the first place, most of us don't know too much about whistlers. We tend to consider them as trash ducks, birds to be shot only when the more succulent table-fare waterfowl are unavailable. But let's be honest. Most ducks can be journeymen fish snatchers too. And all of us have bagged mallards with the unsavory odor of wigglers and other larvae that have turned promised king's dinners into average menus. Maybe it happens more often with whistlers, but many of them provide fine eating, particularly in northern states where their main diets consist of vegetable matter.

But let's discount gourmet qualities entirely. Let's concentrate on sporting qualities. Whistlers fly just as fast as any duck. They're big and they're hard to knock down. There are lots of them. Under proper conditions they decoy well, and, with today's increased activities of fishermen, they fly almost continually in all conditions of weather.

Whistlers normally aren't flock birds. You'll see many more singles and doubles and small bunches than you will big flocks. They're loners by nature, and this is an all-important point. If you have 5,000 Indian-summer bluebills on your favorite lake they'll likely be concentrated in one or two big rafts. But if you have the same number of whistlers they'll be scattered all over the place.

The real clincher in the whistler's nature that will keep your gun barrel warm is the fact that he prefers shoreline waters whether he is feeding or not. Seldom will you find him loafing far out in the lake with the great rafts of bluebills. He likes to be in close, rarely more than 100 yards out from any lakeshore. In fact, goldeneyes are often seen in the close confines of marsh and river waters. They like proximity to land so much that they invariably nest in trees.

Add these factors together and you come up with an amazing answer. Though diver hunters sometimes wish fishermen would get off the lake they are directly responsible for creating tremendously increased flights of whistlers. These fishing boats continually work the shorelines; they continually put scattered bunches of whistlers in the air. And, once in the air, whistlers by nature will fly close to shorelines looking for another cozy nook to drop into. But now what? Here is where I ran into a major stumbling block because the goldeneyes wouldn't decoy to my offshore rig. One night I locked myself in my den and dove into my library of hunting books. I've got almost every book published on waterfowl shooting. I looked up everything I could find under the listings of whistlers or goldeneyes.

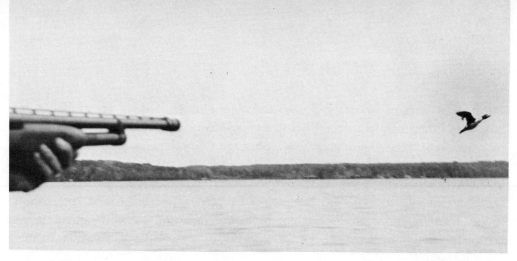

Whistlers are big ducks and hard to bring down, but they offer exceptional gunning to hunters who know their ways.

Certain facts were so obvious that it was plain stupidity that I hadn't recognized them before.

For instance, decoys. Two of the books emphasized that if you want successful whistler shooting, you darn well better use whistler decoys. This fact hit me like a good swift kick. Naturally, I thought. You never see whistlers mixed with other species. They're always by themselves. Brother, how could I have been stupid enough to overlook that all-important fact? And numbers of decoys too. Don't use more than a dozen or so. Whistlers don't bunch up like other ducks.

And blinds. Contrary to much popular opinion, whistlers are extremely wary birds. They'll continually shy away from any unnatural contraption. That thought ruled out floating blinds, layout boats, and all other open-water contrivances. Bluebills and redheads, I reasoned, often decoy with abandon to rigs that a whistler will spot as fake from hundreds of yards away. If you want to bust whistlers you had better work from shorelines. It suddenly dawned on me that I hadn't shot many whistlers in recent years. It also occurred to me that my failure to bag whistlers tied in directly with the period of time when I had switched my diver techniques from shore blinds to floating blinds.

The next morning I was up an hour early, rummaging through the basement and garage for some old whistler decoys that I hadn't used in years. Three hours later the hunt I described at the beginning of this chapter was history.

Since that day I have refined the system to include specific details. Oversized decoys offer a definite advantage because you use only a dozen or so and you have to place them close against the confusing backgrounds of nearby shorelines. You

can buy all sorts of oversized decoys today, but most of them are available only in species other than whistlers. I licked the problem by purchasing giant-sized blue-bills and repainting them in whistler plumage. And I painted most of them as drakes, overemphasizing the white for additional attraction from distance.

Another important factor I discovered is that whistlers hate to decoy against shorelines of tall trees or high banks. Try to keep your background landscape as low as possible. Your blind need not be elaborate as long as you can freeze into complete immobility when ducks are working in. A whistler will spot movement from incredible distance.

As far as decoy placement is concerned, there are only two important factors. I've found that if you bunch eight or ten of them close together, your spread will again have greater distance attraction. The tight knot will show up better than widely spaced decoys. This is important with whistlers; they like to analyze the situation from plenty of distance before making up their mind to funnel in. After placing your tight knot, widely spread another four or five single decoys. These singles offer the illusion of contented birds happily going about their business.

Try to place your decoys over a dark bottom. Whistlers dive for their food. When they spot decoys over a shallow sand bottom they become aware immediately that something is amiss. And don't make the mistake of assuming that your rig attraction will work best only if you locate at the end of a long point of land. Some of my best whistler gunning has occurred over decoys placed along indented shorelines and in the back recesses of bays and bayous.

Whistlers often offer close-range shooting.

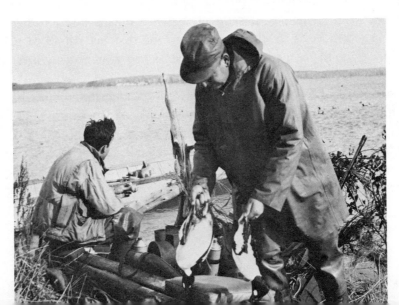

II

Goose Hunting

15

We Never Had It So Good

I've shot geese for many years, but my heart still tries to jump out of my throat when a flock of the wildly screaming big birds zeroes in on my blind. They come like a squadron of bombers, scaling down an invisible stairway in the sky. There's no thrill I've experienced that can compare with it, not even sighting in on a trophy big-game animal.

When I was a boy in Michigan, it was a very rare thing for a hunter to kill a goose in my hunting area. Thousands upon thousands of Canada honkers, snow geese, and blue geese would cut across our fall skies, but the migrating flocks were high and they seldom came down to feed in our fields. Occasionally a tired flock would drop in to rest. Even less occasionally an alert hunter would spot the birds and attempt to stalk them. If the stalk was successful, the gunner would run after his downed goose as if he was seeking an equal weight of solid gold. He would show the big bird to his friends and everybody would marvel that here was a hunter skilled enough to bag a wild goose.

That situation is hard to believe today. Tell a hunter in my area that you shot a couple of geese this morning and you'll get no more attention than if you told him you shot a couple of ducks. No longer is there anything unusual about successfully hunting geese in the counties around my home.

My son shot a snow goose and a blue goose out of one mixed flock a few years ago. A hunting friend and I harvested our respective five-goose limits two days in a row with only a few hours of effort. We spent the rest of both days hunting ducks. Another friend told me that he downed twenty blue and snow geese last season, and he doesn't own a single goose decoy. But Canada geese are the targets for most local hunters. They are the giant birds that were seldom seen at ranges of less than a half mile in the sky thirty years ago.

How did this upsurge in hunting success come about? There are several reasons, and they all point up the fact that goose hunters never had it so good as they do today. I'll describe our local situation first—because the same picture has come into focus in many states—then I'll switch to the scene over all of North America.

Most of my local Canada goose opportunities are made possible by year-round resident flocks. During the last thirty years waterfowl biologists have discovered an amazing fact about the Canada goose. They learned that young Canada goslings, if released into an area at a very early age, will mature and return or remain in that area year after year. This characteristic is not shared by any other species of ducks or geese. All waterfowl except Canada geese will mature, intermingle with other flocks on wintering grounds, then migrate to traditional breeding grounds.

This knowledge of the Canada goose's homing instinct prompted a stocking of a few goslings in the marshes of our local state park years ago by the Michigan Department of Natural Resources. The young geese found plenty of readily available food, miles of lake shores, marshes, and a fast-flowing river that offers open water year round. They matured and, as the biologists predicted, found that their new home offered ideal living conditions. In short, they prospered. The resident flock now numbers about 3,000 birds, and they offer a hunting opportunity that was nonexistent when I was a boy.

Hunting in designated park areas is illegal, but the geese don't confine themselves to restricted-shooting areas. During the fall they fly out to feed on the waste corn left in fields by mechanical harvesters. They know that the tender green shoots of winter wheat fields provide a far superior menu to the natural foods in the park marshes. Today, the sight of a line of brown and gray honkers sliding down over treetops to land in a harvested crop field is a normal experience.

If you're a goose hunter, and your arm cradles a shotgun charged with No. 2 or No. 4 shot, you know what an explosive feeling such a sight can ignite. Stalking

and getting a shot at those geese will be the most thrilling accomplishment in all waterfowling. The birds are well aware that they're working an open-hunting area. And there just isn't any wild creature that's smarter than a Canada honker. You're going to have to be mighty skillful to get the makings of a roast goose dinner. But the opportunity is there, and we'll discuss how to make the most of it in succeeding chapters.

The tremendous boom in our local blue and snow goose gunning is largely a result of agricultural practices that have wiped out many areas of prime puddler-duck habitat. What can be a disaster for ducks can be a windfall for geese. It should be mentioned here that while ducks and geese are combined into a general waterfowl group, there are striking differences between characteristics of the birds. The most important is that although many species of ducks spend less than 10 percent of their time on land, the opposite is true for geese. Most geese do the majority of their feeding on land areas.

The point is that many of the small farms of yesteryear have been replaced by the huge mechanized farms of today. An 80-acre farm producing a variety of crops was a big holding years ago, but an 80-acre field planted entirely to winter wheat is a small holding today. Migrating flocks of geese passed by the small diversified farms thirty years ago. Now it's a different story.

Where the flight once looked down on an uninviting patchwork of brown, they now spot a large dinner table of luscious green wheat or the gold of mechanically picked cornfields. So down they come in the disorganized, bunched-up, low-flying flocks that the knowing gunner recognizes as tired and hungry geese. They don't just swoop down and land anywhere. They cruise with slowly pumping wings, circling one field and then another. Often they rise hundreds of yards above the ground, then they scale lower again in stiff-winged glides. Surely they're going to land now. But they don't. Powerful wings start beating again and the white and dark-blue bodies wink up against the gray sky as the big birds make still another inspection pass.

Finally everything is in order. Now the flock is satisfied that danger is nonexistent. The geese sweep so low that their bodies are almost brushing the ground. They lose so much airspeed that it seems they should stall out. Then there is a last flashing of wings as precise landing spots are selected. Big webbed feet reach for the ground, and suddenly every goose is standing in a rocklike stance of alertness.

Cruising in its characteristic stiff-winged style, a Canada goose cautiously circles a field before gliding in for a landing.

I couldn't even guess at the number of times I've watched that entire marvelous show through 8× binoculars. And every time it's over my pulse is pounding with the anticipation of a successful stalk.

Many times the geese I've watched never reached the climax of activity I described because they were working to my decoys. Those are the times when their final landing approaches are cut short by the roaring of shotguns. The only geese that touch the ground then are dead birds that cartwheel down to crash into sod with the resounding "kerwhump" that makes you wonder how such a heavy bird could fly so gracefully.

And there are other times, days when vicious storms and high wind currents force the migrating snows and blues to fly well below their normal flight lanes. Those are the days when they bear close across the high cliffs and sand-dune peaks edging the Lake Michigan shoreline. There are few of those days, but when they occur I can enjoy the ultimate in pass-shooting opportunities. Some of those geese swish by so close you can almost jab them with your shotgun barrel. I don't say much about those rare sessions because the killing is too easy. If there is such a thing as a dumb goose, it has to be a snow or a blue who simply refuses to vary his line of flight. On those stormy days I've watched flock after flock follow the same flight lane so exactly that it seemed as if they were being pulled by magnets.

I've said more than enough to prove that my local goose shooting is so far superior to what it was years ago that the two extremes can hardly be compared. Perhaps my experience has not been typical, but other hunters all over the nation can tell similar stories, particularly in regard to hunting opportunities afforded by resident flocks of Canada geese. A few examples should prove the point.

Thirty-one goslings were released on a lake north of Denver, Colorado, in 1957. That meager stocking has exploded to a resident population of more than 20,000 honkers. Waterfowl managers have successfully introduced breeding flocks on sixteen national wildlife areas in the North Central states alone. Several states have programs of introducing at least one hundred goslings in several new areas each year. Remember that these are all new areas: lakes and marshes that never in history played host to resident geese.

The list goes on. Michigan has several new goose-producing areas. Florida biologists (who would believe a few years ago that a Canada goose would nest in the Sunshine State!) are even building washtub nesting sites for geese. The idea has proved practical in many states. Maryland boasts several new breeding flocks. The goose-production idea is spreading like wildfire even in Canada. Introduced flocks in Ontario produced hundreds of goslings in short order. The story from Saskatchewan is no less than amazing.

That province's development (named Nis'ku, meaning "large goose" in Cree) is situated on the huge marsh of Eyebrow Lake. Dikes and water-control structures divide the lake into management units ranging in size from 110 acres to 800 acres. Twenty-one goose islands had been constructed, designed to provide basic habitat and resting areas. In 1975 the project got a resident manager, wintering barns (because Saskatchewan is locked in ice during winter months), fenced brooding

In many states, washtub nesting sites have been created to produce resident goose populations.

pens, and all other necessary rearing facilities required in a development of this size.

What will the project accomplish? Goose production is booming, but the area's potential won't be reached until the mid-1980s. It is estimated that by that time up to 3,000 Canada geese will be available each year for stocking purposes across the province. By 1985 a projected total of 35,000 goslings will have been transplanted throughout Saskatchewan. Think about that for a moment. How many

hundreds of thousands of geese will multiply from those mass-produced goslings? Is it any wonder that the modern goose hunter wears a smile a mile wide?

Consider that thought for a moment too. Back in 1931 one of the most famous outdoor writers of that era bemoaned the fact that future generations couldn't hope to enjoy good goose hunting. In one of his books he half apologized for killing more than his share of wild geese. He pointed out that increasing numbers of gunners and decreasing hunting areas might deal a deathblow to the great flocks. In a prophetic way he wrote, "Let us hope that the wild geese never completely disappear into that unknown void from which no traveler ever returns." That's an example of how fast the world can turn.

Today's waterfowl managers have one major stumbling block in their path of producing ever-increasing goose-hunting opportunity. The problem is fast changing from one of how to produce more geese to how to handle them all. To state the problem simply, there aren't enough stopover areas to adequately protect and feed the tremendous flocks that pour out of the north even now. Some examples will illustrate the problem.

Sportsmen bagged 20,321 geese during a recent season in the Illinois counties of Alexander, Union, Williamson, and Jackson. It just so happens that one of the country's largest flocks of Canada geese insists on wintering in the small four-county area. Many times that harvest could be killed if general goose-hunting rules applied to Illinois hunters. But the flock isn't decimated because the United States Department of Interior sets a statewide quota of 25,000 geese. When that number of birds is bagged, the season is closed. Similar regulations apply to the Swan Creek area of Missouri and other sections of the nation.

A somewhat reverse situation developed in California's grain-rich Sacramento Valley during a hunting season a few years ago. A November survey of the state's flyways showed 394,000 dark geese (mostly Canadas) and 321,000 white geese, of which most were snows. Fifteen days later another survey showed the white goose count had erupted to nearly 520,000 birds. Waterfowl officials couldn't believe the astounding increase and they wondered where all the geese had come from.

Such an increase necessitated some kind of action to maintain a more preferable balance of the two species. Strange as it may seem, licensed waterfowl hunters were given the happy task of shooting more geese. The regular season was extended for two weeks on white geese only. The daily bag limit was six, and a lot of hunters knew that they were more than reliving the good old days.

Those examples point up the fact that stopover areas must be increased in both size and numbers. If the job can be accomplished, it's possible that ever-increasing flocks of geese can be spread over more areas of the country and offer better gunning opportunity to more and more hunters.

All state game departments are working on the problem. Let's look at a new phase of management tried by Ohio, a state whose goose population skyrocketed from 9,000 to over 50,000 in seven years. Here's how a biologist for Ohio's Department of Natural Resources explained the project to me:

"We initiated a goose color-banding project in cooperation with the Ohio Division of Wildlife, and the Ohio Cooperative Wildlife Research Unit of Ohio State University. We want the best waterfowl officials available to evaluate results of the study. The initial project consisted of trapping and placing brightly colored plastic neck bands on 600 Canada geese in a period extending from October 15 to January 1. The study gave us detailed information on precise flight patterns.

"Some of our marked geese have been sighted in Alabama, Mississippi, and Illinois. Canadian federal and provincial wildlife authorities alerted their personnel to be on the lookout for these geese when they go north in the spring. They in turn are contacting Arctic Indians about the importance of notifying Canadian mounties if the marked geese are seen.

"It's all part of similar projects undertaken by other states to determine the precise flight patterns geese use. This is only one variety of information waterfowl managers will need to establish the best stopover and wintering areas. Some other considerations will be the clearing of brushy fields for landing areas, planting corn, wheat, rye, and clover, construction of shallow lakes, building nesting areas, and regulation of hunter harvest seasons."

Producing resident flocks and other new goose-management techniques are only part of the bright picture confronting the modern goose hunter. Unlike ducks, most wild geese nest in the permanent water areas of the Arctic and near-Arctic. Their breeding grounds are not subject to the drainage projects and recurring droughts, such as those of 1980 and 1981, that wreak havoc in the duck factories on the prairies of the northern United States and Canada.

About the only human intervention geese are subject to on their spring breeding grounds is the occasional near slaughter carried on by Indians whose families have been prisoners in their tents all winter and are bordering on starvation. No hunter

To obtain precise data on flight patterns, Ohio game managers trapped and banded 600 Canada geese over a two-and-a-half-month period.

knows a goose better than an Indian. When food is a matter of life or death, Indians can kill an awesome number of geese.

Despite this, the overall picture on the far-north breeding grounds couldn't be better. It's a picture that hasn't changed very much in thousands of years. The huge wedges of flying geese will continue to cut through fall skies year after year. There will always be a lot of geese, and that's the main reason goose-hunting seasons run an average of two months in most states, and longer in Canadian provinces. During

the years when duck populations are down, goose hunters can spread decoys and hunt nearly twice as long as their duck-hunting counterparts.

But it's normally far easier to bag a duck than a goose. Ducks aren't as smart or as wary as most members of the honker tribes. In recent years waterfowl managers have recognized that much potential goose shooting is going to waste because, to be quite blunt, the average hunter doesn't have the equipment, the know-how, or the brains to get within shotgun range of most geese.

Huge flocks of geese still darken the sky over Canada's Northwest Territories.

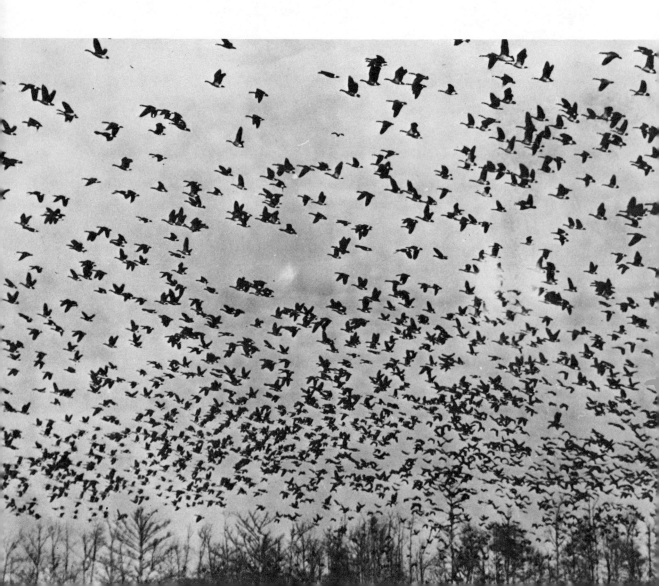

A goose hunter's camp on Currituck Sound, North Carolina. Note the handmade decoys in foreground.

One answer to this problem is the rapidly increasing numbers of state and privately operated goose-hunting areas. Drawings are usually held on the state areas for occupation of blinds on certain dates during the hunting season. Decoys, blinds, and how-to information are supplied by state goose experts for a small fee designed to cover cost of operation of the projects. The permanent blinds are constructed in areas of known goose concentrations. The hunt coordinators are extremely well qualified to help even the novice enjoy the utmost thrills of goose hunting. You just can't ask for a better opportunity to learn a lot about the magic excitement of goose hunting.

The privately owned operations are, of course, in business to make a profit. They charge fees, but their goose-hunting operations are run by experts who have

hunted the big birds for many years. They also have permanent blinds set in areas where bagging a goose is almost a cinch if you have any understanding of how to point a shotgun. Some of these private outfitters use the unbeatable calling card of hundreds of decoys. Some even employ goose callers who are masters of their art. Their repeat business depends exclusively on happy hunters. I know of one private operator in California who boasts that his hunters harvest over 2,500 geese in a single season.

There are many private goose-hunting outfitters scattered across the nation. You won't go wrong if you take advantage of their professional services. A couple of hunting sessions with those fellows will teach you what modern goose hunting is all about. After that you can branch out on your own.

All of the foregoing is a brief story of why goose hunting is getting better as each year passes. In the following chapters of this section I'll describe the techniques that have enabled me to see many a golden-brown roasted goose adorning my dining room table. I love all kinds of properly prepared wild game, but nothing can quite match an expertly cooked goose.

16

The Fantastic Story of Wild-Goose Management

Waterfowl managers will agree that the Canada goose is the most easily managed and the most manipulated species of wildlife on this continent. That statement will be challenged immediately by many a frustrated goose hunter who will claim flat out that the same Canada goose can be the most wary, the most cunning, and the most difficult bird to bag of all waterfowl.

It's an amazing fact that both schools of thought are correct. Why? Because a Canada goose has a superior intelligence that enables him to determine very rapidly whether any given activities of man represent safety or danger. All veteran hunters marvel at how quickly geese can determine the boundaries between a refuge and an open-hunting zone. We won't dwell here on how difficult a goose is to shoot since the subject is covered in other chapters. But the success story of wild-goose management is a story that every waterfowler should know. It's a story pointing out that the trophy bird of waterfowling reacts in astonishing ways to modern principles of management. It's a story suggesting that hunters of the future may enjoy even better goose hunting than we experience today.

Right now, in some places of our country, geese are present in greater numbers than they were in the "old days." I'm not referring here to the introduced resident flocks that we discussed in the last chapter, but to the great migrating flocks that trade between traditional breeding grounds in Canada and wintering grounds in

the United States. What emerges from this welcome fact is the clear-cut principle that quantity and quality goose hunting are worthy and *attainable* goals. Some background will bring the picture into focus.

The first part of this chapter is limited to Canada geese, since they are the most manageable of all wild-goose species. There are about 3 million Canada geese in all of North America. Waterfowl managers are quick to point out that we can no more assess or manage this overall mass of geese than the government of one country could manage the masses of people in several countries. This is no problem since the biologists have divided geese into ethnic and ecological flocks that maintain specific characteristics.

The division begins with the modern knowledge that certain geese will remain within certain distinct flyways. The overall flocks within a flyway can be broken down into various subspecies, and the resulting smaller groups can be separated further into "flocks" or "flights" that use specific breeding, stopover, and wintering concentration areas.

Thus, for example, we can speak of the Mississippi Flyway having within it a Mississippi Valley population of Canadas made up in part of the Horicon flock, which is composed principally of the subspecies classified Interior. So it is that modern goose-management success is based on the fact that we can categorize and work with known statistics. Today's goose biologist doesn't work with unknowns; he manages with facts in much the same manner as an operator of a business concern. Both have specific, proven data with which they can make reliable and realistic decisions.

What can all this accomplish? A good example is Wisconsin's Horicon flock of Canada geese centered at the Horicon National Wildlife Refuge in the southeastern part of the state. Once one of the finest wildlife marshes in North America, it was destroyed by ill-advised drainage projects during the early 1900s. In 1927 strong public support demanded the restoration of this area. By the 1940s, state and federal funds had acquired enough ownership in the marsh so that water could be impounded again. During 1951 the last major water retention structures were closed, and the important part of the restoration battle was won.

The federal government then established a refuge on the northern two-thirds of the marsh, with the primary aim of building an important duck production and goose stopover area. There was no suspicion that Horicon would become one of the largest single Canada goose concentration areas in North America. Migrating

geese traditionally flew over the area, but very few actually stopped on the marsh to rest.

Eventually a few did stop, and they liked what they found. Each year the fall population of Canadas continued to build until it became obvious that management practices were becoming *too* successful. The welfare of the geese was being jeopardized by overshooting on the state-owned southern third of the area.

This situation didn't develop overnight, but the chain of events is almost unbelievable. Not too many years ago, when the fall goose populations reached 50,000, hunters complained bitterly, "The federal government is hoarding all the birds in the refuge area. We can't get good shooting outside the boundaries."

A few years later, complaints were even louder, but from the very opposite quarter. By now the goose population had exploded so rapidly that many birds had to feed off the refuge and hunters quickly cashed in on exceptional shooting. Excessive kills in 1956 and 1957 caused some observers to call for a stop to the "slaughter pen" shooting. In 1959 the Bureau of Sport Fisheries and Wildlife clamped an emergency closure on the area's goose season because the heavy kill was getting out of hand.

This experience brought the bureau and several states together on the question of harvest quotas. The Mississippi Flyway Council agreed that quotas must be set for areas where geese, because of their exploding sheer numbers and high vulnerability, were subject to excessive harvests. In 1960 it was decided that 30,000 geese could be harvested safely from the Mississippi Valley flock without endangering its overall population. What did that regulation accomplish?

By 1965, peak goose numbers on or within 10 miles of the 20,000-acre Horicon Refuge built to 125,000 birds. Compare that to the zero population of geese on the area fifteen years previously. But waterfowl managers are quick to emphasize that the picture isn't as rosy as it appears. During the fall of 1965, crop depredations on surrounding private property were severe in spite of the fact that $50,000 worth of shelled corn was trucked to the refuge and spread for goose food to augment the supply grown in place.

A more serious problem is that the Horicon area is simply too attractive to geese. The birds build up in such numbers that a major share of the flock's overall population cannot be enjoyed elsewhere. Horicon is only one area in the Midwest that has caused Canada geese to change their ancestral habit of migrating to the lower end of the flyway. Many now winter far to the north of their former migra-

tion terminals. The phenomenon is largely man-caused, and the term for it is "short-stopping." A typical case history is that of the Eastern Prairie population of Canadas. Two decades ago this population wintered from Arkansas southward. Now they are content to remain in Missouri. Short-stopping is not confined to any one population or any single flyway. It has reached serious proportions in the Atlantic, Central, and Mississippi flyways.

The solution is twofold: limit the carrying capacity of the present most attractive areas, and lure the "spillover" flocks to other refuges at well-distributed points throughout the flyways. This won't be easy to do, but managers must achieve the goal if goose hunters are to receive equal opportunity throughout the states. Fortunately, plenty of overall goose range is available; the trick is to induce the birds to use it. High-quality wintering grounds in the far southern parts of all flyways were largely unoccupied in the late 1970s. Such grounds could swell the carrying capacity of the overall range.

Is there a limit to how many Canada geese we can have in North America? Biologists tell us that any species of wildlife can reach a population limit whether it is hunted or not. Birds cannot multiply beyond the number that available overall habitat is capable of supporting. After a peak number is reached nature will destroy the surplus through disease and other controls if the excess isn't eliminated by substitute means. This is the exact reason why all types of game hunting, if properly controlled, cannot be classified as the exploitation of a natural resource. It is far better to harvest a surplus crop of game through the enjoyable sport of hunting than it is to waste that crop to the schemes of nature.

It is estimated that 40 percent of the breeding ranges of all Canada goose subspecies is unused. This obviously implies that more geese could be produced if more breeding birds were available to utilize the waiting nesting habitat. Wintering ranges could hold more birds too if, as previously mentioned, the geese can be induced to use them. Modern waterfowl managers know that the limiting factor is the short supply of habitat and improper goose distribution along migration routes. They are well aware that if that habitat can be increased, and used, goose numbers can be increased proportionately. That principle is responsible for the huge numbers of Canada geese we have today. In two decades the Mississippi Flyway population has grown nearly fifteen times from a low of 50,000.

In some places there are now so many Canadas that the birds are a nuisance, even near metropolitan areas.

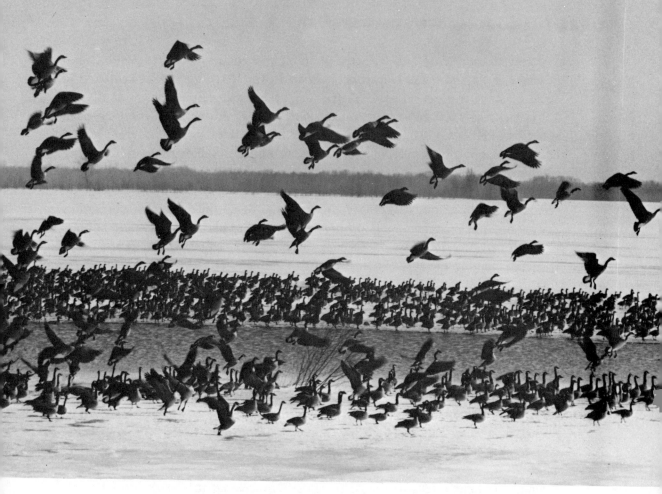

Canada geese seek out water hole near feeding fields in Missouri.

"We continue to have problems with the buildup of resident Canada goose populations in the area surrounding Detroit," said Ed Mikula of Michigan's Department of Natural Resources. Mikula, the state's top waterfowl official, made that statement in 1980. He then went on to tell me: "Local governments, health officials, and homeowner groups are complaining about the birds' droppings left on beaches, lawns, docks, and other areas. We need a longer hunting season to concentrate these geese more. We have to make them more vulnerable to gunning pressure. We simply have too many geese."

During the winter of 1979–80, aerial photo counts conducted by the South Dakota Game, Fish, and Parks Department showed over 100,000 geese concentrated in small open-water areas on Lake Sharpe and Lake Oahe near Pierre.

"As many as 8,000 geese were packed like sardines in one small patch of open water," said K. L. Cool, head of the department's Wildlife Division. "It really scared us. There was a distinct possibility of disease or a blizzard killing thousands of those birds. Nothing happened, but we were just plain lucky. We just have too many geese wintering on portions of the Missouri River. One of these winters we're going to lose a bunch of birds. We have the potential of an outbreak of a contagious disease that could decimate a good portion of our Canada goose breeding population. We have to find ways to disperse the birds over larger wintering areas, and increased hunting pressure should be part of the answer."

Consider, for a moment, the astonishment the old-timer would have registered if he had been able to read the words in this chapter. He surely would have said, "That's all hogwash. It will always be impossible to have too many geese!"

It's a tribute to our modern waterfowl managers that that old-timer's statement couldn't be more wrong.

The future hunting enjoyment that will be gained from increased Canada goose numbers is best told by statistics. Let's consider a present fall flight of 200,000 birds. The calculated allowable harvest is 20 percent, or 40,000 geese. Of those 40,000, data show that the Canadian hunter kill and total flyway crippling losses will total 9,400. That leaves 30,600 honkers left for harvest by United States hunters.

Simple arithmetic tells us that if the flock is increased to 300,000 we'll be able to harvest 45,900 geese in this country. If the flock goes to 400,000 we'll be able to jump our take to 61,200 Canadas. Such facts point out that if management principles can double the size of a given flock they will automatically double the allowable harvest.

The overall picture seems so bright that there must be flaws in it somewhere. There are. Some of the biggest are the curveballs that nature occasionally comes up with. Prime examples are the severe snowstorms that hit Manitoba in June of 1969, and again in 1972. The 1969 storm buried breeding grounds of the Eastern Prairie Canada goose flock just as the young were hatching. A census on the wintering grounds the following January showed that the population of this flock had dropped 30 percent from the preceding year. It's interesting to note that if the

storm had hit a few days earlier or later, much of the disaster would have been avoided.

There are management problems that tie in with nature too. During the three-month period that geese are on wintering grounds, they must be fed. When adverse weather affects the amount of food that is planted for geese, depredation problems on private property develop. Goose populations in some areas may have to be limited when they reach the point where they are too expensive to handle. Controlled feeding operations are often prohibitive from a financial standpoint.

In the biological field of management, the problem of wasted geese will have to be licked. Thousands of birds are now lost to disease, pesticides, pollution, and lead poisoning. Unless continuing research can find solutions these problems will become greater and greater.

The future of goose hunting for other species may not be quite so bright. They can't be managed as easily as Canada geese. Populations will vary according to conditions of natural environment. No specific population goals had been established for blue and snow geese as late as 1981. In fact, no flyway management goals or objectives have ever been spelled out for any geese except Canadas. However, we do have statistics that clear up where we are and where we may be heading.

In all four flyways—Pacific, Central, Mississippi and Atlantic—the Canada goose ranks highest in the number harvested. But the rank of goose species in the hunter's bag shuffles rapidly when the number two position is considered. Snow geese highlight the second-place kill in the Pacific and Central flyways, blue geese get that ranking in the Mississippi Flyway. The rank-of-kill positions change again for third-place honors. Whitefronts fill the bill in the Pacific Flyway, blues in the Central, and snows in the Mississippi.

Such facts show that several species of geese besides Canadas produce plenty of hunting. They further suggest that if management principles can be developed that will build up the numbers of these birds the future of goose hunting will be even brighter than it is. There are some supporting reasons to believe this may happen.

The Canada goose has so preoccupied hunters and waterfowl managers that other kinds of geese have largely been overlooked. Some statistics will show how large this other resource was at the end of the 1970s. The Canada goose population in the Pacific Flyway was 102,000 birds. Contrast that with the 433,000 snow geese, 143,000 brant, 114,000 whitefronts, and 104,000 cackling geese. In other words, Canada geese were outnumbered nearly eight to one.

In the Central Flyway, where 327,000 snow geese led the count, they were out-numbered nearly two to one. Canadas boasted the largest population by far in the Mississippi Flyway, over 700,000. Blue geese were second with 224,000, followed by much smaller numbers of snows and whitefronts. Canadas ruled the roost in the Atlantic Flyway, too, with 679,000 birds, followed by 69,242 brant and 75,000 snow geese. In total, for all of North America, the combined populations of blue geese, snow geese, and whitefronts come close to outnumbering Canada goose flocks. Such a resource deserves increased management attention, but biologists claim that the continental population of blues and snows is increasing without the benefit of management.

Some mysteries of the life cycles of these birds have been solved. It is known that braided river mouths in the far north provide the most suitable breeding

In the Pacific and Central flyways, where snow geese outnumber Canadas, huge flocks build during migrations.

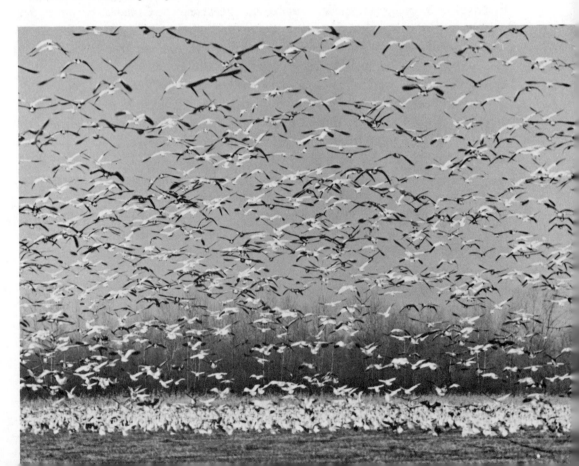

habitat. It is also known that very extensive areas of pond tundra are also available. These areas support light breeding densities though they are very suitable living quarters. They could produce many more geese than they do now. There appear to be vast and suitable areas for the expansion and extension of nesting colonies.

Native marshes on the wintering grounds remain in first-rate condition. In the South, birds are increasingly utilizing cultivated rice lands in apparent preference to the age-old marsh sites. Modern changes in agriculture along the migration route provide an excess of required food in the forms of succulent browse and waste grain. All of these facts support waterfowl management's conclusion that there is far more than adequate year-round range to support present goose populations. In fact, at the end of the 1970s, the blue, snow, and whitefront situation was so favorable that some authorities suggested that waterfowl experts relax and enjoy the bonanza.

But the managers wanted no part of that type of thinking. They were quick to say that very drastic changes in the habits and environment of these geese may develop. They point in particular to the question of how much private crop depredation in southern agricultural lands will be tolerated. The problem is already so serious that the Mississippi Flyway Council suggested that goose-hunting season frameworks be extended to March 1 in Louisiana and Texas. Such increased hunting pressure would be designed to control the depredation problems. It's no secret that management will have to determine how to control existing populations before they can turn attention to producing more geese.

Even so, background studies are being conducted with this purpose in mind since harvest rates of these geese will increase in the future. One biologist put it this way: "It will be necessary to have much more accurate survey data to monitor changes in status so proper control measures can be designed. Until now we have been managing by good fortune. We'll have to come up with solid factual data on migration patterns, harvest surveys, short-stopping, reproduction potential, and a variety of other details before we'll know how well these geese can be managed."

17

How to Identify Geese

Goose identification is relatively simple for several reasons. The big birds are heavier-set and have longer necks than ducks. There are far fewer species of geese than ducks. The appearance of each species is usually quite different from that of other species of geese. The only category where this doesn't hold true is in the various subspecies of Canada geese. Unlike ducks, male and female geese are alike in appearance, and they lack the cere, or soft raised substance at the base of the upper bill. Those are general clues; here are the specifics to look for.

Canada Goose: This goose is divided into six varieties, all bearing the same general markings. The common Canada goose is the best known, most widely distributed, and most plentiful of all geese. It is the only goose found in many sections of the country. It hardly needs description since it is the goose most pictured in photos and drawings. It is a large brownish-gray bird with a long, black neck and head relieved with white cheek patches. The upper body and wings are a gray-brown and each feather is tipped with a paler edge, which produces a barred appearance.

The chest and breast are gray with white-tipped feathers, which also give a barred appearance. The belly and flanks are white. The rump, bill, and feet are black. In flight, Canadas can hardly be mistaken. Formations are usually made up

in the familiar V's, and the frequent telltale honking notes are often heard before the birds are seen.

The only big problem in all goose identification is telling a common Canada (described above) from its larger cousin, the giant Canada; or its small cousins, the western Canada, the lesser Canada, the cackling goose, and the Richardson's goose. Consider a letter I received concerning one of my goose-hunting stories in *Outdoor Life*. The letter was from a California hunter, and it questioned the identity of a flock of flying geese in a photo accompanying the story. As a matter of record, the birds in the photo were lesser Canadas. Here's the letter:

"There is a small controversy presently existing between a hunting buddy and myself concerning these geese. He says the geese in your picture are cackling geese or cacklers. I say cacklers are lesser Canadas and that cackler is another name, not the true name. In other words, we argue over whether it is one goose with two names, or two distinct geese.

"To illustrate his theory, on our last trip to Tule Lake, California, he called upon the wisdom of an expert. This man, who runs a business which pick and cleans birds, has undoubtedly seen thousands of ducks and geese, and he gave us a dramatic presentation.

"He went back into his shop, rummaged around in the baskets of birds awaiting processing, and presently returned with three geese.

"One goose, obviously the largest, was a true, full-fledged honker. He weighed an impressive 13½ pounds. Next to the large honker, the expert laid a smaller honker. Identical to the larger bird except in size, this goose weighed a respectable 6¾ pounds. Finally, he laid the third goose down; it was visibly smaller than the other two, 5 pounds 11 ounces. This goose also had one other obvious difference: a very short bill.

"The expert then pointed to the largest bird and proclaimed almost indignantly, 'This is a honker.' He then pointed to the middle bird and pronounced him a lesser Canada. I could feel my hackles rising. He finally pointed to the smallest and said, 'This is a cackler.' Needless to say I haven't had a peaceful night's sleep since. Please settle this once and for all."

I answered that letter by explaining that the "expert" was probably correct. A cackling goose is a distinct subspecies of the common Canada, and so is the lesser Canada. They are not the same birds going under different names.

To confuse the picture a bit more, let me be quick to point out that in some

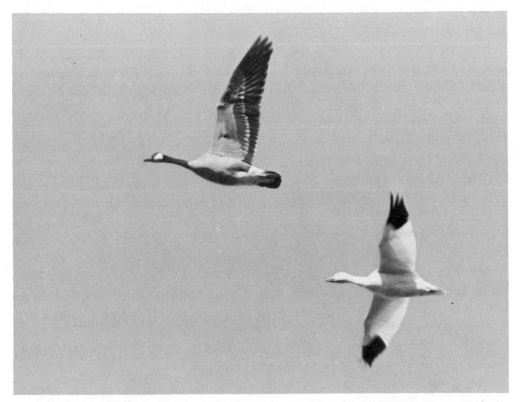

Each goose species is distinctive in appearance. Note the difference between the Canada (left) and the snow goose.

parts of the country lesser Canadas are locally called cacklers. When a Nebraska gunner claims he shot a cackler he couldn't be more sincere, but he also couldn't be more wrong. What he actually bagged was a lesser Canada, simply because there aren't any true cackling geese in his state. Cacklers breed on the western Aleutian Islands, and winter from British Columbia to San Diego County, California. They seldom travel inland farther than the tier of far western states and provinces.

Another case of popular misidentification concerns the Hutchins goose. Many gunners commonly refer to the lesser Canada as Hutch or Hutchinson. This is in error, since the Richardson's goose is the true Hutchins, an entirely different bird.

Anyway, it's easy to get more academic than necessary on this subject. Any of the Canada goose subspecies are fine sporting and table birds. Here are the identification characteristics used for determining which species you bag:

Western Canada Goose: About the same size as the common Canada, though usually a bit darker. The darker coloration is thought to result from the dampness of climate where these birds range on the West Coast from Vancouver Island to Prince William Sound, Alaska. They seldom migrate and don't go far inland. The normally white cheek patches are sometimes a rusty brown. The western Canada also commonly has a nearly white collar at the base of the black neck "stocking."

Lesser Canada Goose: Identical in appearance with the common Canada, except that this bird has a smaller body, a shorter and more stubby bill, and a shorter neck. It's the most abundant of all the western species, and is quite common in the Midwest, though it's seldom seen on the Atlantic Coast.

Cackling Goose: As the smallest member of the subspecies the cackler resembles a minature western Canada. Its voice, a shrill "luk-luk," often seems to be repeated continually. This characteristic is a fine identification clue. If you're a western gunner and you bag an apparent Canada goose that's hardly larger than a mallard, you can be sure that you have a cackler for dinner.

Richardson's Goose (also called Hutchins goose): This bird is identical to the common Canada except for size and voice. It seldom weighs more than 6 pounds, and its honking note is replaced by a trilling "k-r-r-r." It breeds in the northeastern Arctic and migrates down a route following Hudson Bay, then spreading to the Rockies on the west and the Mississippi Valley on the east.

Giant Canada: Thought to be extinct as recently as 1957, these magnificent birds—the true *Branta canadensis maxima*—are making a comeback in the Midwest. You can't mistake them because of their enormous size. They have recorded weights up to 22 pounds, but in coloration they exactly duplicate the common Canada.

Snow Goose: Some confusion exists as to whether there are two species of these birds. A few ornithologists insist that the greater snow goose is a distinct species and should be separated in definition from the lesser snow goose. Most hunters could scarcely care, since, except for being somewhat larger, the greater snow goose is identical in appearance to the lesser snow goose. It should be noted that the smaller variety almost never is found along the Atlantic Coast, although the greater snow goose is strictly an eastern migrant. So, depending on which section of the country you gun, it's easy to determine which variety you bag.

Aside from which names are applied to this goose it's almost impossible to confuse it with other species. In general, this bird is entirely white except for black

Snow geese are easily identified by their white bodies and black wing tips.

Mixed flock of snow and blue geese. These birds have shorter necks and stubbier bodies than Canadas.

wing tips, which are obvious when the birds are in flight. Older birds often have heads tinged with a light reddish tan. The bill can vary from pink to red. Legs and feet are pink with black claws.

Blue Goose: The unusual "goose characteristic" of this bird is that it's gregarious. It will often mix with lesser snows during migration flights. This trait frequently causes an inexperienced hunter to wonder what kind of hybrid goose he has killed. The experienced waterfowler knows that the blue goose has become known as a color phase of the lesser snow goose, but he has certain characteristic markings which cannot be confused with other species.

A long-range clue is this bird's white head and neck, which contrasts with a dark body. Close-up examination will usually show a rust-colored forepart of the head. The body is dusky gray, the under parts are always lighter than the upper parts,

and all wing coverts are grayish blue. The only confusion factor in identification is that blue geese will vary in breast and belly markings. One bird's belly may be almost white, while another's may show colors similar to the back, but lighter in tone.

Blue geese are often known to gunners as "wavies" because of their irregular, shifting, and weaving flight formations. They are of medium size. During hunting seasons few of these birds are found farther west than Texas.

Barnacle Goose: This bird is a European species but is found occasionally along the Atlantic Coast. It looks somewhat like the black brant, except that it boasts a white head and its sides normally show barred markings of white. Also, compared to brant, barnacle geese are less seagoing. They feed on tidal flats and turf close to sand dunes.

Emperor Goose: A medium-sized goose seldom seen outside the western coastal regions of Alaska. It's the most beautiful of all North American geese. The feathers on the back, sides, and chest have black markings with white tips which produce a scale-finish appearance on a silver-gray body. The head and neck are a mixture of white and brown. The bill varies from a pale purple to a flesh color, and the feet are orange-yellow.

Ross's Goose: This bird compares in size with a mallard duck, but looks like a miniature snow goose. It's all white, except for black wing primaries. Primarily a western bird, it enters the United States near the Montana Rockies, then migrates southwesterly to winter in central and southern California. Ross's geese are similar to lesser snow geese in feeding habits and are sometimes found in company with their larger cousins on grazing grounds.

White-fronted Goose: A bit smaller than the common Canada, this bird is often called "specklebelly." The nickname comes from the peculiar brown, white, and black specklelike markings on the belly of the goose. Its most distinguishing feature, however, is the white front of its head. This front, or face, is a band of white running around the entire forepart of the head, beginning behind the bill and extending about halfway to the eyes. The rear edge of the white band is bordered

Emperor Goose

Ross's Geese

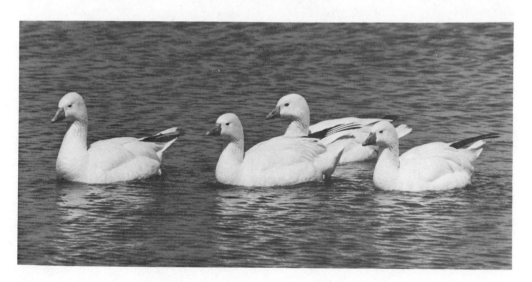

in black. The rest of the head, the neck, and the back are grayish brown. The upper and lower tail coverts are white, and the tail feathers are tipped with white.

White-fronts in flight resemble common Canadas in body contours and V-formations. But they don't honk; they cackle with a "wah-wah-wah-wah" that sounds like laughter. They are grazing birds and prefer field foods to aquatic dinners. White-fronts once were familiar to eastern gunners but now they're typically western. Only an occasional straggler visits the East Coast.

Tule Goose: A larger bird than the white-front, but almost identical in appearance. It has a slightly darker coloration but its habits differ so radically from the white-front that it's classified as a separate species. Tule geese are seldom found in open fields. They much prefer wooded sloughs and marshes harboring thick growth of tules. While white-fronts are wary high fliers, tule geese aren't nearly as suspicious and they are given to low-flying habits. They are seldom bagged except in the far-western states.

American Brant: This bird is the only truly maritime member of the goose fami-

Black Brant

ly in that it is almost always found close to salt water. With the exception of the Ross's goose the American brant is the smallest member of the family. It's only slightly larger than a mallard, and it's found only along the Atlantic Coast. The most distinguishing characteristic is an almost entirely black head, neck, throat, and chest. The black is broken with a roughly crescent-shaped patch of white streaks just under the throat. The sides and front of the breast are gray, the back brownish gray. The lower breast is a light gray fading into a white belly. The feet are black.

Flying flocks of American brant seldom utilize V-formations. Normally they "follow the leader" in long, wavy lines, occasionally bunching into irregular masses without apparent leadership. Although their flight speed appears rather slow, it is actually faster than that of most other geese.

Black Brant: This brant closely resembles the American variety, but is darker. It also has a white neck ring just under the head. Identification is no problem, since these birds are found only on the Pacific Coast during gunning seasons. They decoy well and lack the natural suspicious nature of most other geese. They prefer to fly close to ground or water; rarely do they achieve an altitude of more than 30 yards. They are also truly aquatic and do not graze in fields.

18

Field Shooting with Decoys

The gunner who successfully bags geese over decoys is a specialist who takes a tremendous pride in his hunting ability. The relatively inexperienced hunter can get great duck shooting over his blocks if he happens to rig in the right place at the right time, but such action seldom happens in the goose-hunting game. Ducks, particularly divers, are birds of habit. They will react to given circumstances of blinds and decoys through instinct alone, often exhibiting little reasoning power.

Geese, though sometimes caught unaware, never abandon their native intelligence when working to decoys. They approach with extreme caution, maneuvering with military precision, and usually working with very slow airspeed. They want to inspect every detail of the decoy area for signs of fraud. It's common practice for geese to circle a spread several times, alternately dropping low, climbing, circling, always suspicious.

Because of these traits the hunter who isn't a master with blinds, decoys, and calls seldom kills a limit of geese. Since the game requires a lot of effort and knowledge there are far fewer expert goose hunters than expert duck hunters. But the reward for the successful is sensational.

There is no other sight in all waterfowling that can match the heart-thumping experience of watching a flock of completely fooled geese descend into your decoys. The trophy birds seem enormously large, their exciting honkings ring in

your ears with true music of the wild, and the urge to shoot before the targets are in range is almost overwhelming. On a good day, when this happens several times, you finish a hunt that leaves you exhilarated with memories of unbeatable excitement.

Such adventure goes to the man who understands that decoys must be precisely located with regards to both formation and area hunted. The initial key to success is spotting for feeding flocks. You have to put your decoys in an area where the birds want to come down, and they want to come down where they know they'll find food. If you can find an undisturbed flock of feeding geese in the evening, it's a fair bet they'll come back to the same field the next morning.

Finding the Geese

The best spotting trick is to use the group system. Usually about four hunters will scatter so that they can cover a lot of country. They'll meet at a starting point, drive their vehicles in separate directions, then regroup later to compare notes. One man will almost always find a field holding more geese and offering better shooting possibilities than the discoveries of his partners. Such a technique offers a four-man group a four-times-better chance of discovering a bonanza than if the group had spotted from one vehicle.

Spotting involves no more than slowly cruising potential goose-feeding areas (usually within a 20-mile radius of large lake and river roosting areas) and pinpointing hot spots the birds are working. You do this by driving along back roads, discovering flying flocks, watching them with binoculars, and eventually following them to a field where they finally alight. There is always the chance, of course, of spotting large flocks of birds on the ground.

The next step is equally important. Geese in a field don't offer a shooting opportunity unless you can get gunning permission from the landowner. Visiting with the property owner has several other benefits too. He can tell you if the birds are new arrivals or if they have been using the fields for days. If the latter is true, the odds on a successful shoot are much higher, because the birds are used to a specific dinner table. If they haven't been bothered in a certain spot, they'll return with reduced suspicion.

In any event, now is the time to become as friendly as possible with the farmer. You'll make a lot of points if you bargain with him. Tell him you'll gladly give him a couple of geese for dinner if your hunt is successful. Offering him a $20 bill for hunting privileges breaks a lot of ice too. Maybe he'll prefer to join you in the hunt. If so, offer the invitation immediately. If you can make him a partner in your hunting schemes, you're on your way to great shooting.

Why? Because in most localities the big birds work the grain and wheat fields in the same general areas year after year. Your spotting problems will be greatly reduced if you have farmer friends in key areas who will alert you when goose flights are arriving. They can also tell you which fields the birds are working, and whether they are new geese or have been using the same spot for several days. All such information is extremely helpful for finding the ideal shooting location, or locations. Always obtain permission to hunt as many hot spots as you can.

One of the best tips is to ask permission to hunt a field whether it is posted or not. A lot of farmers will welcome gunners, but they post their property because they don't want strangers on their land. They want to size you up, know who you are and where you're going to hunt. They also want to be assured that any freshly dug pits are refilled when the hunts are over. All you have to do is be courteous, and a farmer can be a big help to you as a goose hunter.

There's another factor to consider too. Some of the best gunning fields are posted because the landowner has already promised shooting rights to other parties. It may well be that such parties are weekend hunters, and the farmer may have no objections if you confine your shooting to midweek. It may also be advisable to contact the other party (get names and phone numbers from the landowner) and try to arrange a group hunt. Unlike most duck-hunting techniques, group goose hunting is sometimes the only way to get top shooting, because the more decoys you spread in a field, the better your chances of success. More on this later.

One last word on asking for permission to hunt. More and more property owners are realizing that their goose fields can be a source of added income. These people want you to come and hunt, but they want you to pay a small fee for the privilege. Usually they'll post their boundary lines with "fee-hunting" signs. But sometimes they'll use regular signs in hopes that you'll ask permission anyway. Incidentally, charges usually run about $12 to $20 per hunter per day. That's a minor cost for a fine day's shoot.

Once a field is selected the decoying area must be determined with care. Stay away from low spots; live geese feed on high ground where they have good vantage spots. Several possible high-ground spots will usually be available. Generally, the best selection will be the exact spot where the geese have been feeding. But keep in mind that a blind has to be absolutely inconspicuous before it will fool geese. If the site doesn't offer fine blind-building possibilities, choose a nearby high spot that does.

Blinds

Most experts prefer to shoot from pit blinds because they offer top concealment. Such blinds vary from quite simple to very elaborate. The type to construct depends on how much shooting you expect to get from the location. If it's a one-shoot deal, a simple, shallow pit will suffice. If you plan on gunning the area several times during one season, and perhaps year after year, then a comfortable and big pit may be the answer.

The simplest pits are one-man affairs containing the hunter in prone position. They are dug about a foot deep, 3 feet wide, and 7 feet long. Some hunters collect weeds and grasses that are native to the area for covering and concealing their bodies. Veterans use a better system. They build pit covers that offer better concealment and more freedom of movement. The covers are light wooden frames covered with stretched chicken wire. Some basic camouflage materials are woven into the wire, but native materials from the scene are placed over the cover at the beginning of the hunt.

The cover also contains a handle in a convenient position on its bottom side. When decoying birds are within shooting range, the concealed gunner grasps the handle, flips the light cover aside, snaps to a sitting position, and begins shooting.

Most such covers are flat, but some goose hunters prefer constructing them in tent form. The latter type allows the hunter to maintain a sitting position. This arrangement offers a bit less effective concealment, but it lets you move your head while keeping circling birds in view. It's more effective when placed in high weeds. In any event, light, portable pit covers can be used again and again in different locations. Their primary advantage is that they offer fine concealment with less work than building a body cover with materials found in the hunting area.

Simplest pit blind is a shallow trench, about a foot deep, in which hunter lies prone and conceals himself with weeds and grasses.

Make your pit cover frame from ¾ × 2-inch lumber. Lap the joints. Make the frame slightly larger than the pit dimensions so that it will rest evenly on all sides of the hole. Cut, stretch, and secure chicken wire to the frame. Large staples work far better than nails. Paint the cover, both frame and wire, with a dead-grass paint. Most hunters construct a single rectangular frame, but some prefer including a crosspiece running across the cover at about the chest position of a prone gunner. The handle is bolted to this crosspiece. With a centrally located handle the ready-to-shoot hunter can flip the cover away to either left or right with ease.

The next simplest pit blind is a one-man hole dug about waist deep. The hole itself will conceal about two-thirds of the gunner. Native brush, weeds, and grasses are piled around the rim of the hole to hide the rest of the body. If the bottom of the hole is muddy, it should be floored with old boards or other suitable materials, since good balance is essential to accurate shooting.

Some one-man pits are dug large enough so that a man can sit in them. When geese approach, lean forward until your head and shoulders move down almost to ground level. This type of pit, too, is rimmed with camouflaging materials.

It's my opinion that one-man pits offer far better gunning than multi-man pits simply because several small holes in the ground are much less conspicuous than one large hole. Camouflage materials around a small hole can make it almost invisible. You can't get that degree of concealment with a big pit holding three or more gunners. But most gunners prefer the companionship of multi-man blinds, and there's no question that they fool a lot of geese. And, as I mentioned earlier, large-group hunts are sometimes the most successful because several spreads of decoys may be combined into one huge flock. I'll still say that five pits holding three men each will produce a better hunt than three pits holding five men each. For the best success, keep your blinds small.

The larger pits should be dug as narrow as possible to eliminate that "big black hole" appearance. I try to dig my pits about 30 inches wide. That's enough to accommodate sitting hunters while still offering elbow room to stand up and shoot. Allow 3 feet of pit length for each hunter. Most pits are dug 3½ feet to 4 feet deep. If they are permanent affairs the walls should be supported with planks to prevent cave-ins. Native screening materials are also arranged around the rims.

The most elaborate pit blind I've ever seen is a manufactured item. Its round fiberglass shell is watertight. A built-in seat adjusts for height and orbits 360°. It's

Hunters shooting from a pit blind which has a wooden cover camouflaged with grass. Better camouflage is afforded by a wooden frame covered with chicken wire woven with native materials.

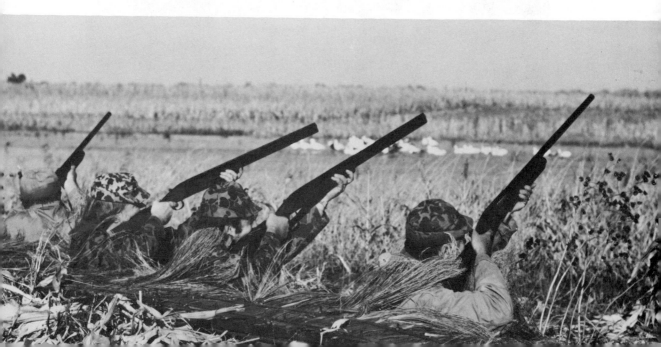

a one-man affair, but it has ample leg room, good footing, and a backrest in all positions. Other features include an under-seat heater, a 10-foot circular shelf, and a gun rest. It's manufactured by Smitty's Duck Blinds of Richmond, California.

Regardless of the type of pit you construct, it's necessary that the "hole dirt" be completely camouflaged or hauled away. The shooting area must appear exactly as it was before you began changing it. The easiest answer is to spread the freshly

One-man pit blind of molded fiberglass, cut away here for photo, is watertight, has built-in seat and heater.

dug dirt around the pit area and cover it with readily available stubble, straw, or grass. If the field is bare of native growth, you'll have to move the telltale earth from the area. This operation can be quite a job.

One time in Saskatchewan my partner and I located a huge flock of speckle-belly geese working a field that had been plowed. What they were eating off that almost-bare ground is beyond me, but they obviously loved their fare. We figured on digging a pit and spreading the ground around the hole. That was the hardest ground I've ever tried digging, but the work was a small problem compared to what we discovered next. The dark dirt progressed down only a foot; then it began changing to ever-lighter colors. Spreading that light-colored ground around our pit would have been an obvious error. We wound up by hauling the dirt to our station wagon in boxes, then driving to a distant swale and dumping it.

The next day's hunt proved worth the effort. We shot our limits of geese with no problems. The following day we killed some more birds, but most of the flock members were wise to us. After that morning's hunt we reboxed our dirt and dumped it back in the pit. The daylight operation wasn't nearly as time-consuming as was the original digging project that we had carried out during dark hours of night.

There are two times to dig a pit: at night and at midday. Don't ever disturb geese during their early-morning and late-afternoon feeding hours. If they witness any human activity on their feeding ground they'll abandon it. And there's always the chance that a few less-wary birds will get hungry at any time of the day. The best practice is to do your pit work at night when there is no chance that the birds can discover your operations.

There are several factors to consider in deciding where a pit should be dug. I've mentioned that it should be on high ground, but it shouldn't be near trees, high shrubs, high banks, shelter belts, and so forth. Geese don't like to decoy against obstructions that block their vision or interfere with their approach patterns. Keep your blinds as far out in open fields as possible.

You should also recognize that geese, particularly Canada honkers, work a feeding field with a system. On the first day they use a field, they'll start in the middle and feed upwind. The birds are very thorough. They'll clean up all the food in the area they're working. When they return the next day they'll begin feeding where they left off. The point to remember is not to dig a pit in an area where the birds have already used up the food. They won't decoy to such a place because they

know it contains nothing to eat. Scout your field till you find the most food closest to the freshest goose droppings. Assuming that all conditions are equal, that is the place to dig your pit.

Though there is a lot of work in pit hunting, it does have several decided advantages over open-water gunning. Perhaps the most important is that you don't have to be concerned with which direction the wind is blowing. When working from a pit in a wide-open field, you can place your decoys at any point of the compass. In other words, you can place your spread exactly where it should be regardless of wind direction. You don't have to bother with boats and their problems. Cripples have almost no chance of escaping, since they can be run down on bare ground. Further, you can usually drive your vehicle in fall fields. That means you can transport all your gear to the shooting site, drive your car to a hiding spot, and walk back empty-handed.

Though we've talked so far about pits, they're not the only types of blinds from which geese are killed. In some areas it's foolish to dig pits because they're not required. The fastest goose shooting I've ever experienced was done from a blind that took about five minutes to construct.

The trip found me in North Dakota where a fence line crossed a huge field. Fences, in flat country, often make fine blinds because they collect windblown tumbleweeds and all types of dead grasses. Native growth of such items as brush, shrubs, and weeds usually are not plowed under in areas immediately adjacent to fences. In effect you have a narrow strip of natural blind materials running the entire length of fence lines. This was the type of setup my partners and I found. We simply made nestlike holes in the available cover and enjoyed a fine shoot. Such blinds are perfect because they make no change in terrain the birds are used to.

One word of caution about using fence-line blinds. Geese are so cautious that they'll never willingly fly down a fence line when cruising at low altitude. They'll always cross over it at right angles. This means that you won't have much success with a fence-line blind if it's running downwind. Find a suitably covered fence with the wind blowing across it. Many novices think that the corner where two fences join at right angles will make a perfect blind site since two sides of the hide are already in place. Forget that thought, because geese shy from such spots.

Other types of above-ground blinds will fill the bill in places where it is impossible to dig a pit. Low river bars and rocky or frozen grounds are examples of such places. Driftwood blinds are best on river bars. They should be constructed on the

North Dakota goose hunters use fencerow thickets for ready-made blind. From the standpoint of camouflage, natural terrain makes the best blinds.

upstream ends of islands, since those are spots where driftwood naturally collects. If you are in rocky country, pile rocks in a semicircle, but make your blind just large enough to crouch behind. Never build a goose blind any larger than is necessary to provide adequate concealment.

Keep in mind that the various types of blinds I've described in the duck-shooting chapters can be used for goose hunting. The key rule to follow is that all successful above-ground waterfowling blinds are constructed of materials that will blend in with surrounding terrain.

Decoys

Attention to detail when placing goose decoys is all-important. Experts always spread their decoys upwind from the blind, not downwind as is the rule in duck hunting. This technique offers two big advantages. First, when the shooting starts, you're not shooting at head-on targets. Since the birds normally glide to the decoys from a downwind position they will come sailing in over your head. This means you'll be shooting straight up and driving your shot into the vulnerable undersides

of the birds. Second, after the gunning starts, geese will always drift back with the wind a bit before climbing, so they are in range longer than if the guns were up-wind of the decoys.

Most veterans rig two flocks of decoys. The main flock consists of both feeding and sentry birds. The second, and smaller, flock is composed of decoys with straight-up heads. They represent newly arrived birds walking rapidly to the food bonanza.

The sentry decoys in the main flock also have straight-up heads. They are placed on the perimeter of the group, since that is where live bird sentries would be posted. Decoys inside the flock should be in feeding positions. All decoys in the large flock are set facing into the wind, as live geese are always ready to explode into the air. Be certain that you place feeder decoys where there is food. Don't bunch the blocks close together. Four dozen decoys spaced 8 feet apart will create almost as much flock appearance as eight dozen spaced 4 feet apart.

How many decoys should you use? It's hard to realize that it's almost impossible to use too many. Here's how one of the best goose hunters I know explained it:

"If we're going to hunt for only an hour or so before work we'll rig about five dozen, but if we're planning on staying out most of the morning, we put out all of our decoys. That's 180 Canada, snow, and blue goose blocks. They're all

Hunters set Canada and snow-goose decoys in pre-dawn darkness. Decoys on edge of flock simulate sentry birds with erect heads; decoys within the flock are set in feeding position.

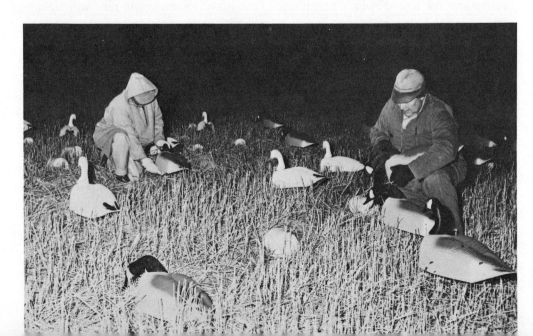

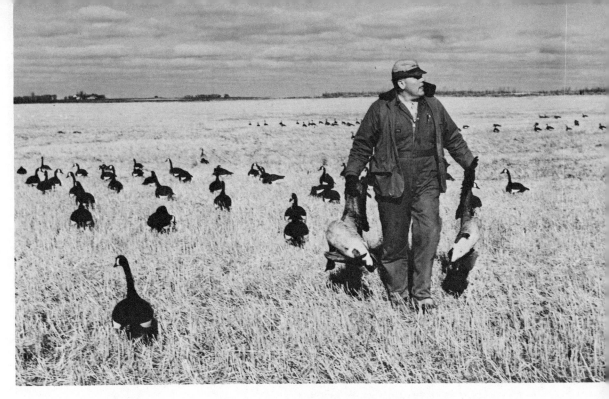

You can never have too many decoys. Hunter carries two honkers from a field covered with huge spreads.

full-bodied. Lots of times we'll also add dozens of white bleach bottles and white paper bags to our spread. That sounds like a lot of work, but the more decoys you use the more shooting you'll get. At times I've hunted with groups using over 300 blocks, and I've seen several spreads of 500 or more."

White bleach bottles and white paper sacks? They are used to simulate feeding snow geese, and they do a fine job when mixed with full-bodied decoys. Large bleach bottles will usually stay put where placed, but paper sacks have to be anchored. The trick is to put a clump of dirt (for ballast) into a blown-up sack, then twist its neck. Incidentally, the paper sacks—get them at your local bakery—are re-flattened after the hunt is over. You can carry one hundred or more of them in your pockets.

Down in Missouri I once hunted over decoys that were even simpler and easier to handle and carry than paper sacks. My hosts ripped old bed sheets into 2-foot squares and hung them on cornstalks and sticks. When a few hundred of the rags are placed, they look like snow geese scattered all over. Those hunters don't use

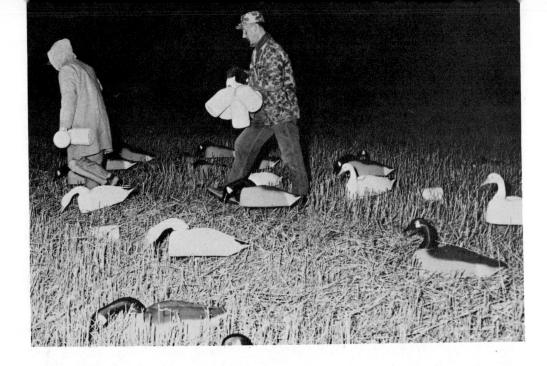

When mixed with full-bodied decoys, white bleach bottles serve as excellent imitations of feeding snow geese.

Squares of white bedsheets tied to sticks simulate a flock of snow geese. Hunters dress in white and lie in the middle of spread.

any kind of blind. They dress in white painter's clothes and stretch out on their backs in the midst of the rig. The system doesn't fool smart geese, but when there are thousands of birds in an area there are always enough dumb ones to provide great shooting.

The best field decoys—from a realism standpoint—are those that conform to the true shape of a live bird. The problem with most such decoys, besides their being quite expensive, is that it's difficult to transport any number of them. There's one way to lick the expense problem—make your own. One company claims that you can make a full-bodied goose decoy for approximately $3.50 with its mold-and-bake kits. They're solid polystyrene plastic, and they're molded without special tools. When the baking job is finished it's up to you to add a realistic paint finish.

The best answer to the transportation problem is to purchase shell-type field decoys with removable any-position heads. Such decoys weigh less than a pound each. The bottom of the bodies is open so that they can be stacked to form a light,

Two Canada goose mounts make realistic field decoys.

Mounted blue goose is the ultimate in realism. Few hunters go to the extreme of using mounted birds for decoys.

This silhouette goose decoy takes on partial full-body dimensions with use of special spreader bar. Dozens of these decoys can be stacked and carried flat, then enlarged at hunt site.

compact bundle. One man can carry a couple of dozen of these decoys over rough terrain without any problem. Several manufacturers produce these decoys.

Most experienced hunters lean toward Canada goose decoys as far as species is concerned. These geese are widespread across the country, they're the smartest members of the goose clan, and they're also the largest. A flock of Canada geese on the ground represents the best sign of safety to all species of geese. But if you're hunting in snow goose country, your rig should contain plenty of white decoys or simulated decoys. White objects can be seen from great distances on fall fields, and they're top calling cards.

Goose-Gunning Technique

This is as good a place as any to mention that hunter movement will flare more geese than poor blinds or poor decoys. Goose hunting is so exciting that many beginners can't resist the urge to move and watch incoming flocks. A turning face is a sure signal of danger. You can camouflage most of your body by wearing clothes that blend with your hunting terrain—an all-important rule—but many hunters forget that an up-turned face is bound to be in direct contrast with native surroundings. Some serious goose hunters won't shave for several days before a hunt. Others use facial grease paint to cut down on unnatural reflections. Some wear camouflage face masks. All observe the rule that you must be absolutely motionless while birds are working approach patterns.

I go by the advice I received many years ago from an old-timer. "No blind is perfect," he said. "If it was you couldn't see through it. If you can see the geese there's always a chance that they can see you. The only way to beat the odds is don't move a muscle. You don't have to watch those birds circle. If they're going to decoy they'll come in straight upwind. Position yourself so that your field of view covers their approach zone, then hold tight."

Of course it's often necessary to move when geese are first spotted in the distance. The rule to follow is to move s-l-o-w-l-y. A gradual change of position is much less noticeable than a quick shifting of the body. And when you do move, place your gun in a "ready" position. Many geese are spooked, after they start in, by needless gun movement.

When hunting in a group it's necessary that all members are alerted as soon as

possible to the presence of approaching flocks. Experts use the "clock-face system". It's a simple system based on the premise that your blind represents the center of a clock face. Suppose that your blind is facing north. Then twelve o'clock would be straight north. If your blind faces east then that direction would be twelve o'clock. Regardless of how your blind may be located, a few quick words of discovery by any partner will alert the group as to where the incoming flock is. Words such as "Flock at nine o'clock" inform you that the birds are to the left of the blind. Twelve-o'clock birds would be straight out in front. Two-o'clock geese would be off the right-center of the blind.

Goose Calls. A goose call is of great advantage in field shooting. Calling geese is far easier than calling ducks because proper sound reproduction is much more easily attained. Also, there are fewer calls to know and the call should be used much less frequently. I won't go into the mechanics of calling here since I covered the subject in Chapter 6.

In most parts of the country it's a good idea to use two goose calls. Snow and blue geese call with a high-pitched yelp, while the voice of the Canada goose is a lower, more guttural tone. Although most geese do a lot of calling in flight, they're much quieter when feeding. Amateurs assume geese are noisy all the time, so they greatly overdo their calling. Don't make this mistake. Use your call frequently to attract flying birds, then space out your "ha-onks" to a few every minute. The birds have already accepted your decoys; a lot of calling at this point will make them mistrustful. A live goose on the ground spends most of his time eating, not talking.

When to Shoot. The goose-hunting decision that separates men from boys is the determination of the proper time to shoot. Geese are so large that inexperienced gunners almost invariably fail to estimate ranges properly. A Canada goose 100 yards away will look as large as a corn-fed mallard at point-blank range. It's human instinct to insist that large flying objects are both close to us and moving slowly. I once observed this phenomenon at the Denver International Airport while returning home from a hunt in Montana.

I was sitting in the observation tower idly watching various types of commercial aircraft take off and land. Jets were taking off on one strip, and the big planes seemed to be moving slowly as they lifted off the ground. After a while the wind

This is the heart-stopping view a pit hunter gets when Canada geese are working perfectly to his decoys.

direction changed slightly and small private aircraft began using a strip adjacent to the runway used by the jets. The first single-engine light plane that moved down the runway seemed to jump into the air, apparently moving swifter than the jets. Minutes later I was watching another small plane make its takeoff run when a large jet zipped past on the adjacent runway. Now the small plane appeared as though it was barely moving.

Several times I've watched mixed ducks and geese take off from the same area. It seems hard to accept that the apparently slow-moving geese put distance behind them just as rapidly as ducks. What's harder to accept is that the geese always appear much closer than the ducks, although all the birds are actually the same distance away. What all this means is that nothing except close observation will prevent a hunter from believing that a goose 100 yards away is closer than a teal at 50 yards.

There are several ways to lick range-estimation problems. One is to place a lone decoy 40 yards downwind from your blind. When incoming birds pass over the decoy they are well within shotgun range.

The basic thing wrong with that system is that geese don't always approach down the ideal flight lane. Some flocks will circle over the decoys, perhaps crossing closest to the blind at any point on the compass. In this case something about the goose itself has to be your clue as to how far away he is. From my experience a better guide than size is feather markings. When colors no longer blend, when I can pick out distinct feather markings, I know my goose is close enough to shoot at. Another good trick—on Canada geese—is to concentrate on looking at the head of the bird. When the bill can be distinguished from the head the big bruiser is well within range. The gleam of an eye, on any species of goose, is another telltale sign. When any goose is close enough to actually distinguish his eye, it's time to start shooting. If your distance vision is unusually poor—or unusually good—these rules may not work, of course.

Where to Shoot. Hitting your target when you do shoot takes knowledge too. Most misses with the first shot result from geese observing the gunner swinging to a shooting position. The birds then have time to change flight paths before shot patterns reach them. The way to lick this problem, as I mentioned before, is to move your gun into a "ready" position long before the birds are in range.

Even so, geese will sometimes spook at the last second. The man who knows how they will react knows what type of shooting opportunity will be presented. Nine times out of ten a goose will tack for a split second downwind before climbing. If your first shot is at an unalerted bird, you naturally should shoot in front of him, but accept it as fixed fact that every shot in goose hunting after the first barrel must be aimed high. The safest thing a scared goose can do is climb, and he always does. Most misses are due to shooting under birds that are rising into the wind. Depending on distance and wind velocity, you'll have to shoot from one to five feet above and in front of your target.

Except for the above thoughts, hitting geese is no more difficult than hitting any other wingshooting target. I'll discuss all of the proper techniques in Chapter 22.

What to Shoot. There isn't much leeway in the determination of the best gun and shot combinations for goose hunting. The birds are big, hardy, and difficult to bring down. I think it's a crime to undergun yourself when hunting these trophy birds. I've killed geese stone dead with a 20-gauge gun loaded with high-base No. 6 shot, but only because they happened to be chance targets while I was duck

hunting. On those occasions I waited till the birds approached almost point-blank range before I pulled the trigger. I've passed up many opportunities when I certainly would have fired if I'd been armed with the proper goose-killing gun and loads.

There are three factors to consider. The more shot pellets that hit a flying bird, the more likely he is to crumple. The heavier the shot pellets—and faster they're traveling—the deeper the penetration and consequently the better the killing power. Third, a tightly choked gun will put more shot pellets on target. Add it all up and the logical goose gun is heavy-bore, full-choked, and capable of handling high-base or magnum loads.

That statement could start an argument with light-gun buffs. I'll just say that I'm one of the group when it comes to any shotgunning except goose hunting. For such birds as quail, doves, and ruffed grouse I shoot an over-under 20-gauge primed with field loads. But it doesn't take much shocking power to drop those targets, and a light gun is faster on the swing and a pleasure to carry all day. None of those conditions exist in goose hunting. In a pit a heavy gun is no burden. Goose hunters have to dress warmly; the kick produced by high-power loads isn't objectionable when absorbed through layers of clothing. And a fast swing is seldom required. As in all decoying work, you are usually aware of incoming birds long before they are in shooting range.

My goose guns are 12-gauge weapons. Both are over-under Winchester which I load with high-base No. 2 shot.

19

Field Shooting without Decoys

This increasingly popular type of gunning is practiced mostly by two types of hunters—the stalker and the strategist. Both types must possess the goose-locating knowledge discussed in the previous chapter. But it's important to know that any flock of geese on the ground represents potential targets to the stalker. Hunters working from blinds must find flocks large enough to justify the work of digging pits and placing decoy spreads. They seldom bother with fields showing less than several hundred birds. In contrast, the stalker may get as much shooting from sneaking up on a pair of geese as he would by stalking a thousand.

The odds on success are much higher with small flocks too. The larger the flock, the tougher the job. Stalking a large group of feeding birds is extremely difficult. The more birds in the flock, the more wary eyes that are looking for the first suspicion of danger.

The stalker has several advantages over the hunter working from a blind. Of most importance is the fact that there are many more small flocks of geese than large flocks. There's simply more opportunity to get shooting. And the stalker often is trying to outwit less-wary birds. Generally, a migrating goose doesn't come down to a field until he is tired and hungry. His mind is absorbed with resting and finding something to eat before continuing his journey. Most shooting from blinds is done in areas where large flocks build up in traditional stopover points year after

year. Once they reach these points they stay long enough to feed heavily and become extremely safety-conscious. That type of wariness is often lacking during the quick rest stops they make en route.

Though I mentioned an important principle in the last chapter I want to repeat it, since it applies to the stalker as well as the hunter using blinds. Always remember that the big birds have a habit of feeding and resting in the same general areas year after year. The smart stalker doesn't scout aimlessly. He limits his spotting to potential goose-feeding areas. My local situation should illustrate the general rule.

Eight miles north of my home there are several adjoining 80-acre farms. The fields of these farms are gently rolling hills edged with woodlands. They draw geese regularly every fall. Though there are many similar fields between my home and the hot spot I've seldom seen geese in them.

Six miles east of that shooting area is another group of fields making up several hundred acres of flat lands. Geese like that place. My third hot spot is sixteen miles southeast of the flats. Though those three areas consist of less than 1 percent of the available fields in the county, they consistently attract at least 50 percent of the migrating geese that stop to rest and feed.

Much of my spotting work is eliminated because I'm aware of that pattern. When the flights are on I drive from one area to the next until I find geese. I'll check each area thoroughly with binoculars for birds on the ground. This technique is extremely important, since grounded geese aren't always easy to see. There are many sections of those fields that are hidden from view when I'm driving on roads. I have to stop and climb hills before I can check out each entire area.

Many times, of course, I won't discover any feeding birds. Then I'll drive from one hot spot to another and focus most of my attention on the skies. I'll be looking for flying flocks that exhibit intentions of landing. Such flocks will be flying low, and they'll be seemingly disorganized while checking out potential landing areas. I may have to use my car and binoculars to keep them in sight. But if they eventually alight my stalk is ready to begin. This is the precise point where most amateurs are almost always doomed to failure because they don't have the specialized knowledge required to make a successful stalk.

First and foremost, a stalking route must be carefully planned. There is always one best route to take, one route that will offer the best combinations of existing cover. The best route is seldom the easiest. My rule is to drive my car along farm roads surrounding the area where the birds are feeding. I look for ditches, creek

bottoms, brush-grown fences, or other types of cover leading into the general direction of the feeding flock. The best route is usually the one that offers thick cover running close to the birds.

Sometimes you'll have to utilize a combination of cover types. Let's say that the birds are feeding on a sidehill field above a weed-grown fence. The targets are straight north of you but the fence runs east and west along the edge of a plowed field. There's no way you can cross the plowed field without being seen. After studying the situation you note that the fence routes over a knoll a half mile to the west. You also notice that the western end of the plowed field borders a woodlot. The trick is to put all these factors together and come up with a plan.

In this hypothetical case the best bet would be to drive down the road and park at the edge of the woodlot. Then use the trees as cover until your stalk brings you to a position where the knoll is between you and the geese. Use that protecting cover to reach the fence line, then crawl through the weeds till you reach a shooting position.

In effect you had to travel west, north, and east behind three different types of cover before your stalk was successful. Experienced stalkers almost always go through similar phases of planning and execution. Sneaking within shooting range of wild geese requires this type of military strategy. You must assume that if your stalking route allows you to see the geese, there is always the chance that they will see you. If solid cover is available—woods, hills, knolls, barns, ravines, etc.—it should be used.

What if no suitable cover is available? There's a trick I've often used in such situations that works like a charm. I'll show myself at a distance, usually about a quarter of a mile away from the birds. They will flush, but if they are tired and hungry they won't be greatly alarmed. They'll likely fly off a short distance, circle a time or two, then sit down in a spot better suited for a stalk.

Though I've made many goose sneaks alone, stalking is best accomplished by a team of two to four hunters. With a team it's possible to sneak up on the birds from two or more directions. Such a maneuver increases the possibilities of at least one gunner getting some shooting.

The best bet is to have one man make the initial stalk from a direction upwind of the birds. He doesn't try to get too close to the targets, for a couple of reasons. First, geese normally feed into the wind. If the upwind man can get within 100 yards or so of the birds they may feed to within shooting range while his partners

There's always one best way to stalk geese feeding in a field, and it usually involves taking advantage of several terrain factors. In this situation, hunter keeps out of sight by beginning stalk behind cover of high knoll. He stays behind knoll until he gets to brushy creek bottom, follows creek bottom to emergent vegetation around pond, then stays in the vegetation until he gains shooting range. No other stalking route is possible because all other terrain is open farm field.

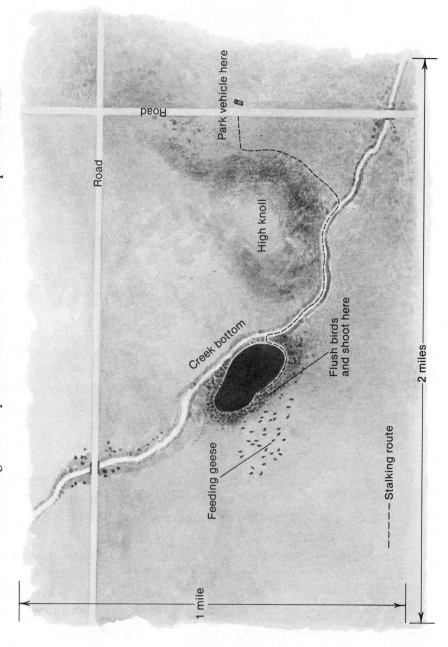

Road

Road

Park vehicle here

High knoll

Creek bottom

Flush birds
and shoot here

Feeding geese

2 miles

1 mile

- - - - - Stalking route

are making their sneak from other directions. Second, geese almost always flush into the wind when they jump. The upwind man will likely get some shooting even if his companions are unsuccessful at sneaking within range. This is why he should be very careful not to flush the birds.

The other members of the team make their stalks from whatever downwind or crosswind directions offer the best cover routes. If terrain conditions are suitable the men should separate and come in on the target zone from several directions. Then, if the birds flush prematurely, somebody is almost bound to get a shot. Keep in mind that in this type of operation nobody knows exactly where his partners will be located when the birds jump. To avoid accidents, no shots should be fired until the geese are clearly above ground cover.

If all goes well, it's a good rule to temporarily stop stalking as soon as you are within reasonable shooting range of the birds. Now's the time to catch your breath, rest a moment, and move your gun to a "ready" position. When you're prepared to fire, continue your sneak. The closer you get, the better the odds on picking your targets and the more time you'll have to accurately place your shots.

Unsuccessful sneaks usually result from lack of attention to details of clothing and stealth. A goose that is being stalked will seldom flush because of unnatural sounds. If he pops too early, it's almost always because he has seen you. The two most common contributing factors to this calamity are improperly colored clothes and fast movements.

A camouflage suit is a top bet if you're sneaking through brushy thickets, but it will stand out boldly if you're stalking through a field of golden cornstalks. It would be just as contrasting if you were crawling through snow and high grasses. Suffice it to say that the color of your clothing should closely match the color of the terrain. Some of the best stalkers I know carry several sets of outer clothing in their cars. Standard brown hunting coats and pants will match many terrain conditions. White painter's suits are great if there's snow cover. Be careful not to display out-of-place colors like the red tops of wool socks. Keep your face down or shielded as much as possible.

Quick movements are especially to be avoided. Never run ahead unless you're completely shielded by solid cover. I've seen expert stalkers move successfully over a few yards of bare ground separating patches of cover. They were successful because they inched forward so slowly that movement was almost imperceptible. The slower your movement the less likely it is to be noticed.

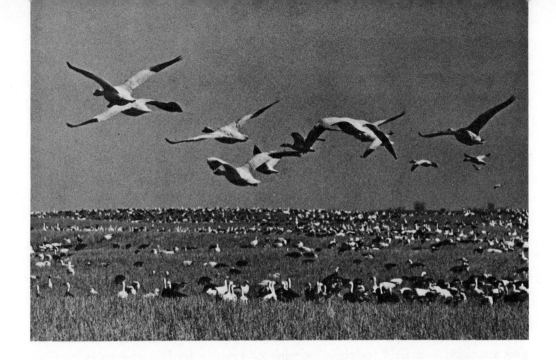

Snows and blues converge on stubblefield. Waste grain is prime attraction.

The stalker who goes home with geese is going to spend a lot of time crawling on his hands and knees and worming ahead on his stomach. That means your legs, arms, hands, and knees are going to take a beating, especially when the ground is frozen. In this game, reinforced pants and jackets or coats are worth every cent of their extra cost. Pants should be cuffless or worn inside boots to prevent snagging on roots, rock, and so forth. The wrist sections of coats or jackets should fit snugly—elastic wrist bands are best—to keep out dirt and snow. Waterproof clothing is a necessity when the ground is wet.

Everything I've said so far in this chapter involves stalking geese you've seen feeding in a specific place. There's another type of sneaking that compares with jumping ducks in potholes. In this case you're stalking a known spot where you hope birds will be resting. Such places are usually secluded potholes, river sandbars, or swamps.

Migrating geese aren't always flying or feeding. They'll often drop down on small waters to rest. Again, they have the habit of selecting the same general areas year after year. Resident flocks of Canada geese do the same thing. Though a resident flock may have scores of potholes to choose from, they'll select a half-dozen or so as choice sanctuaries. Expert goose hunters know these facts and they

know which specific areas are likely to produce the action. They become familiar with these areas, discover the best stalking routes, and hunt them at the proper times.

The proper time is generally during midday. During early mornings and late afternoons the big birds are out in feeding fields stuffing their crops.

Sudden changes in stormy weather will often put migrating geese down in these hot spots. Normally they like to move from north to south with a tailwind. I hope for a strong storm front from the south when the flight is on in my area. When that happens I can be fairly sure that I'll find geese in potholes where I've found them at other times. They'll be sitting out weather conditions they don't want to fight in the air.

The second type of gunner who bags plenty of geese without the use of decoys is the strategist. He doesn't stalk at all. He attempts to figure where the birds are going to land in a field for their morning or evening feeding and hides close to that exact spot before the targets arrive. If his calculations are correct he'll get shooting opportunities at geese gliding over his head at close range.

The system works best with resident flocks and the holdover migrant birds that stay in one area for a relatively long period of time. These are the birds that work established feeding fields day after day. The strategist's success is hinged to the same condition that provides bonanza days for hunters in blinds. There will be shooting only if the birds return to the same field they have been working.

Both types of gunners rely on the spotting methods I described in the previous chapter. After a field is selected the strategist uses several techniques to select a shooting site. His system is based on the knowledge that geese will work a field in much the same manner as a mechanical harvester—in other words, they will begin feeding in one section and work progressively forward. Where they quit feeding today they'll begin tomorrow. The strategist plans on lying in ambush as close to that spot as possible. He can determine the right location even if he has never personally seen the geese that are working the field. He'll walk about in the field until he finds the location of the freshest tracks or goose droppings.

It's unlikely that the ambush spot can be located within shooting range of where the birds will feed. A shallow pit is sometimes the answer, but most gunners of this type don't bother with the effort. They try to use natural cover located directly under the approach-pattern flyway the birds will use. The key to success is in knowing how to find the best gunning position.

Geese normally approach a landing site by gliding into the wind. The knowing hunter realizes that his ambush spot should be downwind from the feeding area and as close as possible to the probable landing spot. (The closer the hunter is to where the birds want to land, the shorter the shooting distance.) If the geese finished their previous day's feeding on high ground, they'll likely plan on landing in the same spot. If they left feed in a low spot or on a sidehill they'll usually land on a better vantage point and plan on walking to the dinner table. They prefer landing on a high area in a field so they'll be in a good position to stand and inspect their surroundings before deciding all is well. In such cases the gunner should assume that the birds will plan landings on the best lookout spot within 100 yards of the feeding area.

The closer flying geese get to the ground the more particular they become about gliding over potential trouble spots. They especially prefer not to fly close to buildings, over high trees, down fence lines, or over high hills. In effect they'll take the most wide-open, generally upwind, route available. The successful strategist must study all terrain factors and determine which low-level approach route his intended targets will most likely select.

After the probable route is determined, the hunter then finds a hiding spot. This is one of the situations in goose hunting where a perfect blind isn't required. Since the birds will be coming in low toward the hunter from a downwind direction, he need not be completely hidden on his upwind side. Most such shooting also occurs in the dim light of early morning, at a time when it's difficult for the birds to distinguish the imperfections of hastily built blinds. Just about any cover made of natural materials breaking the hunter's outline will do the job.

Sometimes no blind at all will be sufficient. I recall one rainy morning when I was hunting in a stubble field. There was no natural cover available near the center of the field where the birds had been feeding. I simply stretched out in the mud below the top of a knoll and spread a few hastily gathered handfuls of straw over my body. But because the light was bad and I was flat on the ground, the incoming geese never noticed me until it was far too late. About twenty honkers seemed to be trying to land in my lap when I snapped to a sitting position and began shooting.

One of the intriguing things about the strategist's hunting system is that the whole show is often over in very short order, especially in those cases where only one small flock is working a field. The gunner simply walks to his selected shooting

site before dawn, hides himself, and waits for the birds that will be coming soon after first light. If shooting develops, it's all over in a hurry. The game is made to order for the man who wants to hunt before going to work. If I plan a longer hunt I often rely on the strategist's system first, then switch to stalking techniques in other fields.

There's another popular way of scoring on geese that doesn't involve the use of blinds, decoys, or calls. A lot of hunters refer to it as the "firing-line" method. Actually it's pass shooting at geese leaving or returning to resting areas. Most shooting opportunities require little skill. You simply position yourself near the perimeter of a resting site and hope geese will fly over you within shooting range while they're leaving or returning from feeding forays. This kind of shooting is usually either a complete flop or a tremendous success.

One expert summed it up well when he said to me, "If you pick the right hiding spot you'll have flocks of geese pouring over your head. No more is involved than guessing which flight paths the birds will use. If you're under one of those flight paths you're going to get shooting, assuming that the geese will be low enough to shoot at."

This type of shooting is practiced mostly near the big refuges and sanctuaries that hold thousands of geese. The "firing-line" description evolved in these places since hunters practically line up in ditches or behind fence lines bordering open-hunting zones. It isn't quality hunting for several reasons. Mostly, too much competition breeds poor sportsmanship. Once in South Dakota I witnessed three hunters practically fighting over a goose that dropped out of a flock. Each of the three men claimed that he had killed the bird. Such hunting also promotes long-range shooting, which in turn produces many lost cripples. The main reason I don't like the game is that it doesn't require outwitting the target. I also dislike hunting or fishing in crowds.

However, pass-shooting opportunities at geese certainly aren't limited to the large refuge areas. Any water area (usually a large lake or river) that the birds use as a roosting area has pass-shooting potential around its edges. Since most geese feed in fields, they have to fly out from and back into home base. During those flights they can be vulnerable.

The best bet is to locate as close as possible to a roosting area, since those are the places where the birds will be flying closest to the ground. Hope for rough and stormy weather on the day you hunt. Geese fly lower on nasty days. And they'll

normally fly out of a roosting area over certain selected routes. They like to ride with the wind after takeoff, so it's a good idea to locate on the downwind side of a roosting area at dawn. When flights return they'll approach into the wind. That means you'll have to reverse your position.

These rules are starting points because a lot depends on the terrain surrounding a roosting area. Some flocks of resident geese I've studied will almost always use the same flight routes out of their roosting lakes. It seems that they refuse to fly over high hills or along roads. They want to go out over open country regardless of wind directions. The best system is to spend several scouting sessions determining the flight patterns used by geese leaving and returning to a roost. Then pick the best hiding spot under a flyway and hunt it on stormy days. Successful pass shooters take time to hide themselves adequately. Geese are always alert when they're flying low. They're quick to spot a suspicious object or any type of movement.

There is one other type of field hunting without decoys that should be mentioned, although it isn't practiced much anymore except on the Hatteras and Ocracoke banks in North Carolina. I think the system could work most anywhere in smooth, level fields, flats, or sandbars. It involves a rolling blind that is built on wheels. The main part of the blind is a framework that is covered with materials native to the area.

The object is to place the blind in an area geese are using and leave it there several days until the birds get used to it and realize that it doesn't offer danger. On the day of the hunt the gunner gets into the blind before dawn and waits for the geese to arrive. Then, slowly, foot by foot, he wheels the blind by pushing until he is within shooting range.

20

Brant Hunting

The big bonus in modern brant hunting is a long season. Brant gunners on the West Coast usually enjoy longer seasons and larger bag limits than duck hunters. Of most importance, brant are often legal targets after other waterfowl seasons have closed. Hunting them is not difficult, but it is a special game of its own that requires specific techniques.

Let's talk about American brant, or Atlantic Coast shooting, first. When this was being written gunning brant along the Atlantic Coast was only a memory. Few waterfowl species ever suffered the setbacks that plagued these birds during the 1970s. In 1971, gunners along the coast took 79,100 brant, nearly double the average annual harvest. Then for reasons still not understood, the birds produced virtually no young on their breeding grounds in the northeastern Arctic lands and on the coast of Greenland.

In 1972 the wintering population totaled only 41,900 brant, down from the 151,000 birds counted in 1970. The gunning season was closed. By 1975 the total wintering population had recovered to 127,000 and gunning was resumed. Then the birds found misfortune again and their numbers dropped to 43,554 by 1978.

"Brant are a boom-and-bust kind of critter," said Warren Blandin, a U.S. Fish and Wildlife Service biologist. "Last winter, 1980, we counted 69,242 brant. The cycle seems to be on the upswing again. If brant populations reach 100,000 this

winter—and that's a strong possibility—we'll probably reopen the season again in 1981."

With such fluctuations in the numbers of these sporting birds, it's anybody's guess whether or not you'll be able to hunt brant along the Atlantic Coast during the year you happen to be reading this book. In any event, here's the way the sport goes.

The best shooting is found in New Jersey from Atlantic City to Cape May. If you want to learn the sport from the observation of experts, go to the tidal bays in that area during late November or early December.

The first rule in brant hunting is to watch the tide. Always put your boat in and go out when the tide is at least half up or half down. At low tide many of the creeks and access ditches lack water. At such times, of course, you can't run your boat out to the bays where the birds are.

The secret of great gunning is simple. Watch daily flights to determine where the birds are going, what time they go there, and what routes they travel. The object is to intercept them with decoys near their feeding area or along their travel routes. Brant will fly definite patterns coinciding with fluctuations of tide. Their favorite food is eelgrass, and they can reach this food best at low tide.

Inexperienced gunners make the mistake of not realizing that brant are stubborn in their habits. They'll readily come to decoys, but only if your decoys are located in a precise spot. In other words, the birds don't like to vary their flight paths. The answer, when your spread isn't working, is to move and keep moving your decoys to different locations in the same general area. A move of only a few hundred yards often means the difference between great shooting and no shooting at all.

Don't worry much about blinds. Brant will often stool to open boats showing no concealment whatever as long as you remain motionless. Some gunners do no more than drape their boats with camouflage netting, burlap, or scattered reeds woven in chicken wire. It isn't so much a question of how good the blind is, but where it's located. Once you get your decoys in the right place it's sometimes necessary to relocate your blind in relation to the spread. In this case, a move of 20 yards or so may be all that's necessary. Normally brant will circle downwind, drop low to the water, then bore straight to the decoys. Most experts initially place their boat blind slightly downwind from the decoys and see how the birds work. If they shy off, the boat is moved in upwind directions until the best combination is found.

Some veterans prefer to gun from a crosswind position, since they'll be shooting at the sides of birds instead of the head-on targets presented when working from an upwind position. The theory here is that brant are big, hardy, heavy-feathered birds, and that they are much more vulnerable to side shots than head-on shots. In any event, the proper brant gun is full-choked, and it should be loaded with high-brass No. 4 shot.

Where you hunt brant depends more on time of day than weather conditions. Again, they have daily timetables that are tied in directly with tide conditions. They feed in shallow bays on an ebbing tide. During high tides they go to inlets searching for sand and gravel to help digest their food, then to resting areas where they wait for the next low tide. As soon as it begins they head back for the feeding areas. They follow these schedules regardless of whether the weather is balmy or stormy. These are the reasons why scouting for the birds' preferred areas is all-important. Once you establish where brant want to be, and when they want to be there, you're well on your way to a great shoot. You don't have to hope brant will fly; you know they'll fly and you know which routes they will use.

The best decoying trick is to locate your blocks out from a point of land so that they'll show against a water background. Brant decoys are basically dark, and if they are spread against a dark-mud bank they'll be hard to spot by passing birds. Some hunters help lick the problem by taking advantage of the fact that the tail coverts of brant are white. They overemphasize this white area when painting their decoys. The enlarged white area is definitely an attention-catcher to passing birds.

Brant decoys require heavier anchor weights than duck decoys, since they are larger and subject to pulling pressures of tides as well as winds. Many hunters multiple-rig their decoys to anchor lines bottomed with a small coffee can filled with concrete. Be sure to run a loop of heavy copper wire through the can before you fill it with the concrete. The wire loop (copper won't rust) serves as a handle and a terminal for decoy lines. Heavy-test lines are necessary to withstand the extra pressures of tides and winds.

Brant decoys are often difficult to purchase, because the best shooting areas are limited. A few mail-order houses and sporting-goods stores (in the hot-spot shooting areas) handle good decoys, but there is a simple way to lick the problem. Buy standard-size goose decoys and repaint them to represent brant. A fortunate thing about brant hunting is that you don't need nearly as big a spread of decoys as you do for goose hunting. A spread of eighteen decoys will pull plenty of birds.

Killing brant can be quite easy if you pick your shots. Like decoying diving ducks, brant tend to bunch up when they flare across decoys. If you hold fire till the "bunching" situation is presented, you can often drop two birds with one shot. But don't flock-shoot on purpose, since it's the easiest way to score zero. Always pick a single target and concentrate on hitting that one bird. If you shoot at the right moment another brant or two may well be within your shot pattern.

Boating safety is a watchword in this game, since you're working with ocean water. On some days the brant bays aren't safe for any boat, but it's common sense to use a boat big enough to handle at least average weather conditions. Some gunners claim that no boat under 16 feet long and equipped with less than a 10-horsepower motor should be used in brant hunting. Sportsmen working from shore blinds can sometimes get away with smaller craft, but it makes no sense at all to push your luck. These same experts claim that they wouldn't think of going out on the bays without a spare motor in their boat. The most important thing is to keep an eye open for sudden changes in weather.

Unlike its eastern counterpart, the black brant of the Pacific Coast prefers to fly in V-shaped formations. Some gunners claim they use the same formation for feeding, and that smart hunters place their decoys in V-spreads.

As I mentioned earlier, a big bonus in brant hunting involves legal shooting after all other waterfowl seasons are closed. This is particularly true with black brant. Open seasons on these birds usually run until late February in California, Oregon, and Washington. In any event the peak of the brant shooting comes after the best gunning is finished with other waterfowl species.

Some years ago many Pacific Coast gunners sneaked into flocks of brant with sculling boats. Such a boat is a very low-profile craft which is propelled with a sculling oar. The oar is operated by a hunter lying flat on his back. But such boats are dangerous on big water. Most hunters now operate from blinds of various types. Shore blinds still produce occasional good shooting, but the modern trend is toward open water blinds. Some of the simplest are best.

Chest waders and white ponchos are used very successfully by gunners along the southern part of the coast. The trick is to find a shallow-water bar offshore, one that's shallow enough so that a man can stand on it in waders. The white poncho gets into the act in areas harboring white pelicans. The theory is that a hunched-over man draped in white somewhat resembles a pelican, birds that brant are used to seeing in bay areas.

These sportsmen rig decoys from a boat, then step over the gunwales into ebbing tides over wadeable bars. One member of the group then runs the boat to a hiding spot along a nearby shoreline. The gunners remain motionless while brant are approaching, then swing into action when the birds hover over decoys. The same practice is commonly referred to as "body-booting" in other parts of the country where it's employed in duck and goose hunting.

Some coastal areas have channel marker buoys that brant are also used to. Body-booters with ingenuity paint floatable barrels to represent the buoys. They anchor them near their decoy spread and hide behind them when birds approach.

Various areas of the coast have buoys, jetties, small islands and other obstructions that jut above the water's surface. Floating blinds of various types are constructed to resemble these obstructions. Almost any type of blind will work if it appears somewhat natural and it is placed along flyway routes used by the birds.

Miscellaneous
Lore

21

Clothing and Equipment

Duck and goose hunting can be a mighty cold and wet sport. The amateur learns in a hurry that proper types of clothing and personal equipment have a considerable effect upon his comfort and success. Misery in wet clothes was often the lot of the old-time market hunter, but the modern hunter doesn't endure such discomfort if he knows what to wear. And what to wear isn't always predicated by current weather conditions. For a certain type of duck hunting I always wear a two-piece foul-weather suit even if there's not a cloud in the sky. Silly? Not when you're going layout shooting.

Layout boats are usually wet, even on calm days. These boats must be towed to shooting positions. Waves created in traveling splash into the boats and soak their floors. Layout boats have such low outlines that they frequently ship water when gunners are changing positions. You may begin hunting on a calm day, but if a wind comes up you can bet on sharing the cockpit with an occasional splashing wave. Since you're lying prone in a layout boat your entire body must be protected from dampness. Layout hunters may appear to be out of their minds when they pull on foul-weather gear during bright sunny days, but they know exactly what they're doing.

There's always something new to learn in this business of selecting proper clothing. A few years ago I discovered a modern trick that's one of the best from

a comfort standpoint. A guest of mine who is a veteran duck hunter showed up one morning at my boathouse wearing a brilliant yellow snowmobile suit.

"My gosh, Keith," I sputtered, "you can't wear that thing in the blind."

"Sure I can," he answered. "The ducks won't see it. As soon as we're rigged out I'll pull my oversize camouflaged rain gear over this suit. The yellow will be hidden and I'll be warm and comfortable."

There's another item of snowmobiling clothing that's ideal for duck and goose hunters. For my money, the felt-packed boots designed for snowmobilers are the best cold-weather boots you can buy. The time-honored practice of wearing hip boots for most types of waterfowling is absurd. You never step in water when working from many types of diver blinds, and seldom when field hunting. If you don't need hip boots, why wear them? It makes much more sense to wear something that's practical.

The first and foremost rule on clothing is to wear enough warm clothes to keep yourself comfortable during any possible weather conditions. Weather can be extremely changeable during fall months. Days that begin with bright and warm dawns may show snowstorms by afternoon. If you're wearing too many clothes you can always take some off, but if you're wearing too few, and you don't have extras, an otherwise fine hunt can turn into a miserable experience.

Personally, I feel that a few items of traditional duck-hunting clothing are ridiculous selections. The popular canvas shooting coat tops my list for all conditions except jump shooting. To begin with, canvas is stiff; it limits the freedom of movement that is so necessary for efficient shotgunning. Second, most canvas hunting coats are short, offering no protection against wet seats in blinds. Most designs don't provide for hoods, an all-important item for the waterfowler. Third, canvas is about the worst material you could choose when looking for warm clothing. To top it all off, these coats and vests are designed with elastic loops for holding a heavy load of shotgun shells. There just isn't any sense of loading your clothing with unnecessary weight when hunting in blinds. Shells and other items of personal equipment should be stored in a small duffel-type hand bag. (More on such bags later.)

I happen to consider the popular hunting caps to be vastly overrated. A billed cap is necessary to shield your eyes when looking into bright sunlight, but in all other conditions it isn't nearly as practical as the woolen stocking caps usually worn by boys. Waterfowling is often associated with strong winds, and strong winds and

billed caps just don't go together well. If I had a dollar for every time I've seen a duck hunter lose his cap to a gust of wind, I could buy another top-quality shotgun. A man with a soaked cap can become miserable in a hurry.

Stocking caps don't blow away. They're lighter and warmer than most caps with visors, and they eliminate the binding problem of ear flaps. Their only drawback is that they're not waterproof, a problem that seldom develops because a hood is far better protection against wetness than any type of cap.

Most hip boots are of poor design for cold-weather hunting because they fit tight around the feet. When you buy them large enough so that two pairs of wool socks can be worn they become clumsy. Somebody once said, "Why is it that when a manufacturer comes out with a top item he often discontinues it?" That statement certainly holds true with the special-design hip boots that L. L. Bean of Freeport, Maine, sold until a few years ago. Bean's hip boots were designed to be worn over shoes. The knowing duck hunter improvised and wore felt or sheepskin pacs instead of shoes inside these boots. The combination was ideal for comfort and warmth.

It's all-important to keep your feet warm. If you get cold feet you're soon cold all over. About the only advice I can offer is not to wear hip boots unless they're absolutely necessary for such activity as wading through sloughs and potholes. Don't buy the ankle-tight type. They're not only the coldest type of footwear, but they're also dangerous in mud or quicksand because you can't get out of them if you became mired. A similar situation develops if your boat capsizes. It's best to purchase loose-fitting boots with ankle straps and put up with the inconvenience of clumsy walking.

There is one situation for which hip boots are made to order—warm-weather hunting from blinds on rainy days. In this case the clumsiness of the boots is negligible since you're not using them for wading purposes and warmth factors aren't important. I've found that a combination of hip boots and knee-length parka rain gear is ideal for staying dry in a blind. Parkas eliminate the constricting confinement of two-piece rain suits. Parkas—get the zipper type—are also far easier to put on and take off during intermittent showers, and they offer far better access to inside pockets of other garments. The hip boots keep your legs dry, while a knee-length parka is long enough to keep the rest of your body dry even when sitting on the wet seats of blinds.

This is the best outfit if you plan to wade. Belt near top of waders will prevent water from flooding legs if you fall. In rainy weather, the addition of a rain jacket will keep you completely dry.

Aside from the examples I've mentioned, I'm convinced that most clothing items for the waterfowler are of top quality. Let's start with underwear, the long-john type.

All-wool is best for cold-weather hunting, but I can't use it since woolen underwear irritates my skin. I prefer two-piece dual-layer cotton suits, since I can change either or both halves as I choose. These insulated suits were developed during World War II. They offer plenty of warmth, except for the very coldest weather.

Another fine bet is wool mixed with cotton, nylon, Dacron, or silk. This type of underwear is warmer than an all-cotton garment and is favored by hunters who are sensitive to wool.

For socks, wool is again best. Wool absorbs perspiration and has the ability to "breathe." Wear nylon socks underneath the wool if you have sensitive skin. All hunting socks should have thick, cushioned feet. Such socks not only are more comfortable but they offer added protection against cold ground and blind floors. Many hunters make the mistake of buying their socks too short. Short socks have a tendency to work down and bunch on the feet, an exasperating situation when you're wearing boots. Knee-length socks are best for comfort, and for turning down over short boots when field hunting.

I can get all sorts of arguments over my choice of hunting pants. Personally, I don't like many of the pants that are designed for hunters. They don't fit well and they have too many useless giant pockets and other nuisances—that's why they don't fit well. Many of these pants are reinforced with rubber in the knees and seat. Well, I prefer my pants to perform their basic function. I can't see the logic in using them for gear carriers and rain suits. I wear plain trousers of hard-finish, water-repellant fabric. In extreme cold weather woolen pants are best, but most waterfowling is practiced in temperatures where plenty of leg warmth is provided by proper underwear. Hard-faced khaki, poplin, or cotton army duck are pretty hard to beat for pants. These materials shed dew, briars, and branches and remain in fine shape. They also fit well without binding in the seat or chafing in the crotch. Remember to buy hunting pants large enough to fit easily over underwear. If they're too tight they'll bind in the cramped quarters of blinds, or when you're kneeling and crawling during stalking sessions.

There are two important factors to look for in shirts. They should be full-cut and they should be light. Waterfowlers move around a lot; a short-tailed shirt won't stay placed where it belongs. Heavy shirts weigh you down. It's better to wear two light shirts than one heavy one. Two close-weave, lightweight woolen shirts will be warmer than one heavy shirt because of the insulating layer of air between the fabrics. For my first shirt I prefer fine-grade, thickly napped cotton flannel that resembles chamois cloth. Such a shirt is softer and more comfortable than wool, though not quite as warm. Another advantage of wearing two shirts is that if the day warms you can take one off. With a single heavy shirt you're stuck with discomfort.

Some of my thoughts on outer garments may seem strange, but they work out fine for me. I don't like heavy coats because of their weight and bulk. I prefer to get the required warmth qualities from underwear and shirts, then use a rain suit for my outer garment. Good-quality rain gear—light material waterproofed with a coating of neoprene—is tough and long-lasting. It allows much more freedom of movement than a heavy coat. A rain suit is excellent as wind-breaking material, and it's top protection against rain, sleet or snow. Rain suits have hoods with tie cords and adjustable wristbands that keep out wind as well as water. In short, a top-quality rain suit seems to have been designed with the waterfowler in mind. Be sure to buy it large enough to go over all your other clothes so you have freedom of movement. I wear medium-size dress shirts, but I buy my waterfowling rain suits in sizes large and extra large.

I also buy outsized quilted underwear shirts for another oddball reason that I find very practical. These modern down-filled suits are extra warm, are ultralight, and have knit cuffs to hold in body heat. For very cold weather I use the upper part of one of these suits as an extra shirt worn over my other shirts. In effect, I use it as a jacket instead of underwear. There's an excellent reason why I do this. Days

Top-quality rain gear is essential for serious diver hunters. Layout boats usually get wet, even on sunny days.

can become much warmer just as they can become much colder. It's far easier to slip out of my insulated shirt if it's on the outside instead of the inside of my other clothing. The same principle holds true if I enter a warm room or cabin.

If you prefer wearing a coat, buy a long-cut type that incorporates the advantage of keeping your hips warm. A down-filled coat is hard to beat; so is the modern design that mixes wool, polyester, and acetate. Such coats trap millions of air cells which hold body heat. Be sure your coat is water-repellant and includes a hood. When buying a coat insulated with down or synthetic materials, always check the manufacturer's tag giving you the temperature rating. In this way you can get a coat that ideally matches your hunting conditions.

The last items of clothing a waterfowler may need are gloves and mittens. If the weather is mild I prefer ordinary cheap cotton working gloves, since they fit tight and don't interfere with gun handling. In colder weather the modern gloves combining thin capeskin with foam-type insulation and nylon linings are the best bets I've found. For very cold weather it's hard to beat leather mittens worn over woolen liners.

I feel that my selection of clothing offers the ultimate for the waterfowler's needs. My outfit is without bulk, permits free body movements, is light in weight, keeps me dry, and fits me properly. There is one other consideration in clothing choice—color. Purchase outside garments in colors that will match your hunting. Waterfowlers must wear clothing that will blend in with their surroundings.

I mentioned earlier that I think it's a mistake for hunters to load their clothing down with the weight of shells, knives, and other gear. You can't avoid the situation if you're marsh walking, but there's no excuse for it if you're working from a blind. In a blind your personal equipment should be stored in a carry-all gear bag. Such bags are actually small duffel bags measuring about 22 inches long by 12 inches wide by 14 inches high. They should have extra-heavy-duty handle straps, padded bottoms, and two-way zipper openings, and they should be made of tough, water-repellant material. Several manufacturers of shooting clothing and sportswear produce bags that are ideal for the waterfowler.

Such bags are becoming very popular because they transport and hold your gear in the most satisfactory manner. In my bag I pack shotgun shells, binoculars, knife, cord, my lunch and thermos of hot coffee, extra gloves, candy bars, rubber gloves for picking up decoys in cold weather, flashlight, duck calls, sunglasses (for use after the hunt is over), small oil can, hand-warmer fluid and hand-warmer. Imagine

Flotation camouflage suit is notable advance in equipment for waterfowlers. It does all the things a life jacket does, and is also extremely warm and waterproof.

trying to load all that stuff into pockets! A duffel bag not only keeps it all together but it also offers protection from the elements. Your personal tastes for accessory equipment may be larger or smaller than mine, but a duffel bag will likely hold most anything your imagination comes up with.

When I'm planning a very-cold-weather hunt in a blind I wouldn't think of leaving home without a charcoal burner. Even a very few pieces of glowing charcoal will quickly take the numbness out of chilled fingers. The important consideration in a burner is that the firebed should be protected from rain or snow. I prefer the small barrel type that's designed for use in ice-fishing shanties.

It's easy to make a good charcoal burner too. Use a large-size coffee can and punch a series of quarter-inch draft holes above the bottom rim. An old cooking-pan cover serves as a fine top. Use an inch or so of sand in the bottom of the can to insulate the heat from the floor of your blind or boat. Be sure you punch your draft holes above the top level of the sand. I carry my charcoal in a heavy-duty plastic bag so it can't get wet. A hot charcoal fire offers the additional advantage of a hot lunch.

Extra equipment can add success as well as comfort to a waterfowling trip. Conditions vary in different sections of the country, so you'll have to come up with your own ideas. During the late part of the season in my area we sometimes have snow. That's why I carry a couple of discarded white sheets to drape over my blind.

Today's quality hand warmers are a real boon for waterfowlers. This one features instant starting, adjustable temperature control, and light weight. It operates in all positions, even upside down.

Wearing outsized white painter's suits is another good camouflage trick for snow-time hunters. I do a lot of hunting from floating blinds, and it's imperative that they be anchored at both ends to ensure proper positioning. Ever since a lost anchor once ruined a hunt, I've always carried a spare. There's spare anchor rope in my boat too. I also include a few extra decoy anchors and decoy cord.

22

Waterfowl Guns and Loads

Successful waterfowl gunning is a vital combination of many specialized factors of knowledge and equipment. The advantages of better decoys, better blinds, new-design duck boats, new calls, proper clothes and boots, and so forth are all parts of the picture. Working knowledge of such equipment is indispensable in coping with today's much-hunted waterfowl. But the items that actually put the birds in the bag—guns and loads—seem somehow to be continually shoved into the background.

Many published opinions still promote the standard waterfowl gun as a long-barreled 12-gauge, full-choked and weighing up to 8 pounds. Whenever ammunition discussion pops up it's usually a plug for heavy shot backed with maximum powder. Is it possible some of us are missing limit bags by adhering strictly to the letter of these timeworn principles? Let's analyze this problem.

Say we are gunning divers over an open-water rig. Incoming ducks bore straight at us, dip for the decoys, then flare broadside as guns come up. If the decoys are spread properly most of our shots will be somewhere under 35 yards. The man shouldering a full-choke and touching off magnum 4's has to aim mighty close to connect with a pattern that's just beginning to open up. But the guy shooting a modified bore with maximum-load No. 7 ½'s is knocking his bird dead with a just-right, more open pattern of properly dispersed density.

How about mallard shooting over decoys in river bottoms or other thick cover? Most of these shots present another close-range situation. Say you're huddled in a brush blind or pressing against a pin-oak tree and mallards are dropping in all around you. How fast are you going to swing that 12-gauge magnum at targets crossing behind or roaring up through tree branches? Could you get to them quicker with a fast-pointing 20-gauge? A lot of today's hunters have found that they can. They have also found that a magnum charge of No. 6's from that 20 is just as deadly as the regular maximum No. 6's from the standard 12.

We can carry this thought further and still be within the realm of common sense. There's even a place for No. 8 shot in the duck-gunning picture—cripple shooting! Estimates at cripple losses run over one-third of ducks dropped. Those resulting over open water usually offer excellent chances of a killing coup-de-grace. Many is the hunter who has laid a string of shot dead center over a swimming limpy only to have the duck dive untouched. What happens is quite understandable.

The target presented is normally the head and neck of the duck and the top of his back. A wing-tipped bird will often show only his bill and the top of his head for the split second it takes him to gulp enough air for another submersion. A No. 4 shot pattern averages 70 percent full of holes bigger than a duck's head. But blast a load of 8's or 7 ½'s out there and you're likely to throw a pattern so dense a good-sized fly couldn't get through. No. 8 shot numbers approximately 410 pellets to the ounce, No. 4's only 135. Does it make more sense to use the light shot? Try it sometime; you'll put ducks in the game bag that would be lost even after going through half a pocketful of No. 4's.

Although we have listed examples to the contrary this chapter is by no means intended just to belittle the big gun with heavy loads. The intention is merely to promote the thought that the all-round duck gun is as much of a myth as the all-round decoy, duck boat, or anything else. It's very likely that the big gun with its choked-to-the-limit barrel and maximum loads of heavy shot has crippled more

unrecovered ducks and geese and contributed to more clean misses than any other single factor in waterfowling.

The big-gun concept originated in the days of less-effective powder loads, at a time when a good share of duck and goose hunting consisted of pass shooting. Here it was, and still is, the most efficient piece of hardware the gunner can shoot. Pass shooting ranges are usually long, requiring the additional killing range of tight chokes and magnum loads. Weight of the gun is negligible in view of the fact that there's plenty of time to swing with targets. The heavy gun, in the hands of an experienced gunner, produces a smoothness of swing highly beneficial in catching up with and swinging past the high fliers.

The heavy gun also will absorb much more recoil than a lighter weapon, a thought to consider with consistent overhead shooting. But, like it or not, good pass shooting is a relatively small part of today's waterfowling. Best opportunities occur early in the morning and late in the evening when ducks and geese swing over feeding areas or roosts. Modern regulations eliminate most of the evening shoot. So today's pass shooting chances are limited to an hour or less after daybreak and the few opportunities that arise from discovering high points of ground that flocks drift over while working to and from feeding grounds. Another discouraging factor is that modern ducks and geese aren't as dumb as their counterparts of years ago. They quickly discover that flying higher and leaving the marshes before daylight greatly increase their changes of staying alive.

The single most important fact that many beginners refuse to accept as truth is that magnum loads are no more powerful from a velocity standpoint than the regular maximum loads. The magnum charge simply puts more shot in a given area at extreme ranges. In order to push the additional shot the powder blast has to be increased proportionately.

The average initial shot velocity of a 12-gauge maximum load of No. 6's 3 feet from the end of the barrel is approximately 1,331 feet per second. That of a 3-inch magnum load is 1,315 feet per second. The striking force per pellet from each load is roughly the same. What dumps the duck way out there is the number of pellets that smack him. The standard load is well opened up, perhaps only a pellet or two hitting the bird. The increased density of the magnum pattern may bust the duck with half a dozen hits. The magnum kills at extreme range only because you hit the duck with more shot.

While we are on scientific facts, let's toss in some more surprises. The gun and

ammunition people have long since discovered that maximum shot velocities produced by modern powders are fully reached in a minimum barrel length of 24 inches. They also know that choke constriction does its full job within inches of the business end of the muzzle. All of this proves that a 24-inch, full-choked tube will throw the same pattern at a given distance as a 32-inch barrel.

To the practical gunner these are important facts. Why burden yourself with the extra weight of a long barrel if it doesn't accomplish anything? Many shooters compromise between the unnecessary weight and the desirable feature of a longer sighting plane and settle at 28 inches overall. All factors considered, the 28-inch barrel is probably used by more knowing waterfowlers than any other length.

Any discussion of waterfowling guns and loads has to be tempered with the realization that hunting conditions vary considerably between different sections of the country, and that the same conditions may completely change in any one area during the course of an entire season. Consider the birds themselves.

Early-season native ducks will be thinner-feathered and easier to kill than late-season birds from the far north that are heavily feathered and laced with thick down. Modified-choke 7 ½'s may be just the ticket early in the season, while the same ranges may require the full-choked knockdown blast of magnum No. 4's to up-end hardy late-season migrants. The tight bore and heavy shot, in this case, have nothing to do with extreme range; but merely the necessity of additional push to ram shot home through armor-plate exteriors of big, fully matured birds.

Hunting conditions may quickly vary from close-range jump-shooting in heavy cover to long-range work over open water. I do most of my waterfowling in the Midwest, where such situations are frequently enjoyed during a single day. Such variables quickly indicate the advantage of several different powder and shot combinations. Even more so, they spotlight the invaluable aid of an adjustable choke device.

Today's waterfowler is blessed with the ability to choose exactly the gun and load combinations which will suit his particular needs best. Gun and ammunition manufacturers have given us opportunities that the old-time gunner never dreamed about. Some years ago the idea that the little 20-gauge would one day be considered a top duck gun was unheard of. Anything less than a 30-inch, full-choked barrel was laughed at. No. 6's were the standard load and if you loosed off with anything else you were looked at with scorn. Such thoughts are fast going the way of the old round-bottomed decoy: gone and forgotten. Today's guns and loads

enable us to put definite advantages on our side, advantages that are more easily attained than any other contributing factor in the vast technicalities of modern waterfowling.

23

Shooting Techniques

Peeking through the cattails edging a backwoods pond, I could see two black ducks resting on a partially submerged log. They were still far out of shotgun range, but George Dorrell and I had an ambush plan. Here were two ducks that didn't have a chance.

George and I were jump-shooting puddlers from a series of ponds located in a big woodland. We had spotted the two blacks before they had any suspicion of trouble. "We've got 'em dead to rights," said George. "I'll circle around. Give me ten minutes, then we'll both sneak straight at them."

Such procedure, theoretically, would force the birds to flush between us. Likely, because of wind direction, they'd fly right over my head.

"I can't miss," I said to myself. "My long dry spell is over!"

When I started sneaking ahead I moved so I could swing left with ease. I angled my cap to cut out a sun that flooded the October landscape with sparkling beauty. Finally I stopped in the shadow of a tree. I wasn't 20 yards away from those ducks.

The bomb suddenly went off. The thunder of beating wings sounded ten times as loud as normal. Then the birds were in the air, seemingly three times average size. They appeared to be flying at no less than 150 miles an hour. My gun felt like lead. I finally touched off a shot. Way high! Then I slammed a couple more. I can still see those blacks slicing away over the painted thickets.

When this happens, friend, you're licked! You've got buck fever so bad your nervous system is choked up with ineptness. The cure? We all know what it is. More shooting! Forget what's happened and just keep hunting. After another dozen shots or so you'll finally connect. Then after another dozen you'll start coming out of the slump. This is solid advice. But it has one tremendous drawback. A few dozen shots at wild game today could represent a big portion of your hunting season. Is there a better way? George showed me within half an hour. "Come on," he said, "let's head for the car. I'm going to get you straightened out right now!"

We drove a couple miles to a small river. George wheeled off the road and braked to a stop. I was meek with disgust. I didn't question his thinking when he said, "Grab a box of shells and we'll get that gun of yours shooting straight again."

He heaved a chunk of wood out into the current. "Paste it," he grunted. I did. A cloud of spray enveloped the target.

"O.K.," he said. "Now you know your gun shoots straight. You can quit worrying about maybe you banged the barrel on something and knocked it out of line."

Silly reasoning? I don't think so. This is the first thought any shotgunner will have when he starts unaccountably missing. And it's the easiest to dispel with this water trick. Half your problem is gone right now. The rest of the answer has to be in your gun handling. George worked on that next. He reached in the back of his car and came up with a hand trap and a stack of clay pigeons. He heaved one hard, straight up.

I slammed the gun to position. The butt settled into my shoulder. I felt my cheek tight against the stock. The barrel lined on target and I pulled. Chips exploded as the pellets ripped home.

The next disc sailed at a faster angle. I missed. I missed some more. George kept throwing and I kept shooting. The targets began blitzing so low and fast I didn't have time to think about lining my gun. I had to shoot quick or not at all. After going through a box of shells I was shooting twice as fast as when I started.

"O.K.," George abruptly exclaimed, "let's go bust some ducks."

We did. I didn't kill my limit, but I nailed a couple of birds that were a lot tougher targets than the two black ducks. On the way home George expounded some shotgun theory I've never forgotten.

"Shotgun success is automatic reaction," he began. "It's like rowing a boat or tieing your bootlace. If you start thinking about what you're doing you'll get all

Shooting a shotgun must be an automatic reflex. Practicing on clay targets is a good way to develop this skill.

tangled up. That's what happened to you. You started missing and right away you tried to analyze what was wrong. Then you were really licked because you were concentrating on gun handling instead of your target. With shotgun shooting you don't have time to figure answers. You've got to let unconscious reaction take care of firing the gun. That's why I always carry a hand trap and clay pigeons. I know of no simpler way to quickly bust a slump. You've got to shoot your way out of it. Lots of shooting! Not tomorrow or next week, but right now!"

Gun Fit

George's long-ago speech left a lot of things unsaid.

In the first place, we have to assume I was shooting a gun that fit me correctly. This assumption is more important than any theory in shotgunning. If your gun doesn't fit your physical characteristics you'll never be a proficient wing shot. This idea is nowhere near as technical as it sounds. By proper fit the experts mean only one thing: that your gun lines straight on target when you quickly throw it to your shoulder.

A simple test offers quick proof. Go grab your gun out of the closet right now and we'll try it. Pick an imaginary target, like that ceiling light or a picture on the wall. Now snap off a quick imaginary shot—both eyes open, no aiming. Now close one eye and look down the barrel. If you're reasonably on target your gun fits close enough. If you see all the barrel, or none of it, your fit is out of whack. If you have to move your head in order to line your eyesight down the barrel, your stock is too long or too short.

If any of these things occur, you'll be wise to have your local gunsmith make adjustments. He can do it in short order. No need to go into technical details here. Your gunsmith can explain it better with examples. It will be the wisest investment in shotgun markmanship you can ever make.

Without proper fit it is impossible to accomplish spontaneous reflex shooting. And good shotgun scoring is always the result of reflex pointing, not aiming. We aim rifles. We point shotguns, in the same manner as we point our finger at a passing airplane. Shotgun technique is directly opposite that of a rifle. With a rifle you place your single bullet with perfect aiming and slow precision trigger squeezing. With a shotgun you "throw" a cloud of shot with lightning reaction.

Relaxing

With that principle accepted, the next question must be how the average guy can improve his score. Let's forget proper choke, shot, and powder combinations, since they were discussed thoroughly in the preceding chapter. We have to point our barrel in the right place before ballistics can become even a minor factor.

I've always remembered a little dissertation I received as a lad from the best wing-shot I've ever known. This old gent recently picked up his last decoy and passed on into his eternal open season. Back in the days when the limit was fifteen ducks per day I watched him in action with an envy bordering on worship. He could afford to hunt most every day of the season. Many is the morning I watched ol' Harry and three or four partners tumble up to seventy-five divers from a point blind. This may sound like a fantastic sin today, but it was perfectly legal then. The point, of course, is that a guy with this kind of experience probably knew a thing or three about pointing his gun. I mustered enough courage one day to row up to his blind with the hopes of talking duck shooting. He was as gracious as he was proficient. He even asked me to stay awhile and kill some bluebills.

After I'd missed a few he grinned and laid a hand on my shoulder. "Sit down and relax, son," he said. "You'll never hit nothin' all tensed up. That's no charging elephant you're shooting at, just a little harmless duck. You'll never kill him any deader by wanting him so bad!"

A lot of years later I had logged enough field experience to realize what Harry meant. It's the exact cause of many of today's misses. We become so trophy-conscious that we shove all other thoughts in the background. We've got to bust that bird right now; we've got to make every shot count. We become far over-anxious. Our nervous system shoots up to fever pitch. So what can we do? My own technique is to concentrate on something to slow down the tempo. Maybe I'll take a short walk. I'll try to identify plant growth, trees, cloud formations, or anything having nothing to do with hunting. I might forget the whole hunt for an hour or so and restring decoys or repair the blind. The entire idea is to engage in some relaxing activity, something that removes your whole consciousness of thought from that next shot. You'll be surprised how tension will loosen.

Range, Rhythm, and Know-How

But let's get back to Harry's duck blind. I noticed things in gun handling that were revelations. I saw, for instance, that Harry never moved his gun until ducks were well within shooting range. When he finally did shoot, it was in one continuous flow of movement. He snapped to a standing position, the gun came to his

shoulder and the shot went off all in one smooth sequence. His reasons made a lot of sense.

"First place," he began, "I get a rhythm of swing when I do everything all at once. If I pointed the gun out there, picked up the duck, and tried tracking him I'd be all out of coordination. Same thing as in throwing a ball. You find your target first, then wind up and follow through. If you don't, you won't hit much. Remember that, son! With a shotgun you have to be loose and liquid. Never try to get into aiming position first!

"There's two really big factors a man must be conversant with if he's a great wingshot. He has to know what his shotgun can do, and what his target will do.

"A shotgun is no cannon. Truthfully, it's a mighty short-range killer. Ninety percent of all kill shots are made at less than 40 yards. Pace off 40 yards sometime; it's a real short distance. Long-range shooting is plain silly; all the ballistic odds are against you. If shotgunners truly accepted this fact, they'd cut down their misses tremendously!"

Harry told me about knowledge of target too, but it didn't make much sense until years later. He was simply saying that if a gunner knows what his target is going to do, he also knows approximately where he is going to point his gun. This is the exact reason why most great wing shots are veteran hunters. And it's also the same reason why many trap and skeet marksmen fail so miserably at connecting with wild game.

Let's say it this way. A man who has killed hundreds of diving ducks over decoys has learned a lot about behavior patterns of diving ducks. He knows what they're going to do, how they'll approach decoys, which way they'll flare and whether they'll go high or low. A man with years of experience at flooded-timber hunting for puddlers knows how these ducks will react when coming down through the trees, and he'll know escape patterns once the guns start booming. Also, a man with this type of experience knows the tricks of finding targets, and thereby gets more shooting opportunities, which in turn makes him more proficient.

The knowing duck hunter is aware that a decoying mallard will tower straight up with discovery of gunners, reaching an almost stationary point before leveling off. Know this point and you have an almost standstill target.

Puddlers jumped from field potholes will bounce up and drive into the wind immediately, allowing the experienced gunner to concentrate his attention in a

small arc instead of a complete circle. The stalking hunter's approach should be made downwind to gain most advantageous shooting positions.

Puddlers jumped in timbered potholes where wind is negligible will usually take the route where they can get out of the trees quickest. That's an obvious knowledge advantage for a team of two hunters, since one man jumps the birds and the other gunner enjoys wide-open shooting.

Divers will seldom tower when surprised or shot at. They curve away in a broad arc, depending on sheer speed for escape. Divers coming in with wingtips just clearing the water will almost always decoy perfectly, enabling the gunner to hold fire until nearest ducks are well within effective range. He then fires his first shot at a bird in the rear of the flock and his last shots at front birds which are still within shooting range.

Divers crossing high and fast will usually pass by; the gunner must be prepared to shoot at the exact instant the flock passes closest to the blind. Such are the things that Harry meant when he pointed out that an expert wing shot must be aware of what his target will do under given circumstances.

Misses

So, how good can you get? I guess maybe ol' Harry's answer might lend more authority than anything I can say.

"I've never had a day of shooting in my life that I haven't missed some setups," he began. "I often take down the gun an' wonder how in hell I missed such an easy shot! The best shot in the world is going to miss occasionally. Some days he's going to miss frequently. I don't let it bother me. Without the misses there'd be no thrill in the hits. If you bust half of 'em you're far above average!"

Nobody is going to get them all! Next time you miss a straightaway, remember this. It will help settle your nerves.

If we accept the fact that successful shotgunning is knowledge, what are the tricks that will help our score?

One big thing is the realization that misses must derive from one of only two sources: natural causes and manmade troubles. Natural causes we can forget, because we can't control them. For instance, you may make a perfect swing on a

gliding mallard, touch off the shot at exactly the right instant, and still miss simply because a tree intercepts your shot charge. Maybe you are goose hunting from a boat and the boat rocks just as you touch the trigger. A list of such excuses is unending. They're legitimate. They happen to all of us.

Manmade troubles can be at least partially controlled.

I feel one of the biggest troubles confronting most gunners is lack of familiarity with their shotgun, simple lack of experience with actual shooting. Since good shotgunning results from reflex action, it logically follows that the more shooting you do the more automatic this reflex action becomes. And here I differ somewhat from the opinions of many gun experts.

Any shooting helps, whether in the field or not. The more you shoot the more you get the "feel" of your gun. Clay-target games are a tremendous help for this reason alone. Crow shooting is better yet, since it's so similar to waterfowling. Regardless of how or at what, get out and run shells through that gun; especially in the weeks just before hunting season.

Leading

Nobody can ever hit a flying target without lead. I don't believe it is possible for any man to tell another exactly how to figure proper lead. In the first place, no two shots are ever the same. Secondly, my interpretation of 3 feet of lead may be a whale of a lot different than yours. Also, you may swing your gun faster or slower than I do. With my method, 3 feet may be just right; with yours the same 3 feet might not be nearly sufficient. So what can you do? Unfortunately, that old bugaboo experience is the true answer. The only point I want to make is that you shouldn't put too much faith in what somebody else tells you in regard to lead. You have to find out for yourself. Personal experimentation is a much faster shortcut to success than promiscuous advice.

But one fact is sure. Most misses result from too little lead. A flying target moves a tremendous distance from the time your brain tells you to pull the trigger and the shell explodes. All wing shooting also involves constant remembering that the passage of shot from a shotgun toward a flying target is not an instantaneous happening. The time lag—between when the gun is fired and the pattern arrives at target—must be compensated for by shooting where the bird is going to be, not

where he is. Compensation for crosswind velocities must be reckoned with too. A 30-mile-per-hour crosswind will blow a shot string 3 feet off target at 30 yards.

A veteran waterfowler, however, will always admit that ducks and geese are consistently easier to hit than most flying game birds. The reasons are obvious.

Most shooting at waterfowl is not hampered by trees and brush as is so often the problem with upland game. In addition, most shots are at birds enticed to the gunner, thereby enabling worlds of time for preparation. What, then, creates the popular belief that duck or goose shooting is so difficult?

The two most important factors are distance and speed. Decoying ducks and geese sustain such pressure on the nervous system that most gunners can't stand the strain; they begin their gunplay at extreme ranges. Decoying birds against open sky look much closer than they actually are. Such reaction is against all logic because if a duck is decoying within 80 yards he is fooled enough to come within 40, assuming, of course, that decoys are properly arranged.

The main problem is that flight speed of waterfowl must be realized in dramatic fashion. Even veteran gunners frequently find it difficult to determine how far a duck moves in the time a load of No. 6 shot travels 40 yards. Ninety percent of missed ducks and geese are led only half enough. It is almost impossible to over-lead, since shotgun pellets string out in a line. The rearward part of this so-called "shot-string" would intercept a flying target even if your main charge passed slightly too far forward. If you're missing, keep shoving out additional lead until you connect. Sometimes the amount will seem ridiculous, but you'll know it's true when you start hitting.

That principle is the single, most important lesson in shotgunning. Average game-load pellets in 12-gauge guns are moving between 900 and 1,000 feet per second. By comparison rifle slugs are zipping to target three times as fast. Such analysis emphasizes the extreme importance of lead.

Choosing a Target. One of the biggest causes of missing is flock shooting. It's an awful temptation to empty your gun into the midst of a flock of decoying ducks or geese. It seems you can't miss. The trouble is that it's ridiculously easy to miss because you're shooting at a lot more air than birds. It may not look that way but it's fact. I lick this problem with a simple trick. I try to pick the biggest bird in the flock. I concentrate on that one individual. This split-second concentration changes confusion to definite purpose. When I'm ready to shoot I have my mind

zeroed on one target. This trick becomes second nature with experience. It works to perfection!

Concentration and conditioning. The biggest nontechnical reason why we miss in the field is that we are not always coordinated for instant action. Our mental approach, our physical condition and even the way we carry our shotgun has more bearing on success than we realize.

Say you're jump-shooting ducks and you haven't flushed a bird in hours. You're disgusted. Your mind wanders. Suddenly a baldpate busts out. By the time your reflexes snap back to reality the target is long gone. It's hard to answer this one, because the only true answer is continual concentration on the task at hand.

Physical condition is something else again. If you sat in last night's poker game until the wee hours you can forget about good shotgunning today. Split-second wing shooting just cannot be compatible with loss of sleep and overindulgence. The best advice here is to save the party sessions until after the hunting season.

Readiness. Proper carrying of your shotgun has the decided advantage of allowing you to shoot faster. Often this is the difference between a fast kill and not getting the shot off at all. Three good positions are recognized: the "ready" position, gun held diagonally across chest, barrel up and finger on safety; the "shoulder" position, gun resting upside down on shoulder, trigger guard up and finger on safety; the "hip rest" position, barrel pointing up and ahead, finger on safety and butt resting on hip. All these positions permit an instantaneous arm flip to snap butt to shoulder and line barrels almost ready-pointed for a quick shot. Practice these positions with plenty of dry firing the year around. It only takes a few seconds. Once you have these gun-mounting tricks mastered, you can't help putting more game in the bag. And they're all natural physical positions. They're perfectly suited to walking or standing comfort.

Mysteries. Recently, I mentioned to a hunting friend that I was writing this chapter. "Yeah," he said shrewdly, "that's fine. Maybe you can answer a question."

I was cautious, but I answered, "Shoot!"

"Remember that day last fall, when you an' I jumped a big greenhead from that little farm pond? There was open sky all around us. He wasn't more than 20 yards

Jump-shooting calls for fast gun handling. This alert hunter, with gun at ready position, is able to shoot instaneously.

Another good gun-carrying position. Shotgun can be whipped to firing position in seconds.

Hip-rest position enables gunner to shoot with lightning speed.

when he busted out. We emptied our guns . . . remember? Never touched him. Now, how come?"

"Well . . . I . . . uh . . . "

"Just a second," he interrupted, "I'm just starting. How about that day last August when we were shooting crows? You couldn't miss an' I couldn't hit anything. And that day goose hunting—I got a double an' filled my limit before you hit number one. Remember that day in the layout boat when I went through half a box of shells an' shot nothing but holes in the air? Now, my question is this: how can guys who do as much shooting as we do come up with terrible exhibitions? How can you be so red-hot one day an' so rotten the next?"

Really, I guess, there is no answer. Perhaps a weak attempt might be this: When a normally fine shot misses an easy chance, one of many indeterminable possibilities have upset his coordinations to the point where they didn't function on schedule.

Maybe that's not too good an explanation, but it's the best I can do. Perhaps

a good alibi might be better. Now we've got something. Plenty of good alibis already exist; more will be developed in the future.

If you happen to come up with a real dandy I hope you'll share it. Every shotgunner appreciates a perfect excuse.

24

Waterfowling Boats

It would be pure folly for me to recommend the best type of duck boat for you. I could make this the shortest chapter in the book by writing a few general statements that cover much of what you should know about duck boats. I could quit there and not confuse the issue, but I won't since selecting the right boat is one of the most important decisions a waterfowler must make. Let's start off with general principles, then I'll add some of my own thoughts that may benefit you.

Extreme variations in geographical conditions over different sections of the country have profound influence on which type of duck-hunting boat is best in any given area. The best boat for hunting scaup in South Dakota might be the poorest, perhaps even the most dangerous, for gunning these same ducks along the Atlantic Seaboard. The best boat for jumping mallards along midwestern rivers would be quite out of place in the huge marshes of California. The rule is that duck hunters' boats differ widely in seaworthiness, design, size, and weight depending on how and where they will be used.

I can't tell you what type of boat you should use simply because I don't know your local duck-hunting conditions. But there are experts in your area who do know the answers. Long ago they determined what type of boat was best for the brand of shooting they were going to find and the type of terrain they were going to hunt. That's why I say this chapter could be the shortest in the book. I could

sum it all up very effectively by saying that the best advice must necessarily come from waterfowling experts who hunt the same local waters that you do. Seek out the old-timers, listen to their counsel, and you won't go wrong.

The only catch in that approach is that expert duck and goose hunters tend to be close-mouthed with amateurs. Put a couple of veterans together and they'll talk half the night about their experiences and hunting theories, but mix an expert with a newcomer and the knowing hunter often has a tendency to clam up. So if you are a beginner it's a good idea to know the basics of duck boats. With this knowledge you can keep the conversation going by asking intelligent questions.

There are two general types of boats used in waterfowling. One is the type from which shooting is done, the other is used for transportation to shooting areas and as an equipment carrier. A good example of the extremes involved here are boats used by layout shooters along the Atlantic Coast and on the Great Lakes.

As I mentioned in a previous chapter, layout boats are designed to be nearly invisible when floating within a large spread of decoys. They are heavy, hard to row, and very uncomfortable to sit in, since they are designed to hold gunners in prone positions. In short, you don't use these tiny and highly unmaneuverable boats to get to a shooting area; you tow them to a specific spot, then anchor them in position.

Since layout gunning is usually best far from shorelines on big waters, it's common sense to use a large boat as a towing vehicle. The towing boats are large for reasons other than safety and speed.

Shooting from a layout boat is arduous. For most gunners an hour or so of lying in a bouncy and usually wet little boat is long enough for a single session. For this reason layout hunters usually work in teams. One or two gunners out of a team of perhaps half a dozen men will take their respective turns in the shooting station. So the towing boat also has to be large enough to carry a group of hunters, piles of decoys, lunches, gear, and so forth.

I was once involved in a layout hunt where the towing boat was a large cabin cruiser equipped with heat, cooking units, a rest room, and other luxuries. The big water was rough during that hunt, almost too rough. Our two-man layout boat was continuously pitching in waves, and the gunners occupying it were whipped with spray from whitecaps. But bluebills were decoying extremely well and the shooting was exceptional.

We took our turns at gunning, then thawing out in the cabin cruiser with the

Gunners in layout boat lie prone in the cockpit, then snap to shooting position when ducks decoy.

comfort of heat and hot food. It was a wonderful hunt, made practical and possible by the combination use of two seemingly unlikely boats. Tell an average gunner that you used a luxury cabin cruiser on a successful duck hunt and he might regard you as the world's greatest liar. Tell his partner that you shot from a tiny boat 4 miles out from the nearest shoreline and he'd suspect you are crazy. But tell them both, at the same time, that the shooting boat was anchored just a few hundred yards downwind from the cruiser and they'll readily understand how the system works perfectly, and is both safe and convenient.

Many duck hunters use a single boat to serve as a shooting station, transportation unit, and equipment carrier. I discussed the best example of this in Chapter 11. There I explained how a 16-foot outboard boat could be rigged with a portable

blind. Such a blind, plus decoys and other gear, are all loaded in the same craft. This rig allows two to four hunters to drive their boat most anywhere and set decoys and shoot where they please.

Even small boats may serve all three purposes. An example of this situation is float hunting on most any small stream or river. The majority of drift hunters don't even use a motor for transportation purposes. They put in at an upstream point and drift to a selected downstream takeout spot. They conceal the front of their boat (that part of the craft that would normally be seen by resting ducks) with native brush and weeds or a simple blind. The technique is a form of floating jump shooting, since the birds aren't readily alarmed by what they assume to be a tiny island floating downstream.

On the smaller and twisting streams float gunners don't even bother with blinds. They depend on stealth, boatmanship, and the concealment of sharp bends in the currents to put them within shooting range of ducks before the birds are aware that trouble is at hand. This type of sport requires a very small, shallow-draft boat, plus the services of an expert paddler and a great sense of balance by the occupants. Still, the boat serves as a shooting station, transportation unit, and equipment carrier.

The best-boat picture gets even more complicated when it's realized that experts in some areas use their boats only for gear carrying or transportation purposes.

You'll find a good example of the former situation in the flooded pin-oak flats of such states as Arkansas and Tennessee. There the flooded oaks often stand so close together that it's difficult to row or paddle a boat between them. Hunters lick the problem by wading the shallow waters and pulling their flat-bottom john boats behind them. Why do they bother with a boat at all? Because wading in that brown-stained and root-laced water is a hazard at best. A hunter loaded with decoys, gun, shells, and other gear may make a misstep while attempting to wade to a shooting area that's often located a mile or more into the timber. It just makes a lot of sense for several gunners to stow their equipment into a boat and tow it through the trees. When they reach their location they hide the boat under downfalls, place their decoys, and spread out to find shooting locations behind the trunks of big oaks.

A top example of where boats are used for transportation only is the prairie pothole country of the North Central states. Hunters there use the deadly tech-

nique of driving to high spots and using binoculars to study the location of ducks on several potholes or small lakes. When they locate a flock that can be stalked easily, they go to work. After the shooting is over the problem of how to retrieve the birds is presented. Some of the smaller potholes can be waded, but the bigger ones often require the use of a boat, especially where dead birds have fallen into emergent vegetation that prevents them from drifting to shorelines.

The answer to the situation is the lightest and smallest boat available, since it will have to be carried from the closest car or truck access. Tiny boats serve the purpose, because rough water doesn't enter the picture. Some veterans at this type of waterfowling claim that folding boats are the best bets. I used one in North Dakota. From a folded packet measuring 38 inches high by 20 inches across it folded out into a boat measuring 6 by 4 feet that weighed slightly over 20 pounds. Another time I hunted with a group of Minnesota duck hunters who used a tiny canvas boat assembled from a prefabricated kit. One man could carry it easily, and it was transported in the rear of a station wagon. Such a boat can readily be tied to the top of a car.

I mention these examples to emphasize that there is no such thing as the best boat to hunt mallards, scaup, teal or any other species. If the North Dakota expert tried to tell the North Carolina coastal mallard hunter that a folding boat was the best craft to use while hunting those birds, he would be laughed at. So it goes in any section of the country. The situation becomes even more perplexing when we reflect on other pertinent factors.

Consider Maine's famed Marrymeeting Bay boat, or the equally well-known Barnegat Bay boat. Both are considered ideally designed for East Coast gunning but they are seldom used in similar waters along the West Coast. Why? Because gunning techniques are slightly different in the two areas and this minor difference is reflected in preferred boat designs.

On the other hand, consider the equally famous sneak boats and layout boats that were also designed by eastern market hunters many years ago. These basic designs proved so perfect that they haven't been improved for well over half a century. Sneak and layout hunting methods are basically the same on big waters anywhere in the country. So it's not surprising to learn that wherever you go in sneak and layout hot spots you'll find boats that are basically identical in design.

I would be remiss not to mention the scull boat while discussing specialized craft.

Like layout and sneak boats the scull version is shallow-draft, is partially decked over, and has an open cockpit. It is used as a shooting station for gunning divers (and occasional puddlers) on open water. Now, you may ask, why in the world should any one of three differently designed boats be accepted as best for hunting the same species of ducks on the same types of open waters?

Well, let's clear that up. The layout boat is designed to be anchored amid a spread of decoys. Its purpose is to be a tiny, almost invisible stationary blind. In contrast, sneak boats are designed to drift with wind or current plus the efforts of a paddler into a flock of decoys holding recently alighted ducks. Sneak-boat hunters drift about 200 yards downwind to their shooting, then they return to an upwind anchored buoy. Sneak boats hold one or two hunters who sit on the floor in the cockpit. They are hidden behind a concealing screen that is hinged to the forepart of the deck. The screen is pushed down by the gunner immediately before shooting.

In further contrast the scull boat is also designed to drift into flocks of resting ducks, but no decoys are used, nor do the hunters return to an anchored position. One system involves drifting down large rivers till a flock of ducks is spotted. Then with a sculling oar, which is a short paddle worked through a hole in the square transom of the boat, the gunner aims and propels his craft noiselessly into shooting range. Other scullers drive shoreline roads along large lakes or bays until they spot a raft of ducks resting out on open water. Then they launch their scull boat and work down on the birds. Sculling is an ideal way to get fine action on those days when ducks aren't flying. It's about the only way to get into the flocks that prefer to raft up far from shore.

The hunter lies on his back in a scull boat in a position where he can just see over the coaming around the cockpit. These boats are designed to ride very low in the water so the craft's outline is minimized. Let's examine why this is necessary for successful gunning.

Earlier I mentioned that drift hunters on rivers conceal their persons and craft with simple blinds that cover the forward end of their boat. The system works, since the blind blends in with very close wooded backgrounds of shorelines. The sneak-boat hunter's concealing screen also works, since his intended targets are reluctant to leave the decoys. In other words, they'll normally hold longer in a specific spot than if there were no attraction to help hold them there. But the sculler doesn't have these advantages; he is attempting to work within shooting range of

birds not held by decoys and he is trying to accomplish this over wide-open stretches of water. When all of this is understood it's easy to realize why a sculling boat must be as inconspicuous and noiseless as possible.

So the theories go with all explanations of the reasons why duck boats must be specialized craft. But required knowledge doesn't end with the correct decision to acquire a certain type of boat. There are types within types, and the differences should be considered.

In general, good duck boats for river and marsh hunting are built low for concealment, narrow in bow for maneuvering through flooded brush and emergent vegetation, and broad in midsection for stability while shooting. Pointed bows and sterns are the choices of gunners who don't need outboard motors. If a motor is involved in your gunning picture, your boat should have a square stern. If you are likely to encounter some rough water, your craft should be decked over to a greater or lesser degree (depending on local conditions) and it should have some sort of cowling.

As to the size of your small boat, there are several questions to ask. Is it large enough to safely transport hunters, decoys, and other gear? Is it seaworthy enough to work the waters you will hunt in any kind of weather? Is it built of materials that will cope best with the terrain where you'll use it? Be sure the answer to all questions is yes.

When I refer to materials, I'm talking about the construction materials of wood, fiberglass, or aluminum. In the old days boats were made of wood, but there are definite advantages to boats built from modern materials. Such modern crafts are far lighter. They require less maintenance. And, in northern states, they are impervious to ice. If you hunt where you may have late-season skim ice to contend with, don't consider a wooden duck boat, large or small. Skim ice can be as sharp as a knife and it can slash wood with ease, especially when you drive through it with an outboard-powered craft.

When we get to boats larger than skiffs we have additional factors to consider. If it's a rowboat it should be equipped with a double set of oarlocks and oars. If your motor quits it's easier for two men to row than one, and if an oar breaks or is lost you'll have a spare so that one man can keep working.

Weight gets into the picture if you don't have a permanent base where you can harbor your craft for the shooting season. If you have to trailer your boat, or boats, you'll have to consider matching the equipment. You'll also have to determine the

Modern fiberglass and aluminum boats allow duck hunters to work in ice that would ruin the wooden boats of yesteryear.

location of launching sites, and this factor alone could be important in deciding what type of shooting you will do and where you'll do it.

Then, of course, there is the problem of how to anchor larger boats that are used as base units for portable blinds. Most floating blinds should be anchored broadside to the wind and secured fore and aft. This keeps the blind in a fixed position. That's very important, since your blind should be motionless, and it should also be located in a general upwind position from decoys to offer the best shooting location.

Tossing out both anchors in a direct upwind position from the blind won't accomplish your purpose, since the boat will still be able to swing through an arc like a pendulum. The boat blind should be moored between two anchor lines running diagonally away from the bow and stern. The following sketch shows the proper alignment.

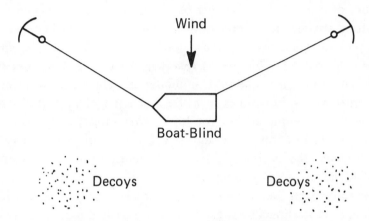

When I first began using boat blinds I lost plenty of shooting opportunities because I didn't know how to anchor properly. My first problem was corrected with the solution I've just explained. Then I had troubles because my anchors were too light. A boat blind is a sizable object, and it catches wind much like a sail. On open water a gust of wind can catch a blind just right, put strain on an anchor line, and drag a light anchor some distance across bottom. As soon as that happens the line becomes slack and the blind begins moving with changing wind pressures. Many flocks of ducks veered from my decoys when they spotted blind movement.

The solution to that problem was better anchors and longer ropes. You should use an anchor that will dig into bottom, and the only way it can dig is if you use a rope long enough so that the anchor lies on its side while the rope is applying pressure. A rule of thumb says that the length of rope from boat to anchor should be at least three times as long as the depth of the water. My trick is to drop one anchor overboard, motor straight away from it for a distance appropriate to water depth, drop the other anchor, reverse the boat to a central position between the anchors, then pull both ropes tight before tying them to fore and aft locations.

I also learned a long time ago that it's ridiculous to pull the anchors aboard each

time you go after downed birds. Not only do you lose your choice mooring location, but you also have to go through the entire anchor-setting act each time you move the blind. It's far simpler to attach floats to the boat ends of your ropes and cast them off when you move. Anything that will float will do the job. I use two old decoys simply because they are handy.

One word of caution about this act. As soon as you cast off your floats they will begin drifting straight downwind from the anchors. Remember that when you return and pick up one float you must hold it in your boat while you motor over to pick up the second. This means that your overall anchor lines must be long enough to prevent the first line from snubbing up tight before you reach the second float. In other words, both lines must be much longer in overall length than the lengths needed to simply anchor the blind. I do most of my anchoring in water depths of 6 to 15 feet, but I use anchor ropes measuring 50 feet each.

All duck boats used as shooting stations should be painted to match local backgrounds. Many hunters assume that if they paint their craft with a flat, dead-grass-color paint they have done all that's necessary. This is a halfway job in my opinion, even for boats used exclusively in marshes and along rivers. No marsh or river shoreline is all one color; it will show several hues of browns, yellows, and greens. The best bet is to use a base coat of dead-grass-color, then add streaks and blobs of colors resembling local foliage. The more randomly the streaks are applied, the more the boat's outline will be obscured.

Sneak, layout, and sculling boats should be painted battleship gray to match the gray waters of cloudy fall days. There is one exception. In northern states, where late parts of the gunning season may show ice and snow, some experts paint these boats flat white. A white boat will blend perfectly with a snow-covered shoreline or a partially frozen lake. Even when there's no snow on the ground or ice on the water, a white boat is often ignored by northern, late-season ducks. I don't know why that is true. If I had to guess I'd say that late-migrating ducks may be used to snow and they therefore pay little heed to anything white. Incidentally, knowing hunters who use white boats usually dress in white clothes.

No chapter on boats would be complete without a few words on safety, other than the inherent safety of the boat itself. For my money gun handling leads the list. When using small boats (such as double-enders and sneak and sculling boats) only the man in the bow should shoot. Such boats, where one hunter is behind his partner, are too confining for the safe handling of two guns, and they are too

small for the stern man to concentrate on anything but paddling and balance. The rule is to change positions after each shooting session. It's a good rule, as I learned many years ago after a couple of dunkings in cold water, and one particularly unnerving experience when my companion in the stern risked a shot. The barrel of his gun must have been inches from my ear when he fired. The muzzle blast almost broke my eardrum and I couldn't hear for a week.

Another practical rule is never to lean a gun against a gunwale in a boat of any size. An accidental blow from an oar or other equipment could knock it falling and could cause it to discharge. The rocking motions of any boat are also likely to upset a gun that isn't resting securely. I think the best rule in boat blinds is to employ notch-type arrangements that are built into blind sections to hold upright gun barrels in place. Such notches can be slots cut into the tops of blinds, or half-round bands of metal bolted to inside positions on the blind. The idea is to locate these barrel-holding notches so that the top of the gun barrel is cradled securely while the butt of the gun is resting solidly on the floor. When your gun is positioned in this manner it's located safely and it's easily reached for quick action.

For some reason the majority of duck hunters are negligent about carrying lifejackets in their boats. This is foolish for several reasons. First, waterfowlers are heavily dressed. Even an excellent swimmer can't swim far in watersoaked clothes. He may not be able to swim at all in waters that will likely be rough and ice-cold. Another important consideration often overlooked is that fall waters are traveled very little. By the time weather gets nasty, most fishermen and tourists have stored their boats. If a duck hunter gets into trouble it's more than probable that he'll have to save himself.

All through this book we have discussed the advantages that modern waterfowlers enjoy, but one of the most modern of all is a safety unit that's outstanding. It's a camouflage suit for duck hunters that incorporates full flotation in both jacket and pants. It does all the things a lifejacket does except look like one. It offers zippered legs, full standup collar with concealed hood, game pocket, deep slash pockets, insulation, and an outer shell of waterproof urethane-coated nylon. The suit is lightweight, full-cut for comfort, and it will float the wearer indefinitely. Retail prices are about $50 for the pants and $80 for the jacket. Stearns Manufacturing Company of St. Cloud, Minnesota 56301 produces the suit.

25

About Retrievers

Most veteran dog men claim there is no such thing as a perfect retriever breed. How well your duck dog performs depends more on you than on what breed he happens to be. The rule is that individual dogs are the best bets for individual owners. A fine way to explain the situation is to tell you about three experiences I've been involved with.

One fellow I know was about twenty-five years old when he purchased his first duck dog, a springer spaniel. The dog was six weeks old when Jack brought him home in May. He had never owned a retriever before, he knew nothing about training a dog, and he didn't have the money to pay for professional training. But he was a fanatic on duck hunting and he had an intense desire to train his dog to be a super hunting partner.

Though he was advised that a springer isn't the best breed for the rigors of water-fowling, he turned down advice to buy a larger dog because he had small children. He figured a springer would make a better pet. Of course that isn't necessarily true, but Jack had his mind made up. It's important to note that this springer's forebears were not hunting dogs. They were purebreds, but outside of that Jack had his work cut out.

And work he did. Every evening after work he took Duke on walks near his small-town home. He spent hour after hour teaching the dog the basic commands

of sit, heel and stay. He housebroke him and he worked with him in the country on weekends. He made sure the dog wouldn't develop a fear of water by introducing him first to shallow ponds where only wading was possible. Gradually he worked up to shallow lake shores, then to deeper waters where he swam with the dog.

Jack used similar careful techniques to make sure Duke wouldn't be gun-shy. First he had a partner fire .22 Shorts some distance away from the dog while he fed him. Gradually he had the partner close the distance over a period of days till Duke paid no attention to the noise of the firearm. During the next month Jack increased the noise factors by progressing to .22 Longs, .22 Long Rifles, a .410 shotgun, a 20-gauge shotgun, and finally a 12-gauge shotgun.

Later, on numerous occasions, Jack took Duke to a local trap and skeet club. On the first trip he parked his station wagon 100 yards from the firing line and sat in the car talking and playing with the dog. The next trip he parked closer to the gunners and opened the car's windows so the reports of the firearms were very distinct. Within several weeks Jack was working with the dog close to the target shooters. By now the dog loved swimming and had no fear of the blasts of firearms.

Jack spent hour after hour during the summer teaching Duke retrieving techniques. First he shot a couple of barnyard pigeons and tied their wings around a piece of cork he had carved to the size of a duck's body. He started training sessions by pitching the unit into water within sight of the dog and letting him fetch it at will. Then, after the dog became enthused with the game, Jack taught him to "stay" until commanded to fetch. Finally he hid the simulated duck and taught Duke to find it by use of hand and arm signals.

By the time that fall's duck season opened Duke was seven months old, he had the benefit of at least one hundred hours of dedicated training, and he and his master were great buddies. It wasn't long after the real shooting began that Duke sensed Jack's great love for duck hunting. It rubbed off on the dog, he knew what he was supposed to do, and he did it with enthusiasm.

Duke lived to fourteen years of age and he was the greatest duck dog I ever saw. Whenever his master picked up a shotgun the dog went wild with joy because he figured he was going hunting. With additional training he became a great trailer, flusher, and retriever of ruffed grouse and woodcock. For years he even loved to retrieve crows. But one day a crippled crow pecked him in his eye and he lost a

lot of interest in the black bandits. After that experience he wouldn't pick up a fallen crow till he pawed it a few times to make sure it was dead.

There were three things that made Duke such an outstanding duck dog. He was purchased young and so had but one master, he received dedicated training, and he developed a natural love for hunting. It's my contention that those three factors are all-important. My other two anecdotes will serve to illustrate.

A hunting friend of Jack's was so impressed with Duke when he was in his prime that he decided to buy a duck dog. He selected a golden retriever and he purchased the dog as a pup. The problem was that this fellow was so tied up with his business that he didn't have the opportunity to properly train the dog. The animal spent so much time in his pen that he would practically run wild when released. By the time he quieted down enough for training sessions he was more interested in playing than learning.

Two years later his owner finally decided to ship him off to a professional trainer. The trainer worked wonders with the dog, but—as so often happens—the dog performed well for his teacher but not for his master. When the two men hunted with the golden his work was excellent, but when his master hunted him alone the dog was confused. Since this man didn't have time to continue the dog's training his potential was never reached. The moral? The dog with a master who has the time, knowledge, and desire for proper training is the dog who will be a great performer.

Knowledge and desire are the key words. My third anecdote makes that point.

A friend of mine made a duck- and goose-hunting trip to Manitoba several years ago. He was guided by a game warden's son who was training two young black Labradors. The Labs had been hunting almost every day for six weeks that year and they had had an entire season of experience the previous fall. In short, they were already dedicated and knowledgeable duck dogs. When my friend's hunt was finished he purchased one of the Labs and brought him home. That was four years ago. Today the dog won't even hunt.

What happened was that my friend had no desire to continue the dog's training, or even to house him properly. He had no dog pen. The Lab slept in the house in winter, outside the rest of the year. He roamed at will, tipped over garbage cans when he felt like it, and generally became a lazy mutt. He is a friendly animal, but he is now so fat and out of condition that he has no interest in hunting.

Everything I've said so far in this chapter is to emphasize an all-important rule: People who are interested in dogs are *really* interested in dogs. A waterfowler who has a great dog owns a winner simply because nothing else will suffice. Without exception he is a dedicated dog fancier. The efforts he spends in training his retriever are not chores, they're labors of love. To this man his dog is much more than an animal, he is a partner who is more than worthy of year-round fine care, companionship, and training. If you're not one of these types the odds are high that you won't own a good duck dog. You may wind up with a fine pet, but it takes work to develop a fine hunting dog.

There are many things to consider in selecting a breed to suit your purposes. The various species of Labradors are best known as waterfowl retrievers, but that doesn't mean all Labs are good. Some are worthless. Most veteran retriever men will say that a springer has several drawbacks. I've already pointed out that one springer was the best duck dog I ever hunted over. I'll raise a few more eyebrows by saying that I once was acquainted with a German short-haired pointer that was a tremendous duck dog. A friend of mine purchased and trained him for grouse hunting, but when that dog found out what duck hunting was all about he loved it. Some years back I hunted with a North Dakota game biologist who owned a small terrier. That tiny black dog fetched ducks with an enthusiasm that couldn't be topped.

I'm certainly not saying that short-haired pointers and terriers should be considered as duck dogs. They may be great retrievers when the going is easy and the weather comfortable, but they're not built physically for the overall tough conditions of duck hunting. The serious duck hunter wants a dog that can take extremes of weather and enjoy it. The animal must also possess the strength to work in rough waters, swift currents, and mucky marshes. Those are the main factors that narrow down the number of breeds that are considered best for waterfowling.

The physically toughest retriever is the Chesapeake Bay dog. He has a double coat that enables him to withstand the roughest and coldest conditions. He'll play around in ice-crusted muck and water with pure enthusiasm when other breeds look for shelter. If you hunt in the northern states, and most of your gunning is devoted to ducks and geese, the Ches may be for you.

The objections to the breed are two. They are big, some weighing up to 100 pounds, and they are not easy to train. These dogs have minds of their own and

a tendency to do things their way. They are bull-headed. It usually takes a dedicated owner many frustrating hours to teach a Ches who the boss really is. Sometimes a good bit of physical persuasion is required to overcome this stubborn attitude. On the other hand, if a Chesapeake gets enough opportunity to hunt he often learns the tricks of the trade more or less by desire, because he naturally loves to retrieve under tough conditions.

Another thing to keep in mind is that the Ches usually doesn't work out well as an upland retriever. His natural desires are to bull ahead and pick up a fallen bird. He doesn't have much use for trailing by scent and wasting time with live birds. This is perhaps the most important factor in the breed's decline in popularity. Most modern waterfowlers are also upland hunters and they want dogs that will work well in both sports.

The various breeds of spaniels (springers and Brittanies particularly) and the golden retriever share the opposite side of the picture. In addition to style and beauty they are affectionate, are relatively easy to train, and they'll work well with birds such as grouse and pheasants. Many seasoned dog men claim that spaniels are more efficient at working with pheasants than they are at working with waterfowl. From my experience I'll say that it depends on the individual dog. Some naturally prefer one sport to another. But if you get a springer that loves water, you'll have the raw material for a great duck dog. Goldens are better bets for big-water gunners because they are larger and stronger than spaniels.

Spaniels and goldens are ideal family dogs, since they are "soft" in temperament. Their greatest drawbacks as retrievers are physical. They can't come close to the Chesapeake's ability to withstand arduous weather. If the going gets too tough they'll lose interest. Another problem centers on their long hair. The coats of these dogs collect burrs, mud, and other items. They also collect a lot of water that flies all over blinds, boats, and hunters when the animals shake. Their coats require attention to prevent matting.

When you consider the facts I've discussed it becomes apparent why Labs are the most popular retrievers. They strike a happy medium in size and they best combine the strong points of the other breeds. They're available in solid black and solid yellow colors. Black Labs are most common. A Lab isn't as strong as a Chesapeake, but he is considerably stronger than a spaniel and he has a bit of an edge over a golden. He has short hair, he loves water, and he is relatively easy to train.

In addition he is usually a fine family dog. I say usually because some Labs can't seem to contain their enthusiasm in a house. They are big enough so that their playful antics may be a problem around small children or delicate furnishings.

With proper training Labs work well on upland birds. They will stay close in and they truly enjoy scenting, trailing, flushing, and retrieving. I'll emphasize proper training because the Lab's basic nature is that of a hard-driving, do-everything-in-a-hurry animal. However, these dogs are very trainable and they have a natural desire to please their masters. Of all the retriever breeds they present the fewest problems to the amateur trainer with waterfowl hunting in mind.

Labrador retriever is the most popular waterfowling dog. He has short hair, a natural affinity for water, and is easy to train.

Although not as hardy as some dogs, the golden retriever works well on water-fowl and is an ideal pet. His long hair requires attention to prevent matting.

The Irish water spaniel deserves mention too. Back in the great days of the old-timers this breed ranked as one of the premier duck dogs. Their popularity has decreased for several reasons. Their appearance isn't too appealing to a lot of people, and they are rather difficult to train. Of more importance was the introduction of Labs and golden retrievers, which surpassed these spaniels in trainability and looks.

General comparisons between the various breeds of retrievers should be only starting points for the man who wants to buy a duck dog. A sportsman should

seek advice from every hunting-dog owner he knows. If possible he should talk to a professional trainer and visit field trials to watch the various breeds in action. He should visit his local library and gather as much information as he can about the breeds he's interested in. He should also consider the type of waterfowling he'll do and the type of terrain where he'll do it. A gunner in Texas doesn't need a Chesapeake, except, possibly, if he hunts coastal waters. A springer might be a bad bet for a northern Maine hunter who contends with ice conditions. The stronger dogs are best bets for big-water conditions; smaller animals will serve well for the waterfowler who limits most of his gunning to potholes and streams.

I should note here my thoughts about professional trainers. The good ones are great. A professional can take your dog and work him into an excellent retriever, provided, of course, that the animal has an inborn desire to hunt. Occasionally, particular individual dogs of the best breeds turn up shy and lack the desire to learn. There is nothing you can do with these animals. If you keep working with them you'll be throwing your time and money away. A professional can tell if a dog has the potential of a good hunter in short order.

The case of a local hunter proves the point. He purchased a springer pup, worked unsuccessfully with him for weeks, then hired a professional. The pro worked the dog for a week, then told the owner, "If you want a fireside dog this is a good one, but he won't make a retriever. He's shy, he has no use for work, and he doesn't like to hunt."

The hunter decided the pro wasn't proficient, so he hired another man. The second trainer came up with the same answer, and it made the hunter mad. He was well off financially and he insisted that the trainer keep the dog for six months. At the end of that period the animal had improved, but he was not even close to being a good working retriever. The dog's owner was now out several hundred dollars and had nothing to show for his money. He sold the springer and has never owned another dog since. That's an unusual case, but you should know that some dogs—of any species—just won't make the grade.

Some wealthy hunters leave their dogs with trainers year-round except for the hunting season. These dogs are so well trained that they usually work out well for part-time masters. But the subject is hardly worth discussing, since so few of us are in the required financial brackets for that type of program.

If you won't miss a few hundred dollars spent on training your dog it will be money well spent. The best bet is to let a trainer handle your dog when he's a

youngster and most susceptible to teaching. A trainer's experience will get the dog started correctly with behavior and retrieving patterns. When you take over the job you'll have a dog that knows what he is supposed to do and when he's supposed to do it. If you diligently continue the program laid out by your trainer, you'll have a fine dog.

A friend of mine who has owned many fine gunning dogs explains it this way:

"I always buy my pups from a trainer who recommends which dog I should purchase. Of course it goes without saying that you should always pick a pup from pedigreed stock. The cost is higher than for nondescript bloodlines, but a good dog costs no more to feed and house than a poor one. Pedigreed dogs are much more likely to have the combinations of strength, intelligence, and hunting instincts that are all-important. A good trainer knows all these things, so he obviously can make the best selection for you.

"Anyway, I'll buy a pup and leave it with the trainer for several months. When I pick the dog up that's the last he'll likely see of the professional, since I strongly believe in the theory of one-master dogs. From there on in I work the dog and he hunts for me, nobody else. Sure, I've spent some money, but I have a retriever of top stock with an ideal beginning to his education. All I have to do is keep working with the dog to keep him on the ball. Keep in mind that a young dog accepts a new and permanent master much more readily than an older animal. My system has always worked great and I surely recommend it."

If you choose to train your own puppy the first step on the road to success is to gain the dog's affection and confidence. The best way to do this is to spend as much time as possible with him. The trick is to be a fine companion . . . most of the time. The dog must learn from the beginning who's boss. When he does something wrong, whap him with a folded newspaper. The paper will make noise and it will sting when it hits, but it won't hurt him. I've found that the folded-newspaper trick works wonders with puppies, but it doesn't make a big impression on older dogs. Overly kind treatment won't work with gunning dogs. Occasional friendly pats on the head or rubbings of the ears are all retrievers want or expect. Treat your dog somewhat as you would a friendly coworker. Show that you enjoy his company, but make it plain by your actions that you expect him to work with you.

A good dog deserves good housing. Personally I believe that retrievers should not be allowed to spend nights in a family home except in southern states. A duck

dog has to be tough, and he should adjust to seasonal temperature changes by sleeping outside in his own house. He should have an insulated dog house with a straw bed. The house should be inside a fenced pen containing a concrete floor. A portion of the pen should offer shade. You must be sure that the pen is kept clean, that the straw is changed occasionally, and that your dog always has drinking water.

I don't object to my dogs being in my home occasionally during normal activity hours. This is fine from a companion standpoint, but it's too much coddling at night. Retrievers are bred to withstand cold and nasty weather. The more they're in it the thicker and more waterproof their coats become. The dog that spends the night by his master's warm bedside is a dog that will shiver and shake after he fetches his first duck the next morning. The more time your dog spends outdoors the better he'll work for you.

The worst things that can happen to a puppy retriever are for it to become gunshy or water-shy. I described how to avoid these problems early in this chapter. I'll add here that each puppy reacts differently to his introductions to firearms and water. Just a few days ago I went with a friend while he showed his new Lab pup a body of water for the first time. The dog took one look at the lake, rushed ahead at full speed, and jumped into the water with a splash. He paddled around with great excitement and thoroughly enjoyed himself.

That's unusual, since most pups take to water and the sounds of gunfire gradually. The time required to indoctrinate them varies with each individual dog. The only rule is to watch the reactions of your pup. If he seems nervous your training sessions will have to be stretched out. Don't rush them since a dog that's gunshy or water-shy is worthless to the waterfowler.

I've only seen one gunshy dog that amounted to anything. She loved to retrieve so much that she gladly went with her owner on shore-blind hunts. But every time the gunners went into action the golden tucked her tail between her legs and ran back into the woods. When the shooting was over she returned to the shoreline and retrieved fallen birds with skill and enthusiasm. She eventually got over her great fear of guns to some extent, but she always cowered when the shooting began. If that golden had been properly trained as a pup she would have been an outstanding gunning dog.

The general training factors are obedience, basic retrieving, steadiness, and advanced retrieving.

By the time a pup is three or four months old he is mature enough to understand that you are trying to teach him something and not just playing. He will learn as a child learns, and like a child he will require time to learn the habits you want him to follow. If you can spend half an hour every other day with him you should be able to turn him into a working retriever in about three months. There isn't room in a single chapter to go into the details—several entire books are available on the training and care of gun dogs—but I'll mention a few highlights.

Early obedience training should be taught on leash, since you must have a quick system of making your pup react to your commands. Off the leash he is free to do as he pleases. Hold training sessions in a relatively isolated area, since cars, people, and other dogs are sure to distract his attention. A back alley or a vacant lot are good bets if you live in a large city. Open fields are tops if your home is in a small town or the country. Eventually, of course, your dog should be so well trained that you can take him anywhere and have him under complete control with voice and hand signals. The basic commands are "sit, "heel," "stay," and "come."

Most amateurs use the "natural" system of teaching a dog to retrieve, while professionals favor the "force" system. The force system involves the use of a training collar which applies pressure to the dog's neck, a piece of training rope, and a fetching object. You apply collar pressure when you give commands so that the dog quickly learns what you want him to do. For example, if your pup picks up the fetching object, but tends to drop it before bringing it back, application of collar pressure will convince him he's doing something wrong.

Another advantage of the force system is that the dog realizes that you are teaching him something and that if he doesn't do as bid he'll hurt. He soon learns to be obedient and that a halfway job won't suffice. The system works great for professionals because they recognize the individual traits of various dogs. Too-anxious training can turn one animal into a cowed and cringing dog, but it may be just the ticket for another.

The "natural" system is easier and safer for the amateur. This system begins with tossing a fetching object in front of the puppy and saying "fetch." The use of an old glove as a fetching object is fine, since it's soft and the dog associates its scent with his master. The game is played over and over until the dog understands the command and what it means. Eventually the distance is increased. Then you become more exacting about his understanding that he must bring the object to you and deliver it. Reward his good jobs with tidbits of food. He'll soon realize that

he doesn't get the food unless he satisfies you. Conduct training sessions when the dog isn't too hungry, for if he is, he'll be more interested in eating than fetching.

After the dog is retrieving promptly it's time to substitute a scented dummy for the glove. You can purchase special dummies for this purpose in sporting-goods stores, or you can make your own. You can buy the scent separately to apply to your dummy, or you can use old duck wings saved for the purpose of attaching to the fetching object.

As the weeks of training go on the pupil is taught to stay in position till told to fetch. First the object is thrown while the dog is held. After this lesson is learned the dog should be taught to stay in one spot while you walk off a few yards and throw the object. Of course the dog is to remain still until commanded to move by the word "fetch."

After this come hand-signal lessons to aid the dog in finding a hidden dummy and training sessions in water and possibly from blinds. He should also be trained on doubles (two fetching objects) so he'll know that his job isn't always done with a single retrieve. If the dog has a hard mouth (bites too hard on the object), a device will have to be rigged to cure the flaw. This can be done by driving nails into the object and bending over their heads, or by wrapping the device with thin strips of sandpaper. In either case the dog's teeth will strike hard, unpleasant items and he'll learn to carry lightly.

Training and proper housing are the biggest chores connected with owning a fine dog, but you'll also have other responsibilities. Grooming, proper shots for worms, proper feeding, and off-season conditioning are all parts of the act. It's a long, slow process of making a fine retriever out of a playful puppy; but life has few finer moments than watching a top gun dog perform.

In addition to being a fine companion your dog will also be a conservationist. A dogless hunter will recover some of his cripples but he won't go home with nearly as many as the man with a retriever. It has been said that such a man is handicapping himself almost as much as if he attempted to hunt waterfowl without a boat. That may be, but I contend that the reason more and more hunters are using dogs is far more emotional. They've simply discovered how much more enjoyable the sport is when practiced with a fine retriever.

26

Proper Home Care of Waterfowl

This duck (or goose) story begins where most end. The day is over, the last flocks have whipped by, the sun has faded, and the big shoot is memory. Now comes a perturbing thought to somewhat dampen righteous enthusiasm: "Who's going to take care of these birds?"

If you are like most modern hunters, casting a hopeful glance at the feminine parties will get you nothing better than a knowing chuckle, or maybe even a "You shot 'em, you clean 'em!" In the long run, this is the better deal anyway. It's part of the atmosphere that goes with the sport. It's also a great feeling to know that you personally have given your choice wild game the expert care it deserves. Such care can be quick and easy if you go at it right.

The biggest headache is removing the seemingly endless layers of down and feathers. The so-called waxing process is the ticket here. If used properly, your birds will come up so clean you will amaze yourself. If this is enough to whet your interest, let's get at it, going through the complete process step by step.

My first rule is to clean my birds the day I shoot them. Commercial meat-packing plant operators wouldn't think of killing an animal and then hanging it a few days before cleaning the carcass. They know that meat spoilage in an uncleaned animal begins soon after death. I feel the same way about game meat.

Assuming we have four birds to prepare, we'll start by rough-plucking two. Here you give your ducks about the same treatment you would any game bird. Cut the wings off at the body with a pair of heavy shears, then the legs just above the second joint. You can also use a sharp knife to notch the bones, then snap them the same way you'd break a stick. Leave the head on; this will serve as handle to hold the bird during later waxing operations. Take off the heavy feathers. Don't fool with any of the down, as this is merely prolonging the job; the wax will later whip it off in a flash.

When finished with rough-feathering the first two birds take an ordinary laundry pail and fill it three-quarters full with hot water. Put it on the stove and switch your burner to high. Add three cakes of paraffin to your hot water. Fill another bucket with cold water and remove it to your area of operations.

While you're rough-plucking your second two birds the wax is melting in the hot water on the stove. About ten minutes will reduce the wax to liquid floating on the water. Now remove the hot-water bucket to your plucking area. Grasp a plucked duck by its head, insert slowly through the melted wax, remove slowly, and repeat once. This procedure impregnates every piece of down with an overall coating of melted wax. Hold the duck above water a few seconds until dripping ceases, then place the bird in a pail of cold water. In a few minutes the paraffin will harden and your prize is ready for peeling.

In the wax removal process, you simply work the material off in much the same manner as peeling an orange, only it comes off much easier, and with it comes every pinfeather and piece of down on the duck. Your bird will be as slick and clean as this book you're reading.

Now let's toss in a few pointers to make your endeavors as efficient as possible. Always use enough wax (any type of home canning paraffin) in your melt. Too much is better than too little. A complete bond must be formed over the entire bird or you will be spending much of your time pulling off many tiny pieces instead of a few large sections. You won't go wrong if you use one cake of wax per duck. Remember to keep your water hot enough. One laundry pail three-quarters full of near-boiling water under the layer of wax melt is sufficient for five or six birds. More than this number will require periodic reheating. Always melt enough wax to dip two or three birds in succession. Experience will prove the rule. A proper job may occasionally require an additional dip for the second or third bird. Be sure

Best way to remove down and pinfeathers from birds is to dip them into paraffin-water solution. When paraffin hardens, you peel it off, leaving birds absolutely clean.

Here's how properly cleaned ducks should look. Wings have been cut off, and the legs just above second joint.

wax is completely cooled and hardened before attempting to remove; only then does it form its best bond.

Sound simple enough? After trying it a couple of times you will establish your own routine and timing and never again will you dread the preparation of that choice duck dinner. In fact, you will be putting your completely cleaned birds in the freezer in about half your usual time. Which gets us to the next point in this routine—proper freezer preparation.

There are almost as many recommended ways of wrapping meat for the freezer as there are species of wild waterfowl. Most provide reasonable protection but offer little convenience and adaptation to special problems of gamebirds. Through the

years I've tried many methods and I've finally evolved one system which works to perfection. All of my ducks are wrapped individually to allow immediate identification, ease of storage and handling, best protection, and ability to defrost only the exact amount to meet any occasion. What else could you possibly want? It's done like this.

After birds are thoroughly cleaned, rinse with cold water and dry inside and out with paper towels. The actual wrapping and freezing can be done immediately, but I prefer to season my birds a couple of days in an open tray in the refrigerator. I don't know if it helps the meat but it does free the duck from all moisture and makes a cleaner and neater job, if nothing else.

Materials consist of plastic freezer bags, a three-quarter-inch roll of masking tape and a crayon or pen for identification markings. Some of the bigger ducks (or geese) will require larger bags, but procedure remains the same. Each bird requires three pieces of tape; one to go around the breast over the clipped-off wing bones, another around the legs, and the third to seal the bag. Length of these strips depends on the size of the various birds but average would be 15 inches, 5 inches, and 1 inch.

A handy system is to rip off the required number of tape strips for all your birds and stick the ends to an easy-to-reach door or wall above your work area. Now simply insert a bird into a sack neck first until he bottoms out at the end of the bag. Be careful the sharp ends of wing and leg bones don't puncture the sides. Press the wing bones in against the body, make sure all air is displaced out of bottom of bag, and tightly wrap the longest piece of tape directly over the bones on the outside of the bag.

Follow the same procedure with the legs, first pressing the sharp ends of the bones in tight against the meat and then taping them in position. The theory here is simply to locate the sharp bones in a position where they cannot puncture the sides of the bag and then to hold them in such a position throughout the frozen period. Now grasp the edges of the open end of the bag and twist the neck to seal off all air. Double over and fasten securely with the small piece of tape.

The final operation is identification, which is marked on the breast tape. I indicate the species, the date, and the quality. Quality depends on whether the bird is prime and how badly it was shot. A big, fat, light-skinned mallard with very few shot holes goes into the freezer marked capital A. The same bird with considerable

shot might be marked A- or B. The system is purely personal. Perhaps a scrawny bluebill might drop way down to D-. However you work it you can't beat the idea for quick reference.

Now that we're checked out on details, consider what you have. First, your game bird is cleaned to perfection; a choice piece of delicious meat 100 percent ready to shove into oven or freezer. Should he go in the freezer you have him stored in an individual package, not jammed together in a bulky mass. You have complete identification, enabling immediate choice as to quality, age in the freezer, and appearance. Then when you consider that you have given your game the best possible care with what is also the easiest and quickest method, you can lick your chops over anticipation of wonderful game dinners on the cold winter nights ahead.

Small geese can be waxed in the same manner as ducks, but you can't completely immerse large geese in a normal-size laundry bucket. I lick that problem by processing the big birds in two steps.

Use the same preliminary steps you would with ducks, except for leaving one leg fully intact. Then dip the bird through the molten wax with the normal head hold. This procedure will enable you to wax at least half the body. Now set the bird aside in a cool area. Don't dip the carcass in cold water at this point, because if water soaks the down and pinfeathers the wax will not bind to them. A good trick is to lay your goose on newspaper placed on a cold basement floor.

Birds go into plastic freezer bags and are marked for future identification.

Cold roast duck is the perfect lunch for hunters in a blind.

It will take ten or fifteen minutes for the paraffin to harden, then you're ready for the next step. During this time you'll have to reheat your wax-water mixture, because your binding material must be fully melted. Now cut off the head of your goose. Reverse the body and dip it neck first, using the leg as a handhold. Immerse the body so that the liquid wax overlaps the previously processed body area. Now you can dip the entire bird in cold water, let the paraffin harden, then strip the bird in the standard manner I've explained.

27

Charcoaled Waterfowl

The waterfowl hunter with an outdoor charcoal rotisserie can discover a gold mine in the field of wildfowl cookery. His dinners can be prepared in the easiest, most efficient, tastiest and tenderest manner yet devised. This is a deal the old-timers never heard of.

Now it can be fun to cook your birds, to watch as they slowly turn golden brown, and to relive the thrills of the hunt with each revolution of the spit. It's so simple that it's almost a crime not to use this method. Charcoal flavor and the electric spit will turn poor ducks or geese into a feast, prime birds into the greatest wildlife eating adventure you can sit down to.

Consider these pleasant facts:

Rotisserie work with most birds, wild or tame, involves constant attention to detail. They are thin-skinned and dry. The terrific heat of charcoal necessitates frequent basting. Not so with ducks and geese; they are thick-skinned and naturally oily. The hot coals singe the skin, retaining juices in the meat. The oils that cook out tend to flow around the birds as they turn on the spit, a built-in basting process. Excess oils drip off. Does it sound better than the old way of letting your choice birds bubble in their own grease in the oven? It can't help but be better!

Most spit-work with chickens and thin-skinned fowl involves lengthy preparation of tying wings and feet and necks together so that loose extremities won't flop all

over during the turning operation. In comparison, wild waterfowl are of such a compact nature that this fancy trussing is unnecessary.

And when the cooking and eating are done, there is no mountain of mess staring everybody in the face—no grease-splattered stove, no roasting pans to wire-brush, no smelly and smoky kitchen. It's done like this:

Salt and pepper birds inside and out. On the average rotisserie you can figure on cooking four to six ducks or two geese. There are three tricks to keep firmly in mind. Follow these secrets and your wild waterfowl dinner can't help but be a gourmet's delight.

1. Your birds should be arranged solidly on the spit so that they will turn firmly and smoothly. This is arranged by making sure the metal rod penetrates through solid bone on both ends of the bird. Start with the backbone approximately 2 inches ahead of the tail. Force the rod through this bone and into the body cavity on a line with the breastbone. Continue through the forward section of the breastbone and out through the opposite side. Repeat with each bird. Alternate the forward thrust through right and left breastbones. This technique will balance the weight of all birds on the spit.

2. To end up with a crisp, juicy bird, a hot fire is necessary to quickly singe the outside skin. Use plenty of coals and wait until they are red-hot before starting to cook. Directly beneath the birds build a trench through the coals with tinfoil to catch excess drippings. A drip pan will also suffice. In any event, if the drippings are allowed to drop on hot coals they will flame up, burning or cooking your ducks too rapidly. The object is a fire hot enough to quickly crisp the skin, thereby retaining body juices, but not so hot as to burn and evaporate natural tenderness. This can't happen if flame is absent.

3. Perhaps most important, don't underestimate the tremendous heat of charcoal. The time required to cook your birds will be much less than in the oven. Using a fork to check tenderness is a good test of when cooking is complete. So is observing color of the skin; a rich golden-brown usually denotes cooking is nearly finished.

An hour will do the job with average ducks, one and one-half hours with geese. Big, grain-fed mallards or wild-celery-fed canvasbacks will naturally take somewhat longer than smaller ducks such as teal or bufflehead. The beauty of this type of

cooking is that the whole process is going on in plain sight. If the fire seems too hot, spread it out a bit.

A few other suggestions are also in order. If you like bread dressing in your ducks, go right ahead and use it just as you would with over-cooked birds. Remember, though, to sew up body cavities so the dressing won't spill out while the birds are turning. Keep in mind that the hottest part of the fire is in the middle of the

To impale a bird properly on spit, force rod through backbone about 2 inches ahead of tail, out through forward section of breastbone. Alternate right and left breastbone with each bird.

When all birds are on spit (above), snug them together by tightening rod forks.

Coals should be red hot when cooking begins (left), in order to singe outside skin quickly and retain body juices. Ducks will be done in an hour; geese take half hour longer.

bed of charcoals; put the biggest ducks in the middle of the spit and the small ones on the outsides. Giblets should be wrapped in two layers of foil and placed near the outside edge of the coals.

That's about all there is to it. Try it once and you'll dig into the best waterfowl dinner you ever had. In fact, if you're like me, you'll even be trying to figure a way to charcoal your birds outside in the middle of winter. They are that delicious!

Regular Grilling

I refined the rotisserie technique many years ago when this spit system of cooking outdoors was first becoming popular. Though I knew I had an ideal method for cooking waterfowl, I was disturbed by the fact that the hunter who didn't own a rotisserie was out of luck. I was determined to discover a way to cook ducks and geese on a regular charcoal grill, the type that just about everybody has in his backyard.

I burned up a lot of ducks before I figured out an answer to the problem of flaming oils. It's the same problem you have in charcoaling overly fat hamburgers or steaks, except that it's greatly magnified because there is so much fat in most species of waterfowl. As that fat heats up it turns to liquid oil. When this oil dribbles onto red-hot charcoal it immediately ignites. The resulting flames produce more heat, which in turn cooks more oil out of your birds. It takes only moments to have your birds engulfed in roaring flames.

You can squirt water onto the charcoal, but this trick will put out much of your fire and ruin the even heating you need for a proper cooking job. You can also close the dampers and the hood or lid of your charcoaler. This approach will put out the flames because it shuts off the supply of oxygen the flames require for burning, but it won't do a thing to stop the dribbling oils. As soon as you open the hood and oxygen returns to the coals, the flames immediately return.

I had just about decided that there was no way I could lick the problem when it dawned on me that if I could slow down the dribbling of oils I might have the answer. In other words, if the supply of oil reaching the coals was insufficient to produce flame the meat would cook in normal manner. After a lot of experimenting, I came up with the following system that works perfectly.

Take a sheet of heavy-duty aluminum foil that measures a bit less than twice the

diameter of your grill. Fold the sheet double. Smooth the doubled sheet out. Next, poke a great many tiny holes through the foil. These tiny holes eliminate the steady dribbling of oils because the liquid can drop through through the holes only as minute drops which sputter—not flame—as they hit the hot coals. The great number of holes in the foil spreads the oils out. This ensures that no concentration of oil hits the firebed in any one spot.

The best system I've found for the production of the holes is the combination of a kitchen fork and a cold burner on an electric stove. I lay my foil over the coils of the burner, then press down on the foil with a smoothing motion of the palm of my hand. This imprints the location of the coils. I then use the fork to stab holes through the narrow openings between coils. By repeating the operation several times I'm able to produce holes throughout the entire expanse of the foil. The object is to produce fork-hole patterns about half an inch apart.

When I first developed this system I cooked my ducks whole. This worked okay, but I later discovered that it's better to cut the birds in half (lengthwise) with game shears, then lay them on the foil-covered grill breast up. Because most of the oils are in the breasts and legs, this trick further slows down the dripping. It also produces a built-in basting system. Lastly, because half a duck is a normal serving per person, your birds are ready to serve as soon as they're cooked. And, of course, it's a lot easier to cut a cold duck in half than it is to cut a hot one.

I use the same system for cooking geese, except that I don't cut the big birds in half. They're not as oily as ducks, and I prefer to carve a whole goose as I do a turkey. Cooking time with the foil system is roughly the same as with the rotisserie technique.

One last tip. I build a mound of charcoal in the firebed (about two dozen or so briquets are enough) for fast ignition. When the briquets are glowing red I separate the mound and move half of the coals to the right side of the firebed, the other half to the left side. This produces even heat throughout the cooking unit, and eliminates extreme heat directly beneath the meat.

Because all charcoalers are different in some aspects of design, I can't tell you exactly how you should regulate your dampers. There are two major factors to keep in mind: low heat does a better cooking job than high heat, but if your two dampers are closed too much your fire will go out for lack of oxygen. In my charcoaler I get the best cooking heat with both dampers (top and bottom) set about halfway open.

28

How to Find Top Waterfowling

If you're a young duck hunter the odds are good you'll change jobs several times before you become an old duck hunter. Perhaps you'll move to another state or across the country. Wherever you go there will be waterfowling hot spots where local hunters find great sport, perhaps better shooting than you found at home.

There are several techniques for discovering where the action is, but you don't have to move to a strange area to use these techniques. Many gunners travel on out-of-state hunts. If you don't hire a guide and you don't know local people you're on your own. You're actually in the same boat as if you had changed your residence. We can go one step further. There can be little doubt that good waterfowling exists in places relatively close to your home town that you haven't discovered. I had this point proved to me again not long ago. The technique I used might be termed "buying information."

You don't actually buy information: you purchase something you need and you get the information as a by-product. I learned the system from a Montana game warden.

"Nonresident hunters make a big mistake out here," he said. "The average guy will go to a hardware or sporting-goods store to buy his license, but he won't buy anything else. Chances are he purchased shells, new socks and gloves, maybe a shirt or coat, food, or any of a dozen other items at home. He might have been able

to buy the same items out here for less money. The point is that if he drops money with local merchants he's in a fine spot to get good local information. If the merchant is a hunter he'll have up-to-the-minute dope on hot spots, top camping areas, condition of back-country roads, names of landowners, and all sorts of fine advice. He might not converse much if you don't buy anything, but he'll feel much more indebted if he's putting some of your money into his cash register."

Back to the incident mentioned earlier. Early in our duck season I heard about some great mallard shooting in an area of sloughs and swamps 30 miles south of my home. I had hunted there many years previous, so I knew where the area was. The day I hunted the place I was astounded at the number of mallards I saw leaving the swamps at dawn. I saw flocks of ducks containing hundreds of birds. Such flocks may not seem large to prairie hunters, but in my section of the country we seldom see flocks of puddlers numbering more than a dozen birds.

Late in the afternoon of that day a few mallards began returning to the swamps. I killed a couple and noted that their crops were stuffed with corn. That was an exciting discovery, because it meant that all those mallards were feeding in corn-fields somewhere within a 10- to 15-mile radius of my hunting site. But such a radius covers an enormous amount of country. Locating the right corn fields on my own would be like finding the proverbial needle in a haystack.

I remembered the Montana warden's advice, and I put his technique to work. I figured my best bets would be the small general stores located in farming country. At the time I was low on a season's supply of shotgun shells. I'd have to purchase shells soon anyway, so I decided to buy a box in each store I found till I got a definite lead on fields the ducks were using.

The next day I had four new boxes of high-base No. 6's before I hit paydirt. A middle-aged woman was tending the tiny roadside store. When I asked about ducks she looked at me as if I was asking about poison. "Ducks?" she grimaced. "I hope I don't see another duck for a long time. My husband shoots all those mallards and I have to clean 'em. Our freezer is half full of ducks. Before the season opened hundreds of mallards were feeding in fields all around here. They've moved out now. Fred says they're over east. He doesn't tell me where he goes hunting, but he sure comes home with ducks."

My next step was to purchase a variety of canned goods and other staples that are always needed at home. I also bought three more boxes of shells. By that time I learned that the lady's husband worked in a factory in a town 10 miles away. I

purchased a bottle of pop and a candy bar. While I worked on them I got a variety of information about the area, farming conditions, the lady's family, and how to cook ducks. Finally I asked if she thought Fred would guide me on a duck hunt.

"He might hunt with you, but I don't think he'd charge anything. Why don't you phone tonight when he's home? I'll tell him what you want."

As it happened, Fred didn't take me out because he wouldn't be able to hunt until the next weekend. But he did suggest I go on my own, and he told me the general area the mallards were using for feeding grounds. That was all I needed. The next evening on a scouting trip I watched hundreds of puddlers pour out of the sky and drop into a stubble corn field. I was sprawled in that stubble the following morning before dawn. I killed my limit of ducks in fifteen minutes.

If I moved to a state where I didn't know anybody and the country seemed strange, the first thing I would do is contact the state department of natural resources (DNR). I would write to the department's information and education section and explain my problem. I would say that I was new to the area, that I was a duck hunter, and that I would like general information on the state's waterfowling opportunities.

When you do this you'll get a lot more detailed information than you would expect. All state conservation departments now have waterfowl specialists. These men work with the duck and goose situation all year round. They have results of hunter surveys, kill statistics, waterfowl population centers, and similar types of information for all areas of the state. Much of this modern information is often available in printed form. One letter of inquiry will likely get you more general gunning information than you could dig up on your own in a year's time.

With these statistics you'll be able to pick potential waterfowling areas near your new home. The next step is to visit the local conservation officer within the area you pick. He'll be able to give you specific information, such as certain lakes where ducks normally build up, access points on marshes, which rivers are the best float-trip possibilities, and so forth. Not only will he be able to tell you these things, it's part of his job to pass on this type of information. If you're located in a coastal area he'll advise about hunting problems involving tides, location of blinds, and other special situations.

You're now ready to begin scouting trips and making investigations on your own. But before discussing the best techniques I want to make one all-important general point.

It's a fact that 10 percent of all waterfowlers—in any area in any state—bag 80 percent of the ducks and geese harvested. This small part of the hunting army represents the local experts. If you can get next to some of these men, meet them and establish friendships, you've got a big part of the problem licked. How to do this? One of the best bets is to join a local sportsman's club or Ducks Unlimited chapter. Show that you're interested in helping with club projects. It's on these work projects that you'll meet dedicated hunters and fishermen. If you can meet one expert waterfowler, and become friendly enough to be invited on a hunting trip, your quest for hot-spot information will be just about licked.

Conservation officers and sporting-goods dealers are other top sources for names of local waterfowling experts. If you're an expert in your own right you'll likely strike it rich when you introduce yourself to some of these men. The best hunters don't like to waste time with amateurs, but they're usually more than willing to talk shop with seasoned veterans. A good trick is to carry photographs of your prize oversize decoys, some of your hunting scenes showing you with a limit bag of birds, or pictures of your duck boat and other items of equipment. Expert duck and goose hunters are a close-knit clan. In the waterfowling game total strangers can become close friends in a hurry.

If you can't make out in that fashion there are several ways to develop your own store of information. Maps of local areas are a fine starting point. I discussed how to use maps for this purpose in Chapter 5. Highway maps offer a picture of general areas and roads, but topographic maps are tops for spotting water areas, contours of the land and all-important terrain factors. Go back to Chapter 5 for details on where to obtain these maps.

Lake contour maps (for inland hunters) and United States Geodetic Survey maps (for coastal hunters) are top bets. They show shoreline details—for locating ideal blind sites—and water depths for determining where you can place decoys. Water depth details also must be known by hunters working with tides and permanent blinds of the platform type. Many a beginning coastal hunter has made the mistake of building a blind in what appeared to be a perfect site during high tide. The problem, of course, is that during low tide the gunner finds himself surrounded by acres of mud with no ducks in sight.

Such mistakes aren't made by hunters who take the time to get good local advice and combine it with the benefits from studying maps. Atlantic Coast waterfowlers

should write to the Director, United States Coast and Geodetic Survey, Atlantic Coast, 439 West York Street, Norfolk, VA 23510. Gunners working the Pacific Coast should write to the Director, United States Coast and Geodetic Survey, Pacific Coast, 1801 Fairview Avenue East, Seattle, WA 98102. For the Great Lakes and connecting waters, the right address is the United States Lake Survey, 630 Federal Building, Detroit, MI 48226. When writing these agencies ask for a free illustrated index sheet that shows areas mapped and the prices of individual maps. You can easily pick out the ones covering the areas you're interested in. Then you can order specific maps at prices shown on the index sheet. Individual inland lake contour maps are available from state conservation departments.

Other top sources for maps are the U.S. Forest Service, the Bureau of Land Management, the United States Corps of Engineers, and various state agencies. You can't go wrong by writing the waterfowl specialist in your state DNR. He'll be able to tell you which state and federal maps will be of the most benefit for your particular situation, and he'll tell you where to get them. Many state departments have their top waterfowling areas mapped out in detail. Such maps are free.

Scouting trips and personal investigations of your own can uncover gold mines of information. The two techniques to use are scouting during closed seasons and scouting during open seasons. A different approach is used with each system. Let's take open-season scouting first.

Tom Westcott, a local duck hunter, knows how to use this technique perfectly. He moved to my town with no knowledge whatever of the area's waterfowling possibilities. I didn't know Tom at the time, but I knew of him through his son, who went to school with my son and played football with him. I often heard Tom's boy mention his dad's weekend hunting trips. I gathered that his hunts weren't too successful during the early part of his first season. But as the gunning weeks wore on I learned that Tom was finding his share of the shooting. I wondered how he did it. Later, after I met him, I found out.

"I was primarily interested in divers," he said. "I just asked questions in sporting-goods stores about which lakes in the area were the best diver waters. Then, when the flights came in, I spent a lot of days scouting instead of hunting. I trailered my boat to several different lakes and cruised slowly. I checked to see which areas held blinds. I looked for decoy layouts and I watched flying ducks to determine flight paths and feeding areas. It wasn't long before I discovered which lakes

attracted the most ducks, and the sections of those waters that offered the best gunning possibilities. That's when I started hunting, and I had fine luck."

I've used varieties of Tom's system several times to great advantage. Let's call the technique "looking for evidence."

One time in Saskatchewan a farmer said to my partner and myself, "If you fellows want to shoot a bunch of ducks you ought to head for Devil's Lake. I don't hunt myself, but my boys really rack 'em up down there. They don't use decoys. They just pick out the mallards and pass-shoot them as they fly over."

Bob and I thought we had a great lead, but when we arrived at the lake our hopes diminished. The lake was big and we couldn't spot any natural pass-shooting points or narrows.

"We'll have to find the spot," I said. "Let's walk down to the shoreline, then head in opposite directions. You head north along the water's edge and I'll walk south. Keep your eyes open for empty shotgun shells or matted places in high weeds where gunners have used natural blinds. If those guys were pass-shooting from a particular spot it's likely they left some evidence."

Eventually I came to a weedy flat that had looked inundated from a distance. I found it to be dry land instead of the mud that I'd been struggling through. The flat angled out into the lake in sort of a semicircle. As I walked on I began finding signs of evidence I was looking for. I spotted a few duck feathers, the type of breast feathers that are jolted loose when a duck killed in the air smacks into weeds or ground. Shortly, near the water's edge, I found a simple blind that wasn't much more than an opening in the reeds. Empty shotgun shells were scattered around the area. It was obvious that somebody had done a lot of shooting there.

I fired a shot in the air as a signal to Bob, then I waved him over when I caught his attention. We settled down in the potential hot spot to wait for ducks that should return to the lake after afternoon feeding sojourns in stubble fields. When the ducks arrived most of the flocks winged over our heads in ideal shooting range. We had a ball. I'll never know why those mallards used a flight path that routed directly over our weedy flat, but I can surely say that it was one of the best pass-shooting spots I've ever seen.

In many places natural pass-shooting meccas will be apparent to the observant gunner. Several of these situations come to mind. One is a long narrow finger of land separating a Wisconsin inland lake from Lake Michigan. Much of that strip of land consists of a mixture of wooded hills and high sand dunes. There are two

places where the dunes are lower. Those two spots are 100-yard-wide gaps in the hills. When diving ducks leave Lake Michigan to feed in the food-rich smaller lake, they almost always roar through those gaps. It's a trait of divers not to fly any higher than necessary when going directly to feeding areas. That trait provided my partners and me with many mornings of fine shooting. We crouched behind clumps of high dune grasses and pass-shot at bulletlike targets as they zipped by.

I recall a large lake in Texas that is almost divided by a long, brushy point. Ducks barely clear the thickets when they trade between the far ends of the lake. I've enjoyed wonderful shooting in that place.

Once in Manitoba, Ben Gregory, myself, and our Indian guide were jump-shooting puddlers from a canoe. We were moving slowly through reeds along the lake's shoreline when we noted flock after flock of divers crossing the north end of a small wooded island far out in the lake. There was no apparent reason why those birds would fly the same route, but it became more and more obvious that we had found a natural flyway. We cashed in the knowledge by paddling to the end of the island and hiding our canoe in brush. So many ducks flew by in easy shooting range that we picked our targets—all drakes.

These bonanzas resulted from observing the flying routes that ducks used in a given area. I can only recall one instance where I discovered a top shooting spot by accident, and even then it wasn't all a stroke of good luck.

I'm a firm believer in the theory that a successful waterfowler makes his own luck. That's why it bothered me no end when a local druggist always seemed to kill limits of early-season puddlers with no trouble at all. He wasn't even an avid duck hunter. He owned no decoys and no boats, and he wouldn't think of going hunting unless the day showed balmy Indian-summer weather. Such a man seldom finds fast shooting, but this fellow would bring his birds to his drugstore to prove his triumphs. It was a source of wonderment to several veteran hunters, myself included.

The word was that the druggist found his action somewhere on the Sable River, a long waterway that flows through several counties. It's a good float-hunting stream. I've made scores of trips down its crooked currents. It was on one of those trips that I saw the druggist walking near the river's edge. That discovery led to some answers.

In the first place the area was far from any roads or trails that I knew of. If the man didn't own a boat, how did he get in there? I also surmised that he wasn't

the type who enjoyed walking. There had to be some kind of a trail allowing him to drive close to the area. The next day I made another float trip and I pulled my little duck boat into shoreline brush near where I had seen the man. I walked into the woods and soon came to a hill. I climbed the slope with the intention of getting a bearing on my location. The top of the hill turned out to be an abandoned farm field grown thick with weeds. Something odd caught my eyes.

I thought I was seeing things when I stared at what appeared to be a weathered duck blind in the middle of the field. "Couldn't be," I mused to myself. "There isn't any water near that place."

Closer inspection showed that the construction was indeed a vintage and recently used shooting station. Duck feathers and empty shotgun shells were much in evidence. I was utterly confused until I analyzed the geographic position of the spot. About 100 yards to the west I saw the river's surface glimmering behind a stand of hardwoods. I walked east to the edge of the field and discovered the river again almost straight below me at the bottom of the hill. Then the answer dawned on me. The blind was located in a narrow neck of land where the river flowed in a huge horseshoe shape. To the west the currents turned sharply north for a quarter of a mile, then routed east, and finally back southwesterly to the spot below the hill where they turned east again.

The answer was now obvious. To a flying duck the big horseshoe bend was clearly visible. At this particular place the birds wouldn't bother following the route of the river. They saved time by crossing over the high field. Somehow the druggist had observed this characteristic and had built his blind directly under a natural flyway. How he got to the spot was also obvious when I spotted abandoned farm buildings near the south edge of the field. There had to be some sort of trail road into the old farm. When I confronted him with the results of my discovery he seemed amused. "I've often wondered how long it would take somebody to find my blind," he grinned. "The property belongs to my uncle, and it's posted on the front. Tell you what. You can hunt from the place as long as you let me know when you're going to use it."

That experience ties in closely with the advantages to be gained from scouting during closed seasons. In this case I'm referring to watching flights of local puddlers to determine where they go, where they come from, and what flyway routes they use. If I'd happened to be scouting early-fall flights of mallards in that particular area it's a good bet I'd have found the spot on my own. In any event, just

getting out in duck country before gunning begins is always a good bet for finding hotspots.

The best trick for locating farm-country ducks is to ask the people who are familiar with the hot spots for information. You won't get much dope if you just drive into a farmer's yard and ask him if he knows where you can hunt ducks. Maybe he does and maybe he doesn't, but he isn't going to pass on information unless he wants to. You have to get him into a position where he is genuinely interested in helping your hunting efforts. There are several ways of doing this.

I've found great duck-shooting opportunities because I also enjoy crow hunting. Some farmers hate crows. If you help a man eliminate some of the crows that plague him you'll make friends in a hurry. In addition you increase your gunning activity. During all my crow hunts (gaining shooting permission is almost a foregone conclusion) I always question my host about fall duck-hunting possibilities. If you've helped the farmer he'll more than likely help you.

Many farmers are also bothered by barnyard pigeons. When these birds take up residence in a barn they can make a mess of stored grain, machinery, and equipment with their droppings from rafters. Find a farmer who wants to get rid of his problem pigeons and you'll find some exciting shotgunning in addition to a friendly contact. The pigeons aren't hard to locate. When you spot a few sitting on the peak of a barn roof you can bet there are many more inside the structure. The procedure from there is easy. Simply stop and tell the farmer that you noticed the birds. Make the suggestion that if he wants to get rid of them you'll gladly help him. Explain that you won't shoot near the buildings and that all your shots will be at flying targets. The technique is to flush the birds from the barn, then wait outside for incoming shots as the pigeons return.

A friend of mine is very successful with the photography system. First he finds farmlands harboring potholes or small marshes. Then he contacts the landowner and explains that he enjoys taking pictures of farm buildings. His key to success is promising the owner an 8 × 10 glossy print of his best photo. When he delivers the picture, or pictures, he is well on his way to having found a new friend. He doesn't begin talking duck hunting until a fine relationship is well cemented.

Another system to use is to buy something from the landowner. Many farmers have truck gardens, and they welcome summer customers. Not only do you make a new contact but you'll be getting better produce and lower prices than you'll find in city stores. This is another version of the information-buying technique I men-

tioned early in this chapter. The difference is that in this case you're trying to get fine hunting dope during off seasons. Such farmers advertise their products with roadside signs.

The most unusual technique I know of is used by a friend who isn't a duck hunter. He employs his method to locate grouse swales and pheasant covers. He would be just as successful if he were looking for duck hot spots. His secret is taking his family to the increasingly popular rural church dinners. These summer get-together dinners are staged as money-raising stunts by many church congregations. The meals are huge, delicious, and reasonably priced. Tickets are available to the public.

"The point is," George says, "that I meet a lot of farmers at these sessions. I'm meeting them at a time when I'm well scrubbed and neatly dressed. In other words I don't look as much like a bum as I would in my hunting clothes. When I meet these men I introduce them to my wife and children. I don't even mention hunting until we become fairly well acquainted and I've established the fact that I'm a respectable family man. Actually, any hunting leads I get are by-products of delightful evenings. Those rural church suppers are great fun."

Spring and summer exploring trips are always good bets for discovering places used by ducks. I once found a beaver pond loaded with baldpates when I was hunting mushrooms in late April. Another time I found a hidden backwater when I was exploring the trout-fishing possibilities of a small stream. Several times I've watched puddlers glide into isolated backwoods ponds when I was float-fishing rivers. Such spots should be marked down for investigation when waterfowl seasons are open.

Much of what I've said applies only to the states where local ducks are hatched and raised. But if you live in one of those states the rule is to keep your eyes and ears open no matter where you go in rural areas during the six months preceding opening dates of waterfowl seasons. You never know when you'll see ducks or hear tips on where flocks are located. Puddler ducks may set up housekeeping wherever there is water. Strangers can find these hot spots as well as residents. The rules of the game have nothing to do with how long you have lived in an area. Newcomers often cash in on the best waterfowling because they know how to find it.

29

Waterfowl Migration Patterns

They were big ducks, and they were interested in the oversized diver decoys in front of our floating blind.

"Cans!" Dick McCarty hissed.

The flock was 300 yards away, close-knit, boring straight at us. Then the wings starched and the big bodies were dipping in the approach pattern that makes a duck hunter's heart almost climb out of his throat. They sideslipped, dropped landing gear, then curved beyond the outside corner of the decoys. We heard the wind roar under their cupped wings in the same instant we saw the short necks and puffy round heads.

"Redheads!" we whispered in unison.

They picked up speed, banked, and barreled back. When we bounded upright they were 30 yards out, coming as if they intended to fly into the blind. Dick shot first, and a brilliantly colored drake cartwheeled. I fired as the flock flared, and shot under. A duck crumpled as Dick's gun roared again. My second shot connected and a drake tipped over and fell belly up.

That was the start of a long week of duck hunting back in 1958. We were on a lake close to my home on Lake Michigan's east shore. Dick, who passed on a few years ago, was a native of eastern Wisconsin. We met in college and began

hunting ducks together in 1943, sometimes on his side of the big lake, sometimes on mine. Though our homes were only 80 airline miles apart, we had long been puzzled by the striking differences in our home state waterfowling. That redhead action triggered another of our many discussions on the oddities and puzzles of duck migration.

How did it happen, we had wondered many times, that each fall there was excellent redhead shooting on the east side of Lake Michigan, but very little where Dick hunted, while his home area witnessed tremendous canvasback buildups but mine got very few cans?

"If ducks really follow north-to-south flyways we should see lots of both species on each side of the big lake," Dick remarked that morning.

"These redheads didn't migrate north to south," I told him. "Their main breeding range is in south-central Canada. They had to migrate east to get here. So do a lot of other ducks. Take cans, for example. You get good shooting on them, I don't, but they turn up again in the Lake Erie marshes 250 miles southeast of here. Maybe they fly nonstop from your section to there, then nonstop again in the same direction to Chesapeake Bay."

"And yet everybody has talked about four north-south flyways since the year one," Dick mused. "Just how do ducks and geese get from their nesting grounds to their winter homes?"

Countless hunters have pondered that same question.

"I don't know," I admitted. "Maybe someday there'll be a scientific study that will explain actual migration routes. If that ever happens I'll bet a couple million waterfowl hunters are going to have some food for thought."

Well, that scientific study became a reality a few years ago.

Quietly and without fanfare, a twenty-four-page report on waterfowl migration was published in June 1968 by the Illinois Natural History Survey. A carefully researched, in-depth study, it was authored by Frank C. Bellrose, a veteran wildlife specialist with the survey. Bellrose had been taking duck censuses, carrying out other waterfowl research, and recording the passage of ducks and geese through Illinois since 1938.

In the foreword of his report Bellrose said, "It has been over three decades since Frederick Lincoln defined and mapped the four waterfowl flyways of North American in 1935. Lincoln based his flyway maps entirely on banding data. No attempts

have been made since to update the maps of routes within the flyways. Numerous band recoveries provide evidence that flyway routes as outlined by Lincoln are in need of revision.

"Recently I was requested to prepare a report for the Bureau of Sports Fisheries and Wildlife on the migration paths of waterfowl within the Mississippi Flyway and across this flyway to the Atlantic Coast. Waterfowl biologists who saw drafts of my maps suggested improvements and extension of the regions covered. The project grew to include all areas of the United States east of the Rockies."

Frank Bellrose left few stones unturned. His findings are based on seven different information sources as contrasted with the late Fred Lincoln's one. The directions and paths taken by waterfowl flights were deduced from band recoveries, visual sightings from the ground and from aircraft, and radar surveillance. The number of birds using these routes of passage was determined from waterfowl counts during migration and from annual winter inventories.

In all, Bellrose and the people who assisted him analyzed some 75,000 recoveries resulting from the banding of 500,000 ducks and geese. Ground observers of the Mississippi Flyway Council cooperated with him for ten years in recording waterfowl sightings, and he collected reports of aircraft sightings from various sources in the North Central states for five years.

Radar operators at twenty-seven United States Weather Bureau stations, scattered over the entire country east from Minnesota and Texas, contributed reports of more than 45,000 radar sightings. Migrating flocks of waterfowl can be tracked by radar and their course determined, just as is done in the case of aircraft and ships. Because radar generally tracks only 25 to 50 miles out, and stations are about 250 miles apart, it is not possible to follow flights continuously. They can be kept track of as they move from one area to another across the continent, however, and the direction of the migration can be determined, affording a good idea of where the birds are going. Radar also reveals the density of a flight.

Finally, waterfowl censuses and winter inventories in the Atlantic, Mississippi and Central flyways were carefully evaluated by Bellrose and his staff. Then all the material was reviewed, and improvements to make it more accurate were suggested by representatives of the three flyway councils, the Bureau of Sport Fisheries and Wildlife, numerous refuge managers, game agents and waterfowl biologists.

In short, a staggering amount of detail was collected, analyzed and correlated.

Did the findings support the thirty-four-year-old concept of four separate flyways running north and south across the country? They did not. Instead, they came closer to blowing that concept into a myth.

The maps that accompany this chapter tell the story. They contain some real eye-openers for duck hunters.

Bellrose calls his mapped paths "migration corridors" rather than flyways, and they are far more numerous than the latter. His maps, bearing little resemblance to the flyway maps that have been published for more than a quarter-century, show dozens of such corridors, many of which do not follow a north-south direction but cross established flyway borders instead.

"Migration corridors differ from flyways in being smaller and more precisely defined," he explained, "and they often transcend flyways. Many flight corridors which cross the Central Flyway terminate in the Mississippi, and most of the corridors leading to wintering grounds in the Atlantic Flyway first cross the Mississippi to get there."

Bellrose makes the further point that often waterfowl do not take a beeline to their destination. They make major detours to reach good feeding and resting areas, then change direction when they leave to get back on the right course.

An interesting exception to flight corridors crossing flyway boundaries is the flights of 650,000 black ducks that move almost due south down both the Atlantic and Mississippi flyways from nesting grounds in New Brunswick, Quebec, Ontario, and the northern states eastward from Wisconsin.

The canvasback migration, on the other hand, affords an excellent illustration of a flight corridor running across flyways. Assembling in the Lake Winnipeg district of Manitoba, a major staging area for cans, redheads and bluebills, the canvasbacks migrate southeast. Some 250,000 of them show up each fall on the lower Detroit River and the western end of Lake Erie. Yet, of that number, no more than 15,000 winter in the Mississippi Flyway. The rest continue southeast to the Atlantic Coast, chiefly in the Chesapeake Bay area.

Another example concerns pintails that move south from northern latitudes into Nebraska. A few of the flocks continue in a southerly direction toward Texas, but the bulk of the flights veer west to winter in California and the west coast of Mexico.

The Bellrose maps make it clear that the flight corridors used by diving ducks

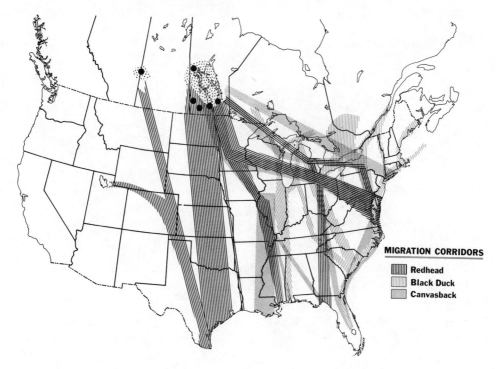

Flight corridors used by three duck species. Note that only black ducks fit long-held flyway theories.

Migration corridors used by divers east of the Rockies. These routes are distinct from those used by puddlers.

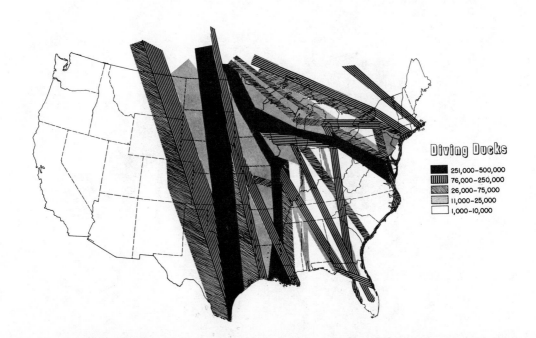

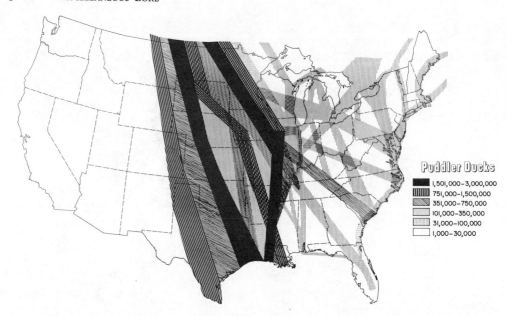

Migration corridors, by density, used by puddlers east of the Rockies. Note the prominent southeast flow.

Migration corridors used by fall flights of Canada geese. Goose migration routes vary dramatically from those used by ducks, and most do move basically from north to south.

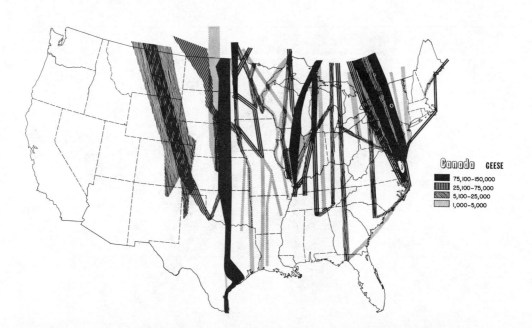

are distinct from those used by the puddlers. Diver hunters in states east of the Mississippi, who have complained for years that hunting regulations based largely on prairie mallard populations are unfair to them, are probably right.

Finally, the maps show that in most instances goose migration corridors vary dramatically from those used by ducks. The majority of the goose flights, Canadas, blues, and snows alike, do move basically from north to south.

In addition to his maps of flight corridors, Bellrose reported on the numbers of waterfowl that migrate each fall and on the makeup of the flights by species.

Despite periodic slumps in their populations, an average of about 17.5 million, not counting bluewing teal and the sea ducks, went south annually in the United States east of the Rockies from 1960 to 1966, he says. These were lean years, too.

Mallards and pintails made up half of the flights, with mallards alone accounting for 40 percent, or about 7 million birds. Bluebills, the most abundant of the diving ducks, constituted 15 percent of the total. Redheads were second in abundance among the divers.

Perhaps the most surprising original thing about the Bellrose findings was the stony silence with which they were received by waterfowl officialdom.

In carrying out his long study, and in the year it took him to put his findings together, the Illinois waterfowl specialist enjoyed the full cooperation of the Bureau of Sport Fisheries and Wildlife and of the game departments of many states.

"Without their unstinting help we could not have done the job," he said.

At the time the report was published, 3,000 copies were distributed to duck managers, state and federal game officials, outdoor writers, and others interested in waterfowl migration and management. In other words, all the government agencies that fix hunting regulations (based on flyway concepts now shown to be outdated) were fully aware of the study and its implications. Yet neither the bureau nor any state game department commented on the report or made any announcement of it.

The Bellrose findings constitute a major breakthrough in the scientific management of waterfowl. They say in effect that past policies and hunting regulations were based in part on incomplete or faulty information. They point the way toward more realistic regulations. In view of their importance it seemed mystifying that they did not attract more attention at the top levels of official waterfowl circles.

When I asked in 1968 about his agency's reaction to the report, John Gottschalk,

who was then director of the Bureau of Sport Fisheries and Wildlife, had this to say:

"The Bellrose findings are biologically sound, but management and regulation of ducks by the flight corridor idea would pose great difficulties in administration and enforcement. At present we see nothing more workable than the four-flyway concept. Admittedly it does not reflect the niceties of duck behavior. We know, for example, that migration routes and nesting and wintering areas may even change from year to year, depending on food and water conditions. But the flyway concept is the best tool we have for managing a continental waterfowl population."

In spite of official coolness to the Bellrose report, however, there has been growing evidence in recent years that the bureau is moving cautiously away from rigid management by flyways and in the direction the report recommends. The bonus seasons of the late 1960s on mallard drakes, in what the bureau called the High Plains Unit of the Central Flyway, was an excellent illustration.

The unit included part of Colorado east of the Continental Divide and those portions of Montana and Wyoming within the Central Flyway. The bonus seasons, on greenhead drakes only, ran from mid-December through early January, with a daily limit of four and possession limit of eight.

This came at a time when the continental mallard population was at a critically low level, but was based on the fact that the population in that unit was high and that there was an actual surplus of drakes, largely underhunted.

Gottschalk told me that a bonus season of this kind was first proposed by Montana game officials in 1965, three years before the Bellrose report appeared. "However, many of our staff people have read the report and it may have influenced them in favor of such a season," he conceded, adding, "We are constantly looking for ways to utilize underutilized waterfowl populations. That search has gone on for ten years."

In any case, the special seasons on mallard drakes and bonus scaup seasons through the 1970s is certainly the kind of thing Frank Bellrose had in mind when he wrote, "Migration corridors such as I have mapped provide a base for managing the duck kill on smaller regional areas than the present flyways."

I'll be the first to admit that duck hunters who study the maps and then throw their hats in the air and yell, "I told you so. We're being robbed!" will be making a big mistake. This report is no magic formula opening the door to longer seasons

and larger bag limits, things many hunters dream about. I view it only as a starting point, an important step that should result in a better understanding of the mysteries of migration, and pave the way for management policies in the 1980s in accordance with that understanding.

The average hunter tends to judge shooting restrictions in the light of duck conditions in his own area. But the odds against any one hunter's analyzing correctly the ups and downs of a continental crop are prohibitive. The annual harvest of waterfowl has to be controlled to prevent overhunting, according to information gathered by hundreds of specialists from all over the United States and Canada, not according to what you or I might like for our own local area.

It's a tough assignment, but I'm convinced the key field men and conservation department biologists are doing a conscientious job. I have good reason for saying that. As an outdoor magazine staff editor, I'm constantly involved with biologists and game officials from many states. I have yet to work with one who is not totally dedicated to his responsibilities, well qualified, and deeply interested in promoting better hunting and fishing.

I've heard the charge made time and again that the duck hunter's problem is that he represents such a small minority, about 2 million out of some 20 million hunters who buy licenses each fall, that officialdom doesn't worry much about his complaints. "Duck hunters just don't rate," one refuge man put it.

Federal officials wonder about these charges, however. They point to the many bonus seasons offered in the 1970s as proof they're trying to permit the maximum amount of duck hunting possible without endangering the future. The additional harvest opportunities available today indicate that modern waterfowl managers are indeed utilizing information such as the Bellrose report.

Everybody familiar with duck hunting puts a big share of the blame for restrictive regulations on the hunters themselves. The early teal seasons were a case in point. The Bureau of Sport Fisheries and Wildlife gave hunters thousands of extra days of sport. What the hunters (or at least some of them) gave themselves was a fat black eye. Wood ducks supposedly were shot in places where there was not a teal to be seen, and in all so many ducks were killed illegally that the special seasons were discontinued in 1968 while waterfowl managers evaluated bag statistics. The final report indicated that the illegal kill was not as bad as first indicated. The special teal seasons were still going in 1981.

As a biologist of the Colorado Game Research Center said, in connection with recent special mallard-drake seasons in that state, "It all boils down to one thing. If hunters will learn to identify ducks, and if they are willing to abide by the regulations, they can expect liberal seasons. But without such cooperation, officials must make overall rules that will protect the ducks that are in danger of being overharvested."

So the feeling persists with knowledgeable waterfowl managers that flyway-wide regulations are in need of a modern approach. The Bellrose report has plenty of new facts to justify additional new changes. Does it have enough dynamite in it to enable waterfowl hunters to stand up and be counted?

Maybe it does. For a sample of some of the dynamite, take a look at my home state of Michigan. It's located in the Mississippi Flyway and regulations for that entire flyway are based chiefly on mallard populations produced in the prairie-pothole regions of Canada and the North Central states. That's as it should be for such states as Minnesota, Iowa, Illinois, and Missouri. But the Bellrose map shows that while a major puddler corridor passes across all of those states, it doesn't even come close to Michigan.

In contrast, another of the maps shows one major and several submajor diver corridors crossing Michigan from west to east. Ed Mikula, waterfowl biologist of the Michigan Department of Natural Resources, tells me that diver hunting over open-water spreads accounts for twice as many man-days as any other method in this state. Bluebills make up a big share of the Michigan duck kill, and the experts all agree they are sometimes underharvested. Such knowledge resulted in bonus bluebill seasons that began in Michigan in 1970. During the following decade the huge flights of bluebills that normally crossed Michigan began shifting to a Mississippi River flyway route. As a result, the Michigan bonus season on these ducks was closed in 1980.

Kansas is another state that offers a sound argument against all-out regulations by flyways. It has a major corridor for diving ducks and another for puddlers, both passing dead center across the middle of the state. Though far removed from the prairie breeding grounds, it should show plenty of ducks during migration. It does, but not entirely for that reason. It also produces a lot of its own.

"If most of the ducks shot in Kansas were raised in the prairie factories to the north, we wouldn't see many until the flight reaches us," a biologist of the Game

Commission told me. "It doesn't work that way. Last fall we had 75,000 ducks on Cheyenne Bottoms alone two weeks before the season opened. We've got so many ducks that our hunters shake their heads when they read about shortages.

"We're in the middle of some of the best flyway corridors in the nation," he continued, "but that's not all. I don't think the federal people take into sufficient account how many ducks are produced outside the prairie regions. Bellrose tells of relatively stable numbers of migrants each fall, regardless of the success or failure of the prairie nesters. I think local hatches are one of the big reasons. Such theories should be investigated."

Among the many biologists, game managers, and veteran duck hunters in the Mississippi and Central flyway states with whom I discussed the Bellrose study, one complaint recurred again and again. All too often, hunting seasons don't coincide with migration schedules.

"The Bellrose report would be even more of a masterpiece if it pinpointed migration timetables," said an outdoor writer in South Dakota. "My state and Michigan are in approximately the same latitude, yet last fall Michigan's season ended while the second half of South Dakota's split season didn't open until a week later. Somebody guessed wrong. Bellrose has turned the spotlight on outdated flyway-concept management. It would be another big step in the right direction if we had sound information on average timetables in the various flight corridors."

That makes sense, but I had to remind him that nobody can control weather, and to a great degree weather controls migration.

I had an experience some years ago during the first week of October that shows how knotty that particular problem can be. I was on a moose hunt in the marsh areas of northern Manitoba, and those marshes were loaded with teal, both greenwings and bluewings. Twenty states had had a special teal season in September that year, designed to take advantage of migrations that are supposed to move down the Mississippi and Central flyways before the regular duck season opens. I guess those thousands of teal I saw didn't know they had been scheduled to go south a month earlier.

30

The Future:
The Beginning of Sense

During the early 1900s much talk and a profuse amount of writing about the senseless slaughter of waterfowl alarmed a great many people. They demanded some sort of governmental action that would adequately check the wanton slaughter. When the roar of the public became loud enough, corrective measures were studied and resulted in a series of federal controls.

In 1913, Congress passed the Weeks-McLean Act, prohibiting duck shooting in spring and summer. Then came the Migratory Bird Treaty Act between the United States and Canada in 1918, the Migratory Bird Conservation Act of 1929 (federal acquisition of waterfowl refuge areas), a treaty with Mexico in 1937, followed by such legislation as the Coordination of Wildfowl Conservation Activities Act, the Federal Aid to Wildlife Restoration Act and many others. The Migratory Bird Hunting Stamp Act of 1934 required duck hunters to purchase a federal duck stamp (originally $1, now $7.50) prior to hunting. This act began putting money in funds for beginning of restoration work.

The treaties with Canada and Mexico formed agreements to share the responsibility of perpetuating the migratory birds of the entire continent. More and more influential people became interested in these conservation movements, resulting in much publicity and nationwide acceptance. Market gunning and spring shooting had been outlawed. So had live decoys, bait, and guns over a 10-gauge size. Fall

shooting seasons had been cut in length, with restrictions on such factors as blinds, use of power boats, hunting hours, and number of birds killed. All of these timely restrictions put hunting of web-footed wildlife in a purely recreation category, luring most people into the erroneous belief that duck shooting had been saved forever.

Legislation in the early 1900s outlawed various types of hunting, but it was soon discovered that controlling the harvest effectively checked only a small part of total waterfowl losses. The 1935 International Wild Duck Census estimated only 42 million wild ducks left on the breeding range, less than one-fifth the estimated population in 1900. A United States biological survey was less optimistic. It offered a figure of 30 million over the entire continent. These startling figures brought realization that production of more birds was many times more important to salvation than control of gunning. The big question, of course, was, what had happened to conditions previously producing untold millions? To what factors could we attribute the blame?

Simply stated, it was man's conquest of water and marsh, the ingredients that constitute breeding grounds and home to all waterfowl. Without these basics ducks cannot live. Destroying the marshes and their water is more effective than poison. Man's drainage of the great prairie marshes began as a presumed agricultural necessity; it ended in realization that man himself suffered more than wildlife, for neither man nor birds can endure without water.

During the First World War, agricultural products brought high prices. Word from Washington promoted and encouraged production of more wheat, corn, and everything else the farmer could raise. Wild lands were cultivated; ponds, sloughs, and marshes were drained under instructions from the Department of Agriculture. Canadian marshes felt the drain pipes and irrigation ditches the same as ours. The Second World War and population explosions since demanded more and more food. Drainage projects continued unchecked. Was it all necessary?

It produced the strange situation of government funds paying farmers to curtail crop production, while at the same time subsidizing drainage to provide more tillable acres. The inconsistency is still compounded when the duck hunter pays for a federal waterfowl hunting stamp. The stamp funds are totally earmarked to acquire waterfowl nesting and refuge areas. Many of the lands authorized for acquisition or lease for waterfowl are the same lands Congress once voted to subsidize for drainage and increased crop production!

Conservationists are quick to acknowledge that agriculture comes first as food and ducks second as recreation. But, they say, if both can be maintained, with benefit to each other, then surely man will be the ultimate winner.

The importance of marsh to ducks takes in terrific scope. H. Albert Hochbaum, in his excellent book *The Canvasback on a Prairie Marsh*, concisely presents the picture:

> Man's attitudes towards a marsh and a mountain are much the same; both must be conquered. The mountain is conquered that it may be used, the marsh that man may be rid of it. The tedious conquest of the mountain is complete when its peak is scaled by automobiles; but, looming blue above the prairies, the mountain never loses all of its majesty, all of its mystery, nor quite all of its wilderness.
>
> The marsh is conquered easily, in the hope that we may have something "better" in its place. Such conquest is complete. An eagle still rides the wind above the mountain, but where the fens are gone the wild duck comes no more. A patch of nettles, parched and cracked earth, a swirl of dust on a summer day—that is the vanquished marsh.
>
> Look at the map of western Canada. Let your eye sweep from Winnipeg, in Manitoba, to Edmonton, in central Alberta. Above this line is the wilderness, all but townless. Below is the prairie. This is the land where wheatfields reach as far as the eye can see; where cattle roam boundless pastures; where horizons are marked only by grain elevators and mirage. This is the land of man's modern conquest. This was the vast land of marshes!
>
> But, still, this is the land of marshes. Many are gone where man must live; but on an April morning one may stand on a prairie knoll with his feet in pasque flowers, his head in the heavens, and see before him myriads of wildfowl on marshes reaching beyond the horizon. This will always be the land of marshes for man's values are changing. In many parts of this great prairie, restoration replaces conquest. Tules grow, water ripples, and wild ducks nest where there were no wild ducks in recent years. Conquests of man have pressed hard upon those borders, but there still exists a solitude as wild and clean and fresh as the peak of an unscaled mountain.

Man's values began their change, and restoration of his conquests spurted forward with the formation of Ducks Unlimited in 1937. The purpose of this nonprofit group of American sportsmen is simply to restore water to drained Canadian marshlands, control this water, and produce wild ducks under the management of skilled waterfowl technicians. The dominion and provincial governments of Canada

offered complete cooperation. Leading Canadian sportsmen and businessmen offered to help in every way possible. Canadian farmers, impoverished by drought, hailed the idea of damming up drainage ditches and restoring water for ducks as a boon not only to wildlife but to agriculture as well. They offered free use of their lands wherever needed. By February 1938, over $100,000 had been contributed by duck hunters. This sum increased to $20,239,789 in 1979 alone. During the last four years of the 1970s, Ducks Unlimited has netted nearly $60 million, or 55 percent of the $108,184,000 it has raised since 1937. Almost 82 percent of DU's total dollars has been raised since 1970, and most of the money has been spent on wetland conservation in Canada, where over 70 percent of North America's waterfowl are hatched. As a result, millions of acres of habitat have been reserved and developed to help stabilize continental waterfowl populations.

To add to and develop the millions of wetland acres already under its wing, DU set a 1980 fund-raising goal of $25 million. What will this money buy? Well, it will buy more than DU's 1979 program, which resulted in development of 78,900 acres and 601.5 shoreline miles of new nesting habitat. One hundred and thirty-eight waterfowl-producing projects were completed, and 22 more were scheduled to begin operation in the spring of 1980. Total habitat worked on in 1979 was 490,000 acres. This was part of the 1,659,126 acres of waterfowl habitat that DU has developed since 1937.

Such facts as these, coupled with the vast technical knowledge and accomplishment of United States and Canadian governments, tend to ensure that wild ducks have a very promising future. Reflect, for instance, that wild duck populations skyrocketed from a low of 30 million in the mid-1930s to over 150 million in the mid-1950s.

Much has been done; much knowledge has been assimilated. Much more is yet to be accomplished. But, as with all projects of such magnitude, money is only part of the act. Knowledge and proper management application will, in the end, determine ultimate success. In the 1930s nobody knew much about the problems of ducks. Facts had to be determined, evaluated, measured, and either adopted or dropped. These studies are still increasing in scope. Realms of knowledge have been originated, tested, and proved. Take migration, for instance.

Waterfowl migration is commonly considered as a mere north-south movement coinciding with seasons of weather. It is, however, such a complicated and mysteri-

ous condition of nature that it has aroused the interest and study of thinking men since the beginning of written history. Until recent years, motivation and direction of migration was only guessed at. Now certain facts can be stated with definite authority. (See Chapter 30 for complete details.)

Many migration truths have been determined through the extensive application of banding: a process of attaching a metal leg band to trapped birds, releasing them, then plotting movement of direction and distance at time of band recovery, usually by return from hunters.

The number of wild ducks that have been banded is fantastic. Many of these birds are trapped and banded on breeding marshes while flightless from molt. Eventual recovery of bands averages around 6 percent. Each band returned by a hunter brings prompt reply, telling where the bird was banded, when, and at what age. The United States Fish and Wildlife Service reports that over 16 million birds (of all species) have been banded, and a half million more are being added each year. Well over 1,250,000 recovery and return records are now available for study. From such extensive information general wild duck migration routes, distribution to wintering and breeding grounds, mortality, and other important factors have been determined, lending authoritative help to problems of regulation and management.

Such data have been the basis of management principles that have accomplished so much to date. What comes next? What is to become of the new facts that waterfowl managers will continue to discover? What processes or procedures do they visualize in achieving better duck hunting in the future? Just where are we heading? Where are we now?

The answer to the last question must be understood by the concerned duck hunter before he can appreciate the guidelines of waterfowl management. That answer is best presented with facts and statistics.

Duck hunting attracts far more attention than goose hunting, simply because there are a lot more ducks than geese. During recent years continental wild duck populations have averaged 100 million birds. Goose numbers have averaged about 4,500,000. But while goose populations have been increasing steadily, duck numbers have fluctuated greatly. In 1957—the best duck-hunting year in the 1950s—120 million ducks flew south. By 1961—only four years later—those enormous flocks had been reduced to only 77 million birds. That huge population drop was directly associated with drought in the prairie "duck factories." Is it any wonder

that marsh restoration and water-control projects are the most important keys to great duck hunting?

It's interesting to note how sales records of federal duck stamps reflect the highs and lows of our duck populations. In 1934, the first year the stamp was required of waterfowl hunters, sales totaled about 635,000. Annual sales passed 1 million in 1939, eventually peaking at nearly 2.5 million during the great hunting years of the mid-1950s. Then came the drought years of the early 1960s, and sales decreased to almost 1 million. As the flocks built back up, so did duck stamp sales. The total sold in 1979 was well over 2 million. Traditionally, the Mississippi Flyway has had the largest sales and the Atlantic Flyway the lowest. The Central Flyway usually takes second place, but it dropped to the last position when the prairie duck populations plunged during 1962–66. When the flocks rebuilt in the late 1960s the Central Flyway regained second place and has maintained this ranking.

There's another interesting fact that comes to light with the study of duck stamp sales. It appears that participation in waterfowl hunting depends on the amount of habitat for ducks in relation to the number of people in an area. A comparison of duck stamp sales with human populations shows that a high proportion of the resident population enjoys duck hunting in states such as North Dakota that have much habitat and few people. Conversely, in Pennsylvania and Ohio, where there is little habitat and large human populations, only a small percentage of the people hunt waterfowl. Perhaps California has more duck hunters than any other state, but only eight out of every 1,000 Californians go duck hunting.

How many ducks does the average hunter bag? The seasonal duck harvest is the largest in the Pacific Flyway, where the average kill is 10.1 birds per hunter. The smallest average seasonal bag is 4.2 ducks in the Atlantic Flyway. The figures for the Central and Mississippi flyways are 6.1 and 5.7 respectively. The average number of hunting trips made for waterfowl—both ducks and geese—has been highest in the Pacific Flyway, with a figure of 5.5. Trips per hunter have been lowest in the Atlantic Flyway, 4.8, and intermediate in the Central and Mississippi flyways, 5.1 each.

Harvest figures become more impressive when totals are considered. In 1957, United States hunters bagged over 12 million ducks. That kill dropped to a little more than 4 million in 1962 but bounced back to new modern highs in the 1970s. During those years about 15 million ducks were bagged annually in the United States and Canada. Normally, the largest share of the kill comes from the Missis-

sippi Flyway; the Pacific, Central, and Atlantic flyways place second, third, and fourth respectively.

It is well to keep in mind, however, that averages don't mean much when compared with hunter skill. A much different picture develops when it is realized that 10 percent of our duck hunters take over 80 percent of the total harvest. These dedicated hunters know how, when, and where to fill their limits more often than not. As pointed out elsewhere in this book, success in duck hunting depends more on knowledge of the game you're playing than any other type of hunting.

In any event, all duck hunters have to pay for duck stamps, hunting licenses, guns, and ammunition. It is these sales that supply much of the money used for restoration of habitat and the development of management techniques that will assure our future hunting opportunities. How much money is involved? Federal funds collected through excise taxes on hunting and fishing equipment totaled over $35 million during the first half of 1979 alone. A big portion of this was due to an upsurge in the sales of sporting arms and ammunition. Many people don't know that hunters pay the 11 percent excise tax when purchasing guns and shells. This is a tax that hunters actually asked to be levied. It was started back in 1937 by the famous Pittman-Robertson Aid in Wildlife Restoration Act. But it was in 1965 that the gunner really threw the public a curve. With excise taxes being lifted from a number of consumer items a new generation of hunters joined the shooting industry in insisting that the tax be maintained. The resulting sums are devoted to projects for the development of wildlife resources. Many waterfowl hunting areas owe their life to Pittman-Robertson money.

Through this tax sportsmen have paid about $550 million during the last thirty years. Waterfowl hunters specifically have paid more than $170 million in federal duck stamp fees. Such figures and statistics indicate that today's duck hunters are in a far more fortunate situation than were our counterparts back in the waterfowl depression days of the 1930s. In those days there was no money and little knowledge of waterfowl management. The question now is, where will our money and our technical abilities take us in our quest for better hunting?

In some ways the management of wild ducks will continue to be a baffling challenge, since the resource is here today and gone tomorrow. It's also a resource that roams the length and breadth of North America. For these reasons wild duck management requires a high level of cooperative work internationally as well as between and within states. It is a kind of management best handled through councils.

That is the reason why we have flyway councils today. The councils are made up of waterfowl experts and technicians—state, federal and international—who form committees to study and solve management problems. Each council's responsibility is to help develop and support a sound waterfowl management program for the future as well as the present.

Are the councils successful? In March 1969, the Bureau of Sport Fisheries and Wildlife's director, John Gottschalk, paid this tribute to the flyway councils: "The flyway councils established about twenty years ago were formulated for the express purpose of better waterfowl management. Next to the Migratory Bird Treaties, their creation is the most significant step that has ever been taken. They are excellent forums for communication, for understanding the problems, and for finding solutions in a cooperative, scientific way. The concepts and understanding developed by and through the councils are vital to proper waterfowl management."

Council studies have given us a very good picture of what future gunning opportunities may be. They point out that today's waterfowl populations are none too large for present public needs and that public needs of the future will be even greater. Any look into the future must begin with an analysis of what we have today.

The 1980s began with over 100 million game ducks, geese, and coots in North America. Waterfowl hunters in the United States approached 2 million; in Canada they numbered about 400,000. Habitat conditions (up until the droughts of 1980 and 1981) were the best since the mid-1950s. In the United States there were about 70 million acres of waterfowl habitat. Canada held at least 5 million basins capable of holding water on the prairies plus an extensive but undetermined number outside the prairie area. The wild duck crop of 1979 was the best of any year in modern history. Managers had every reason to believe that most of their programs were successful.

Future population goals for all waterfowl must be regarded as gross planning guides which cannot be static because the habitat which yields the waterfowl resource is not static. The greatest single management problem is to reserve enough suitable habitat to meet future needs of ducks and geese. The question is, can this habitat be retained if, as predicted, the "home" market (Canada and the United States) increases by some 50 million people and the world market for cereal grain doubles before the end of this century?

The key to the answer is in how much duck "real estate" private and government organizations can hold or control for the use of waterfowl. The Ducks Unlimited success story (there is now a Ducks Unlimited of Mexico too) is only one of the bright spots. Another good example is the Canadian Wildlife Service. In 1966 that organization initiated a $50 million habitat preservation program to be carried out over a ten-year period. In the United States the Bureau of Sport Fisheries and Wildlife set a goal in the early 1960s of acquiring 2.5 million acres of wetland habitat. For this purpose, Congress authorized a loan fund not to exceed $105,000,000. Duck stamp receipts are added to this figure. State programs are getting into the act also. Minnesota alone owns about 220,000 acres of wetlands.

Other ideas on how to hold wetland habitat are taking hold too. Easements on property instead of outright purchase permit each dollar to control more land. Private drainage problems may be reduced if landowners would find it equally as profitable, or more so, to preserve wetlands as to destroy them. This could come about by initiating a "water bank" concept styled after the soil bank programs that paid farmers not to grow crops. Other approaches could be legal in nature. A fine example is the so-called Reuss Amendment that now prohibits the Department of Agriculture from furnishing technical or financial assistance in draining of key wetlands. Another encouraging sign is that government agencies, such as the Soil Conservation Service, are working more and more with wildlife experts in the planning of watershed projects. The purpose is to determine how some change in plan or extra development might increase wetland areas instead of destroying them.

Private duck clubs enter into the picture too. In the Mississippi Flyway alone an estimated 5,000 waterfowling clubs control a minimum 2.5 million acres of waterfowl habitat. It's astonishing to learn that as much as 22 percent of the moderate-to-high-value waterfowl habitat south of Canada may be under duck-club control. This is fine, since clubs encourage production of ducks and they aid in waterfowl distribution by maintaining refuges and special restrictions. In addition, as gunning opportunities increase more hunters become interested in clubs. Consequently more private lands are purchased for club use and more habitat is developed. Waterfowl managers are identifying and formulating ways to assist clubs and other private wildlife-interest groups in intensifying and improving their wetlands.

The boom in farm ponds and large impoundments should be considered. Kansas alone boasts more than 100,000 farm ponds built on private property. Most land-

owners built their ponds for water storage and fishing opportunities, but a lot of them also produce ducks. There is no question that hundreds of thousands of ducks are now being produced in states south of the traditional nesting areas. Small ponds are being built on federal property too. Nearly 12,000 of them have been developed by the Bureau of Land Management in Montana and the Dakotas. Within ten years waterfowl production from BLM ponds is expected to include 200,000 ducks and 30,000 geese per year.

But managers know that well over 50 percent of the continent's waterfowl habitat is privately owned. They are striving to find ways to make consideration for wetlands a bigger part of overall land-use programs. Today, nobody can even guess at the huge numbers of extra ducks that could be produced if more private landowners became interested in the subject. Conservation agencies must play a more important role in tying private waterfowl management into the total program. All of these facts are encouraging signs that duck hunting could be better in the future than it is today.

But there are discouraging signs too. Overall losses in wetland habitat will continue to outweigh gains. Duck populations are too dependent on a habitat type that varies from excellent to terrible according to uncontrollable weather conditions. Ducks are less subject to management than geese. Modern agricultural practices benefit geese but are a detriment to ducks. On top of all this the human population explosion means an ever increasing number of hunters who must divide the harvest. Waterfowl managers estimate that the duck-hunting army will likely increase by 33 percent by the year 2000.

Wastage of birds will become increasingly important. In fact, reducing the amount of waste is one of the most promising ways of compensating for any loss in production. Increasing enforcement efficiency is one way to reduce waste. Another way is to clear up pollution and reduce losses from lead poisoning, botulism, fowl cholera, and other maladies. A third approach is through the reduction of crippling losses. All will require increased emphasis by the management agencies in the future.

That's the blackest side of the future picture that may prove to be not so black at all. Duck managers are likely to find ways to mitigate the extremes of duck populations during high and low population years. They concede that a high population year could show 150 million ducks over North America. That's about 50 million more than we had during the banner gunning years of the mid-1950's.

One of the biggest problems for biologists is to accurately determine how much wetland habitat is required to support 150 million ducks. Managers will have to determine how to distribute the enormous flocks that may be produced during top nesting years. In terms of people they agree that it's possible to provide fine shooting opportunities for up to 3 million gunners, far more than we have today. Waterfowl management's plan is to provide hunters with the opportunity to harvest an average of about eight ducks per individual per year. In other words, the goal is an overall fall harvest of as many as 20 million ducks during high population years.

To accomplish this managers will have to develop detailed data on the potential carrying capacity of the wetland habitat that we have now and will have in the future. So far, management techniques haven't been able to achieve the potential carrying capacity of some areas because there are two aspects to habitat evaluation. One has to do with production habitat, the other with migration and wintering grounds. The modern approach to this problem is to subdivide states and areas into units of study. The objective is to acquire a storehouse of information and facts concerning all the life phases of waterfowl, and to relate this information to estimated hunting pressure in each unit. This information is being acquired on a county basis. It will then be built into a unit level, then up to state level, and finally to the continental level. No one knows what the final results will imply, but it is reasonable to assume that managers will discover new and successful management techniques that can't even be guessed at today. Present models for management will likely change as the planning gets more sophisticated.

There are several other factors that make the modern duck hunter smile too. As human populations grow there seems to be a tendency on the part of some hunters to be satisfied with more artificial situations than we like to think of as ideal. The majority of gunners want to hunt the hard way—on their own—but others are content to hire guides, join clubs, or shoot on controlled hunting areas where fine shooting often comes easily. Another factor is the exploding number of shooting preserves where gunning flighted mallards can be enjoyed from September to March.

By far the biggest boon to the modern duck hunter is the management technique termed waterfowl species management. We'll discuss the subject in detail in the next chapter, but it should be mentioned here because it offers today's gunner many additional days in the field. Consider some facts.

A few years ago the total length of the duck season in many North Central states was forty days. Now gunners in these same states begin shooting in September during a species-management season on teal. Then comes a regular fifty-day season beginning in October. After that comes a point-system season stretching to mid-December. Because of extra hunting allowed through species-management applications, the gunning season jumped from forty days to nearly three months. That's the kind of hunting that the old-timers enjoyed during the good old days.

Index